Global.

That's the *Creativity Annual*. Each year, the book shows new and exciting work from all over the globe, from six continents. (And if penguins ever start creating ads and graphic design, we may have all seven continents.)

Local.

That's the *Creativity Annual*. Unlike many of the other annuals, *Creativity* recognizes great work, no matter where it originates. You are likely to see work in *Creativity* from Boston and Bangkok and Birmingham. The new technologies have leveled the playing field in the graphics world in recent years, and *Creativity* is the leader in showing great work from unexpected sources.

Big City.

That's the *Creativity Annual*. Yes, great local work is shown in *Creativity*. But so is some of the best work in the world from advertising and graphic design centers such as New York, Chicago, Los Angeles, London, Singapore, Hong Kong, Sydney, and others.

Fresh.

That's the *Creativity Annual*. New work. Fresh ideas. Always exciting. Always informative.

If you're in the creative world of advertising and graphic design, the *Creativity Annual* is the one source unlike all the others.

Editor

The **Creativity Annual** presents the winning entries from **Creativity 33**, an international advertising and design competition. From thousands of entries, an elite few are awarded The Gold Medal Ⓒ, identifying the work as "Best of the Best."

Table of Contents

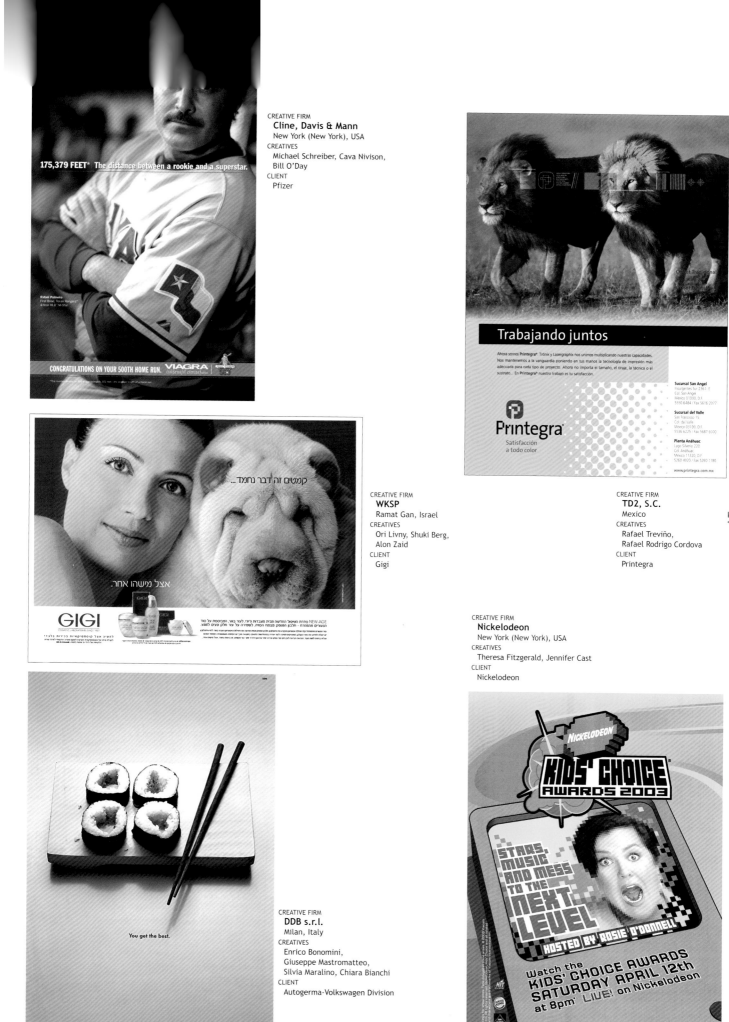

175,379 FEET* The distance between a rookie and a superstar.

Rafael Palmeiro
First Base, Texas Rangers
4-time MLB® All-Star

CONGRATULATIONS ON YOUR 500TH HOME RUN. VIAGRA (sildenafil citrate) tablets

CREATIVE FIRM
Cline, Davis & Mann
New York (New York), USA
CREATIVES
Michael Schreiber, Cava Nivison,
Bill O'Day
CLIENT
Pfizer

Trabajando juntos

Ahora somos **Printegra®** Trónix y Lasergraphix nos unimos multiplicando nuestras capacidades. Nos mantenemos a la vanguardia poniendo en tus manos la tecnología de impresión más adecuada para cada tipo de proyecto. Ahora no importa el tamaño, el tiraje, la técnica o el sustrato... En Printegra® nuestro trabajo es tu satisfacción.

Printegra®
Satisfacción
a todo color

Sucursal San Angel
Insurgentes Sur 2361-E
Col. San Angel
Mexico 01000, D.F.
5550 6484 / Fax 5616 2072

Sucursal del Valle
San Francisco 15
Col. del Valle
Mexico 03100, D.F.
5536 6225 / Fax 5687 6000

Planta Anáhuac
Lago Silverio 220
Col. Anáhuac
Mexico 11320, D.F.
5260 4020 / Fax 5260 1180

www.printegra.com.mx

CREATIVE FIRM
WKSP
Ramat Gan, Israel
CREATIVES
Ori Livny, Shuki Berg,
Alon Zaid
CLIENT
Gigi

CREATIVE FIRM
TD2, S.C.
Mexico
CREATIVES
Rafael Treviño,
Rafael Rodrigo Cordova
CLIENT
Printegra

5

קמטים זה דבר נחמד ...

אצל מישהו אחר.

GIGI

NEW AGE

CREATIVE FIRM
Nickelodeon
New York (New York), USA
CREATIVES
Theresa Fitzgerald, Jennifer Cast
CLIENT
Nickelodeon

You get the best.

CREATIVE FIRM
DDB s.r.l.
Milan, Italy
CREATIVES
Enrico Bonomini,
Giuseppe Mastromatteo,
Silvia Maralino, Chiara Bianchi
CLIENT
Autogerma-Volkswagen Division

Volkswagen Rentals.

NICKELODEON
KIDS' CHOICE AWARDS 2003

STARS, MUSIC AND MESS TO THE NEXT LEVEL

HOSTED BY ROSIE O'DONNELL

Watch the
KIDS' CHOICE AWARDS
SATURDAY APRIL 12th
at 8pm LIVE! on Nickelodeon

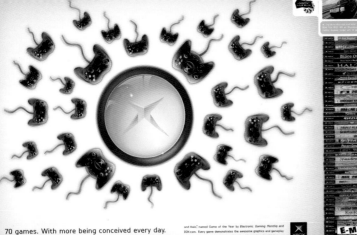

70 games. With more being conceived every day.

Explore the ever-expanding family of Xbox games, such as Spider-Man,™ The Movie, Tony Hawk's Pro Skater 3,™ RalliSport.™

and Halo,™ named Game of the Year by Electronic Gaming Monthly and IGN.com. Every game demonstrates the awesome graphics and gameplay only available on Xbox. So, stand back and watch us multiply.

XBOX

www.xbox.com

Some ag lenders are harder to fall in love with than others.

It's scary how much farmers are limited when it comes to securing a loan from most financial institutions. Farm Credit Services is staffed with ag lending experts who serve farmers exclusively — so we offer a wider array of loan products, with more flexible terms, than any other farm lender. We can even help you work interest rate changes to your advantage, especially with real estate loans. Ask a neighbor about us, then give us a call. You'll find our solutions attractive from any angle.

Farm Credit Services
OF ILLINOIS
We Understand

6

HAIR?

FAT CHANCE.

But you can influence
your kids'
decisions about drinking.

Kids do listen to parents about some things. In fact, on the subject of underage drinking, kids consider parents their number one influence.* Use that influence while you can. Talk to your kids about underage drinking now. For a free "Family Talk" guide, visit familytalkonline.com or call 1-800-359-TALK.

We All Make A Difference

*71% of 8-17 year olds, 2002 Roper Youth Report.

Not to mention the part you brought home.

IT'S ALL ABOUT BEING HERE
THE MEADOWLANDS

GIANTS STADIUM CONTINENTAL AIRLINES ARENA MEADOWLANDS RACE TRACK

Never Follow

AVOID THOSE
ANNOYING
WAKE-UP CALLS.

DON'T SLEEP.

BRECKENRIDGE

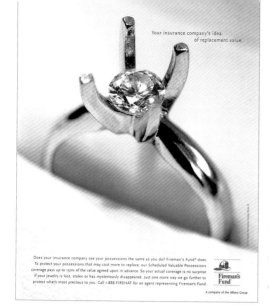

Your insurance company's idea
of replacement value.

Does your insurance company see your possessions the same as you do? Fireman's Fund® does.
To protect your possessions that may cost more to replace, our Scheduled Valuable Possessions
coverage pays up to 150% of the value agreed upon in advance. So your actual coverage is no surprise
if your jewelry is lost, stolen or has mysteriously disappeared. Just one more way we go further to
protect what's most precious to you. Call 1-888-FIREHAT for an agent representing Fireman's Fund.

Fireman's Fund
A company of the Allianz Group

CREATIVE FIRM
Gardner Geary Coll Inc.
San Francisco (California), USA
CREATIVES
Lee Mincy, Naomi Maloney,
Toby Burditt, John Coll
CLIENT
Fireman's Fund Insurance Co.

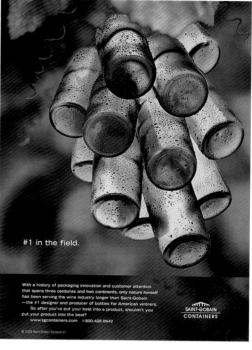

#1 in the field.

With a history of packaging innovation and customer attention
that spans three centuries and two continents, only nature herself
has been serving the wine industry longer than Saint-Gobain
—the #1 designer and producer of bottles for American vintners.
So after you've put your best into a product, shouldn't you
put your product into the best?
www.sgcontainers.com 1-800-428-8642

© 2023 Saint-Gobain Corporation

SAINT-GOBAIN
CONTAINERS

CREATIVE FIRM
The Weightmer Group
New York (New York), USA
CREATIVES
Ed Huber, Chris Collins,
Christo Holloway
CLIENT
Saint-Gobain

7

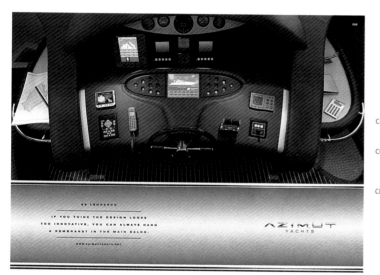

IF YOU THINK THE DESIGN LOOKS
TOO INNOVATIVE, YOU CAN ALWAYS HANG
A REMBRANDT IN THE MAIN SALON.
WWW.AZIMUTYACHTS.NET

AZIMUT
YACHTS

CREATIVE FIRM
DDB s.r.l.
Milan, Italy
CREATIVES
Enrico Bonomini,
Giuseppe Mastromatteo,
Alessandro Campani
CLIENT
Azimut S.P.A.

CREATIVE FIRM
Robin Gara Advertising
Cazenovia (New York), USA
CREATIVES
Robin Gara, Chris Collins
CLIENT
Oneida Ltd.

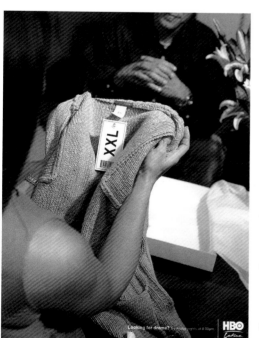

XXL

Looking for drama?

HBO
Latino

CREATIVE FIRM
**Dieste Harmel
& Partners**
Dallas (Texas),
USA
CREATIVES
Aldo Quevedo,
Carlos Tourné,
Alex Duplan,
Jaimé Andrade,
Christian Hoyle
CLIENT
HBO Latino

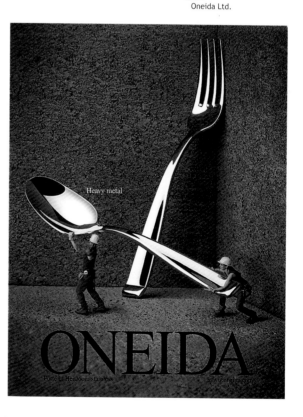

Heavy metal

ONEIDA

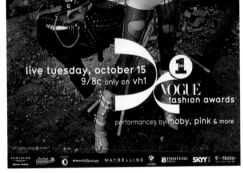

get ready

CREATIVE FIRM
McClain Finlon Advertising
Denver (Colorado), USA
CREATIVES
Dan Buchmeier,
Gregg Bergan,
Eric Liebhauser,
Jeff Martin
CLIENT
Foresight Ski Guides

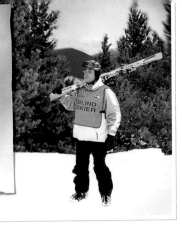

CREATIVE FIRM
VH1 Off Air Creative
New York (New York), USA
CREATIVES
Nigel Cox Hagen,
Phil Del Bourgo,
Nancy Mazzei,
Traci Terrill
CLIENT
VH1

8

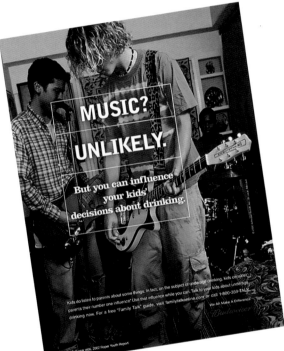

CREATIVE FIRM
Lawrence & Ponder Ideaworks
Newport Beach (California), USA
CREATIVES
Lynda Lawrence,
Matt McNelis,
Gary Frederickson
CLIENT
Fireman's Blend

CREATIVE FIRM
Rodgers Townsend
St. Louis (Missouri), USA
CREATIVES
Tim Varner,
Mike Dillon,
Evan Willnow
CLIENT
Anheuser-Busch Inc.

CREATIVE FIRM
McKinney & Silver
Raleigh (North Carolina), USA
CREATIVES
David Baldwin,
Jon Wagner,
Keith Greenstein,
Lara Bridger,
Mark Teringo,
Bob Ranew,
Tony Simmons,
Dino Valentini,
Barbara Eibel
CLIENT
Audi of America, Inc.

CREATIVE FIRM
J. Walter Thompson
New York (New York), USA
CREATIVES
Alex Wilcox,
Larry Silberfein,
Young Seo
CLIENT
Tanqueray

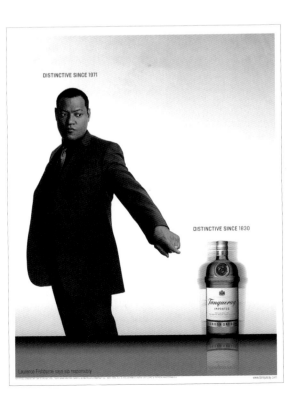

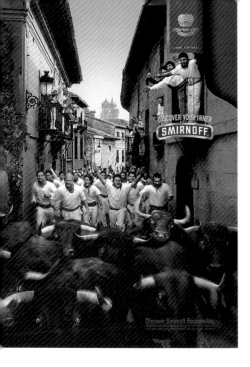

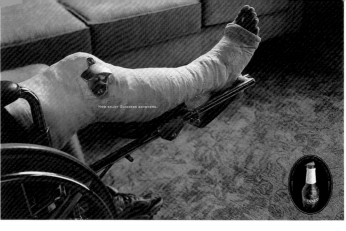

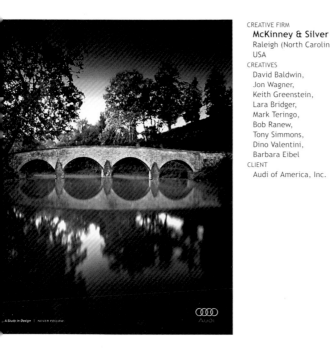

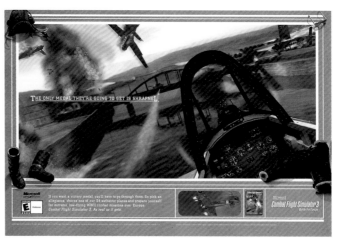

9

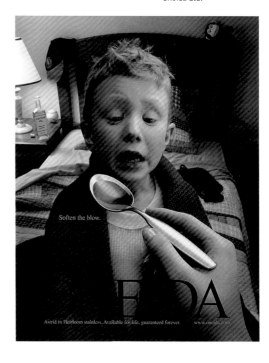

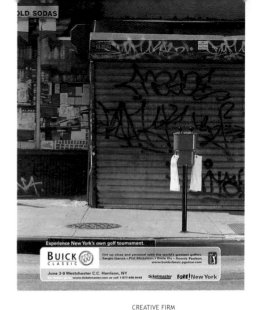

UNLIKE THEIR
CAMOUFLAGE COUSINS,
THESE WEREN'T
DESIGNED TO BLEND IN.

HUMMER
FOOTWEAR ♦ LIKE NOTHING ELSE.

10

Canon

IT SHED 30%

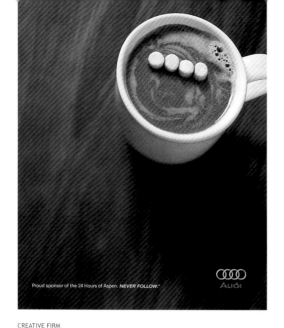

CREATIVE FIRM
BBDO N.Y.
New York (New York),
USA
CREATIVES
Ted Sann,
Gerry Graf,
Joel Rodriguez,
Harold Einstein
CLIENT
Guinness

Proud sponsor of the 24 Hours of Aspen. *NEVER FOLLOW.*

CREATIVE FIRM
McKinney & Silver
Raleigh (North Carolina), USA
CREATIVES
David Baldwin, Jon Wagner, Keith Greenstein,
Lara Bridger, Mark Teringo, Bob Ranew,
Tony Simmons, Dino Valentini, Barbara Eibel
CLIENT
Audi of America, Inc.

CREATIVE FIRM
McCann-Erickson Korea
Seoul, Korea
CREATIVES
Hae-Jung Park,
Ran-Hee Lee
CLIENT
Sony Korea

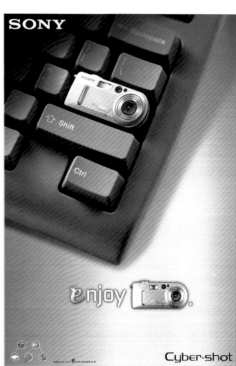

SONY

enjoy. Cyber-shot

11

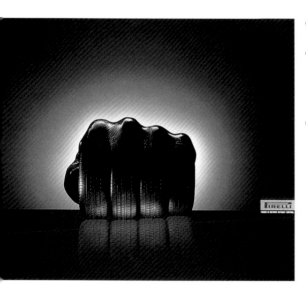

CREATIVE FIRM
Armando Testa
Torino, Italy
CREATIVES
Leonardo Nicastro,
Maurizio Sala,
Michele Mariani,
Davide Bodini,
Studio Immagine,
Carlo Pozzi
CLIENT
Giancarlo Rocco Di
Torrepadula

PIRELLI

CREATIVE FIRM
J. Walter Thompson
New York (New York), USA
CREATIVES
Michael Hart, Troy Scarlott, Alan Wolk
CLIENT
Ragu

UNLEADED FUEL?

JET FUEL?

CREATIVE FIRM
McKinney & Silver
Raleigh (North Carolina),
USA
CREATIVES
David Baldwin,
Jon Wagner,
Keith Greenstein,
Lara Bridger,
Mark Teringo,
Bob Ranew,
Tony Simmons,
Dino Valentini,
Barbara Eibel
CLIENT
Audi of America, Inc.

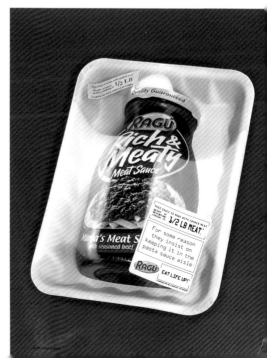

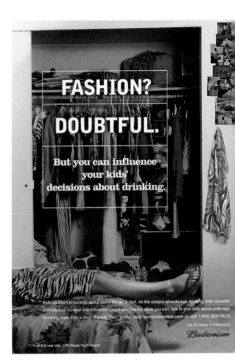

CREATIVE FIRM
Gardner Geary Coll Inc.
San Francisco (California), USA
CREATIVES
Lee Mincy, Naomi Maloney,
Deborah Jones, John Coll
CLIENT
Williams-Sonoma

CREATIVE FIRM
McKinney & Silver
Raleigh (North Carolina), USA
CREATIVES
David Baldwin, Jon Wagner, Dino Valentini
CLIENT
Full Frame Documentary Film Festival

CREATIVE FIRM
Rodgers Townsend
St. Louis (Missouri), USA
CREATIVES
Tim Varner, Mike Dillon,
Evan Willnow
CLIENT
Anheuser-Busch Inc.

12

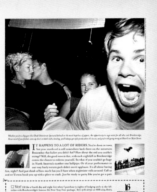

CREATIVE FIRM
McClain Finlon Advertising
Denver (Colorado), USA
CREATIVES
Gregg Bergan,
Jeff Martin,
Eric Liebhauser,
Robert Rasmussen
CLIENT
Breckenridge Ski Resort

CREATIVE FIRM
Dieste Harmel & Partners
Dallas (Texas), USA
CREATIVES
Aldo Quevedo, Carlos Tourné, Alex Duplan,
Jaimé Andrade, Christian Hoyle
CLIENT
HBO Latino

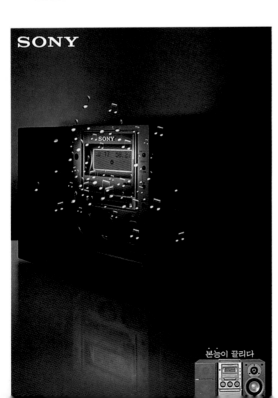

CREATIVE FIRM
McCann-Erickson Korea
Seoul, Korea
CREATIVES
Hae-Jung Park, Yun-Chun Kim,
Soo-Hee Yang, So-Hyun Park
CLIENT
Sony Korea

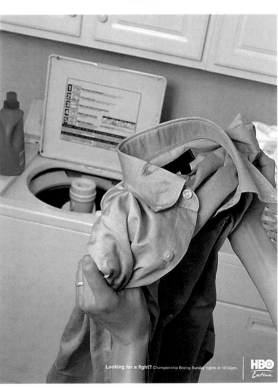

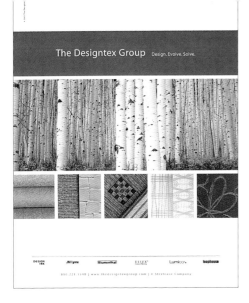

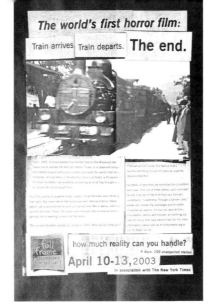

몸도 마음도 채웠는가?
6년근 명품 홍삼, 정관장

CREATIVE FIRM
flourish
Cleveland (Ohio), USA
CREATIVES
Christopher Ferranti, Henry Frey,
Steve Shuman
CLIENT
The Designtex Group

CREATIVE FIRM
McKinney & Silver
Raleigh (North Carolina), USA
CREATIVES
David Baldwin, Jon Wagner, Dino Valentini
CLIENT
Full Frame Documentary Film Festival

CREATIVE FIRM
McCann-Erickson Korea
Seoul, Korea
CREATIVES
Hae-Jung Park, Woo-Rack Ahn,
JH Cho, Jong-Eun Kim
CLIENT
KGC (Korea Ginseng Corp.)

CREATIVE FIRM
Grey Aarhus
Denmark
CREATIVES
Henry Rasmussen,
Thomas Hoffman
CLIENT
GRAM

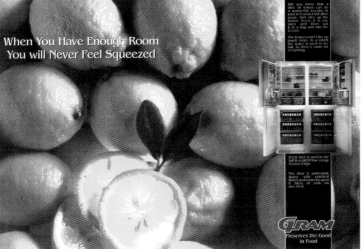

13

CREATIVE FIRM
McKinney & Silver
Raleigh (North Carolina), USA
CREATIVES
David Baldwin, Jon Wagner, Keith Greenstein,
Lara Bridger, Mark Teringo, Bob Ranew,
Tony Simmons, Dino Valentini, Barbara Eibel
CLIENT
Audi of America, Inc.

CREATIVE FIRM
BBDO N.Y.
New York (New York), USA
CREATIVES
Ted Sann, Gerry Graf,
Joel Rodriguez, Harold Einstein
CLIENT
Guinness

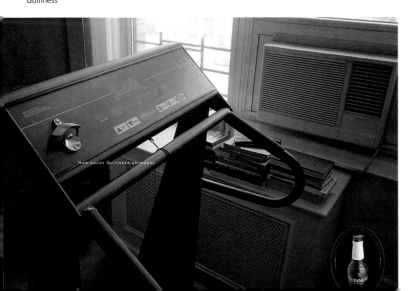

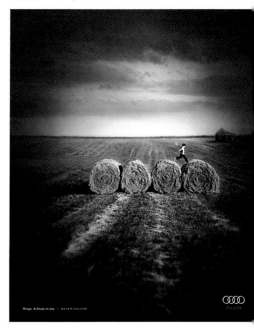

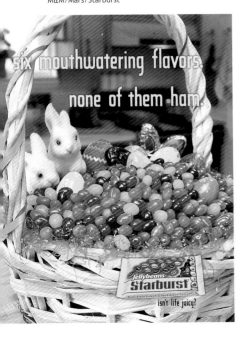

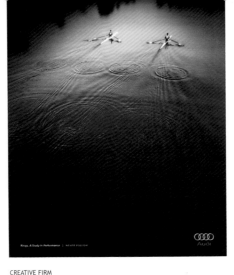

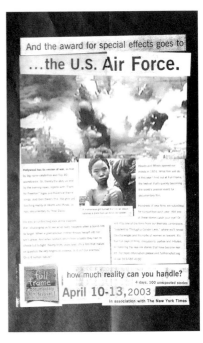

14

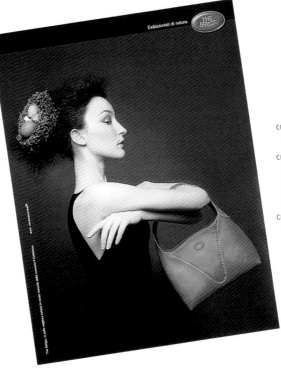

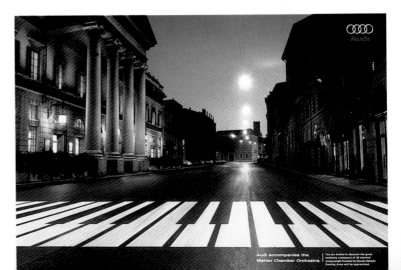

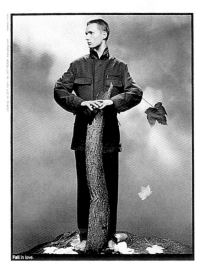

a l l e g r i

CREATIVE FIRM
Armando Testa
Torino, Italy
CREATIVES
Maurizio Sala, Michele Mariani,
Paola Balestrieri, Sonia Cosentino,
Philippe Cometti, Ugo Manzon,
Pier Paolo Pacchiarotti
Art+Commerce Paris
CLIENT
Dismi-Allegri

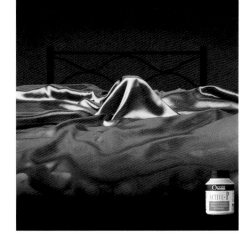

CREATIVE FIRM
Vibes Communications
Singapore
CREATIVES
Ronald Wong, Denis Ong,
Lee Jen, J-Studio
CLIENT
Ocean Health

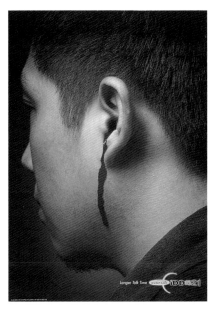

CREATIVE FIRM
Vibes Communications
Singapore
CREATIVES
Ronald Wong, Denis Ong,
Lee Jen, J-Studio
CLIENT
Sunpage IDD

CREATIVE FIRM
McKinney & Silver
Raleigh (North Carolina), USA
CREATIVES
David Baldwin, Jon Wagner,
Dino Valentini
CLIENT
Full Frame Documentary
Film Festival

15

CREATIVE FIRM
VH1 Off Air Creative
New York (New York), USA
CREATIVES
Nigel Cox Hagen, Nancy Mazzei,
Phil DelBargo, Traci Terrill
CLIENT
VH1

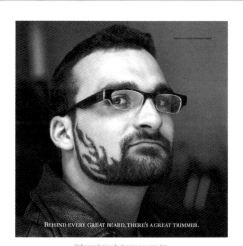

BEHIND EVERY GREAT BEARD, THERE'S A GREAT TRIMMER.

CREATIVE FIRM
Grey Worldwide N.Y.
New York (New York), USA
CREATIVES
Jonathan Mandell, Frank Krimmel,
Carmine Licata
CLIENT
Remington

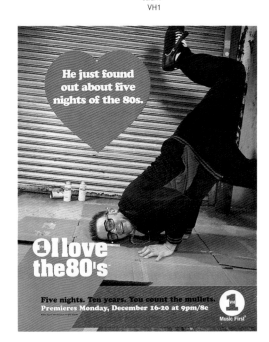

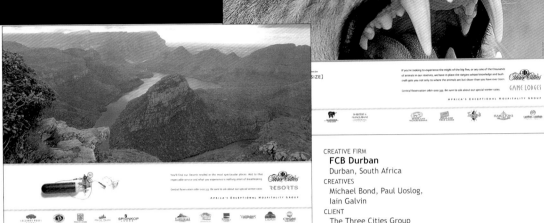

CREATIVE FIRM
FCB Durban
Durban, South Africa
CREATIVES
Michael Bond, Paul Uoslog,
Iain Galvin
CLIENT
The Three Cities Group

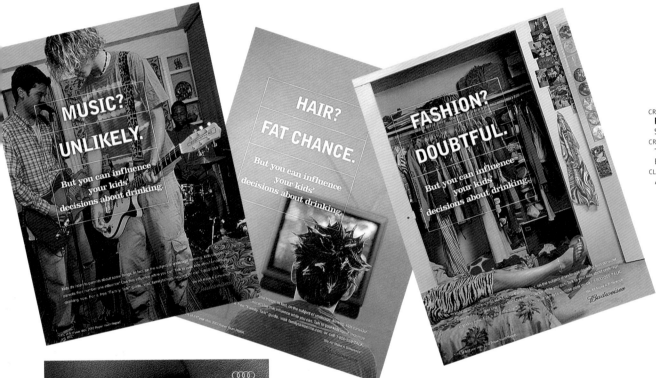

CREATIVE FIRM
Rodgers Townsend
St. Louis (Missouri), USA
CREATIVES
Tim Varner, Mike Dillon,
Evan Willnow
CLIENT
Anheuser-Busch Inc.

CREATIVE FIRM
McKinney & Silver
Raleigh (North Carolina), USA
CREATIVES
David Baldwin, Jon Wagner,
Keith Greenstein, Lara Bridger,
Mark Teringo, Bob Ranew,
Tony Simmons, Dino Valentini,
Barbara Eibel
CLIENT
Audi of America, Inc.

SAFELY REMOVES REALLY
BAD PET STAINS.
AS IF THERE ARE ANY
GOOD ONES.

OxiClean lifts out the worst organic stains and odors from your carpet and upholstery, without the damaging effects of chlorine bleach. Perhaps today will be the day you reclaim your home territory from your pets.

Millions believe for a reason.

UNTIL KIDS FIGURE OUT
THE DIFFERENCE BETWEEN
A SLEEVE AND A NAPKIN.

OxiClean attacks organic stains and odors in laundry (and carpets, for that matter) and lifts them out like magic. And it's color safe, so it won't damage fabrics the way chlorine bleach will. Which is more than can be said for your children.

Millions believe for a reason.

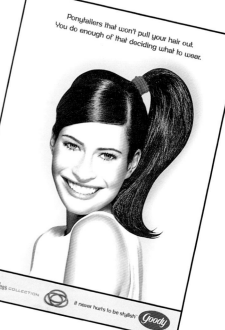

HELPING TEENS COVER UP
HOUSE PARTIES SINCE 1992.

OxiClean attacks stains on carpet and upholstery, and lifts them out like magic. Its color safe, too, so it won't damage fabrics the way chlorine bleach will. As a parent, you may have already seen it in action. Whether you know it or not.

Millions believe for a reason.

CREATIVE FIRM
McClain Finlon Advertising
Denver (Colorado), USA
CREATIVES
Gregg Bergan, Jeff Martin
CLIENT
Orange Glo

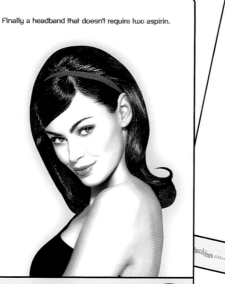

Remember the special moments, Not the mess you left behind.

Simple Green® is the economical and safer alternative cleaner that works on any washable surface. Trust in Simple Green, and enjoy the moments that make memories.

Experience a world of safer cleaning: www.simplegreen.com

CREATIVE FIRM
Sunshine Makers, Inc.
Huntington Beach (California), USA
CREATIVES
Norman Lao, Wesley J. Su,
Russ Scott
CLIENT
Simple Green

17

Remember the special moments, Not the mess left behind

Simple Green® is the economical and safer alternative cleaner that works on any washable surface. Trust in Simple Green, and enjoy the moments that make memories.

Experience a world of safer cleaning: www.simplegreen.com

CREATIVE FIRM
McCann-Erickson
New York (New York), USA
CREATIVES
Steve Ohler, Jeff DiFiore,
Melissa Bonazzi
CLIENT
Goody

Finally a headband that doesn't require two aspirin.

THE timeless COLLECTION it never hurts to be stylish™ goody

Ponytailers that won't pull your hair out.
You do enough of that deciding what to wear.

timeless COLLECTION it never hurts to be stylish™ goody

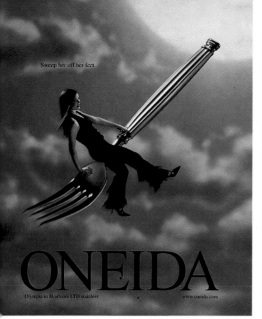

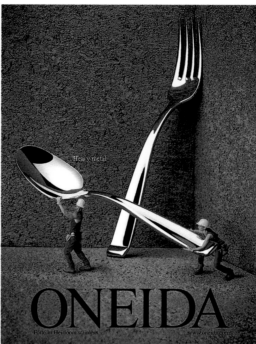

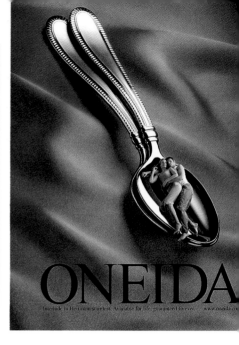

18

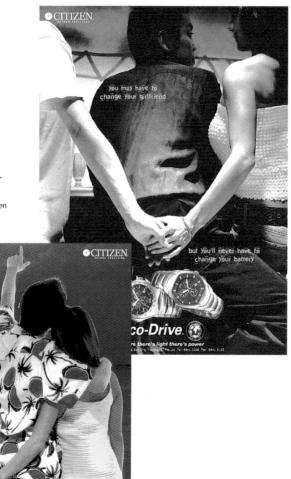

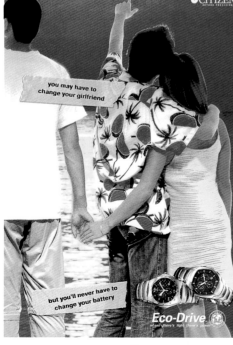

19

a square peg for your round hole.

there's more than one way to share a starburst.

Starburst
isn't life juicy?

let the mooching begin.

Starburst
isn't life juicy?

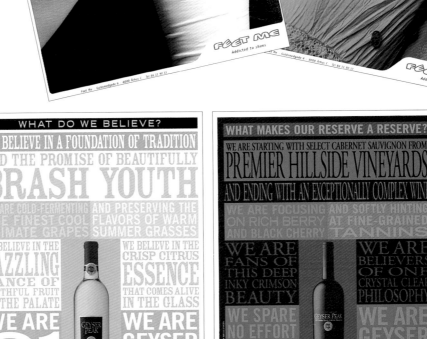

20

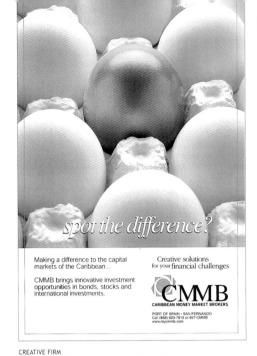
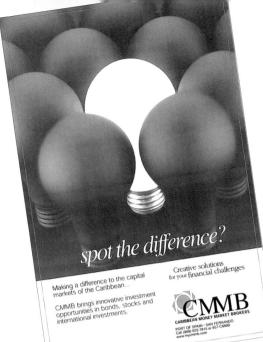
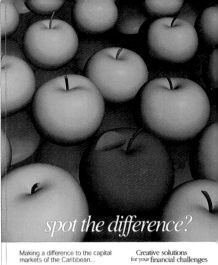

spot the difference?

Making a difference to the capital markets of the Caribbean...

CMMB brings innovative investment opportunities in bonds, stocks and international investments.

Creative solutions for your financial challenges

CMMB
CARIBBEAN MONEY MARKET BROKERS
PORT OF SPAIN · SAN FERNANDO
Call (868) 623-7815 or 657-CMMB
www.mycmmb.com

CREATIVE FIRM
All Media Projects Limited (Ample)
Trinidad & Tobago, West Indies
CREATIVES
Glen Forte, Nicole Jones
CLIENT
Caribbean Money Market Brokers (CMMB)

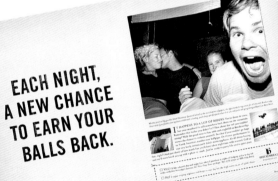

EACH NIGHT, A NEW CHANCE TO EARN YOUR BALLS BACK.

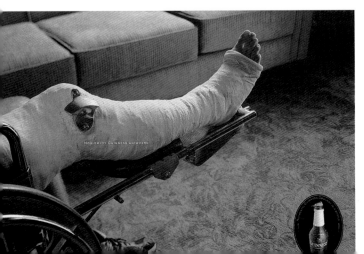

THE HILL MAY DOMINATE YOU.

BUT THE TOWN WILL STILL BE YOUR BITCH.

CREATIVE FIRM
McClain Finlon Advertising
Denver (Colorado), USA
CREATIVES
Gregg Bergan,
Jeff Martin,
Eric Liebhauser,
Robert Rasmussen
CLIENT
Breckenridge Ski Resort

21

CREATIVE FIRM
BBDO N.Y.
New York (New York), USA
CREATIVES
Ted Sann, Gerry Graf, Joel Rodriguez, Harold Einstein
CLIENT
Guinness

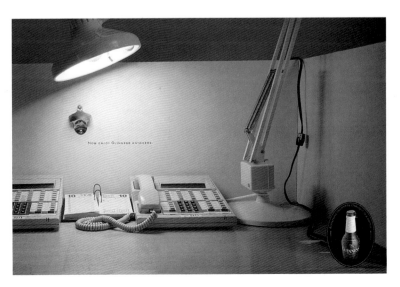

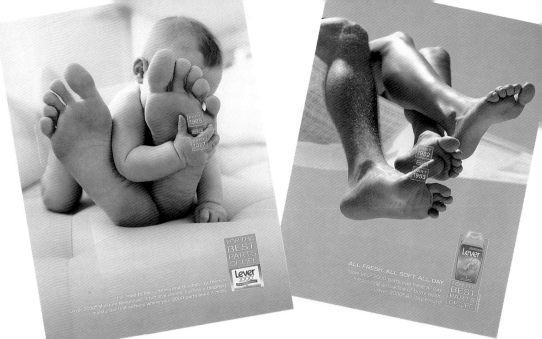

CREATIVE FIRM
J. Walter Thompson
New York (New York), USA
CREATIVES
Michael Hart, Denise Reynolds,
Mary Anne Infante
CLIENT
Lever 2000

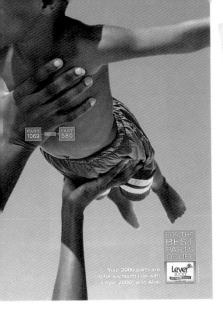

JUST BECAUSE YOUR SON
THROWS LIKE A GIRL, IT DOESN'T MEAN
HE HAS TO EAT LIKE ONE.

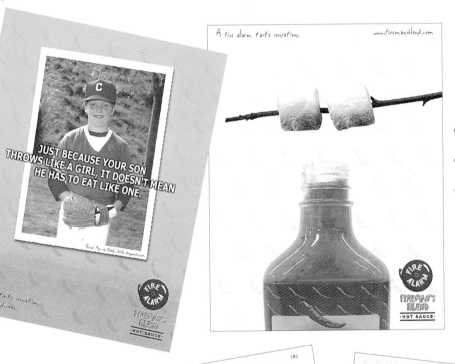

CREATIVE FIRM
Lawrence & Ponder Ideaworks
Newport Beach (California), USA
CREATIVES
Lynda Lawrence, Matt McNelis,
Gary Frederickson
CLIENT
Fireman's Blend

CREATIVE FIRM
J. Walter Thompson
New York (New York), USA
CREATIVES
Ed Evangelista, Chris D'Rozario,
Jay Sharfstein, Can Williamson
CLIENT
Diamond Trading Company

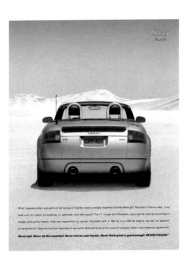

CREATIVE FIRM
McKinney & Silver
Raleigh (North Carolina), USA
CREATIVES
David Baldwin, Jon Wagner, Keith Greenstein, Lara Bridger, Mark Teringo, Bob Ranew, Tony Simmons, Dino Valentini, Barbara Eibel
CLIENT
Audi of America, Inc.

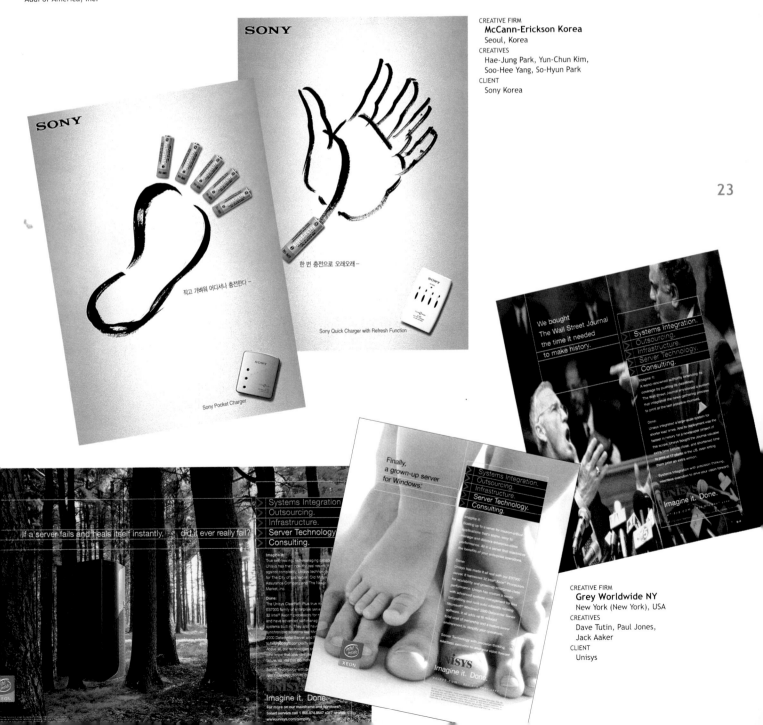

CREATIVE FIRM
McCann-Erickson Korea
Seoul, Korea
CREATIVES
Hae-Jung Park, Yun-Chun Kim, Soo-Hee Yang, So-Hyun Park
CLIENT
Sony Korea

23

CREATIVE FIRM
Grey Worldwide NY
New York (New York), USA
CREATIVES
Dave Tutin, Paul Jones, Jack Aaker
CLIENT
Unisys

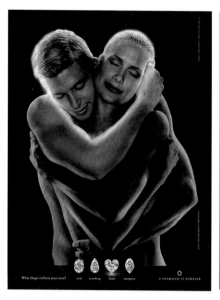
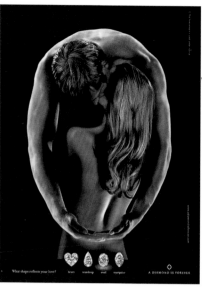
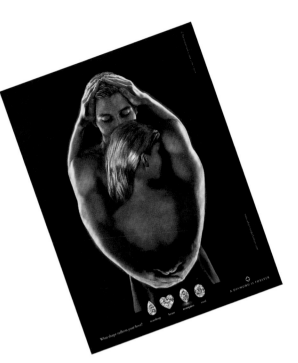

CREATIVE FIRM
J Walter Thompson
New York (New York), USA
CREATIVES
Chris D'Rozario, Ed Evangelista,
Erik Izo, John Wagner
CLIENT
Diamond Trading Company

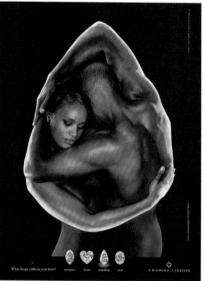

24

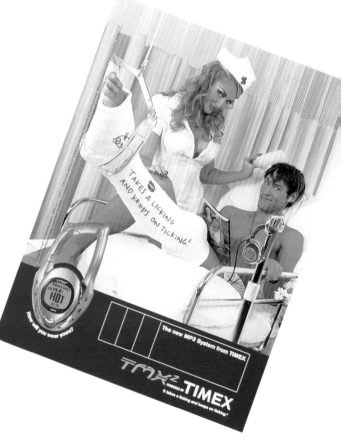

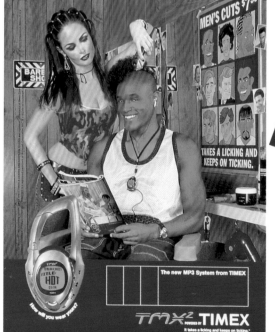

CREATIVE FIRM
The Sloan Group
New York (New York), USA
CREATIVES
Wyndy Wilder, Cliff Sloan
CLIENT
Timex

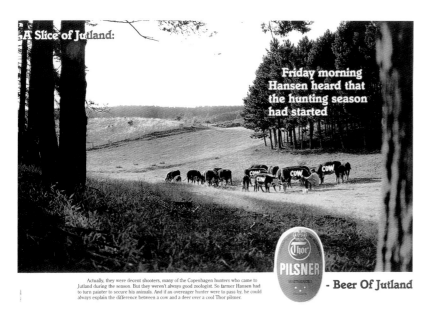

A Slice of Jutland:

Friday morning Hansen heard that the hunting season had started

Actually, they were decent shooters, many of the Copenhagen hunters who came to Jutland during the season. But they weren't always good zoologist. So farmer Hansen had to turn painter to secure his animals. And if an overeager hunter were to pass by, he could always explain the difference between a cow and a deer over a cool Thor pilsner.

- Beer Of Jutland

CREATIVE FIRM
Grey Aarhus
Denmark
CREATIVES
Henry Rasmussen, Gaba Jensen
CLIENT
Thor Pilsner

Phase 2 Personal Training / 919 872 8007 / www.phase2personaltraining.com

CREATIVE FIRM
McKinney & Silver
Raleigh (North Carolina), USA
CREATIVES
David Baldwin, Lisa Shimotakahara,
Philip Marchington
CLIENT
Phase II

25

UNDERSTANDING BUSINESS FROM THE INSIDE OUT.

CREATIVE FIRM
Rodgers Townsend
St. Louis (Missouri), USA
CREATIVES
Michael McCormick,
Luke Partridge,
Evan Willnow
CLIENT
St. Louis Post-Dispatch

CREATIVE FIRM
Rodgers Townsend
St. Louis (Missouri), USA
CREATIVES
Michael McCormick, Luke Partridge,
Evan Willnow
CLIENT
SBC Corporation

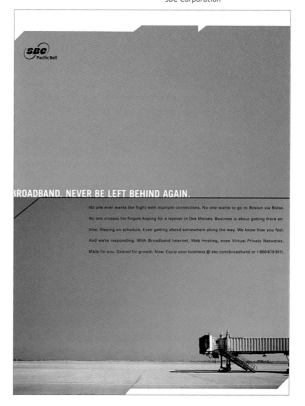

BROADBAND. NEVER BE LEFT BEHIND AGAIN.

No one ever wants the flight with multiple connections. No one wants to go to Boston via Boise. No one crosses his fingers hoping for a layover in Des Moines. Business is about getting there on time. Staying on schedule. Even getting ahead somewhere along the way. We know how you feel. And we're responding. With Broadband Internet, Web Hosting, even Virtual Private Networks. Made for you. Geared for growth. Now. Equip your business @ sbc.com/broadband or 1-800-679-9111.

CREATIVE FIRM
McKinney & Silver
Raleigh (North Carolina), USA
CREATIVES
David Baldwin,
Jon Wagner,
Dino Valentini,
Bob Ranew,
Tony Simmons,
Mark Teringo,
Barbara Eibel,
Keith Greenstein
CLIENT
Audi of America, Inc.

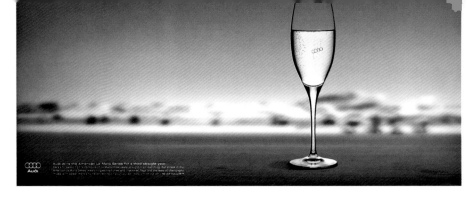

CREATIVE FIRM
McKinney & Silver
Raleigh (North Carolina), USA
CREATIVES
David Baldwin, Jon Wagner, Dino Valentini, Bob Ranew,
Tony Simmons, Mark Teringo, Barbara Eibel, Keith
Greenstein
CLIENT
Audi of America, Inc.

CREATIVE FIRM
McKinney & Silver
Raleigh (North Carolina), USA
CREATIVES
David Baldwin, Lisa Shimotakahara,
Philip Marchington
CLIENT
Bikram's Hot Yoga

CREATIVE FIRM
Rodgers Townsend
St. Louis (Missouri), USA
CREATIVES
Mark Motley,
Kris Wright
Evan Willnow,
Michael McCormick,
CLIENT
Ameren Corporation

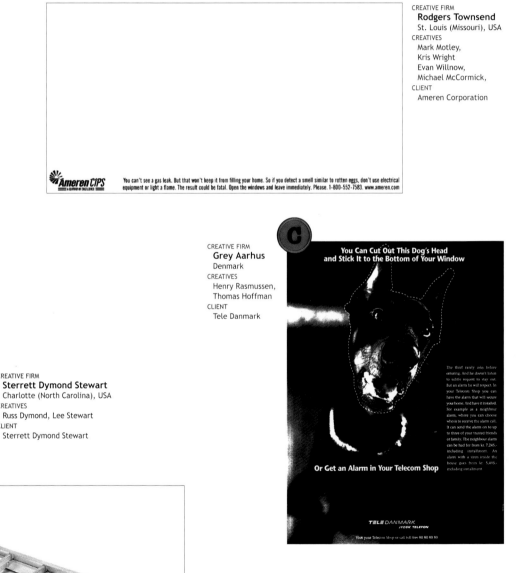

CREATIVE FIRM
Grey Aarhus
Denmark
CREATIVES
Henry Rasmussen,
Thomas Hoffman
CLIENT
Tele Danmark

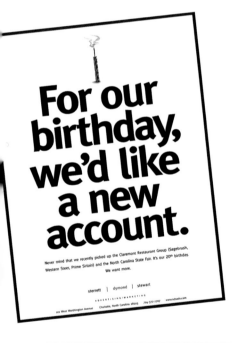

For our birthday, we'd like a new account.

Never mind that we recently picked up the Claremont Restaurant Group (Sagebrush, Western Steer, Prime Sirloin) and the North Carolina State Fair. It's our 20th birthday.
We want more.

sterrett | dymond | stewart
ADVERTISING/MARKETING
101 West Worthington Avenue Charlotte, North Carolina 28203 704-372-3702 www.sdstudio.com

CREATIVE FIRM
Sterrett Dymond Stewart
Charlotte (North Carolina), USA
CREATIVES
Russ Dymond, Lee Stewart
CLIENT
Sterrett Dymond Stewart

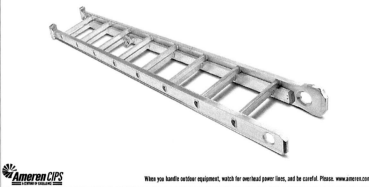

CREATIVE FIRM
Rodgers Townsend
St. Louis (Missouri), USA
CREATIVES
Mark Motley,
Kris Wright,
Michael McCormick,
Evan Willnow,
CLIENT
Ameren Corporation

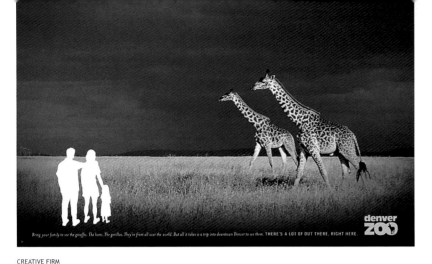

CREATIVE FIRM
McClain Finlon Advertising
Denver (Colorado), USA
CREATIVES
Jeff Martin, Gregg Bergan, Tom Leydon
CLIENT
Denver Zoo

Hoje é dia dos Einsteins e dos Da Vincis.

Escolhemos dois grandes ícones da ciência e das artes para, através deles, homenagear todos aqueles que trabalham pela ciência e pela cultura.
Todos aqueles que fazem de suas vidas um meio de produção e difusão do conhecimento.
O que faz a grande diferença do homem em relação às outras espécies.
Que o faz único, capaz de operar verdadeiros milagres no campo da ciência e das artes, como, por exemplo, a Teoria da Relatividade e a Mona Lisa.
Que o faz evoluir:
Para essas pessoas, entre elas nossos professores, alunos e ex-alunos, uma salva de palmas.

5 DE NOVEMBRO.
Dia de Ciência e da Cultura.

Na Unama, todo dia é dia da Ciência e da Cultura.

Unama
Universidade da Amazônia
Educação para o desenvolvimento da Amazônia.

CREATIVE FIRM
Mendes Publicidade
Belém, Brazil
CREATIVES
Oswaldo Mendes, Maria Alice Penna, Antônio Moura
CLIENT
Unama

CREATIVE FIRM
McKinney & Silver
Raleigh (North Carolina), USA
CREATIVES
David Baldwin, Lisa Shimotakahara, Philip Marchington
CLIENT
Bikram's Hot Yoga

CREATIVE FIRM
McKinney & Silver 27
Raleigh (North Carolina), USA
CREATIVES
David Baldwin, Jon Wagner, Dino Valentini, Bob Ranew, Tony Simmons, Mark Teringo, Barbara Eibel, Keith Greenstein
CLIENT
Audi of America, Inc.

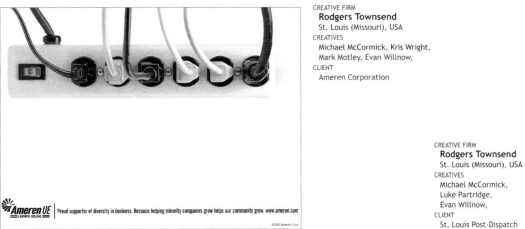

Ameren UE | Proud supporter of diversity in business. Because helping minority companies grow helps our community grow. www.ameren.com

©2002 Ameren Corp

CREATIVE FIRM
Rodgers Townsend
St. Louis (Missouri), USA
CREATIVES
Michael McCormick, Kris Wright, Mark Motley, Evan Willnow,
CLIENT
Ameren Corporation

CREATIVE FIRM
Rodgers Townsend
St. Louis (Missouri), USA
CREATIVES
Michael McCormick, Luke Partridge, Evan Willnow,
CLIENT
St. Louis Post-Dispatch

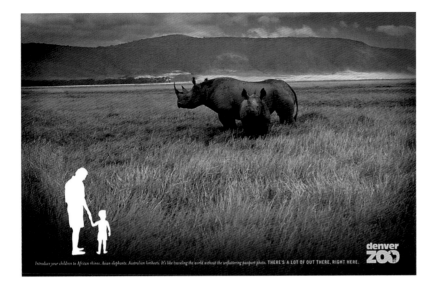

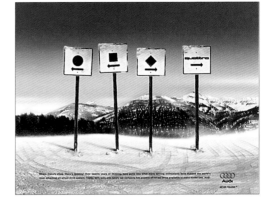

CREATIVE FIRM
McClain Finlon Advertising
Denver (Colorado), USA
CREATIVES
Jeff Martin, Gregg Bergan,
Tom Leydon
CLIENT
Denver Zoo

CREATIVE FIRM
McKinney & Silver
Raleigh (North Carolina), USA
CREATIVES
David Baldwin, Jon Wagner, Dino Valentini, Bob Ranew,
Tony Simmons, Mark Teringo, Barbara Eibel, Keith
Greenstein
CLIENT
Audi of America, Inc.

play ground centre forward goal

enjoy the kick

CREATIVE FIRM
Mudra Communications Pvt. Ltd.
Ahmedabad, India
CREATIVES
Sajit Surendran, Nitin Pradhan
CLIENT
Dairy Den Ltd.

CREATIVE FIRM
Rodgers Townsend
St. Louis (Missouri), USA
CREATIVES
Tom Townsend, Luke Partridge,
Tom Hudder
CLIENT
SBC Corporation

CREATIVE FIRM
McKinney & Silver
Raleigh (North Carolina), USA
CREATIVES
David Baldwin, Jon Wagner, Dino Valentini
CLIENT
Full Frame Documentary Film Festival

CREATIVE FIRM
Rodgers Townsend
St. Louis (Missouri), USA
CREATIVES
Michael McCormick,
Luke Partridge,
Evan Willnow,
CLIENT
St. Louis Post-Dispatch

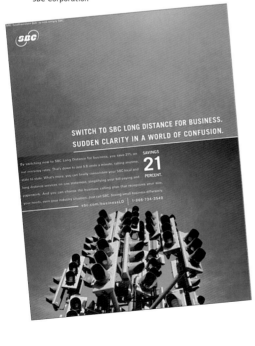

SWITCH TO SBC LONG DISTANCE FOR BUSINESS.
SUDDEN CLARITY IN A WORLD OF CONFUSION.

SAVINGS
21
PERCENT.

sbc.com/businessLD 1-866-734-3540

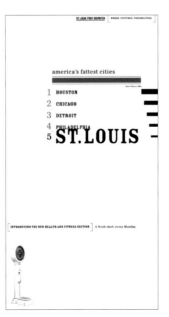

america's fattest cities

1 HOUSTON
2 CHICAGO
3 DETROIT
4 PHILADELPHIA
5 **ST.LOUIS**

INTRODUCING THE NEW HEALTH AND FITNESS SECTION A fresh start, every Monday.

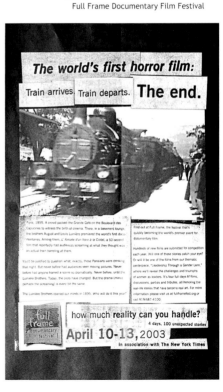

The world's first horror film:

Train arrives. Train departs. **The end.**

how much **reality** can you handle?
4 days, 100 unexpected stories

April 10-13, 2003

In association with The New York Times

CREATIVE FIRM
Lawrence & Ponder Ideaworks
Newport Beach (California), USA
CREATIVES
Lynda Lawrence, Matt McNelis,
Gary Frederickson
CLIENT
Salon Platinum

CREATIVE FIRM
Rodgers Townsend
St. Louis (Missouri), USA
CREATIVES
Michael McCormick, Luke Partridge,
Evan Willnow
CLIENT
SBC Corporation

CREATIVE FIRM
Grey Aarhus
Denmark
CREATIVES
Henry Rasmussen, Gaba Jensen
CLIENT
Thor Pilsner

29

CREATIVE FIRM
McKinney & Silver
Raleigh (North Carolina), USA
CREATIVES
David Baldwin, Lisa Shimotakahara,
Philip Marchington
CLIENT
Phase II

CREATIVE FIRM
McKinney & Silver
Raleigh (North Carolina), USA
CREATIVES
David Baldwin, Jon Wagner, Dino Valentini
CLIENT
Full Frame Documentary Film Festival

CREATIVE FIRM
Rodgers Townsend
St. Louis (Missouri), USA
CREATIVES
Michael McCormick,
Luke Partridge,
Evan Willnow
CLIENT
St. Louis Post-Dispatch

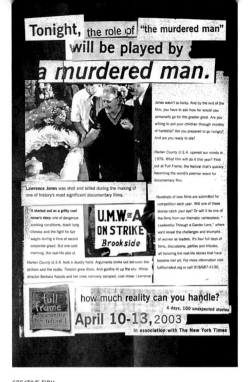

30

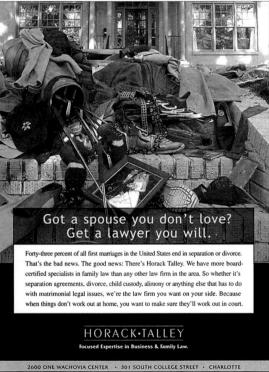

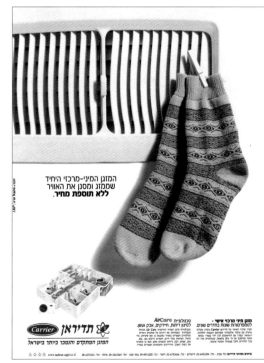

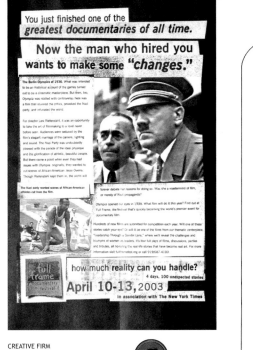

You just finished one of the **greatest documentaries of all time.**

Now the man who hired you wants to make some "changes."

The Berlin Olympics of 1936. What was intended to be an historical account of the games turned out to be a cinematic masterpiece. But then, too, Olympia was riddled with controversy: here was a film that stunned the critics, provoked the Nazi party, and infuriated the world.

For director Leni Riefenstahl, it was an opportunity to take the art of filmmaking to a level never before seen. Audiences were seduced by the film's elegant marriage of the camera, lighting and sound. The Nazi Party was undoubtedly pleased with the parade of the ideal physique and the glorification of athletic, beautiful people. But there came a point when ever they had issues with Olympia. Originally, they wanted to cut scenes of African-American Jesse Owens. Though Riefenstahl kept them in, the world will

The Nazi party wanted scenes of African-American athletes cut from the film.

forever debate her reasons for doing so. Was she a mastermind of film, or merely of Nazi propaganda?

Olympia opened our eyes in 1938. What film will do it this year? Find out at Full Frame, the festival that's quickly becoming the world's premier event for documentary film.

Hundreds of new films are submitted for competition each year. Will one of these stories catch your eye? Or will it be one of the films from our thematic centerpiece, "Leadership Through a Gender Lens," where we'll reveal the challenges and triumphs of women as leaders. It's four full days of films, discussions, parties and tributes, all honoring the real-life stories that have become reel art. For more information visit fullframefest.org or call 919/687-4100.

how much reality can you handle?
April 10-13, 2003
4 days, 100 unexpected stories
in association with The New York Times

CREATIVE FIRM
McKinney & Silver
Raleigh (North Carolina), USA
CREATIVES
David Baldwin, Jon Wagner, Dino Valentini
CLIENT
Full Frame Documentary Film Festival

CREATIVE FIRM
Sterrett Dymond Stewart
Charlotte (North Carolina), USA
CREATIVES
Russ Dymond, Lee Stewart
CLIENT
Horack Talley

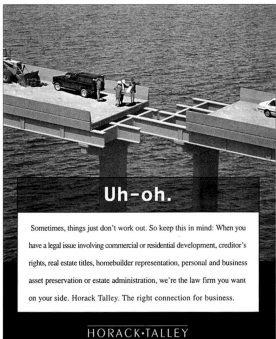

Uh-oh.

Sometimes, things just don't work out. So keep this in mind: When you have a legal issue involving commercial or residential development, creditor's rights, real estate titles, homebuilder representation, personal and business asset preservation or estate administration, we're the law firm you want on your side. Horack Talley. The right connection for business.

HORACK·TALLEY
Focused Expertise in Business & Family Law.

2600 ONE WACHOVIA CENTER · 301 SOUTH COLLEGE STREET · CHARLOTTE
704/377-2500 · WWW.HORACKTALLEY.COM

Jerry still knows how to make the right moves.

It was more than a great opportunity that brought Jerry West to Memphis. It was a great city with great people. But that's something we knew all along. Thanks, Jerry, for bringing your leadership to the Grizzlies and for giving Memphis even more to be proud of. We know you're going to love it here as much as we do.

FIRST TENNESSEE
All Things Financial.

CREATIVE FIRM
Thompson & Company
Memphis (Tennessee), USA
CREATIVES
Michael Thompson, Alan Wolstencroft, Sloan Cooper
CLIENT
First Tennessee Bank

CREATIVE FIRM
McKinney & Silver
Raleigh (North Carolina), USA
CREATIVES
David Baldwin,
Lisa Shimotakahara,
Philip Marchington
CLIENT
Bikram's Hot Yoga

UNDERSTANDING BUSINESS FROM THE INSIDE OUT.

31

CREATIVE FIRM
Rodgers Townsend
St. Louis (Missouri), USA
CREATIVES
Michael McCormick,
Luke Partridge,
Evan Willnow
CLIENT
St. Louis Post-Dispatch

CREATIVE FIRM
Armando Testa
Torino, Italy
CREATIVES
Marco Alberizzi, Damiano Possenti, Elena Murnigotti, Leonardo Nicastro, Nicola Morello, Dario Anania, Pietro Verri, Davide Carrari, Rossino
CLIENT
Heineken

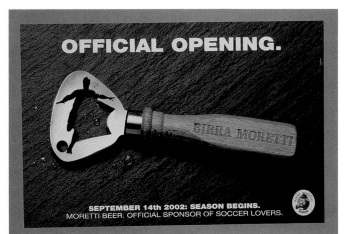

OFFICIAL OPENING.

BIRRA MORETTI

SEPTEMBER 14th 2002: SEASON BEGINS.
MORETTI BEER. OFFICIAL SPONSOR OF SOCCER LOVERS.

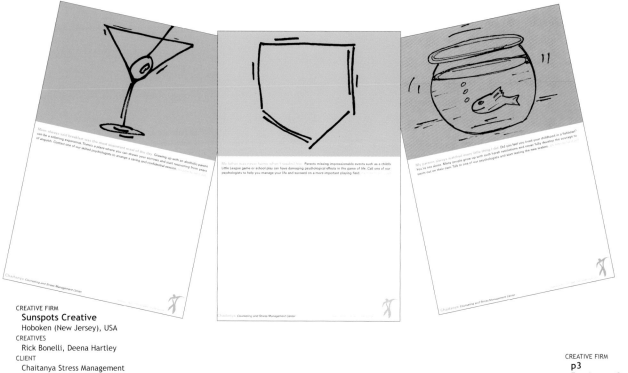

CREATIVE FIRM
Sunspots Creative
Hoboken (New Jersey), USA
CREATIVES
Rick Bonelli, Deena Hartley
CLIENT
Chaitanya Stress Management
Center

32

CREATIVE FIRM
p3
Farmington (Connecticut), USA
CREATIVES
James Pettus, Patrick Dugan
CLIENT
MartiniMagic

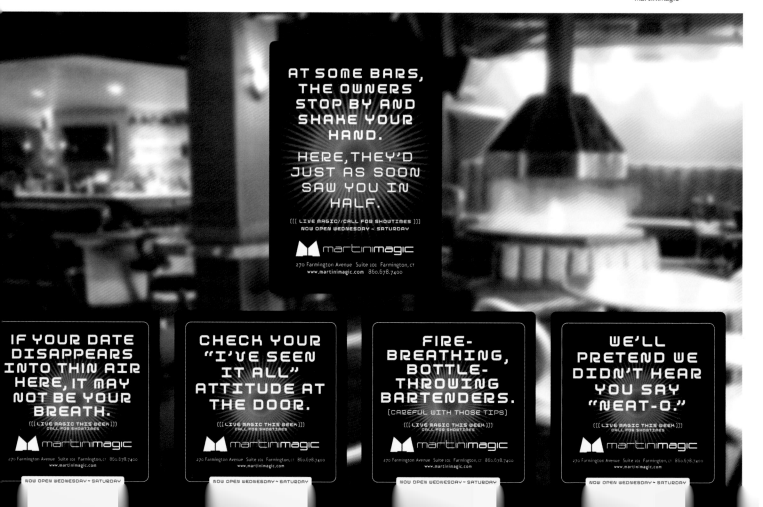

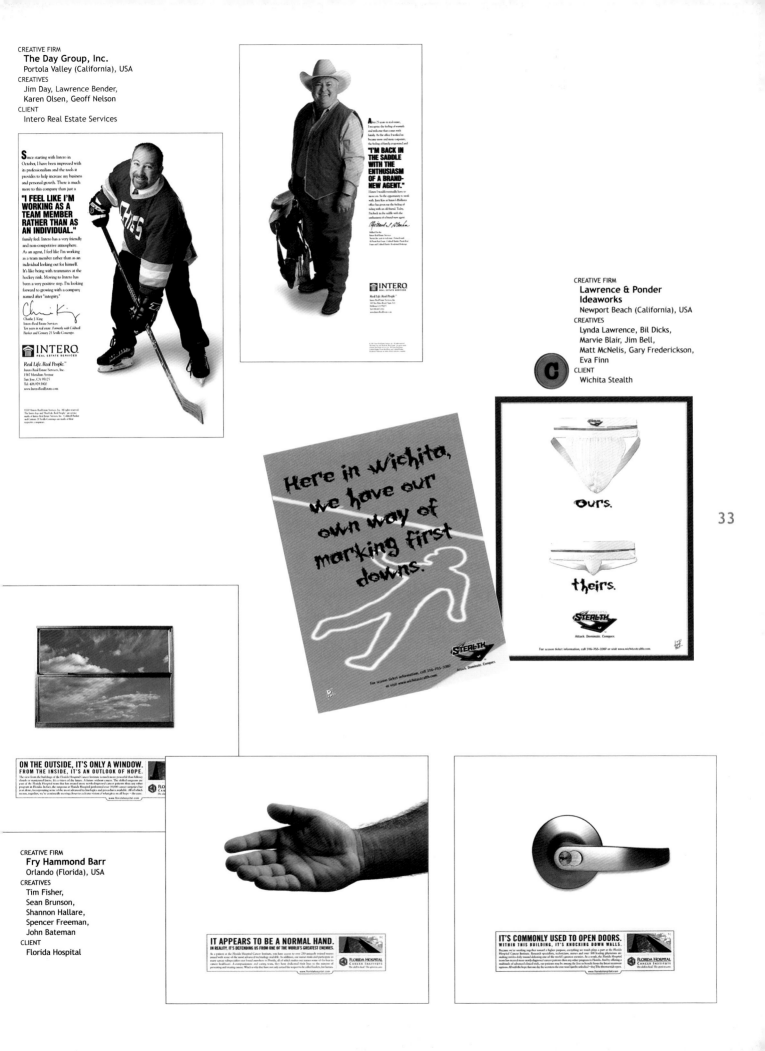

CREATIVE FIRM
The Day Group, Inc.
Portola Valley (California), USA
CREATIVES
Jim Day, Lawrence Bender,
Karen Olsen, Geoff Nelson
CLIENT
Intero Real Estate Services

CREATIVE FIRM
Lawrence & Ponder Ideaworks
Newport Beach (California), USA
CREATIVES
Lynda Lawrence, Bil Dicks,
Marvie Blair, Jim Bell,
Matt McNelis, Gary Frederickson,
Eva Finn
CLIENT
Wichita Stealth

33

CREATIVE FIRM
Fry Hammond Barr
Orlando (Florida), USA
CREATIVES
Tim Fisher,
Sean Brunson,
Shannon Hallare,
Spencer Freeman,
John Bateman
CLIENT
Florida Hospital

CREATIVE FIRM
McKinney & Silver
Raleigh (North Carolina), USA
CREATIVES
David Baldwin,
Lisa Shimotakahara,
Philip Marchington
CLIENT
Bikram's Hot Yoga

CREATIVE FIRM
All Media Projects Limited (AMPLE)
Trinidad & Tobago, West Indies
CREATIVES
Charmaine Daisley, Gary Clarke,
Astra Da Costa, Nicole Jones
CLIENT
BP Trinidad and Tobago LLC (BPTT)

CREATIVE FIRM
Rodgers Townsend
St. Louis (Missouri), USA
CREATIVES
Michael McCormick,
Luke Partridge,
Evan Willnow
CLIENT
St. Louis Post-Dispatch

CREATIVE FIRM
Mudra Communications Pvt. Ltd.
Gujarat, India
CREATIVES
Sajit Surendran, Anupama Purohit,
Jagdish Acharya
CLIENT
Supreemo Fashion World Pvt. Ltd.

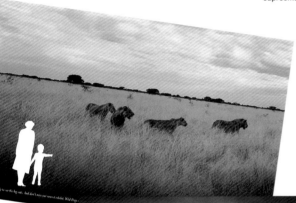

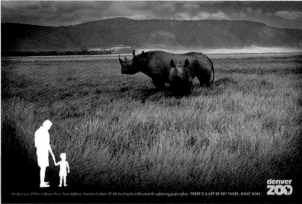

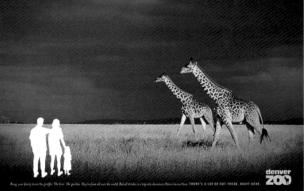

35

CREATIVE FIRM
McClain Finlon Advertising
Denver (Colorado), USA
CREATIVES
Jeff Martin, Gregg Bergan,
Tom Leydon
CLIENT
Denver Zoo

CREATIVE FIRM
Rodgers Townsend
St. Louis (Missouri), USA
CREATIVES
Michael McCormick,
Luke Partridge,
Evan Willnow
CLIENT
St. Louis Post-Dispatch

CREATIVE FIRM
McKinney & Silver
Raleigh (North Carolina), USA
CREATIVES
David Baldwin, Lisa Shimotakahara,
Philip Marchington
CLIENT
Phase II

36

CREATIVE FIRM
Scanad
Denmark
CREATIVES
Henry Rasmussen, Simon Ronsholt,
Phillip Helbo, Kim Michael
CLIENT
Kulturselskabet Stilling

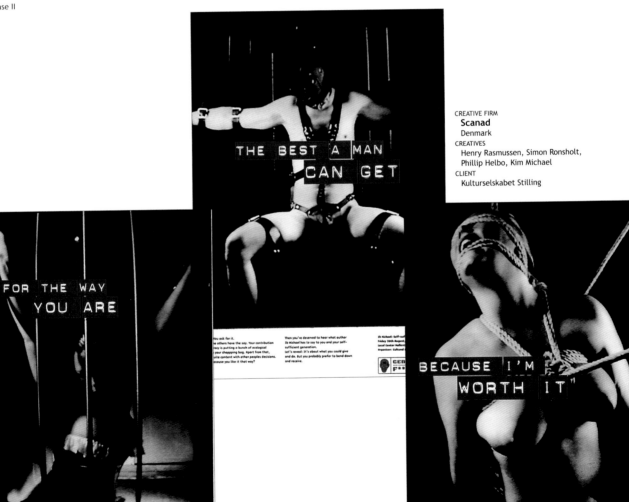

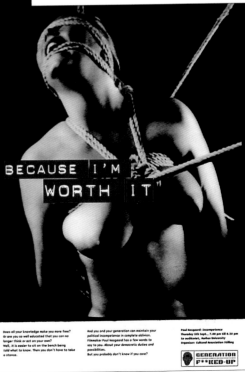

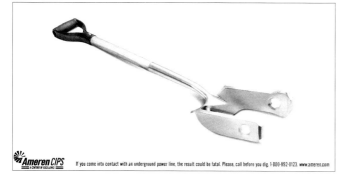

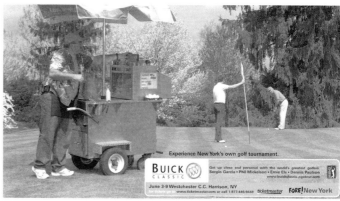

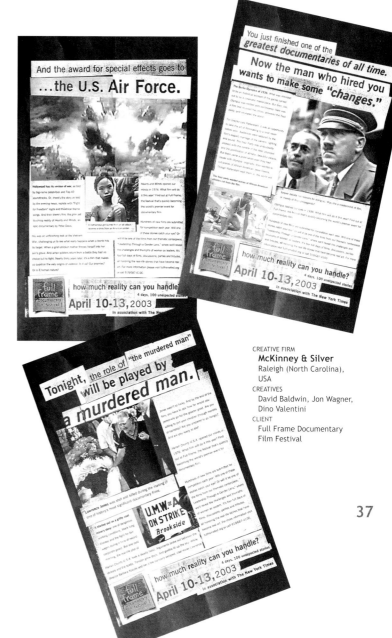

CREATIVE FIRM
Rodgers Townsend
St. Louis (Missouri), USA
CREATIVES
Mark Motley, Kris Wright,
Michael McCormick,
Evan Willnow
CLIENT
Ameren Corporation

CREATIVE FIRM
McKinney & Silver
Raleigh (North Carolina),
USA
CREATIVES
David Baldwin, Jon Wagner,
Dino Valentini
CLIENT
Full Frame Documentary
Film Festival

37

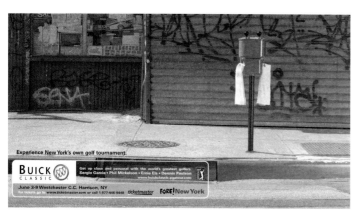

CREATIVE FIRM
Grey Worldwide NY
New York (New York), USA
CREATIVES
Kubert Skollar, Mark Catalina,
Brian Fallon
CLIENT
Buick Classic

CREATIVE FIRM
Nickelodeon
New York (New York),
USA
CREATIVES
Deb Krassner,
Theresa Fitzgerald,
Aaron McDanell,
Thomas Simperdofer,
Sergio Cuan, Steve Crespo
CLIENT
Nickelodeon

38

CREATIVE FIRM
DDB s.r.l.
Milan, Italy
CREATIVES
Enrico Bonomini,
Giuseppe Mastromatteo,
Cristina Marcellini,
Stefano Tumiatti,
Valentina Costantini
CLIENT
Autogerma-Volkswagen Division

CREATIVE FIRM
Excelda Manufacturing
Brighton (Michigan), USA
CREATIVES
Melissa McIntosh
CLIENT
Bickmore

CREATIVE FIRM
Recess
Mission Viejo (California), USA
CREATIVES
Robert Harrold, Matt McNelis
CLIENT
Eye Spy Shop

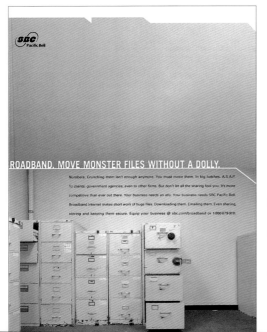

CREATIVE FIRM
Rodgers Townsend
St. Louis (Missouri), USA
CREATIVES
Michael McCormick,
Luke Partridge,
Evan Willnow
CLIENT
SBC Corporation

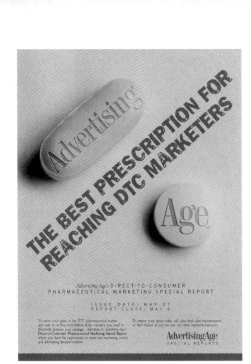

King
Kong?

My

Big

Fat

ZERO

39

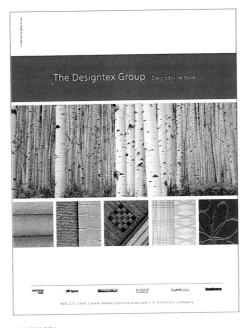

40

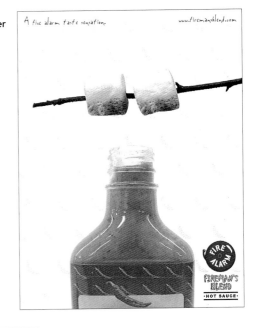

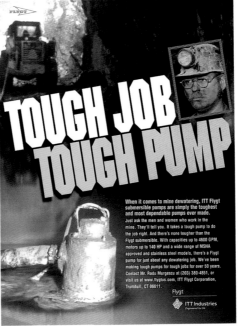

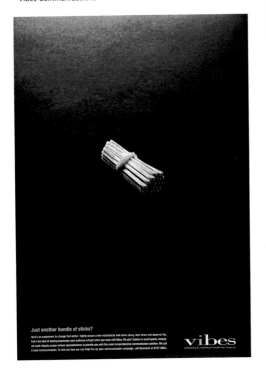

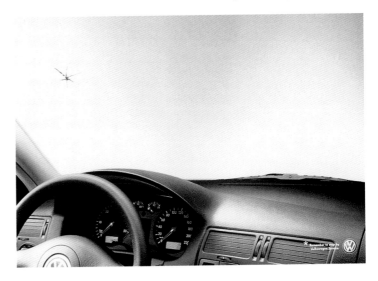

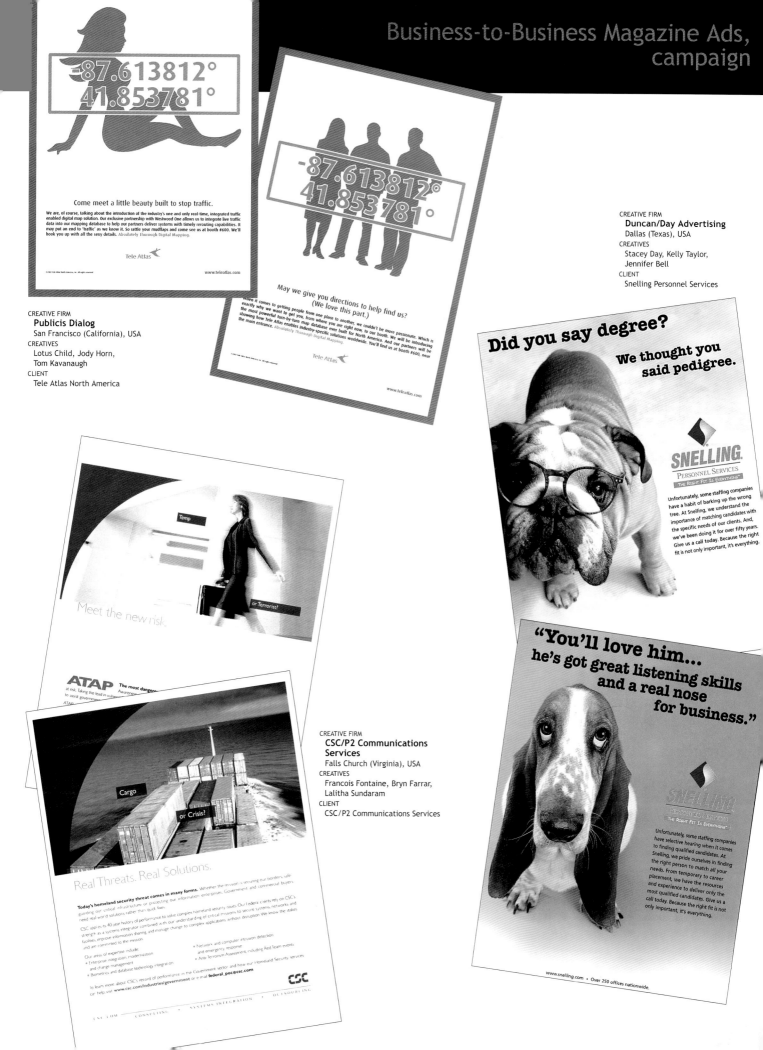

=87.613812°
41.853781°

Come meet a little beauty built to stop traffic.

We are, of course, talking about the introduction of the industry's one and only real-time, integrated traffic enabled digital map solution. Our exclusive partnership with Westwood One allows us to integrate live traffic data into our mapping database to help our partners deliver systems with timely rerouting capabilities. It may put an end to 'traffic' as we know it. So rattle your mudflaps and come see us at booth #600. We'll hook you up with all the sexy details. Absolutely Thorough Digital Mapping.

Tele Atlas
www.teleatlas.com

-87.613812°
41.853781°

May we give you directions to help find us?
(We love this part.)

When it comes to getting people from one place to another, we couldn't be more passionate. Which is exactly why we want to get you, from where you are right now, to our booth. We will be introducing the most powerful turn-by-turn map database ever built for North America. And our partners will be showing how Tele Atlas enables industry-specific solutions worldwide. You'll find us at booth #600, near the main entrance. Absolutely Thorough Digital Mapping.

Tele Atlas
www.teleatlas.com

CREATIVE FIRM
Publicis Dialog
San Francisco (California), USA
CREATIVES
Lotus Child, Jody Horn, Tom Kavanaugh
CLIENT
Tele Atlas North America

CREATIVE FIRM
Duncan/Day Advertising
Dallas (Texas), USA
CREATIVES
Stacey Day, Kelly Taylor, Jennifer Bell
CLIENT
Snelling Personnel Services

Did you say degree? We thought you said pedigree.

SNELLING
PERSONNEL SERVICES
THE RIGHT FIT IS EVERYTHING

Unfortunately, some staffing companies have a habit of barking up the wrong tree. At Snelling, we understand the importance of matching candidates with the specific needs of our clients. And, we've been doing it for over fifty years. Give us a call today. Because the right fit is not only important, it's everything.

Temp
Meet the new risk.
or Terrorist?

ATAP The most dangerous...
Awareness...

Real Threats. Real Solutions.

Today's homeland security threat comes in many forms. Whether the mission is securing our borders, safeguarding our critical infrastructure or protecting our information enterprises. Government and commercial buyers need real-world solutions rather than quick fixes.

CSC applies its 40-year history of performance to solve complex homeland security issues. Our Federal clients rely on CSC's strength as a systems integrator combined with our understanding of critical missions to secure systems, networks and facilities, improve information sharing and manage change to complex applications without disruption. We know the stakes and are committed to the mission.

Cargo
or Crisis?

Our areas of expertise include:
• Enterprise integration modernization and change management
• Biometrics and database technology integration

• Network and computer intrusion detection and emergency response
• Anti-Terrorism Assessment, including Red Team events

To learn more about CSC's record of performance in the Government sector and how our Homeland Security services can help, visit www.csc.com/industries/government or e-mail federal_poc@csc.com

CSC
CSC.COM • CONSULTING • SYSTEMS INTEGRATION • OUTSOURCING

CREATIVE FIRM
CSC/P2 Communications Services
Falls Church (Virginia), USA
CREATIVES
Francois Fontaine, Bryn Farrar, Lalitha Sundaram
CLIENT
CSC/P2 Communications Services

"You'll love him... he's got great listening skills and a real nose for business."

SNELLING
PERSONNEL SERVICES
THE RIGHT FIT IS EVERYTHING

Unfortunately, some staffing companies have selective hearing when it comes to finding qualified candidates. At Snelling, we pride ourselves in finding the right person to match all your needs. From temporary to career placement, we have the resources and experience to deliver only the most qualified candidates. Give us a call today. Because the right fit is not only important, it's everything.

www.snelling.com • Over 250 offices nationwide.

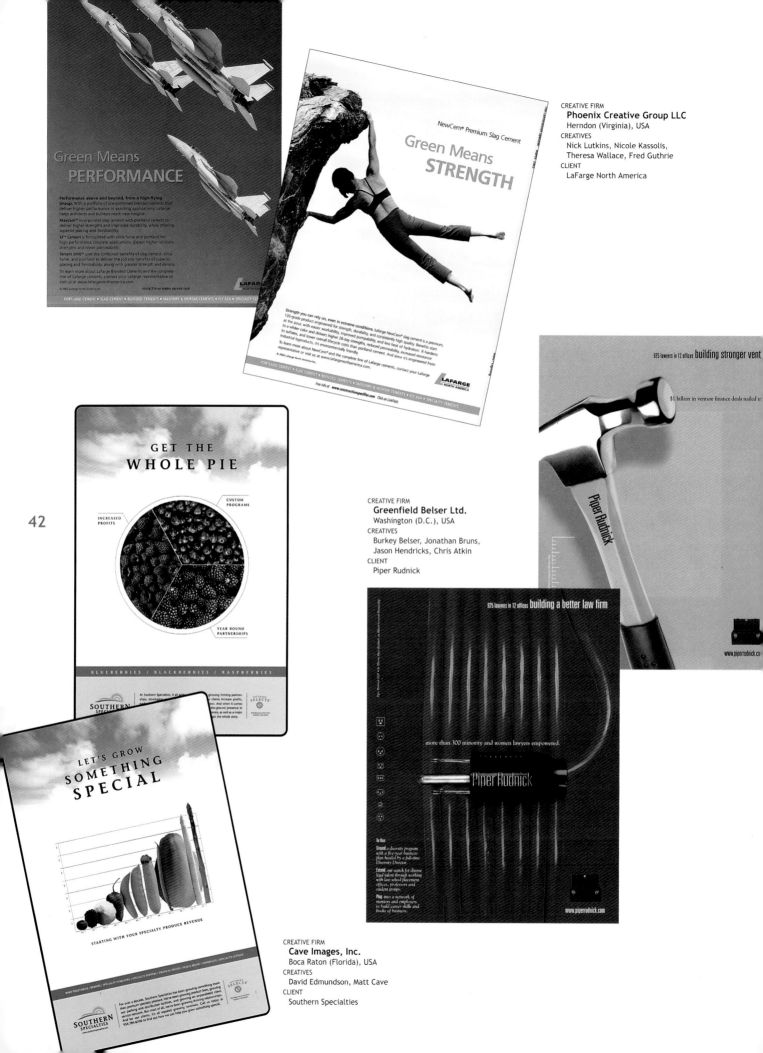

Green Means
PERFORMANCE

Performance above and beyond, from a high-flying lineup. With a portfolio of pre-portioned blended cements that deliver higher performance in exacting applications, Lafarge helps architects and builders reach new heights.

MaxCem™ incorporates slag cement with portland cement to deliver higher strengths and improved durability, while offering superior placing and finishability.

SF™ Cement is formulated with silica fume and portland for high performance concrete applications. Expect higher ultimate strengths and lower permeability.

Tercem 3000™ uses the combined benefits of slag cement, silica fume, and portland to deliver the job site benefits of superior placing and finishability, along with greater strength and density.

To learn more about Lafarge Blended Cements and the complete line of Lafarge cements, contact your Lafarge representative or visit us at www.lafargenorthamerica.com.

PORTLAND CEMENT • SLAG CEMENT • BLENDED CEMENTS • MASONRY & MORTAR CEMENTS • FLY ASH • SPECIALTY CE

NewCem® Premium Slag Cement

Green Means
STRENGTH

Strength you can rely on, even in extreme conditions. Lafarge NewCem® slag cement is a premium, 120-grade product engineered for strength, durability, and consistently high quality. Benefits start at the pour, with easier workability, improved pumpability, and less heat of hydration. It hardens to a whiter color and delivers higher 28-day strength, reduced permeability, increased resistance to sulfates, and lower overall lifecycle costs than portland cement. And since it's engineered from industrial byproducts, it's environmentally friendly.

To learn more about NewCem® and the complete line of Lafarge cements, contact your Lafarge representative or visit us at www.lafargenorthamerica.com.

PORTLAND CEMENT • SLAG CEMENT • BLENDED CEMENTS • MASONRY & MORTAR CEMENTS • FLY ASH • SPECIALTY CEMENTS

Free info at www.constructionspecifier.com Click on LinkPath

CREATIVE FIRM
Phoenix Creative Group LLC
Herndon (Virginia), USA
CREATIVES
Nick Lutkins, Nicole Kassolis,
Theresa Wallace, Fred Guthrie
CLIENT
LaFarge North America

42

GET THE
WHOLE PIE

INCREASED
PROFITS

CUSTOM
PROGRAMS

YEAR ROUND
PARTNERSHIPS

BLUEBERRIES / BLACKBERRIES / RASPBERRIES

SOUTHERN
SPECIALTIES

At Southern Specialties, it all ... growing thriving partnerships, developing ... clients increase profits, ... packing and distribution facilities and growing an expanding ... service network. But most of all, we've been growing thriving relationships. And for our clients, it's all equaled growing ... mula, as well as a major ... get the whole story.

LET'S GROW
**SOMETHING
SPECIAL**

STARTING WITH YOUR SPECIALTY PRODUCE REVENUE

LEAFY VEGETABLES / BERRIES / SPECIALTY TOMATOES / SPECIALTY PEPPERS / TROPICAL FRUITS / PEAS & BEANS / ASPARAGUS / SPECIALTY LETTUCE

For over a decade, Southern Specialties has been growing something more than premium specialty produce. We've been growing product lines, growing our packing and distribution facilities and growing an expanding ... service network. But most of all, we've been growing thriving relationships. And for our clients, it's all equaled growing something ... Call us today at 954.784.6300 to find out how we can help you grow something special.

SOUTHERN
SPECIALTIES

CREATIVE FIRM
Cave Images, Inc.
Boca Raton (Florida), USA
CREATIVES
David Edmundson, Matt Cave
CLIENT
Southern Specialties

CREATIVE FIRM
Greenfield Belser Ltd.
Washington (D.C.), USA
CREATIVES
Burkey Belser, Jonathan Bruns,
Jason Hendricks, Chris Atkin
CLIENT
Piper Rudnick

925 lawyers in 12 offices **building stronger vent**

$1 billion in venture finance deals nailed in

Piper Rudnick

www.piperrudnick.co

925 lawyers in 12 offices **building a better law firm**

more than 300 minority and women lawyers empowered.

Piper Rudnick

In the
Ground a diversity program with a five-year business plan headed by a full-time Diversity Director.

Extend our search for diverse legal talent through working with law school placement offices, professors and student groups.

Plug into a network of mentors and employers to build career skills and books of business.

www.piperrudnick.com

IT'S WHAT KEEPS
JOBS
FROM BECOMING
INCIDENTS

Education. Training. Awareness. It's what enables your safety program. Utility Safety Conference & Expo is the only event where the top experts in the utility safety field address the issues you face everyday. Improve your safety operations by attending 30 all-new CSP and CUSA credited seminars presented by industry experts; exploring hundreds of the latest safety products; and networking with your industry peers. You won't find this much utility safety expertise and information anywhere else.

The Best Thinking In Utility Safety Is Here.™
April 22-24, 2003 San Antonio, TX Henry B. Gonzalez Convention Center

Visit utilitysafety.com or call (847) 462-5767

CREATIVE FIRM
Practical Communications Inc.
Palatine (Illinois), USA
CREATIVES
Brian Danaher, Curtis Marquardt,
Jeremy Waybright
CLIENT
Utility Safety Conference & Expo

BECAUSE THERE ISN'T
ALWAYS TIME
TO REFER TO THE
SAFETY MANUAL

UTILITY SAFETY CONFERENCE & EXPO is the only event where the top experts in the utility safety field address the issues you face everyday. Earn CSP and CUSA credits in 30 EDUCATIONAL SEMINARS by experts who have been up high in the buckets, down low in the trenches and everywhere in between, including Boola Nordlage, where life inspired the movie "Bolt." Explore hundreds of the latest SAFETY PRODUCTS and NETWORK WITH SAFETY PROFESSIONALS who take safety as seriously as you do. You won't find this much expertise and information on utility safety anywhere else.

The Best Thinking In Utility Safety Is Here.™
April 22-24, 2003 San Antonio, TX Henry B. Gonzalez Convention Center

Visit utilitysafety.com or call (847) 462-5767

THE BRAIN IS YOUR
BEST PPE.
USE IT.

CREATIVE FIRM
Collaborate
San Francisco (California), USA
CREATIVES
Robin Raj, Kait Courlang,
Jack Ramsey, Claude Halcomb
CLIENT
Tibco Software

YOU'RE CUTTING COSTS, TRIMMING STAFF AND MAKING DO WITH LESS.

SO HOW ARE YOU SUPPOSED TO GROW REVENUE?

The answer is integration. TIBCO Software's proven integration solutions will help your company cut costs while increasing the capability, agility and efficiency of your business. By unifying and optimizing your existing assets—people, processes and legacy systems—you can do more with what you already have. And do it better.

TIBCO gives you the benefits of real-time business, getting information where and when it's needed and coordinating activities end-to-end. You'll automate processes, while giving people the information to make better decisions and act more quickly. It's what we call The Power of Now.™ Our unbiased approach, proven technology and easily-deployed integration solutions can help you grow your business even in today's difficult environment.

TIBCO is the leading independent integration software provider.

Delta Air Lines, NASDAQ and Pirelli are among more than 2,000 leading companies we've helped to cut costs and drive revenue. Learn how we can help your company do more with less. Call 800-420-8450, or visit us at www.tibco.com/cwb

⟫TIBCO
The Power of Now™

CREATIVE FIRM
Design Guys
Minneapolis (Minnesota), USA
CREATIVES
Steven Sikora, Katie Kirk
CLIENT
Leggett & Platt

43

design
fixtures
mannequins
art
accessories
manufacturing

it's all in how you look at it

Some will look at TREND and see a new division of LEGGETT & PLATT. Some will see a company with great custom design capabilities. First and foremost, we want companies to see as an innovative group of people committed to creating new ways to look at things. See us at Global Shop. Booth 1023.
CONTACT: Denise Waldo - VP Sales and Marketing - 612.332.6261 - www.leggettblg...

trend
by Leggett & Platt

REAL-TIME BUSINESS ISN'T JUST ABOUT GETTING INFORMATION FASTER.

IT'S ABOUT MAKING SURE YOUR BUSINESS CAN TAKE ADVANTAGE OF IT.

In a true real-time business, everything moves faster. Your data is always where and when it's needed. You coordinate activities and automate processes end to end. You enjoy greater visibility and understanding. And you have the ability to drive your business with new immediacy.

TIBCO Software's proven integration solutions enable real-time business. By unifying and optimizing your existing assets—people, processes and legacy systems—you can do more with what you already have. And do it better. It's what we call The Power of Now.™ Our unbiased, independent approach and easily-deployed integration solutions can help you grow your business even in today's difficult environment.

As the world's leading independent integration software provider, TIBCO has helped more than 2,000 companies take advantage of real-time business. Discover how you can put The Power of Now to work. Call 888-558-4226 or visit us at www.tibco.com/xxx

REAL-TIME IN ACTION: DELTA AIR LINES

Delta Air Lines partnered with TIBCO to create the Delta Nervous System, which connects Delta's 13 business units and 30 databases, and handles more than 5 million daily business events.

"The ability to share information with our employees and customers in real-time, and to automate how we share it, has allowed us to transform our business, improve customer service, and reduce costs."
—Curtis Robb, Delta Air Lines CIO.

⟫TIBCO
The Power of Now™

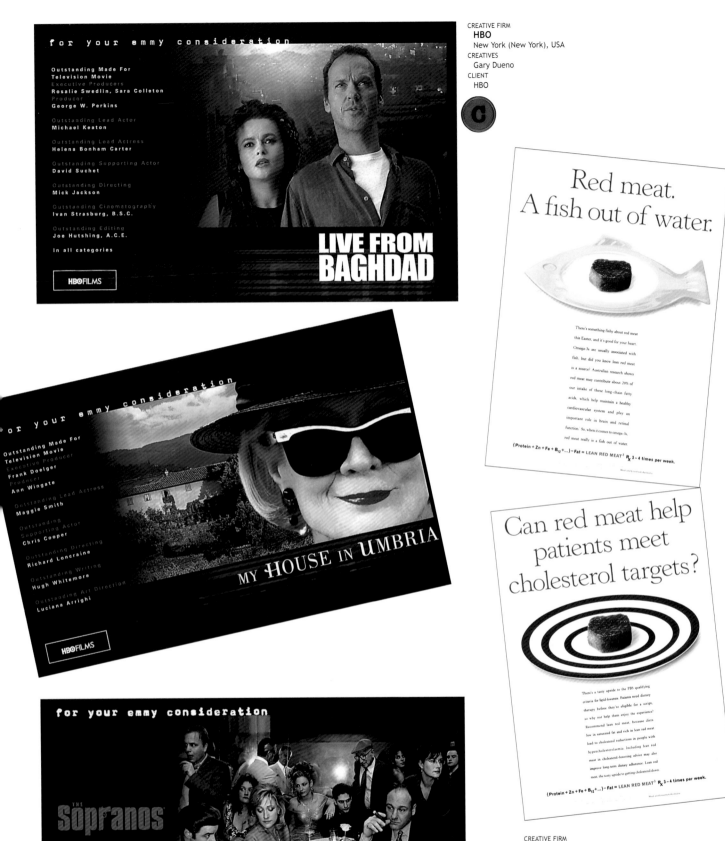

CREATIVE FIRM
HBO
New York (New York), USA
CREATIVES
Gary Dueno
CLIENT
HBO

for your emmy consideration

Outstanding Made For
Television Movie
Executive Producers
Rosalie Swedlin, Sara Colleton
Producer
George W. Perkins

Outstanding Lead Actor
Michael Keaton

Outstanding Lead Actress
Helena Bonham Carter

Outstanding Supporting Actor
David Suchet

Outstanding Directing
Mick Jackson

Outstanding Cinematography
Ivan Strasburg, B.S.C.

Outstanding Editing
Joe Hutshing, A.C.E.

In all categories

LIVE FROM BAGHDAD

HBOFILMS

or your emmy consideration

Outstanding Made For
Television Movie
Executive Producer
Frank Doelger
Producer
Ann Wingate

Outstanding Lead Actress
Maggie Smith

Outstanding
Supporting Actor
Chris Cooper

Outstanding Directing
Richard Loncraine

Outstanding Writing
Hugh Whitemore

Outstanding Art Direction
Luciana Arrighi

MY HOUSE IN UMBRIA

HBOFILMS

for your emmy consideration

The Sopranos

"...as no single film or
ordinary television series
could, 'The Sopranos'
has taken on the
texture of epic fiction."

– *The New York Times*

HBO

Red meat.
A fish out of water.

There's something fishy about red meat
this Easter, and it's good for your heart.
Omega-3s are usually associated with
fish, but did you know lean red meat
is a source? Australian research shows
red meat may contribute about 20% of
our intake of these long-chain fatty
acids, which help maintain a healthy
cardiovascular system and play an
important role in brain and retinal
function. So, when it comes to omega-3s,
red meat really is a fish out of water.

{Protein + Zn + Fe + B₁₂ +...} – Fat = LEAN RED MEAT³ Rₓ 3 – 4 times per week.

Meat and Livestock Australia

Can red meat help
patients meet
cholesterol targets?

There's a tasty upside to the PBS qualifying
criteria for lipid-lowerers. Patients need dietary
therapy before they're eligible for a script,
so why not help them enjoy the experience?
Recommend lean red meat, because diets
low in saturated fat and rich in lean red meat
lead to cholesterol reductions in people with
hypercholesterolaemia. Including lean red
meat in cholesterol-lowering advice may also
improve long-term dietary adherence. Lean red
meat, the tasty upside to getting cholesterol down.

{Protein + Zn + Fe + B₁₂ +...} – Fat = LEAN RED MEAT³ Rₓ 3 – 4 times per week.

Meat and Livestock Australia

CREATIVE FIRM
Sudler & Hennessey
North Sydney, Australia
CREATIVES
Peter Ryan, Adam Taor
CLIENT
Meat & Livestock Australia

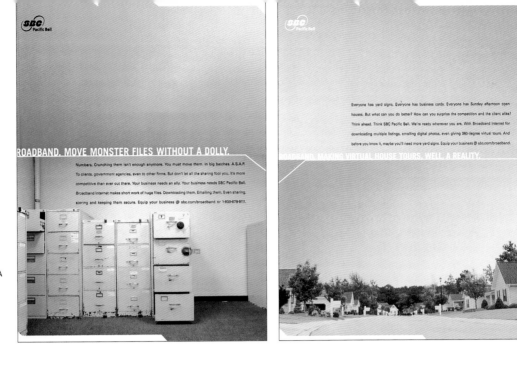

BROADBAND. MOVE MONSTER FILES WITHOUT A DOLLY.

Numbers. Crunching them isn't enough anymore. You must move them. In big batches. A.S.A.P. To clients, government agencies, even to other firms. But don't let all the sharing fool you. It's more competitive than ever out there. Your business needs an ally. Your business needs SBC Pacific Bell. Broadband Internet makes short work of huge files. Downloading them. Emailing them. Even sharing, storing and keeping them secure. Equip your business @ sbc.com/broadband or 1-800-679-9111.

Everyone has yard signs. Everyone has business cards. Everyone has Sunday afternoon open houses. But what can you do better? How can you surprise the competition and the client alike? Think ahead. Think SBC Pacific Bell. We're ready whenever you are. With Broadband Internet for downloading multiple listings, emailing digital photos, even giving 360-degree virtual tours. And before you know it, maybe you'll need more yard signs. Equip your business @ sbc.com/broadband.

BROADBAND. MAKING VIRTUAL HOUSE TOURS. WELL, A REALITY.

CREATIVE FIRM
Rodgers Townsend
St. Louis (Missouri), USA
CREATIVES
Michael McCormick,
Luke Partridge,
Evan Willnow
CLIENT
SBC Corporation

CREATIVE FIRM
The Ungar Group
Chicago (Illinois), USA
CREATIVES
Tom Ungar, Mark Ingraham, Doug Bening
CLIENT
American Hardware Manufacturers Assn.

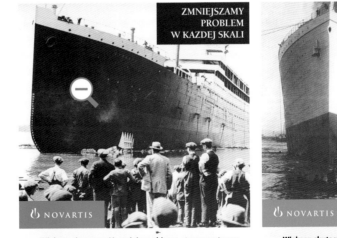

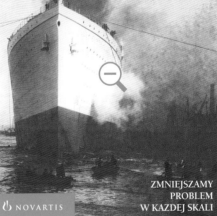

ZMNIEJSZAMY PROBLEM W KAZDEJ SKALI

Większa skuteczność, mniejsze objawy – teraz wystarczy tylko jedna iniekcja na miesiąc

Tekst reklamowy, informacje fachowe, treść zgodna z filozofią marki. Sandostatin LAR is the only convenient once-a-month therapy for superior control of hormonal hypersecretion. Tekst reklamowy, informacje fachowe, treść zgodna z filozofią marki. Sandostatin LAR is the only convenient once-a-month therapy for superior control of hormonal hypersecretion.

 Sandostatin LAR

NOVARTIS

Sandostatin LAR
octreotide · IM
Więcej korzyści

CREATIVE FIRM
Moby Dick Warszawa
Warsaw, Poland
CREATIVES
Marcin Kosiorowski,
Anna Bal, Anna Kmita
CLIENT
Novátis

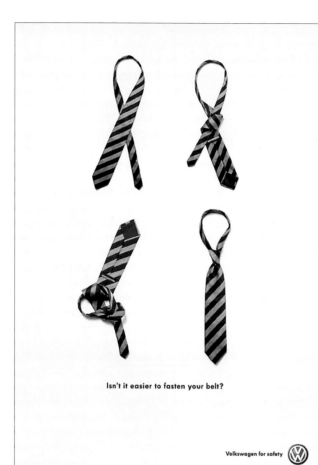

Isn't it easier to fasten your belt?

Volkswagen for safety

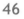

46

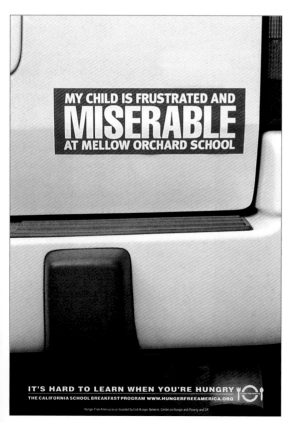

MY CHILD IS FRUSTRATED AND
MISERABLE
AT MELLOW ORCHARD SCHOOL

IT'S HARD TO LEARN WHEN YOU'RE HUNGRY
THE CALIFORNIA SCHOOL BREAKFAST PROGRAM WWW.HUNGERFREEAMERICA.ORG

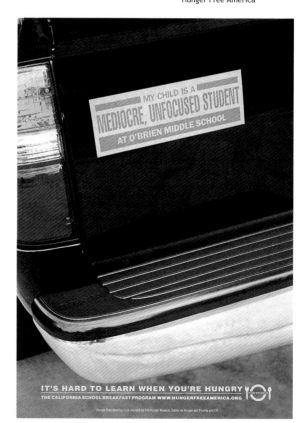

MY CHILD IS A
MEDIOCRE, UNFOCUSED STUDENT
AT O'BRIEN MIDDLE SCHOOL

IT'S HARD TO LEARN WHEN YOU'RE HUNGRY
THE CALIFORNIA SCHOOL BREAKFAST PROGRAM WWW.HUNGERFREEAMERICA.ORG

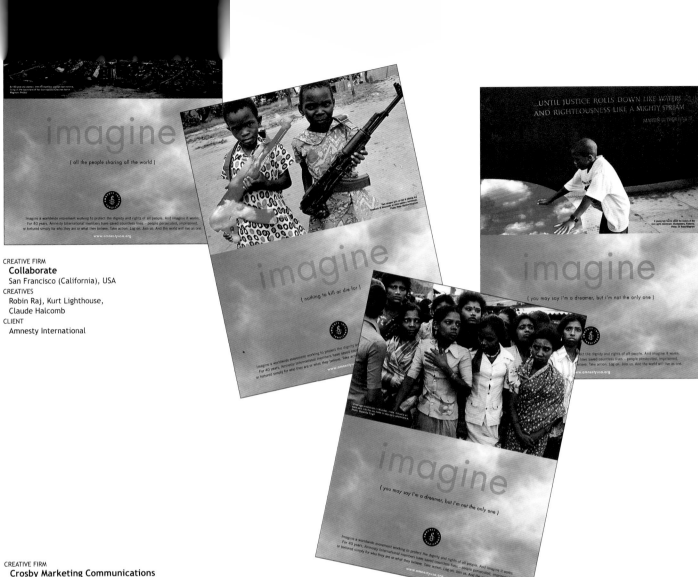

CREATIVE FIRM
Collaborate
San Francisco (California), USA
CREATIVES
Robin Raj, Kurt Lighthouse,
Claude Halcomb
CLIENT
Amnesty International

CREATIVE FIRM
Crosby Marketing Communications
Annapolis, (Maryland), USA
CREATIVES
Ron Ordansa, Mark Walston,
Peter Howard
CLIENT
Catholic Campaign for Human Development

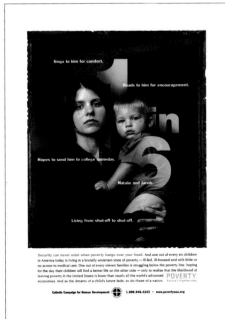

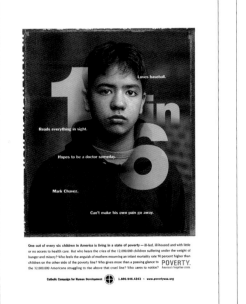

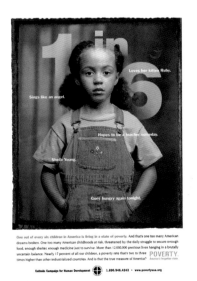

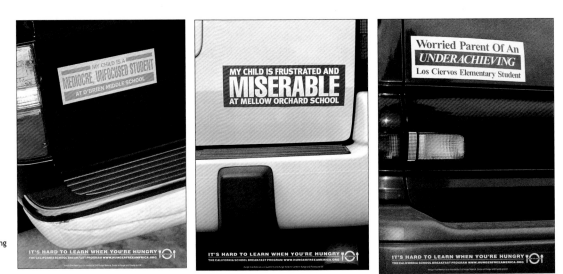

CREATIVE FIRM
AMP
Costa Mesa (California), USA
CREATIVES
Luis Camano, Roger Poirier,
Carlos Musquez, Cameron Young
CLIENT
Hunger Free America

48

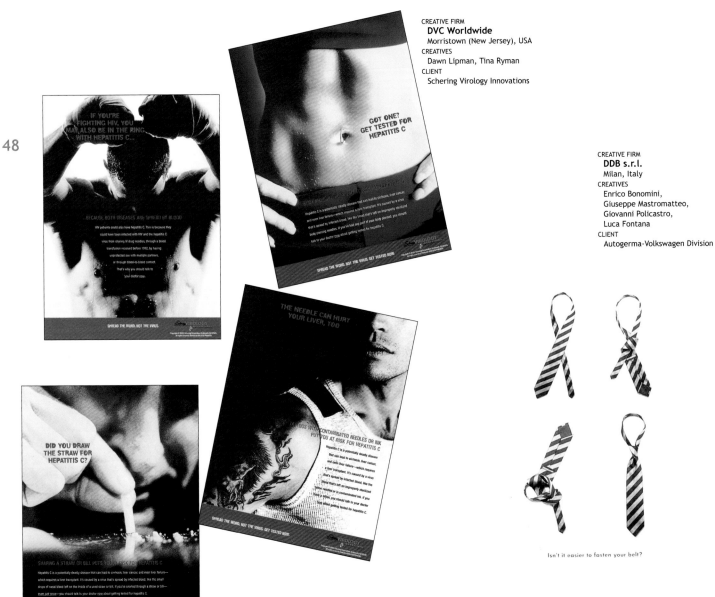

CREATIVE FIRM
DVC Worldwide
Morristown (New Jersey), USA
CREATIVES
Dawn Lipman, Tina Ryman
CLIENT
Schering Virology Innovations

CREATIVE FIRM
DDB s.r.l.
Milan, Italy
CREATIVES
Enrico Bonomini,
Giuseppe Mastromatteo,
Giovanni Policastro,
Luca Fontana
CLIENT
Autogerma-Volkswagen Division

Isn't it easier to fasten your belt?

Volkswagen for safety

When you stand up straight, you become one inch taller. Doesn't sound like much. But, if everyone in America does that, it adds up to 24,000,000 feet. Which is equal to 17,646 World Trade Center Towers. And that's a sight the whole world should see.
Walk Proud. 9-11-02

CREATIVE FIRM
The Ungar Group
Chicago (Illinois), USA
CREATIVES
Tom Ungar, Mark Ingraham,
Doug Bening
CLIENT
The Ungar Group

No one ever described peace as brutal.

citizen *peace* building

CREATIVE FIRM
Thompson & Company
Memphis (Tennessee), USA
CREATIVES
Mark Robinson,
Amanda Petty,
Rick Baptist,
Dave Smith,
Puffer Thompson
CLIENT
Blues Foundation

ONCE AGAIN THE BLUES ARE AT A CROSSROADS
ONLY THIS TIME IT'S NOT SATAN WAITING
IT'S THE MAYOR OF BATON ROUGE.

MEMPHIS IS HOME OF THE BLUES. BUT IT MAY NOT BE FOR LONG. BATON ROUGE IS TRYING TO LURE THE BLUES FOUNDATION AWAY FROM ITS RIGHTFUL OWNER. YOUR FINANCIAL HELP CAN STOP THEM. TO CONTRIBUTE, CALL 527-2583.
MEMPHIS HAS THE BLUES. LET'S KEEP THEM.

CREATIVE FIRM
Lawrence & Ponder Ideaworks
Newport Beach (California), USA
CREATIVES
Lynda Lawrence, Gary Frederickson, Judy Devine,
Jim Bell, Marvie Blair
CLIENT
UCI Citizen Peace Building

49

BEFORE YOU LET THIS

TURN INTO THIS,

CALL 1.800.230.PLAN.

Unless you're ready for kindergarten carpools, you should check out our full range of services.

Birth control • Emergency contraception • STD screening and treatment
Male services • Pregnancy testing and options • Education

Planned Parenthood®
Orange and San Bernardino Counties

www.plannedparenthoodOSBC.com

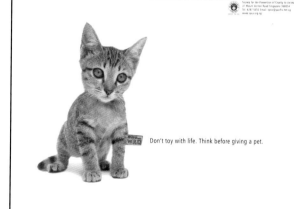

Don't toy with life. Think before giving a pet.

CREATIVE FIRM
Zender Fang Associates
Singapore
CREATIVES
Dollah Jaafar, Mike Tan,
Geraldine Oh, Mark Law,
Lee Jen, J Studio,
Esa Sidin, Sophia Tan
CLIENT
SPCA Singapore

CREATIVE FIRM
Lawrence & Ponder Ideaworks
Newport Beach (California), USA
CREATIVES
Lynda Lawrence, Matt McNelis,
Gary Frederickson
CLIENT
Planned Parenthood

Don't toy with life. Think before buying a pet.

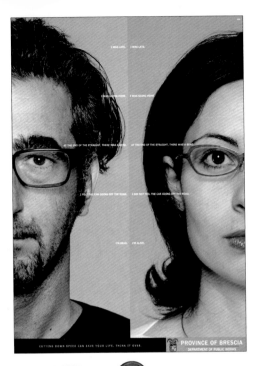
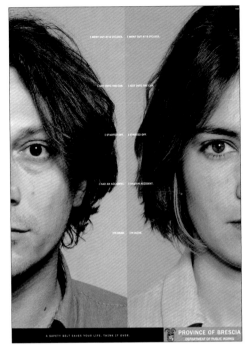
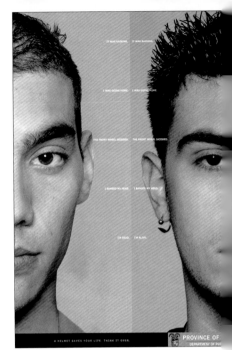

CREATIVE FIRM
DDB s.r.l.
Milan, Italy
CREATIVES
Enrico Bonomini,
Marco Turconi
CLIENT
Province of Brescia

50

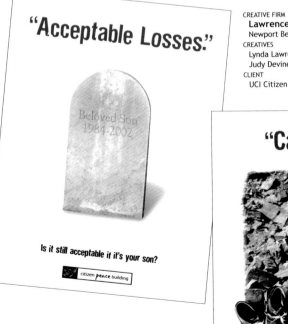

"Acceptable Losses."

Beloved Son
1984-2002

Is it still acceptable if it's your son?

citizen *peace* building

CREATIVE FIRM
Lawrence & Ponder Ideaworks
Newport Beach (California), USA
CREATIVES
Lynda Lawrence, Gary Frederickson,
Judy Devine, Marvie Blair, Jim Bell
CLIENT
UCI Citizen Peace Building

"Casualties:"

A casualty to a distant General
is murder when it's your daughter.

citizen *peace* building

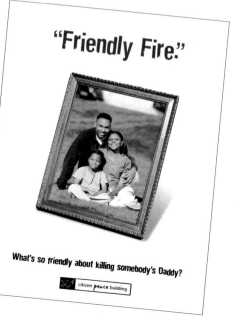

"Friendly Fire."

What's so friendly about killing somebody's Daddy?

citizen *peace* building

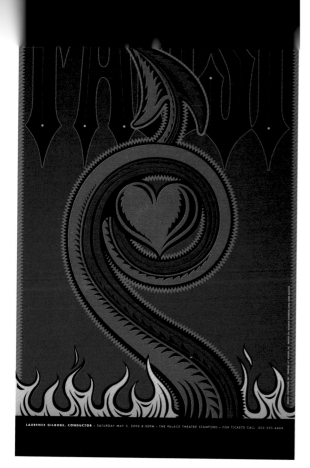

CREATIVE FIRM
Tom Fowler, Inc.
Norwalk (Connecticut), USA
CREATIVES
Thomas G. Fowler
CLIENT
Connecticut Grand Opera and Orchestra

CREATIVE FIRM
2 Women & A Computer
Gainesville (Florida), USA
CREATIVES
Linda Conway Correll, Elaine Wagner
CLIENT
Seekonk Congregational Church

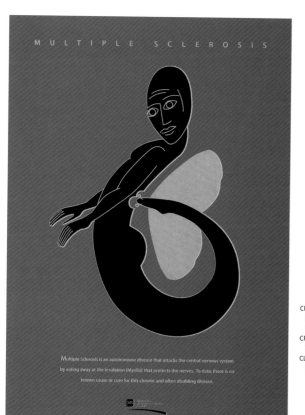

CREATIVE FIRM
Winter Advertising Agency
Temecula (California), USA
CREATIVES
Mary Winter, Rachel Kelly
CLIENT
CA. Riverside Ballet

CREATIVE FIRM
Zygo Communications
Wyncote (Pennsylvania), USA
CREATIVES
Scott Lasgrow
CLIENT
National Multiple Sclerosis Society

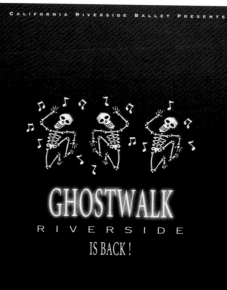

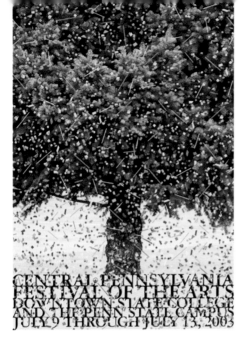

CENTRAL PENNSYLVANIA
FESTIVAL OF THE ARTS
DOWNTOWN STATE COLLEGE
AND THE PENN STATE CAMPUS
JULY 9 THROUGH JULY 13, 2003

CREATIVE FIRM
Sommese Design
Port Matilda (Pennsylvania), USA
CREATIVES
Lanny Sommese, Joe Shumbat,
Nate Bishop
CLIENT
Central Pennsylvania
Festival of the Arts

SHORT OF
PAT BOONE
COVERING A ROBERT JOHNSON SONG,
THIS IS THE BIGGEST
ABOMINATION
THE BLUES COULD EVER SUFFER.

MEMPHIS IS HOME OF THE BLUES. BUT IT MAY NOT BE FOR LONG. BATON ROUGE IS TRYING TO LURE
THE BLUES FOUNDATION AWAY FROM ITS RIGHTFUL OWNER.
YOUR FINANCIAL HELP CAN STOP THEM. TO CONTRIBUTE, CALL 527-2583.
MEMPHIS HAS THE BLUES. LET'S KEEP THEM.

CREATIVE FIRM
Thompson & Company
Memphis (Tennessee), USA
CREATIVES
Mark Robinson, Amanda Petty, Rick Baptist,
Dave Smith, Puffer Thompson
CLIENT
Blues Foundation

CREATIVE FIRM
Lewis Moberly
London, England
CREATIVES
Mary Lewis, Bryan Clark,
Chris Ridley
CLIENT
Geffrye Museum

CREATIVE FIRM
TD2, S.C.
Mexico
CREATIVES
Rafael Rodrigo Cordova
CLIENT
Casa de la Sal

52

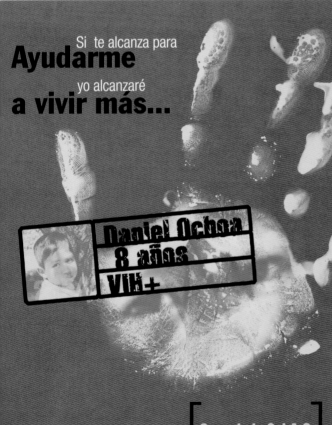

Si te alcanza para
Ayudarme
yo alcanzaré
a vivir más...

**Daniel Ochoa
8 años
VIH+**

"Nunca es tarde para hacer feliz a alguien" **Casa de la Sal A.C.**

Córdoba No. 76, Col. Roma Sur
México, D.F. 06700
Teléfono: Fax:
5514-0628 5207-8042
e-mail: casadelasal@prodigy.net.mx
www.mati.net.mx/casadelasal

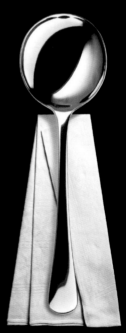

GEFFRYE MUSEUM
LONDON

Cutting Edge - An exhibition of
English cutlery and place settings

CREATIVE FIRM
Finished Art, Inc.
Atlanta (Georgia), USA
CREATIVES
Donna Johnston, Kannex Fung,
Sutti Sahunalu
CLIENT
Movie Machanix and International
Speedway Corp.

CREATIVE FIRM
VMA, Inc.
Dayton (Ohio), USA
CREATIVES
Amy Baas, Kenneth Botts
CLIENT
Dayton Area Heart
and Cancer Association

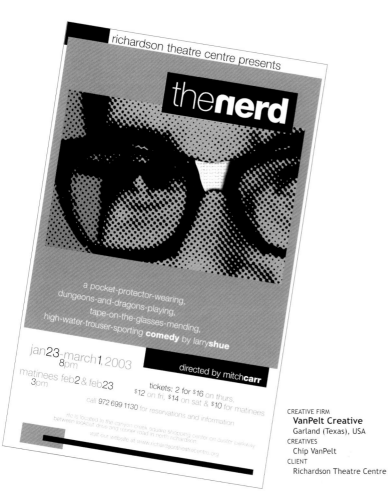

CREATIVE FIRM
KOREK Studio
Warsaw, Poland
CREATIVES
Wojtek Korkuc, KOREK
CLIENT
Osrodek Kultury Ochoty

CREATIVE FIRM
VanPelt Creative
Garland (Texas), USA
CREATIVES
Chip VanPelt
CLIENT
Richardson Theatre Centre

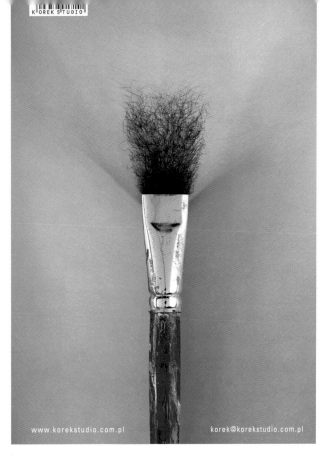

www.korekstudio.com.pl korek@korekstudio.com.pl

CREATIVE FIRM
KOREK Studio
Warsaw, Poland
CREATIVES
Wojtek Korkuc,
KOREK

54

CREATIVE FIRM
PriceWeber
Louisville (Kentucky), USA
CREATIVES
Larry Profancik, Martá Garcia,
Frederick Hagan
CLIENT
Brown-Forman Beverages Worldwide

CREATIVE FIRM
Chandler Ehrlich
Memphis (Tennessee), USA
CREATIVES
Mike Leon, Mike Yue,
Guy Stieferman, Marina Scott
CLIENT
Memphis Convention & Visitors Bureau

CREATIVE FIRM
**Herman Miller In
house design**
Zeeland (Michigan), USA
CREATIVES
Andrew Dull, Dick Holm,
Nick Merrick
CLIENT
Herman Miller Inc.

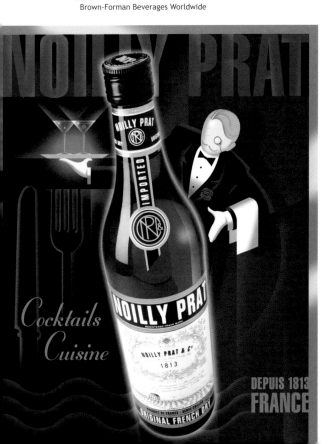

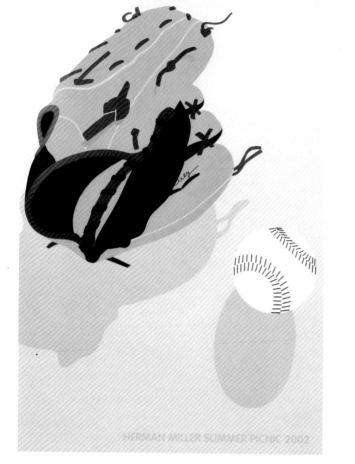

CREATIVE FIRM
Herman Miller In house design
Zeeland (Michigan), USA
CREATIVES
Brian Edlefson
CLIENT
Herman Miller Inc.

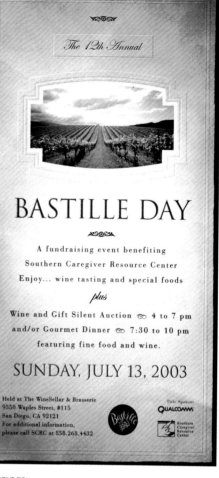

CREATIVE FIRM
QCCG
San Diego (California), USA
CREATIVES
Chris Dillman, Christopher Lee,
Rhea Bishop, Cyndi Bramwell
CLIENT
Southern Caregiver Resource

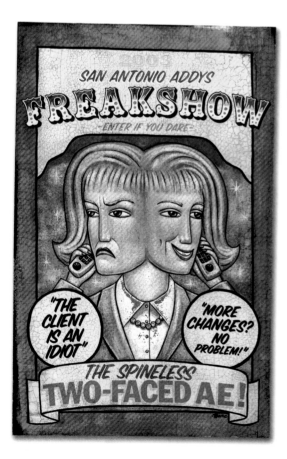

CREATIVE FIRM
Toolbox Studios, Inc.
San Antonio (Texas), USA
CREATIVES
Stan McElrath, Paul Soupiset,
Marc Burckhardt
CLIENT
AAF San Antonio

CREATIVE FIRM
Trudy Cole-Zielanski Design
Churchville (Virginia), USA
CREATIVES
Trudy Cole-Zielanski

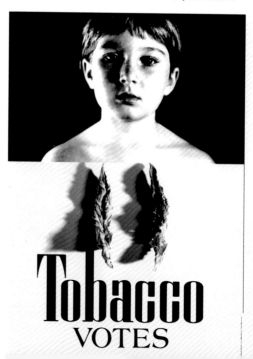

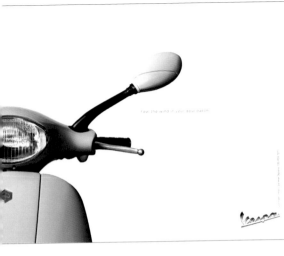

CREATIVE FIRM
McClain Finlon Advertising
Denver (Colorado), USA
CREATIVES
Jeff Martin, Gregg Bergan,
Eric Liebhauser, Dan Buchmeier
CLIENT
Vespa

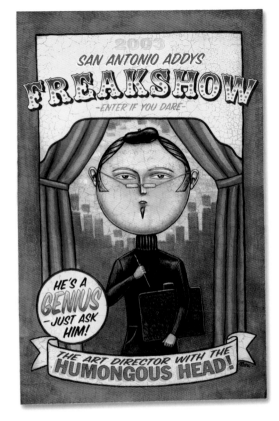

CREATIVE FIRM
Toolbox Studios, Inc.
San Antonio (Texas), USA
CREATIVES
Stan McElrath, Paul Soupiset,
Marc Burckhardt
CLIENT
AAF San Antonio

56

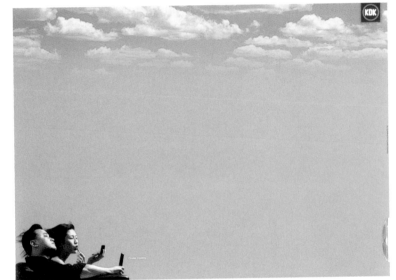

CREATIVE FIRM
Vibes Communications
Singapore
CREATIVES
Ronald Wong, Denis Ong,
Lee Jen, J-Studio
CLIENT
KDK Fan

CREATIVE FIRM
Popular Mechanics
New York (New York), USA
CREATIVES
Bryan Canniff
CLIENT
Popular Mechanics

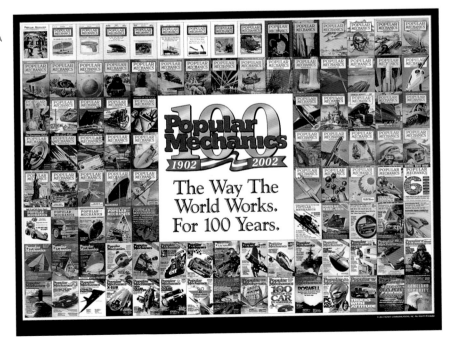

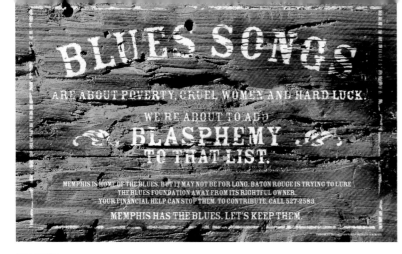

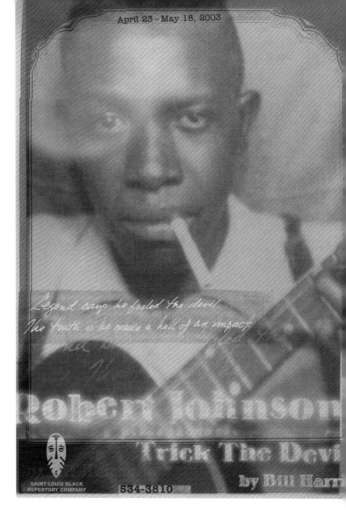

CREATIVE FIRM
Thompson & Company
Memphis (Tennessee), USA
CREATIVES
Mark Robinson, Amanda Petty,
Rick Baptist, Dave Smith,
Puffer Thompson
CLIENT
Blues Foundation

CREATIVE FIRM
QCCG
San Diego (California), USA
CREATIVES
Grant Kroeger, Christopher Lee,
Karen Allen
CLIENT
Southern Caregiver Resource

CREATIVE FIRM
Rodgers Townsend
St. Louis (Missouri), USA
CREATIVES
Erik Mathre, Michelle Vesth,
Kris Wright, Tom Hudder
CLIENT
St. Louis Black Repertory Co.

57

CREATIVE FIRM
The Star Group
Cherry Hill (New Jersey), USA
CREATIVES
Jan Talamo, Dave Girgenti,
Zave Smith
CLIENT
David Michael Flavors

THE 11TH ANNUAL
BASTILLE DAY

Bastille

ANNOUNCING THE 11TH ANNUAL BASTILLE DAY CELEBRATION.
A FUND RAISING EVENT BENEFITING SOUTHERN CAREGIVER RESOURCE CENTER.
ENJOY...WINE TASTING AND SPECIAL FOODS PLUS WINE AND GIFT SILENT AUCTION 4 TO 7 PM AND/OR GOURMET
DINNER 7:30 TO 10 PM FEATURING FINE FOOD AND WINE.
SUNDAY JULY 14 2002

chardonnay title sponsor
QUALCOMM

Southern
Caregiver
Resource
Center

Held at the WineSeller & Brasserie
9550 Waples street, #115, San Diego, CA. 92121

For additional information, please call SCRC at:
(858) 268-4432

1-800-DM-FLAVORS www.DMflavors.com

Sure, we can do that.

dm

2003

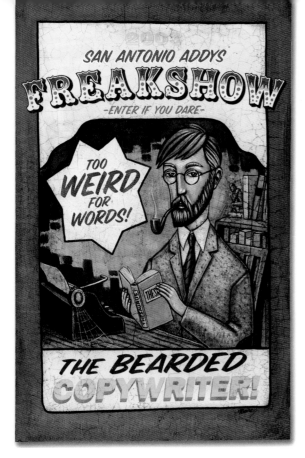

CREATIVE FIRM
Toolbox Studios, Inc.
San Antonio (Texas), USA
CREATIVES
Stan McElrath, Paul Soupiset,
Marc Burckhardt
CLIENT
AAF San Antonio

58

CREATIVE FIRM
Gold & Associates, Inc.
Ponte Vedra Beach (Florida), USA
CREATIVES
Keith Gold, Dick Molay, Jan Hanak, Lans Stout
CLIENT
The First Tee

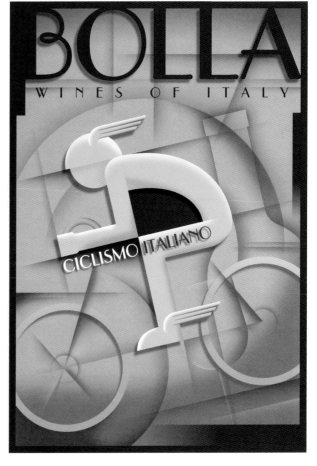

CREATIVE FIRM
PriceWeber
Louisville (Kentucky), USA
CREATIVES
Larry Profancik, Martá Garcia,
Frederick Hagan
CLIENT
Brown-Forman Beverages Worldwide

CREATIVE FIRM
**Liquid Agency
Inc.**
San Jose (California),
USA
CREATIVES
Charlotte Jones,
Joshua Swanbeck
CLIENT
AIGA

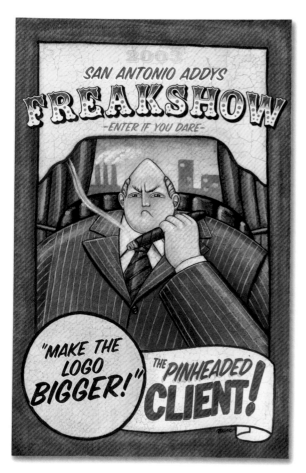

CREATIVE FIRM
Chandler Ehrlich
Memphis (Tennessee),
USA
CREATIVES
Mike Leon,
Mike Yue,
Guy Stieferman,
Marina Scott
CLIENT
Memphis Convention &
Visitors Bureau

CREATIVE FIRM
Toolbox Studios, Inc.
San Antonio (Texas), USA
CREATIVES
Stan McElrath, Paul Soupiset,
Marc Burckhardt
CLIENT
AAF San Antonio

59

CREATIVE FIRM
Bernard Chia
Singapore
CREATIVES
Bernard Chia
CLIENT
Bukit Ho Swee
Community Centre

CREATIVE FIRM
CSC/P2 Communications Services
Falls Church (Virginia), USA
CREATIVES
Bryn Farrar, John Houseman

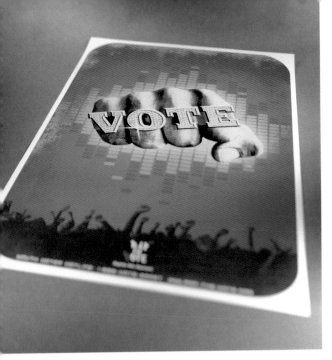

CREATIVE FIRM
Zeesman Communications, Inc.
Culver City (California), USA
CREATIVES
Joseph Kaiser, Trish Abbot
CLIENT
Rock the Vote

60

CREATIVE FIRM
Chandler Ehrlich
Memphis (Tennessee), USA
CREATIVES
Mike Leon, Mike Yue,
Guy Stieferman, Marina Scott
CLIENT
Memphis Convention & Visitors Bureau

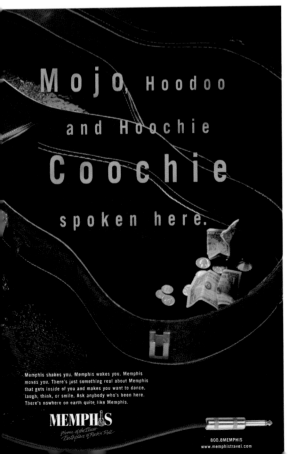

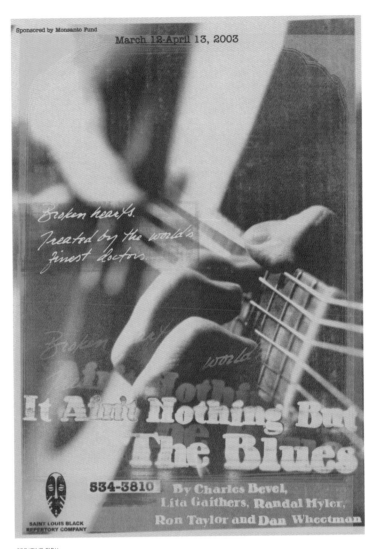

CREATIVE FIRM
Rodgers Townsend
St. Louis (Missouri), USA
CREATIVES
Erik Mathre, Michelle Vesth,
Kris Wright, Tom Hudder
CLIENT
St. Louis Black Repertory Co.

CREATIVE FIRM
Thompson & Company
Memphis (Tennessee), USA
CREATIVES
Mark Robinson, Amanda Petty, Rick Baptist,
Dave Smith, Puffer Thompson
CLIENT
Blues Foundation

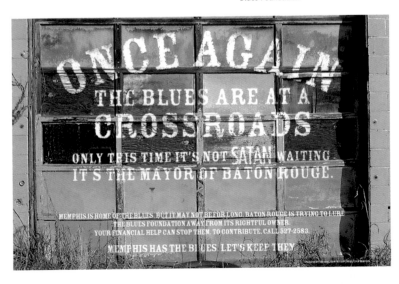

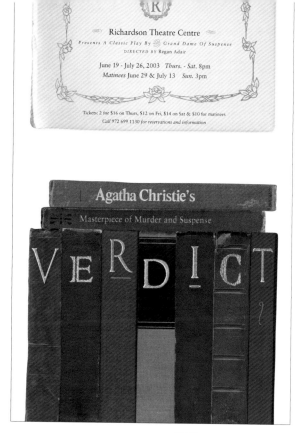

CREATIVE FIRM
VanPelt Creative
Garland (Texas), USA
CREATIVES
Chip VanPelt
CLIENT
Richardson Theatre Centre

CREATIVE FIRM
Philippe Becker Design
San Francisco (California), USA
CREATIVES
Philippe Becker
CLIENT
Napa Valley Vintners Association

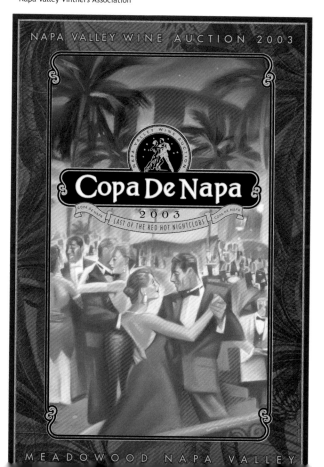

CREATIVE FIRM
Tom Ventress Design
Nashville (Tennessee), USA
CREATIVES
Tom Ventress
CLIENT
Razors Edge Productions

61

CREATIVE FIRM
Crosby Marketing Communications
Annapolis (Maryland), USA
CREATIVES
Ron Ordansa, Tom Hight,
Mark Walston
CLIENT
Advertising Association of Baltimore

CREATIVE FIRM
GOLD & Associates, Inc.
Ponte Vedra Beach (California), USA
CREATIVES
Keith Gold, Peter Butcavage
CLIENT
GOLD & Associates, Inc.

62

CREATIVE FIRM
KO Design Institute
Tokyo, Japan
CREATIVES
Koshi Ogawa, Tsuyoshi Ryu,
CLIENT
KO Design Institute

CREATIVE FIRM
KOREK Studio
Warsaw, Poland
CREATIVES
Wojtek Korkuc, KOREK
CLIENT
Front Film AB

CREATIVE FIRM
AMP
Costa Mesa (California), USA
CREATIVES
Luis Camano, Carlos Musquez, Enrique Ahumada
CLIENT
Tiger Sport

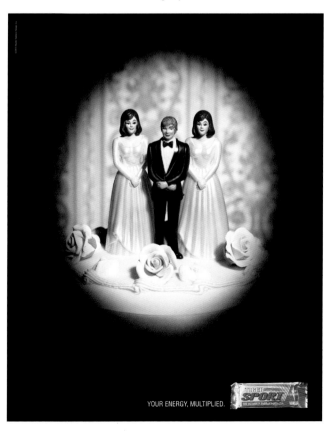

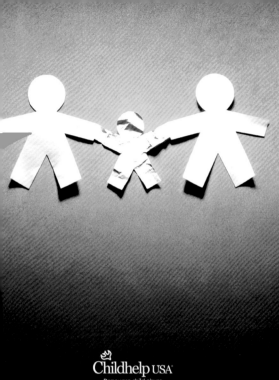

Childhelp USA®
Denounce child abuse.
1·800·4·A·CHILD®.

CREATIVE FIRM
Dieste Harmel & Partners
Dallas (Texas), USA
CREATIVES
Aldo Quevedo, Patricia Martinez,
Juan Carlos Hernández
CLIENT
Childhelp USA

CREATIVE FIRM
Kiku Obata + Company
St. Louis (Missouri), USA
CREATIVES
Rich Nelson
CLIENT
The Shakespeare Festival of St. Louis

REFLECTIONS IN BLACK
SMITHSONIAN AFRICAN AMERICAN PHOTOGRAPHY

63

CREATIVE FIRM
Tom Ventress Design
Nashville (Tennessee), USA
CREATIVES
Tom Ventress, Chester Higgins Jr.,
Addison Scurlock, Jonathan Eubanks,
Amalia Amaki
CLIENT
First Center For The Visual Arts

CREATIVE FIRM
McClain Finlon Advertising
Denver (Colorado), USA
CREATIVES
Jeff Martin, Gregg Bergan,
Eric Liebhauser, Dan Buchmeier
CLIENT
Vespa

THE SHAKESPEARE FESTIVAL OF SAINT LOUIS
MAY 31 – JUNE 15, 2003 FOREST PARK
PERFORMANCE 8:00 PM NIGHTLY EXCEPT TUESDAY
FREE ADMISSION

MACBETH

DIRECTED BY RICK SORDELET

WILLIAM SHAKESPEARE

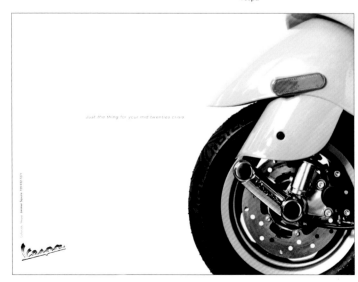

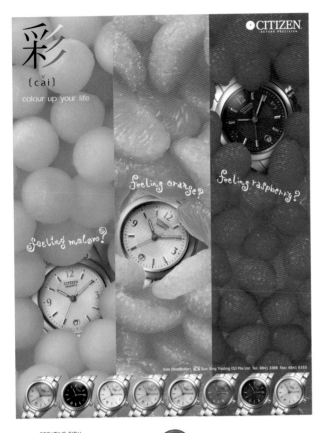

彩
[cǎi]

colour up your life

Feeling melon?

Feeling orange?

Feeling raspberry?

CITIZEN

CREATIVE FIRM
Planet Ads & Design P/L
Singapore
CREATIVES
Hal Suzuki,
Michelle Lauridsen
CLIENT
Citizen Watches (H.K.) Ltd.

64

CREATIVE FIRM
Liquid Agency Inc.
San Jose (California),
USA
CREATIVES
Joshua Swanbeck,
Alfredo Muccino
CLIENT
San Jose Downtown
Association

metro's
MUSIC IN THE PARK

20
02

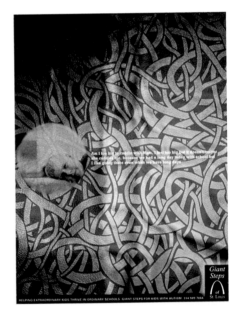

CREATIVE FIRM
Rodgers Townsend
St. Louis (Missouri), USA
CREATIVES
Tom Townsend,
Tom Hudder,
Evan Willnow
CLIENT
Giant Steps

CREATIVE FIRM
Toolbox Studios, Inc.
San Antonio (Texas), USA
CREATIVES
Paul Soupiset, Raquel Savage,
Seymour Chwast
CLIENT
USAA

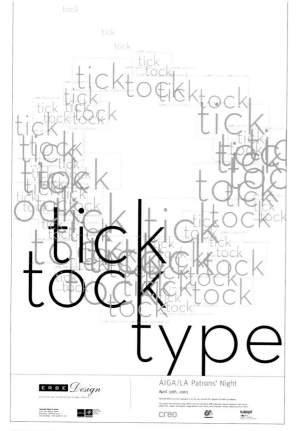

CREATIVE FIRM
Erbe Design
South Pasadena (California), USA
CREATIVES
Maureen Erbe, Efi Latief, Karen Nakatani
CLIENT
A.I.G.A., Los Angeles Chapter

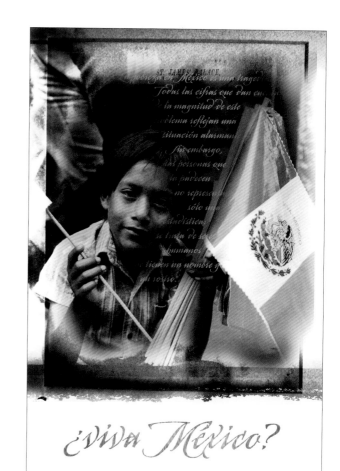

CREATIVE FIRM
TD2, S.C.
Mexico
CREATIVES
Rafael Rodrigo Cordova
CLIENT
Casa de la Sal

65

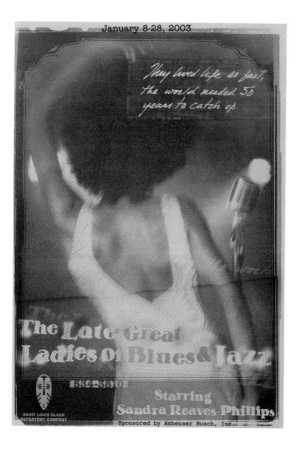

CREATIVE FIRM
Rodgers Townsend
St. Louis (Missouri),
USA
CREATIVES
Erik Mathre,
Michelle Vesth,
Kris Wright,
Tom Hudder
CLIENT
St. Louis Black
Repertory Co.

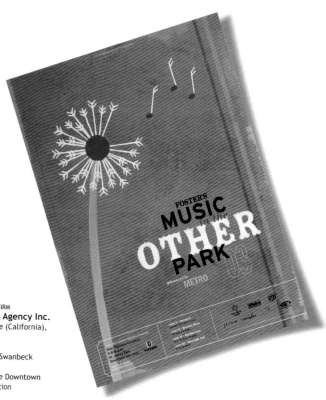

CREATIVE FIRM
Liquid Agency Inc.
San Jose (California),
USA
CREATIVES
Joshua Swanbeck
CLIENT
San Jose Downtown
Association

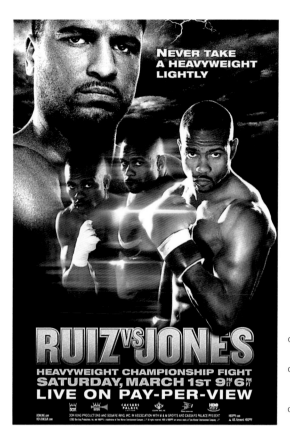

CREATIVE FIRM
HBO
New York (New York), USA
CREATIVES
Gary Dueno, Jose Mendez,
Sean Pompesello,
Venus Dennison
CLIENT
HBO

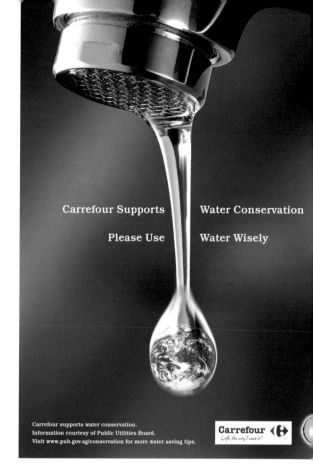

CREATIVE FIRM
Planet Ads & Design P/L
Singapore
CREATIVES
Hal Suzuki, Tominaga Norboru,
Michelle Lauridsen
CLIENT
Carrefour Singapore

66

CREATIVE FIRM
Brown
Regina (Saskatchewan), Canada
CREATIVES
Dean Fleck, Mike Woroniak
CLIENT
Regina Big Brothers

CREATIVE FIRM
One Hundred Church St.
Logan (Utah), USA
CREATIVES
R.P. Bissland
CLIENT
Summer Fest

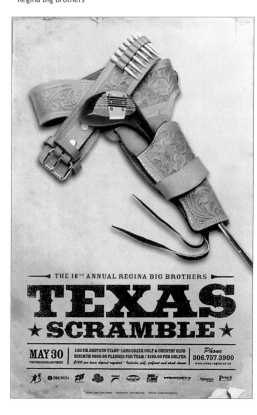

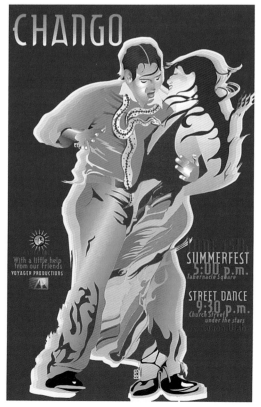

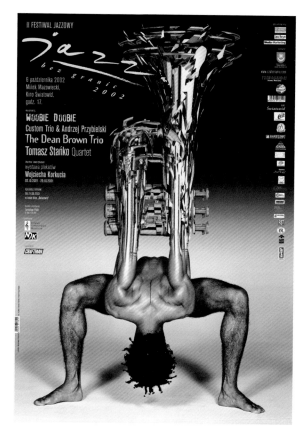

CREATIVE FIRM
KOREK Studio
Warsaw, Poland
CREATIVES
Wojtek Korkuc,
KOREK
CLIENT
Municipality of Minsk Mazowiecki

CREATIVE FIRM
Heye & Partner GmbH
Bavaria, Germany
CREATIVES
Markus Lange, Gudrun Muschalla,
Florian Drahorad, Roberto Petrin
CLIENT
McDonald's Germany

CREATIVE FIRM
Concepts 3
Saskatoon (Saskatchewan), Canada
CREATIVES
Christian Jensen, Dani Van Driel
CLIENT
Friends of the Broadway Theatre

67

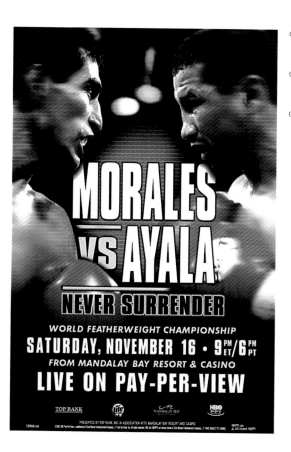

CREATIVE FIRM
HBO
New York (New York),
USA
CREATIVES
Jose Mendez,
Sean Pompesello,
Venus Dennison
CLIENT
HBO

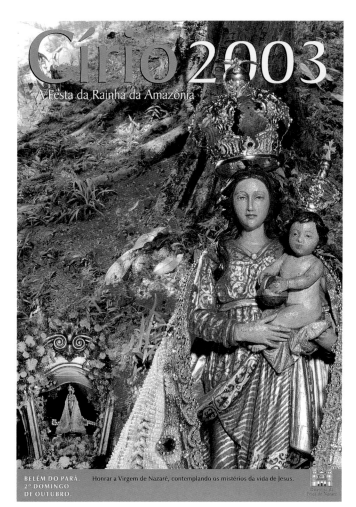

BELÉM DO PARÁ. 2º DOMINGO DE OUTUBRO. Honrar a Virgem de Nazaré, contemplando os mistérios da vida de Jesus.

68

CREATIVE FIRM
Mendes Publicidade
Pará, Brazil
CREATIVES
Oswaldo Mendes, Maria Alice Penna,
Luiz Braga
CLIENT
Diretoria da Festa de Nazaré

CREATIVE FIRM
Purdue University
West Lafayette(Indiana),USA
CREATIVES
Li Zhang
CLIENT
Purdue Repertory Dance Company

CREATIVE FIRM
Rodgers Townsend
St. Louis (Missouri), USA
CREATIVES
Michael McCormick, Luke Partridge,
Evan Willnow
CLIENT
Circus Flora

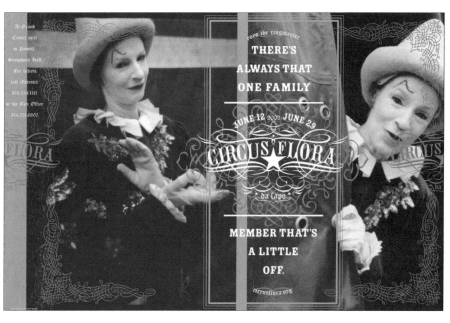

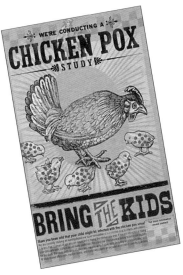

CREATIVE FIRM
GlaxoSmithKline Creative Services
Research Triangle Park (North Carolina), USA
CREATIVES
Todd Coats, Phil Hansley, David Watts,
Toby Roan
CLIENT
GSK Clinical Trials

CREATIVE FIRM
KO Design Institute
Tokyo, Japan
CREATIVES
Koshi Ogawa
CLIENT
Group Eyes

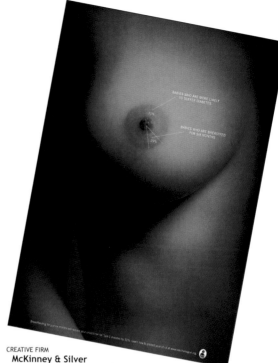

CREATIVE FIRM
McKinney & Silver
Raleigh (North Carolina), USA
CREATIVES
David Baldwin, Lara Bridger, Barbara Eibel
CLIENT
La Leche League

CREATIVE FIRM
Wendell Minor Design
Washington (Connecticut), USA
CREATIVES
Wendell Minor, Margaret Gallagher
CLIENT
Putnam

69

CREATIVE FIRM
Wolken Communica
Seattle (Washington), USA
CREATIVES
Johann Gomez, Kurt Wolken
CLIENT
Bellevue Art Museum

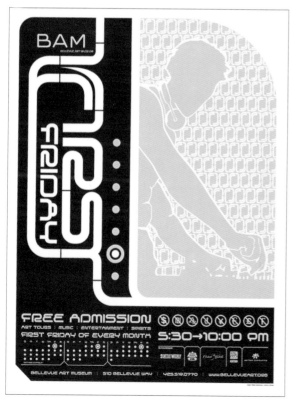

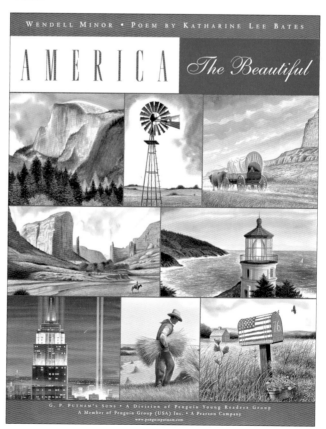

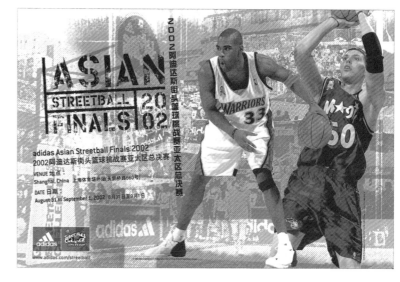

*www.giesingteam.de

70

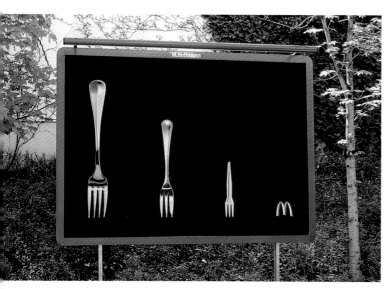

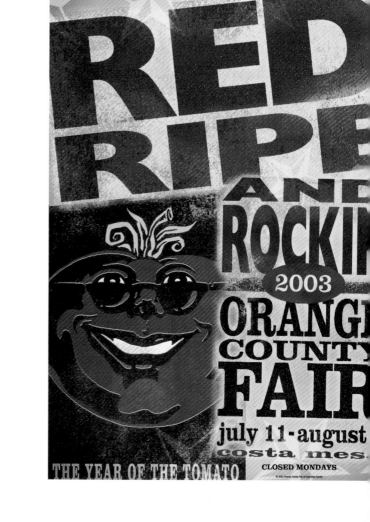

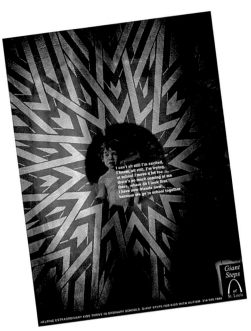

CREATIVE FIRM
Rodgers Townsend
St. Louis (Missouri), USA
CREATIVES
Tom Townsend, Tom Hudder,
Evan Willnow
CLIENT
Giant Steps

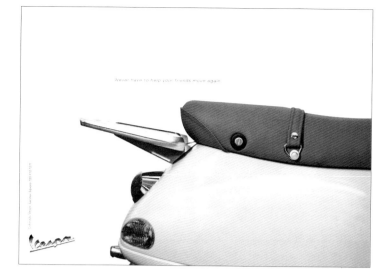

CREATIVE FIRM
McClain Finlon Advertising
Denver (Colorado), USA
CREATIVES
Jeff Martin, Gregg Bergan,
Eric Liebhauser, Dan Buchmeier
CLIENT
Vespa

CREATIVE FIRM
One Hundred Church St.
Logan (Utah), USA
CREATIVES
R.P. Bissland
CLIENT
Logan Track & Drinking Club

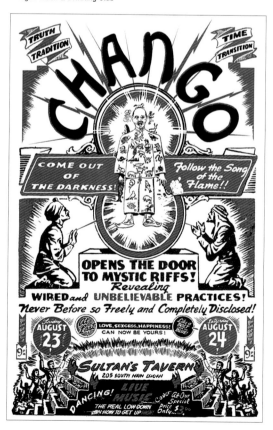

CREATIVE FIRM
One Hundred Church St.
Logan (Utah), USA
CREATIVES
R.P. Bissland, Gary Snyder
CLIENT
Ken Sanders Rare Books

71

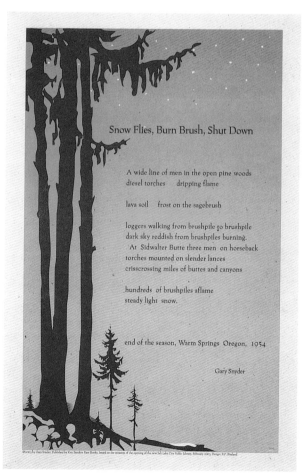

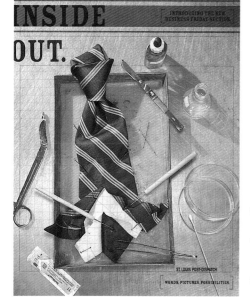

UNDERSTANDING BUSINESS FROM THE INSIDE OUT.

INTRODUCING THE NEW BUSINESS FRIDAY SECTION.

ST. LOUIS POST-DISPATCH

WORDS. PICTURES. POSSIBILITIES.

72

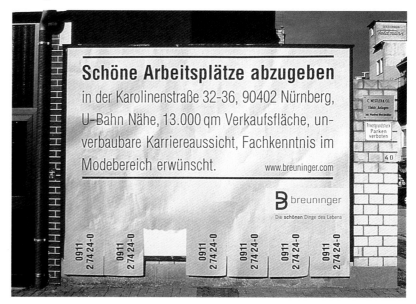

The Durham Fair

THE EIGHTY-THIRD ANNUAL
DURHAM FAIR
SEPTEMBER 27 - 29 2002

FOREVER STRONG

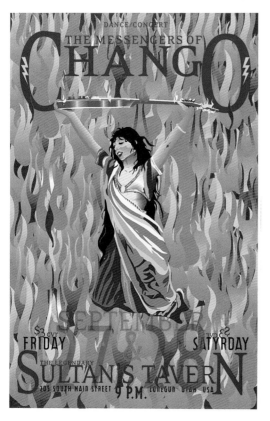

DANCE/CONCERT
THE MESSENGERS OF
CHANGO

THE LEGENDARY
FRIDAY
SATURDAY
SULTAN'S TAVERN
205 SOUTH MAIN STREET LOGAN, UTAH USA
9 P.M.

Schöne Arbeitsplätze abzugeben

in der Karolinenstraße 32-36, 90402 Nürnberg,
U-Bahn Nähe, 13.000 qm Verkaufsfläche, un-
verbaubare Karriereaussicht, Fachkenntnis im
Modebereich erwünscht.

www.breuninger.com

breuninger
Die schönen Dinge des Lebens

0911 27 42 4-0

The crisp, clean air coming off an approaching mountain.
The occasional 18-wheeler stirring up the fresh powder.
The growing concern that your fingers are frozen to your grips.
Relax, you're not alone. **BMW Motorcycle Owners of America**

A network of over 36,000 BMW motorcycle owners for news, tips, trip planning and roadside assistance when you need it most. **bmwmoa.org**

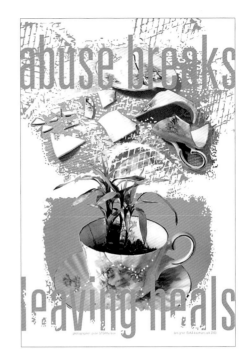

CREATIVE FIRM
Rodgers Townsend
St. Louis (Missouri), USA
CREATIVES
Michael McCormick, Tom Hudder,
Evan Willnow
CLIENT
BMW Motorcycle Owners Assoc.

CREATIVE FIRM
Elka Design
Buffalo (New York), USA
CREATIVES
Elka Kazmierczak, Peter Storkerson
CLIENT
Crisis Services of Buffalo

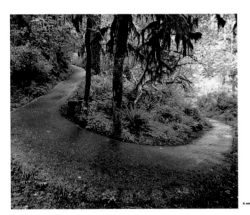

The smell of wet evergreens washing over you. The leftover
raindrops filtering through the forest canopy. The sloshing
of a 64-ounce lemonade you had about 100 miles back.
Relax, you're not alone. **BMW Motorcycle Owners of America**

A network of over 36,000 BMW motorcycle owners for news, tips, trip planning and roadside assistance when you need it most. **bmwmoa.org**

73

CREATIVE FIRM
Rodgers Townsend
St. Louis (Missouri), USA
CREATIVES
Michael McCormick, Tom Hudder,
Evan Willnow
CLIENT
BMW Motorcycle Owners Assoc.

CREATIVE FIRM
Rodgers Townsend
St. Louis (Missouri), USA
CREATIVES
Michael McCormick, Luke Partridge,
Evan Willnow
CLIENT
Circus Flora

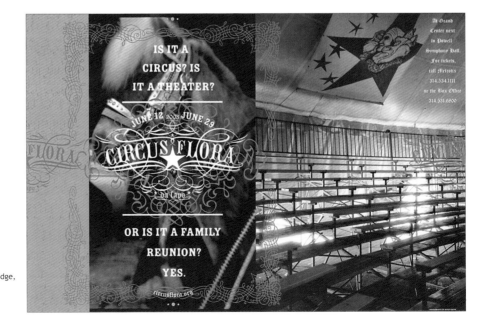

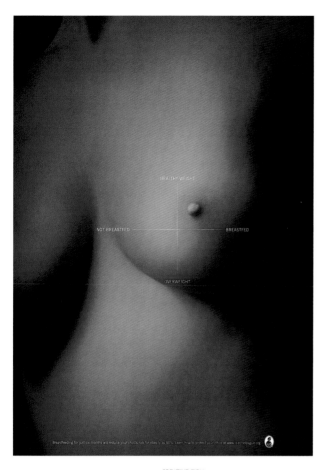

74

CREATIVE FIRM
McKinney & Silver
Raleigh (North Carolina), USA
CREATIVES
David Baldwin, Lara Bridger, Barbara Eibel
CLIENT
La Leche League

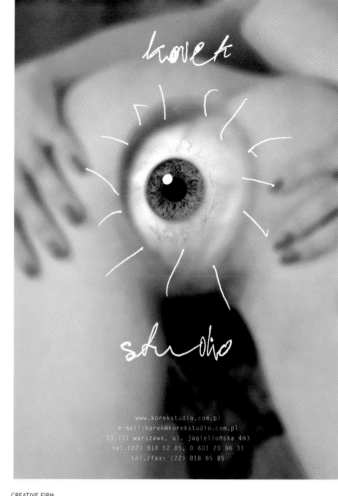

CREATIVE FIRM
KOREK Studio
Warsaw, Poland
CREATIVES
Wojtek Korkuc,
KOREK

CREATIVE FIRM
Russell-Creative Services
Tacoma (Washington), USA
CREATIVES
Jay Hember
CLIENT
Russell

CREATIVE FIRM
Thompson & Company
Memphis (Tennessee), USA
CREATIVES
Mark Robinson, Amanda Petty,
Rick Baptist, Dave Smith,
Puffer Thompson
CLIENT
Blues Foundation

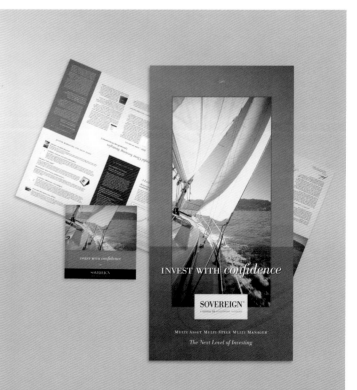

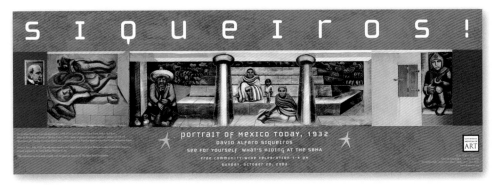

CREATIVE FIRM
Barbara Brown Marketing & Design
Ventura (California), USA
CREATIVES
Jon A. Leslie, Holden Color
CLIENT
SBMA

CREATIVE FIRM
Rodgers Townsend
St. Louis (Missouri), USA
CREATIVES
Michael McCormick,
Luke Partridge,
Evan Willnow
CLIENT
St. Louis Post-Dispatch

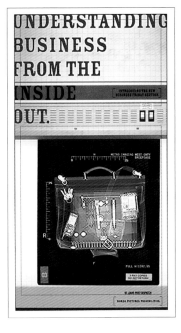

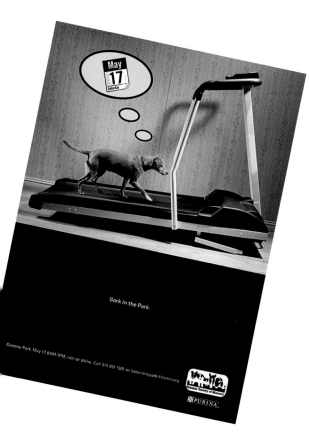

CREATIVE FIRM
Rodgers Townsend
St. Louis (Missouri), USA
CREATIVES
Tom Hudder,
Tom Townsend,
Evan Willnow
CLIENT
Humane Society of
Missouri

75

CREATIVE FIRM
Rodgers Townsend
St. Louis (Missouri), USA
CREATIVES
Michael McCormick, Luke Partridge,
Evan Willnow
CLIENT
Circus Flora

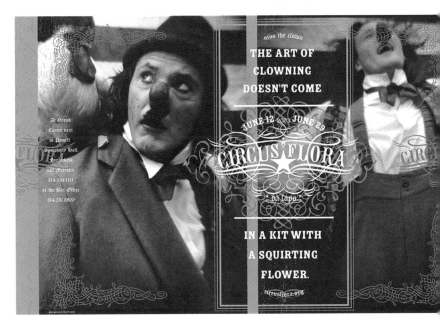

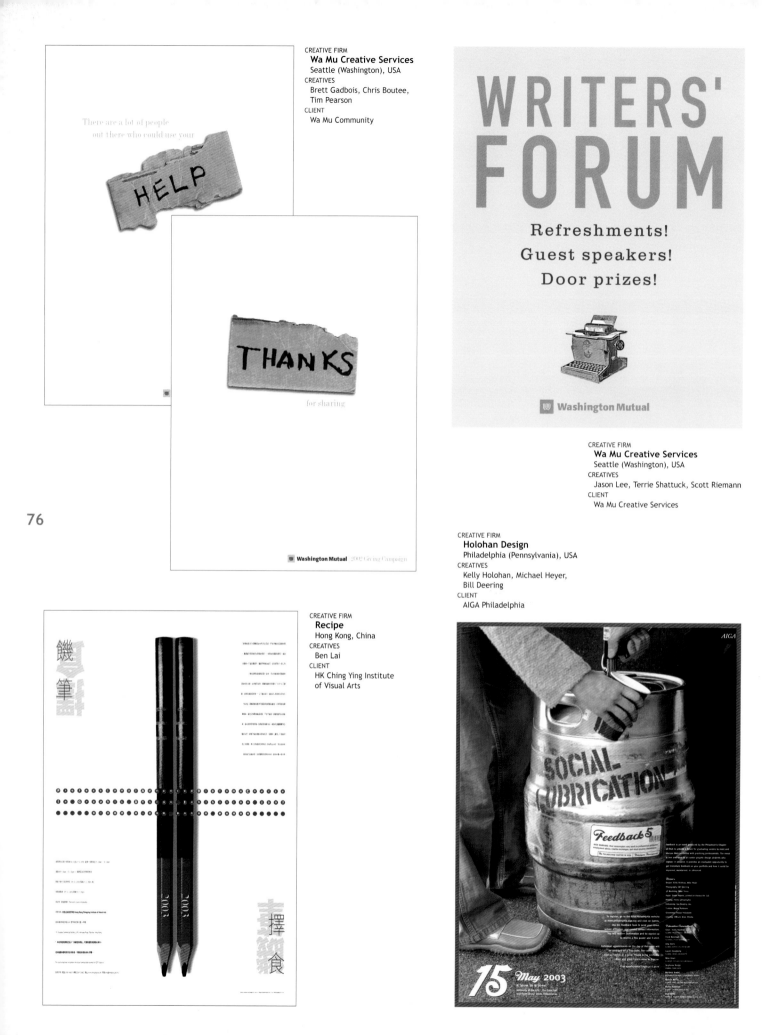

CREATIVE FIRM
Wa Mu Creative Services
Seattle (Washington), USA
CREATIVES
Brett Gadbois, Chris Boutee,
Tim Pearson
CLIENT
Wa Mu Community

There are a lot of people
out there who could use your

HELP

THANKS

for sharing

Washington Mutual 2002 Giving Campaign

WRITERS' FORUM

Refreshments!
Guest speakers!
Door prizes!

Washington Mutual

CREATIVE FIRM
Wa Mu Creative Services
Seattle (Washington), USA
CREATIVES
Jason Lee, Terrie Shattuck, Scott Riemann
CLIENT
Wa Mu Creative Services

CREATIVE FIRM
Holohan Design
Philadelphia (Pennsylvania), USA
CREATIVES
Kelly Holohan, Michael Heyer,
Bill Deering
CLIENT
AIGA Philadelphia

CREATIVE FIRM
Recipe
Hong Kong, China
CREATIVES
Ben Lai
CLIENT
HK Ching Ying Institute
of Visual Arts

SOCIAL LUBRICATION

Feedback 5

15 May 2003

76

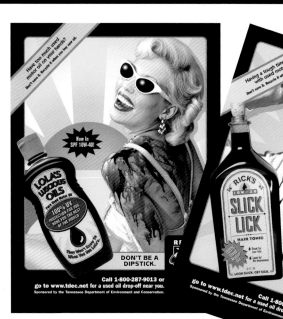

CREATIVE FIRM
Bohan Advertising/Marketing
Nashville (Tennessee), USA
CREATIVES
Kerry Oliver, Kevin Hinson,
Darrell Soloman
CLIENT
Tennessee Department of
Environment & Conservation

CREATIVE FIRM
Rodgers Townsend
St. Louis (Missouri), USA
CREATIVES
Tom Townsend, Tom Hudder,
Evan Willnow
CLIENT
Giant Steps

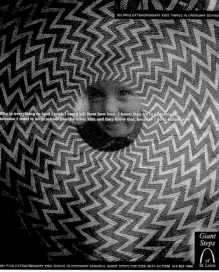

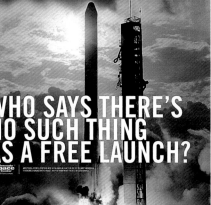

CREATIVE FIRM
Fry Hammond Barr
Orlando (Florida), USA
CREATIVES
Tim Fisher,
Sean Brunsun,
Tom Kane,
Shannon Hallare
CLIENT
Kennedy Space Center

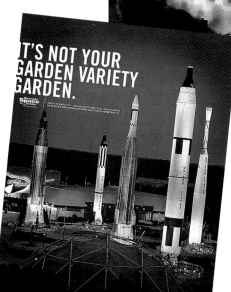

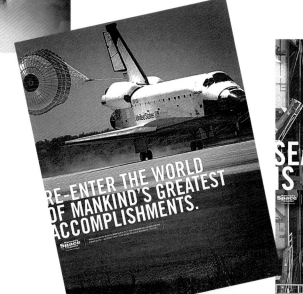

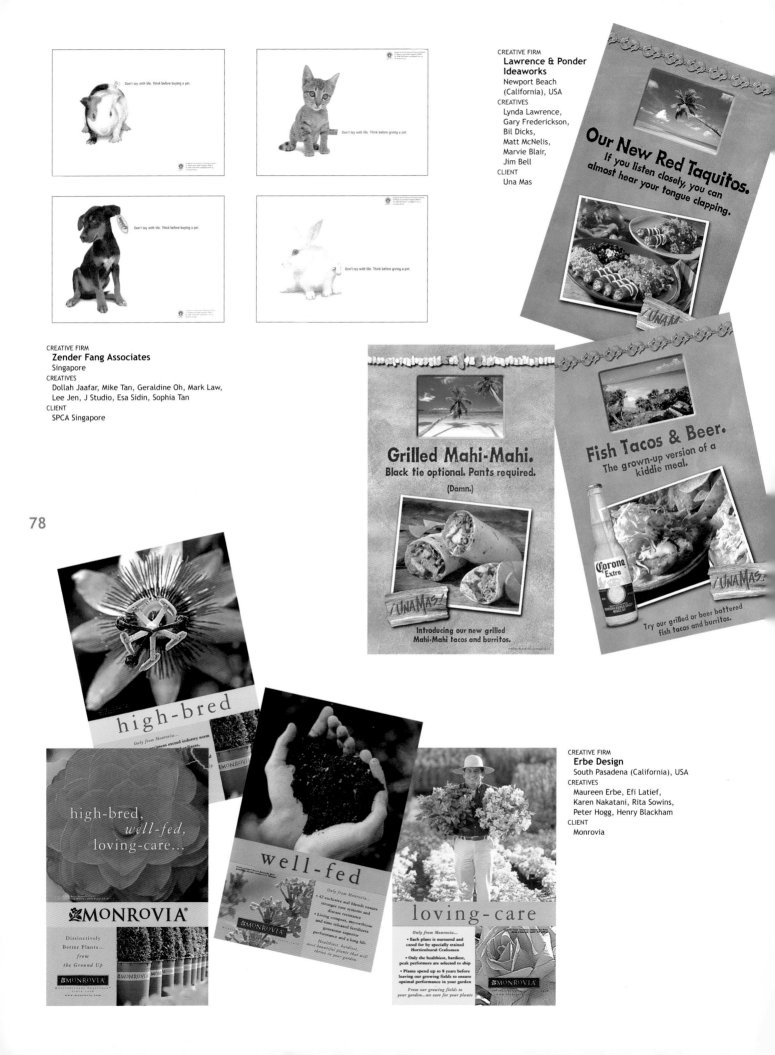

78

CREATIVE FIRM
Rodgers Townsend
St. Louis (Missouri), USA
CREATIVES
Erik Mathre, Michelle Vesth,
Kris Wright, Tom Hudder
CLIENT
St. Louis Black Repertory Co.

CREATIVE FIRM
Rodgers Townsend
St. Louis (Missouri), USA
CREATIVES
Tom Hudder, Michael McCormick,
Evan Willnow
CLIENT
BMW Motorcycle Owners
Association

79

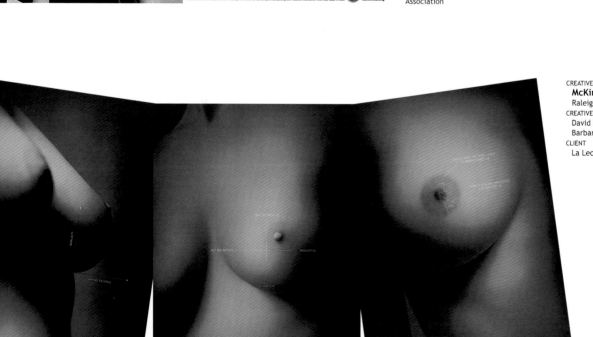

CREATIVE FIRM
McKinney & Silver
Raleigh (North Carolina), USA
CREATIVES
David Baldwin, Lara Bridger,
Barbara Eibel
CLIENT
La Leche League

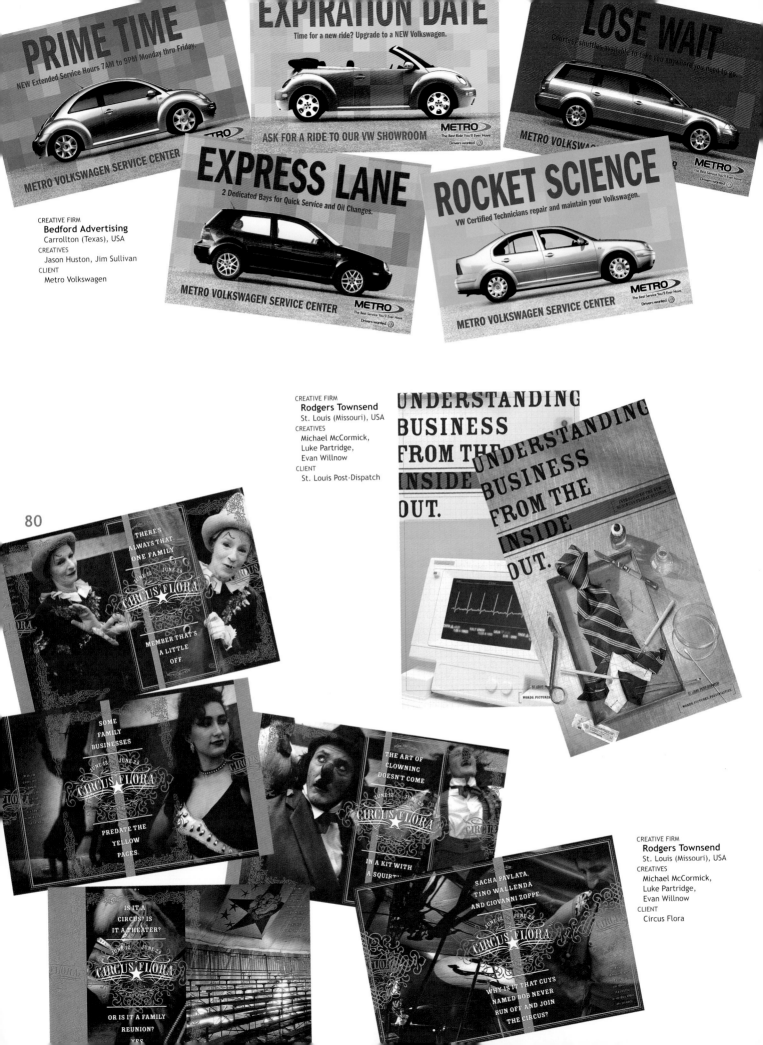

PRIME TIME
NEW Extended Service Hours 7AM to 9PM Monday thru Friday.
METRO VOLKSWAGEN SERVICE CENTER

EXPIRATION DATE
Time for a new ride? Upgrade to a NEW Volkswagen.
ASK FOR A RIDE TO OUR VW SHOWROOM
METRO
The Best Ride You'll Ever Have
Drivers wanted

LOSE WAIT
Courtesy shuttles available to take you anywhere you need to go.
METRO VOLKSWAGEN
METRO
The Best Service You'll Ever Have
Drivers wanted

EXPRESS LANE
2 Dedicated Bays for Quick Service and Oil Changes.
METRO VOLKSWAGEN SERVICE CENTER
METRO
The Best Service You'll Ever Have
Drivers wanted

ROCKET SCIENCE
VW Certified Technicians repair and maintain your Volkswagen.
METRO VOLKSWAGEN SERVICE CENTER
METRO
The Best Service You'll Ever Have
Drivers wanted

CREATIVE FIRM
Bedford Advertising
Carrollton (Texas), USA
CREATIVES
Jason Huston, Jim Sullivan
CLIENT
Metro Volkswagen

CREATIVE FIRM
Rodgers Townsend
St. Louis (Missouri), USA
CREATIVES
Michael McCormick,
Luke Partridge,
Evan Willnow
CLIENT
St. Louis Post-Dispatch

80

UNDERSTANDING BUSINESS FROM THE INSIDE OUT.

UNDERSTANDING BUSINESS FROM THE INSIDE OUT.

THERE'S ALWAYS THAT ONE FAMILY MEMBER THAT'S A LITTLE OFF.
CIRCUS FLORA

SOME FAMILY BUSINESSES PREDATE THE YELLOW PAGES.
CIRCUS FLORA

THE ART OF CLOWNING DOESN'T COME IN A KIT WITH A SQUIRT
CIRCUS FLORA

IS IT A CIRCUS? IS IT A THEATER? OR IS IT A FAMILY REUNION? YES
CIRCUS FLORA

SACHA PAVLATA, TINO WALLENDA AND GIOVANNI ZOPPE
WHY IS IT THAT GUYS NAMED BOB NEVER RUN OFF AND JOIN THE CIRCUS?
CIRCUS FLORA

CREATIVE FIRM
Rodgers Townsend
St. Louis (Missouri), USA
CREATIVES
Michael McCormick,
Luke Partridge,
Evan Willnow
CLIENT
Circus Flora

What would you do without it?

It's a jolting thought — life without water. Can't drink. Brown lawns. Swimming's out.

Yeah, we like water and we need plenty of it. But our supplies are running low.

What are we gonna do?

Stop wasting. Start consuming. Make every drop count.

What would you do without it?

It's a jolting thought — life without water. Can't drink. Brown lawns. And let's not forget about flushing.

Yeah, we like water and we need plenty of it. But our supplies are running low.

What are we gonna do?

Stop wasting. Start consuming. Make every drop count.

CREATIVE FIRM
Rassman Design
Denver (Colorado), USA
CREATIVES
John Rassman, Glen Hobbs
CLIENT
Colorado Bar Association

CREATIVE FIRM
Pool Design Group
Englewood (Colorado),
USA
CREATIVES
Jeanna Pool,
Penny Banks,
Diane Bowen
CLIENT
Texas Agricultural
Extension Service

CREATIVE FIRM
Toolbox Studios, Inc.
San Antonio (Texas), USA
CREATIVES
Stan McElrath, Paul Soupiset,
Marc Burckhardt
CLIENT
AAF San Antonio

81

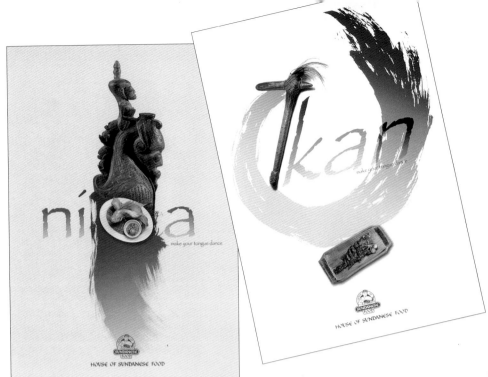

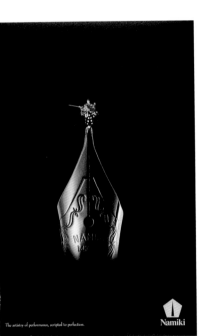

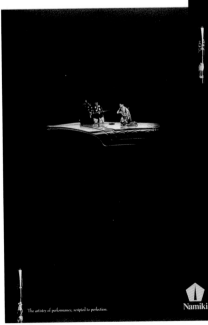

82

CREATIVE FIRM
Vibes Communications
Singapore
CREATIVES
Ronald Wong, Denis Ong,
Lee Jen, J-Studio
CLIENT
Philip Kingsley

CREATIVE FIRM
atomzi! Pte Ltd
Singapore
CREATIVES
Patrick Lee, Marvin Das
CLIENT
House of Sundanese

CREATIVE FIRM
Vibes Communications
Singapore
CREATIVES
Ronald Wong, Juliana Sim,
Lee Jen, J-Studios
CLIENT
Pilot Namiki

CREATIVE FIRM
Vibes Communications
Singapore
CREATIVES
Ronald Wong, Denis Ong,
Lee Jen, J-Studio
CLIENT
Princess Toaster

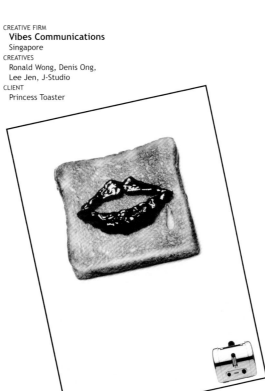

CREATIVE FIRM
Heye & Partner
Bavaria, Germany
CREATIVES
Ralph Taubenberger, Jonas Ruch,
Philipp Heimsch
CLIENT
Breuninger

83

HOW LONG CAN ONE WOMAN HOLD BACK
THE FORCES THAT WANT TO DAM A RIVER
AND DISPLACE HER PEOPLE?

CREATIVE FIRM
Collaborate
San Francisco (California), USA
CREATIVES
Robin Raj, Kurt Lighthouse,
Claude Halcomb, Keba Konte
CLIENT
Amnesty International/Sierra Club

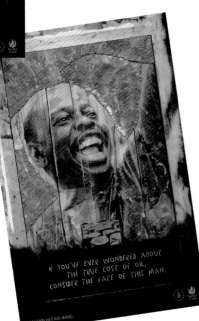

IF YOU'VE EVER WONDERED ABOUT
THE TRUE COST OF OIL,
CONSIDER THE FATE OF THIS MAN.

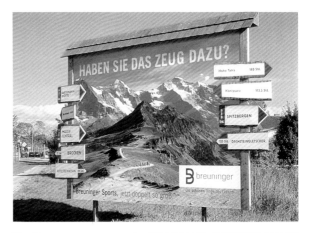

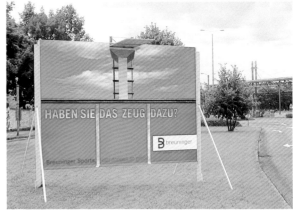

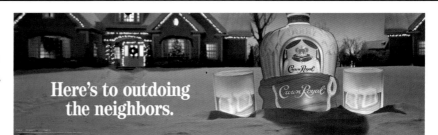

84

Because life is
more than a game.

PERSEVERANCE
Pass It On.

THE FOUNDATION FOR A BETTER LIFE

MOJO, Hoodoo and
Hoochie COOCHIE
spoken here.

MEMPHIS
MemphisTravel.com

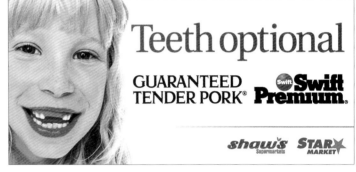

Teeth optional

GUARANTEED
TENDER PORK®

Swift
Swift Premium.

shaw's
Supermarkets

STAR MARKET

85

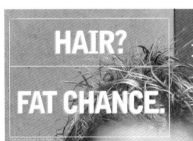

HAIR?

FAT CHANCE.

But you can influence your kids'
decisions about drinking.

1-800-359-TALK

We All Make A Difference
Budweiser

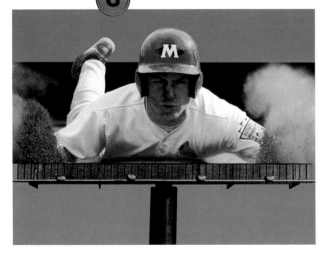

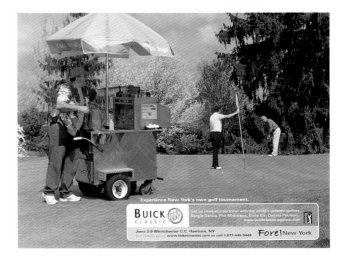

Experience New York's own golf tournament.

BUICK
CLASSIC

*Fore!*New York

June 2-9 Westchester C.C. Harrison, NY

First you'll Cry,
then You'll cry
for More

MEMPHIS
MemphisTravel.com

Overcaem dyslexia.

HARD WORK
Pass It On.

THE FOUNDATION FOR A BETTER LIFE

SBC
Pacific Bell

BROADBAND. NEVER BE LEFT BEHIND AGAIN.

sbc.com/broadband

86

Really fast business loans. **FIRST CITIZENS BANK**
Do something amazing™

MUSIC?

UNLIKELY.

But you can influence your kids'
decisions about drinking.

1-800-359-TALK

We All Make A Difference
Budweiser

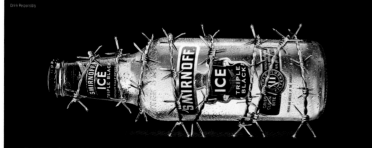

NEW SMIRNOFF ICE TRIPLE BLACK. A CRISP CLEAN BITE.

BENGAL: 8,381 MILES
BENGAL TIGER: 10 MILES

MANCHURIA: 6,993 MILES
MANCHURIAN CRANE: 5 MILES

CREATIVE FIRM
Bohan Advertising/Marketing
Nashville (Tennessee), USA
CREATIVES
Kerry Oliver, Kevin Hinson
CLIENT
Nashville Zoo

87

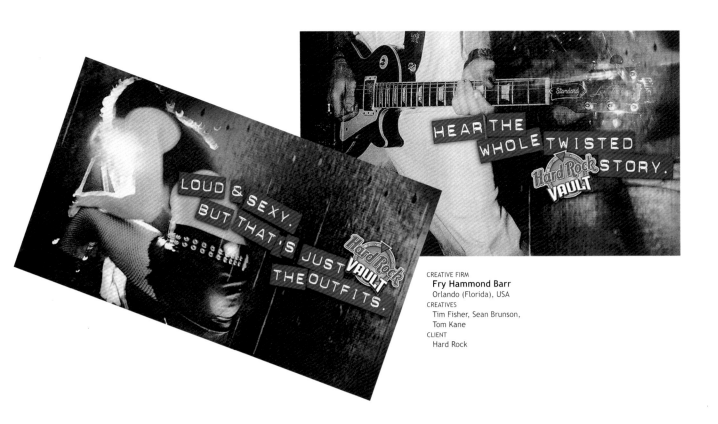

CREATIVE FIRM
Fry Hammond Barr
Orlando (Florida), USA
CREATIVES
Tim Fisher, Sean Brunson,
Tom Kane
CLIENT
Hard Rock

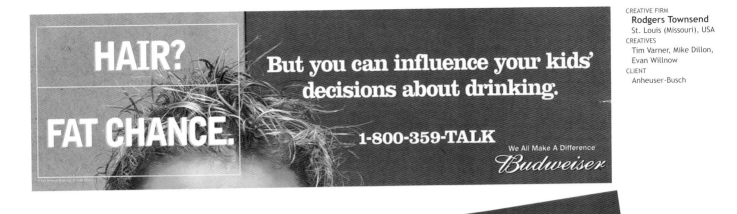

CREATIVE FIRM
Rodgers Townsend
St. Louis (Missouri), USA
CREATIVES
Tim Varner, Mike Dillon,
Evan Willnow
CLIENT
Anheuser-Busch

HAIR?

FAT CHANCE.

But you can influence your kids' decisions about drinking.

1-800-359-TALK

We All Make A Difference
Budweiser

MUSIC?

UNLIKELY.

But you can influence your kids' decisions about drinking.

1-800-359-TALK

We All Make A Difference
Budweiser

88

CREATIVE FIRM
Gardner Geary Coll Inc.
San Francisco (California), USA
CREATIVES
Lance Anderson, Naomi Maloney,
John Coll
CLIENT
Rolling Hills Casino

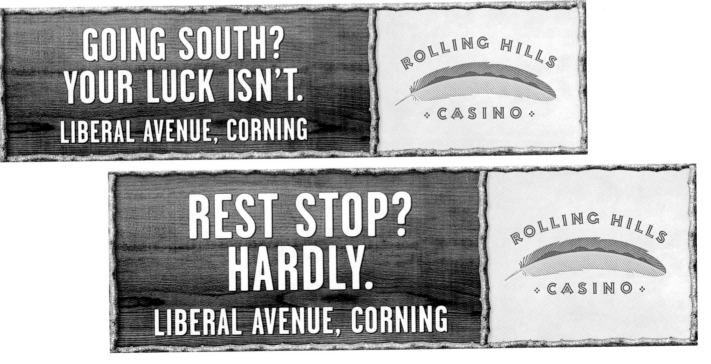

**GOING SOUTH?
YOUR LUCK ISN'T.**
LIBERAL AVENUE, CORNING

ROLLING HILLS
CASINO

**REST STOP?
HARDLY.**
LIBERAL AVENUE, CORNING

ROLLING HILLS
CASINO

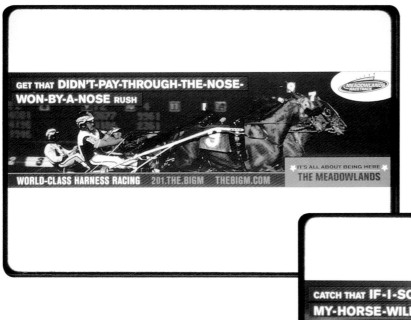

CREATIVE FIRM
The Sloan Group
New York (New York), USA
CREATIVES
Wyndy Wilder, Elizabeth Bernard,
Jay Sandusky, Alicia Potter
CLIENT
The Big M-Meadowlands

CREATIVE FIRM
BBK Studio
Grand Rapids (Michigan), USA
CREATIVES
Sharon Oleniczak, Brian Hauch,
Julie Ridl, Photsphere Studio
CLIENT
Spectrum Health

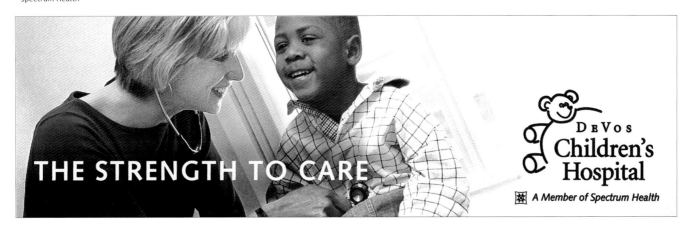

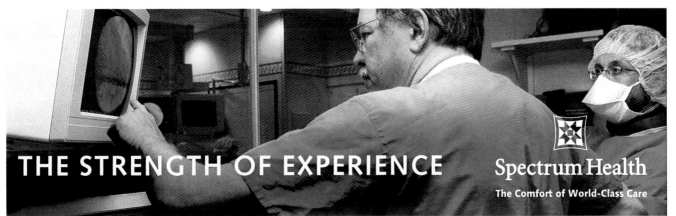

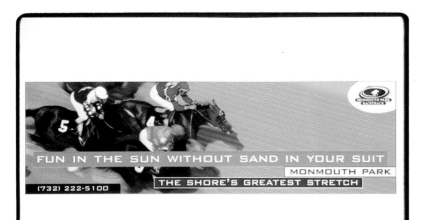

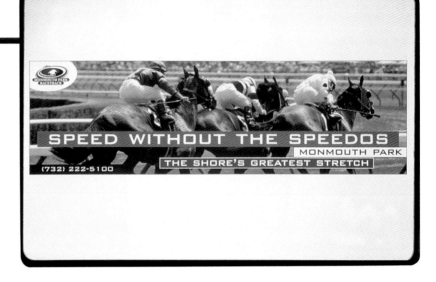

CREATIVE FIRM
The Sloan Group
New York (New York), USA
CREATIVES
Wyndy Wilder, Elizabeth Bernard,
Jay Sandusky, Alicia Potter
CLIENT
Monmouth Park

90

CREATIVE FIRM
J Walter Thompson
New York (New York), USA
CREATIVES
Ed Evangelista, Chris D'Rozario,
Erik Izo, Garth Horn, John Wagner
CLIENT
Diamond Trading Company

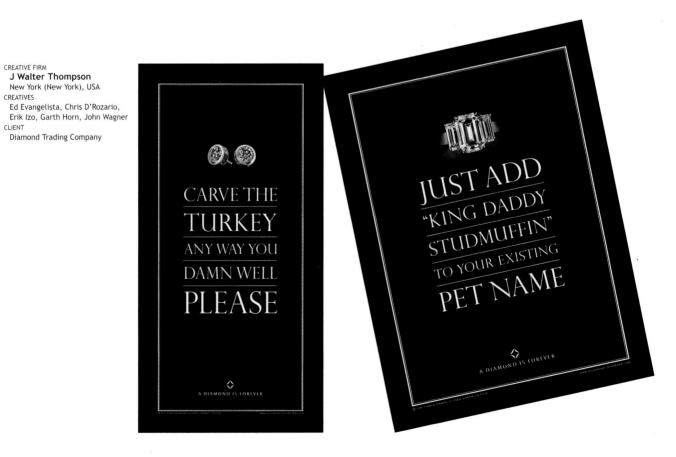

CREATIVE FIRM
Bohan Advertising/Marketing
Nashville (Tennessee), USA
CREATIVES
Kerry Oliver, Kevin Hinson
CLIENT
Country Music Hall of Fame & Museum

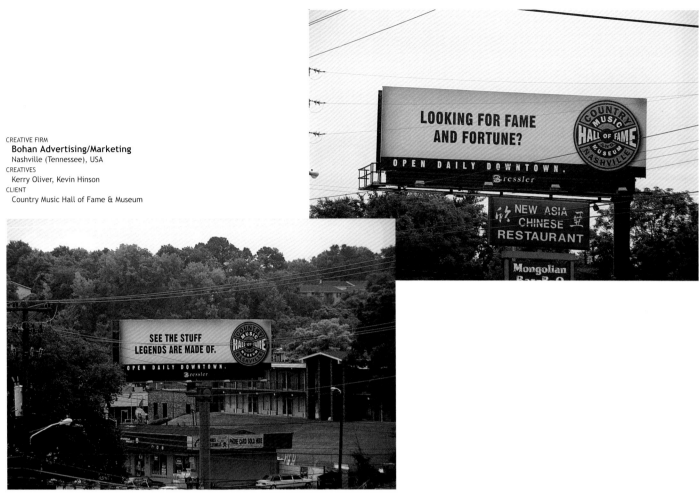

91

CREATIVE FIRM
McKinney & Silver
Raleigh (North Carolina), USA

I'm a trolley. Really.

From now through March, this shuttle will be running in the trolley's place.

CREATIVE FIRM
Thompson & Company
Memphis (Tennessee), USA
CREATIVES
Mark Robinson, Rick Baptist,
Dave Smith
CLIENT
MATA

92

CREATIVE FIRM
Rodgers Townsend
St. Louis (Missouri), USA
CREATIVES
Tom Townsend, Tom
Hudder,
Evan Willnow
CLIENT
St. Louis Rams

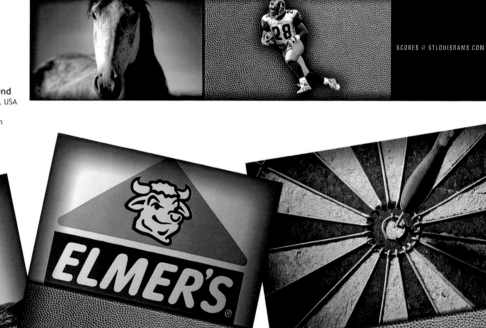

SCORES @ STLOUISRAMS.COM

ELMER'S

SHOP @ STLOUISRAMS.COM

STATS @ STLOUISRAMS.COM

PHOTOS @ STLOUISRAMS.COM

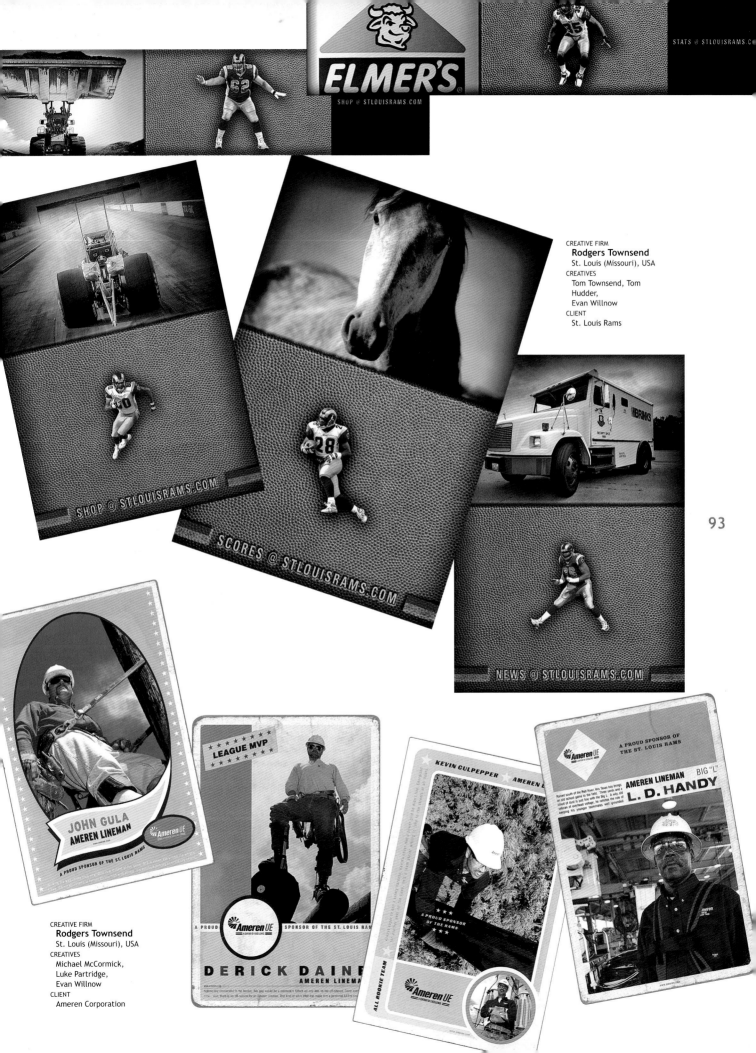

ELMER'S
SHOP @ STLOUISRAMS.COM

STATS @ STLOUISRAMS.C...

CREATIVE FIRM
Rodgers Townsend
St. Louis (Missouri), USA
CREATIVES
Tom Townsend, Tom
Hudder,
Evan Willnow
CLIENT
St. Louis Rams

SHOP @ STLOUISRAMS.COM

SCORES @ STLOUISRAMS.COM

NEWS @ STLOUISRAMS.COM

93

JOHN GULA
AMEREN LINEMAN
A PROUD SPONSOR OF THE ST. LOUIS RAMS

LEAGUE MVP
A PROUD *Ameren UE* SPONSOR OF THE ST. LOUIS RAMS
DERICK DAINE...
AMEREN LINEMA...

KEVIN CULPEPPER AMEREN L...
A PROUD SPONSOR
OF THE RAMS
ALL ROOKIE TEAM
Ameren UE

Ameren UE A PROUD SPONSOR OF
THE ST. LOUIS RAMS
AMEREN LINEMAN BIG "L"
L. D. HANDY

CREATIVE FIRM
Rodgers Townsend
St. Louis (Missouri), USA
CREATIVES
Michael McCormick,
Luke Partridge,
Evan Willnow
CLIENT
Ameren Corporation

BROADBAND. LONGER HOURS ARE OVERRATED.

sbc.com/broadband

BROADBAND. DON'T BE THE LAST ONE TO GET ON

sbc.com/broadband

BROADBAND. IF YOU'RE NOT GOING UP, YOU'RE GOING DOWN.

sbc.com/broadband

BROADBAND. NEVER BE LEFT BEHIND AGAIN

sbc.com/broadband

CREATIVE FIRM
Rodgers Townsend
St. Louis (Missouri), USA
CREATIVES
Michael McCormick,
Luke Partridge,
Evan Willnow
CLIENT
SBC Corporation

94

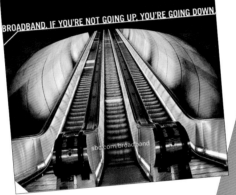

HAIR?

FAT CHANCE.

But you can influence
your kids'
decisions about drinking.

1-800-359-TALK

We All Make A Difference

Budweiser

MUSIC?

UNLIKELY.

But you can influence
your kids'
decisions about drinking.

1-800-359-TALK

We All Make A Difference

Budweiser

CREATIVE FIRM
Rodgers Townsend
St. Louis (Missouri), USA
CREATIVES
Tim Varner,
Mike Dillon,
Evan Willnow
CLIENT
Anheuser-Busch

된다. 마지막 순간의 승부는 **Rebound** 로 결정된다.

멋진 장면은 끊임없이 **Rewind** 된다. 히트친 노래는 꼭 **Remix** 버전 이 나온다. 유명한 음반은 **Recording** 부터 다르다.

Rewind

Re -

/\I\\ **enjoy AIWA**

CREATIVE FIRM
McCann-Erickson Korea
Seoul, Korea
CREATIVES
Hae-Jung Park, Ky An,
Jung-Wook Pyo, Moon-Sun Choi
CLIENT
AIWA

CREATIVE FIRM
Rodgers Townsend
St. Louis (Missouri), USA
CREATIVES
Tom Townsend, Tom Hudder,
Evan Willnow
CLIENT
St. Louis Rams

95

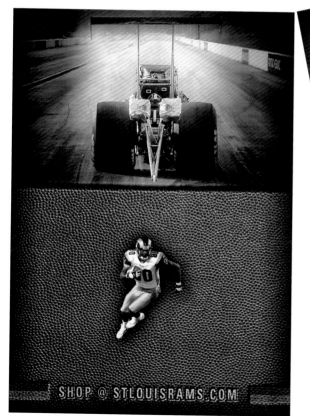

SHOP @ STLOUISRAMS.COM

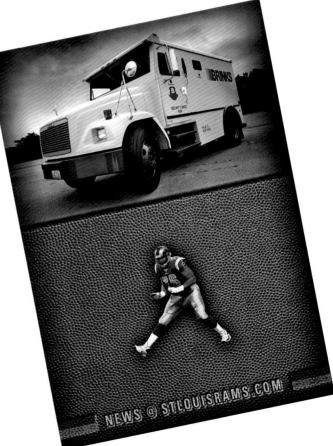

NEWS @ STLOUISRAMS.COM

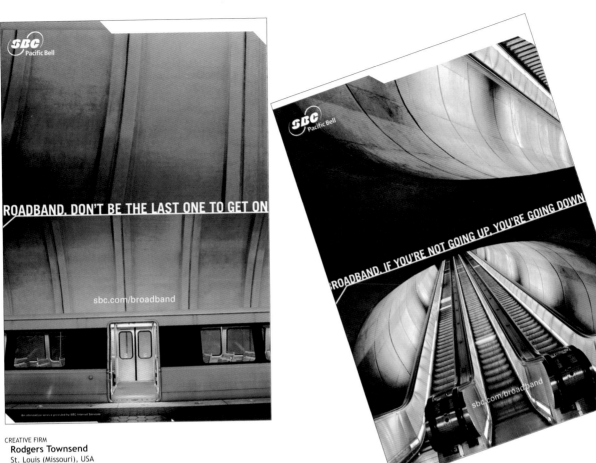

CREATIVE FIRM
Rodgers Townsend
St. Louis (Missouri), USA
CREATIVES
Michael McCormick,
Luke Partridge,
Evan Willnow
CLIENT
SBC Corporation

96

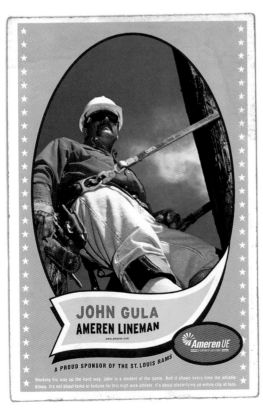

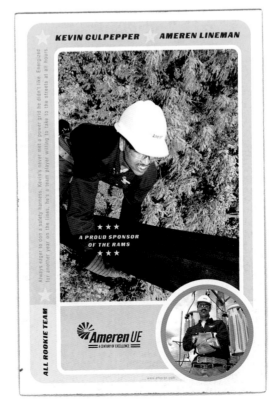

CREATIVE FIRM
Rodgers Townsend
St. Louis (Missouri), USA
CREATIVES
Michael McCormick,
Luke Partridge,
Evan Willnow
CLIENT
Ameren Corporation

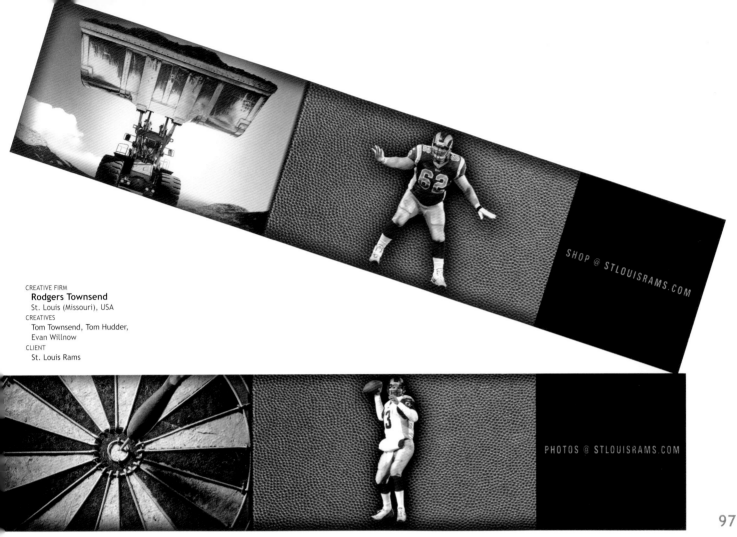

CREATIVE FIRM
Rodgers Townsend
St. Louis (Missouri), USA
CREATIVES
Tom Townsend, Tom Hudder,
Evan Willnow
CLIENT
St. Louis Rams

97

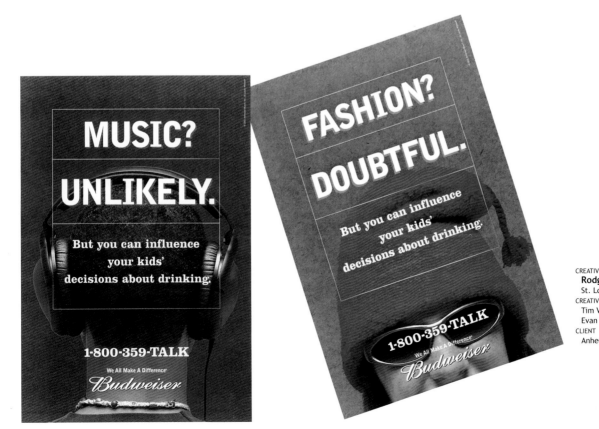

CREATIVE FIRM
Rodgers Townsend
St. Louis (Missouri), USA
CREATIVES
Tim Varner, Mike Dillon,
Evan Willnow
CLIENT
Anheuser-Busch Inc.

CREATIVE FIRM
Karacters design group
Vancouver (British Columbia), Canada
CREATIVES
Maria Kennedy, Roy White,
Jeff Harrison
CLIENT
Finning International Ltd.

CREATIVE FIRM
Herman Miller
In house design
Zeeland (Michigan), USA
CREATIVES
Stephen Frykholm, Brian Edlefson,
Clark Malcolm
CLIENT
Herman Miller Inc.

CREATIVE FIRM
Epigram Pte Ltd
Singapore
CREATIVES
Beh Kayyi, Frank Pinckers
CLIENT
JTC Corporation

98

CREATIVE FIRM
Lexicon Design
Singapore
CREATIVES
Jacqueline Thng,
Yen Wee Liang,
Tom Tang
CLIENT
Hiap Moh Corporation Ltd

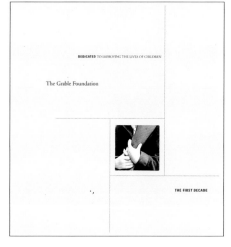

CREATIVE FIRM
Ukulele Brand Consultants Pte Ltd
Singapore
CREATIVES
Kim Chun-wei, Yvonne Lee
CLIENT
Monetary Authority of Singapore

CREATIVE FIRM
Kolbrener
Pittsburgh (Pennsylvania), USA
CREATIVES
Mike Kolbrener, Clyde Hare
CLIENT
The Grable Foundation

CREATIVE FIRM
UCSF Publications and IE Design
Manhattan Beach (California), USA
CREATIVES
Marcie Carson, Carol Kummer
CLIENT
UCSF Comprehensive Cancer Center

CREATIVE FIRM
Viadesign
San Diego (California), USA
CREATIVES
Scott Pacheco, Stephan Donche,
Eric Schellhorn
CLIENT
Jack in the Box Inc.

CREATIVE FIRM
Bertz Design Group
Middletown (Connecticut), USA
CREATIVES
Ted Bertz, Richard Uccello
CLIENT
United Technologies Corporation

99

CREATIVE FIRM
Nesnadny + Schwartz
Cleveland (Ohio), USA
CREATIVES
Mark Schwartz, Joyce Nesnadny,
Michelle Moehler, Keith Pishnery,
John Coplans
CLIENT
The Progressive Corporation

CREATIVE FIRM
Griffith Phillips Creative
Dallas (Texas), USA
CREATIVES
Brian Niemann, Pete Lacker
CLIENT
Daisytek

CREATIVE FIRM
LF Banks & Associates
Philadelphia (Pennsylvania), USA
CREATIVES
Lori Banks, Charlotte Markward
CLIENT
Pennsylvania Turnpike Commission

CREATIVE FIRM
Taylor & Ives Incorporated
New York (New York), USA
CREATIVES
Alisa Zamir,
Daniel Caspescha
CLIENT
Marsh & McLennan Companies, Inc.

CREATIVE FIRM
**Missouri Botanical
Garden in-house**
St. Louis (Missouri), USA
CREATIVES
Elizabeth McNulty,
Ellen Flesch,
Bryan Reckamp

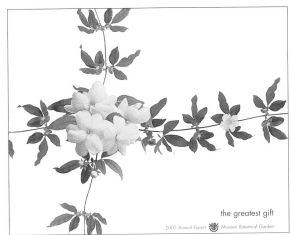

the greatest gift

2002 Annual Report Missouri Botanical Garden

100

*through the eyes:
portraits of caring*

CREATIVE FIRM
Anjaro Designs
San Francisco (California), USA
CREATIVES
Jacques Rossouw, Cynthia Chiarappa,
Dan Mills
CLIENT
California Pacific Medical Center

CARIBBEAN COMMERCIAL BANK

Annual Report 2002

Putting *You* Centrestage

CREATIVE FIRM
All Media Projects Limited (AMPLE)
Trinidad & Tobago, West Indies
CREATIVES
Cathleen Jones, Desmond Jutla,
Images Studio, Julien Greenidge,
Scrip-J Printers Ltd.
CLIENT
Caribbean Commercial Bank

CREATIVE FIRM
Howry Design Associates
San Francisco (California), USA
CREATIVES
Jill Howry, Clay Williams
CLIENT
Nuvelo

Life Improved

Nuvelo
ANNUAL REPORT 2002

S,H&E | 02 *Safety
Health
Environment*

N.V. Nederlandse Gasunie S,H&E ANNUAL REPORT 2002

CREATIVE FIRM
Erwin Zinger Graphic Design
Groningen, The Netherlands
CREATIVES
Erwin Zinger
CLIENT
N.V. Nederlandse Gasunie

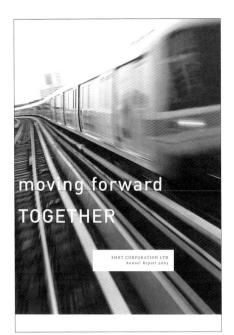

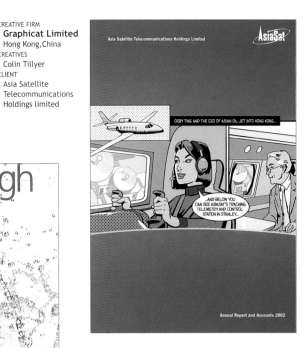

CREATIVE FIRM
Graphicat Limited
Hong Kong,China
CREATIVES
Colin Tillyer
CLIENT
Asia Satellite
Telecommunications
Holdings limited

CREATIVE FIRM
Epigram Pte Ltd
Singapore
CREATIVES
Paul Van Der Veer,
Justin Guariglia
CLIENT
SMRT Corporation Ltd

CREATIVE FIRM
Lexicon Design
Singapore
CREATIVES
Jacqueline Thng,
Yen Wee Liang,
Caslyn Ong
CLIENT
NTUC Fairprice Co-operative Ltd

101

CREATIVE FIRM
Taylor & Ives Incorporated
New York (New York), USA
CREATIVES
Alisa Zamir
CLIENT
St. Francis Hospital

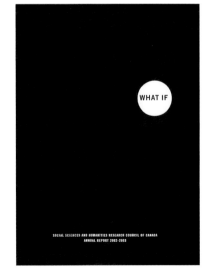

CREATIVE FIRM
Mendes Publicidade
Belém, Brazil
CREATIVES
Oswaldo Mendes, Maria Alice Penna
CLIENT
Banco da Amazônia

CREATIVE FIRM
Iridium, a design agency
Ottawa (Ontario), Canada
CREATIVES
David Daigle, Mario L'Écuyer,
Headlight, Rick Doyle, Joel Rogers,
Stephen Mallon, Wayne Eastep,
Shannon Ross, Jean-Luc Denut
CLIENT
SSHRC

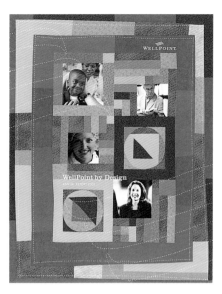

CREATIVE FIRM
Baker Designed Communications
Thousand Oaks (California), USA
CREATIVES
Heather Rim, Gary Baker, Brian Keenan,
Kate Rivinus, Lon Harding
CLIENT
WellPoint

CREATIVE FIRM
Taylor & Ives Incorporated
New York (New York), USA
CREATIVES
Alisa Zamir,
Bruce Davies
CLIENT
Labranche & Co. Inc.

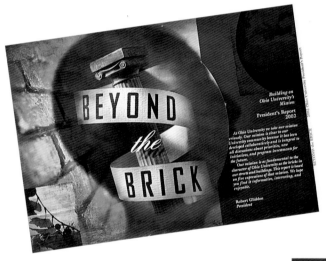

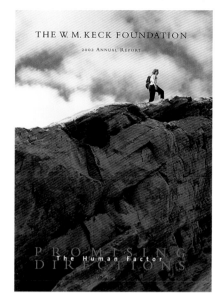

CREATIVE FIRM
The Jefferies Association
Los Angeles (California), USA
CREATIVES
Ron Jefferies, Hauchee Chung
CLIENT
The W.M. Keck Foundation

102

CREATIVE FIRM
Taylor & Ives Incorporated
New York (New York), USA
CREATIVES
Alisa Zamir,
Daniel Caspescha
CLIENT
Cushman & Wakefield, Inc.

CREATIVE FIRM
**University Communications
& Marketing**
Athens (Ohio), USA
CREATIVES
Mary Dillon, Mark Krumel,
Melissa Calhoun, Richard Tuschman,
Rick Fatica
CLIENT
Ohio University

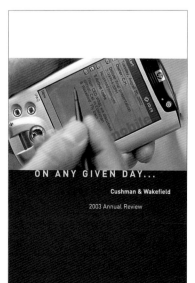

CREATIVE FIRM
VSA Partners
Chicago (Illinois), USA
CREATIVES
James Koval, Steve Ryan,
Dan Knuckey, Brock Conrad,
Katie Heit
CLIENT
The Coca-Cola Company

CREATIVE FIRM
Howry Design Associates
San Francisco (California), USA
CREATIVES
Jill Howry, Clay Williams
CLIENT
First Republic Bank

CREATIVE FIRM
**Computer Associates
In-house Design Department**
Islandia (New York), USA
CREATIVES
Elisamuel DeJesus,
Joanne Kaufman

CREATIVE FIRM
Graphicat Limited
Hong Kong,China
CREATIVES
Colin Tillyer
CLIENT
Noble Group Limited

CREATIVE FIRM
Hazelden Publishing
Center City (Minnesota), USA
CREATIVES
Don Freeman, David Swanson,
Linda E. Peterson
CLIENT
Hazelden

CREATIVE FIRM
Greenfield Belser Ltd.
Washington (D.C.), USA
CREATIVES
Burkey Belser, Siobhan Davis,
Jennifer Myers, Brett Mannes
CLIENT
Weil, Gotshal & Manges

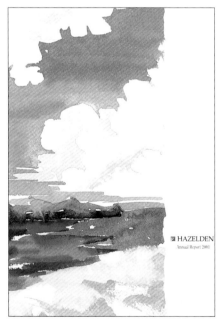

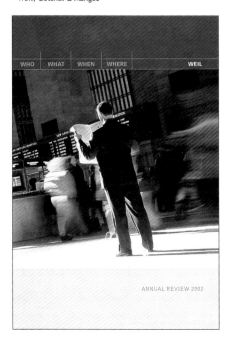

CREATIVE FIRM
Signi
Mexico City, Mexico
CREATIVES
Rene Galindo, Marga Lopez
CLIENT
GEO

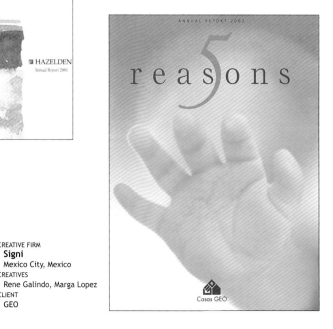

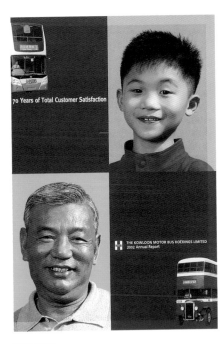

CREATIVE FIRM
Kan & Lau Design Consultants
Hong Kong, China
CREATIVES
Freeman Lau Stu Hong, Veronica Cheung,
Vinci Fung
CLIENT
The Kowloon Motor Bus Holdings Ltd.

CREATIVE FIRM
Graphics 2 LLC
Scottsdale (Arizona), USA
CREATIVES
Colleen Steinberg, Catherine Menor,
Kathy Feeney, Jeff Noble, various
photographers
CLIENT
St. Joseph's Foundation/
Barrow Neurological Foundation

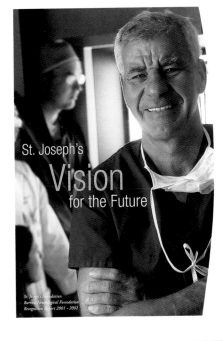

CREATIVE FIRM
INC Design
New York (New York), USA
CREATIVES
Meera Singh, Trevor Paccione
CLIENT
Commonwealth Telephone Enterprises

104

CREATIVE FIRM
Wyant Simboli Group Inc.
Norwalk (Connecticut), USA
CREATIVES
Julia Wyant, John Simboli,
Jennifer Duate, Rob Gary,
Tod Bryant, Julie Theriault
CLIENT
Steinway Musical Instruments Inc.

CREATIVE FIRM
Vorwerk & Co. UG
Wuppertal, Germany
CREATIVES
Hermann Michels
CLIENT
Vorwerk

CREATIVE FIRM
Baker Designed Communications
Santa Barbara (California), USA
CREATIVES
Caroline Leakan, Gary Baker,
Brian Keenan, Hollie Greenwood,
Myron Beck
CLIENT
CKE Restaurants, Inc.

105

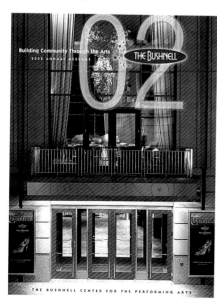

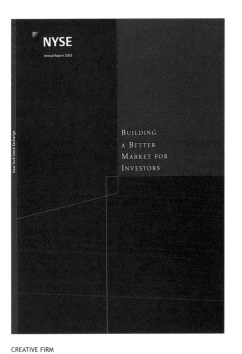

CREATIVE FIRM
Taylor & Ives Incorporated
New York (New York), USA
CREATIVES
Alisa Zamir, Pamela Brooks
CLIENT
New York Stock Exchange, Inc.

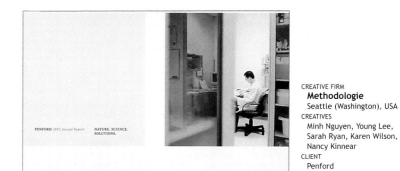

CREATIVE FIRM
Methodologie
Seattle (Washington), USA
CREATIVES
Minh Nguyen, Young Lee,
Sarah Ryan, Karen Wilson,
Nancy Kinnear
CLIENT
Penford

CREATIVE FIRM
Lawrence & Ponder Ideaworks
Newport Beach (California), USA
CREATIVES
Lynda Lawrence, Simone Beaudoin,
Ellen Laning
CLIENT
Second Harvest Food Bank

There's a
rising concern in
Orange County.

2001 ANNUAL REPORT

CREATIVE FIRM
Taylor & Ives Incorporated
New York (New York), USA
CREATIVES
Alisa Zamir, Pamela Brooks
CLIENT
The Reader's Digest Association, Inc.

CREATIVE FIRM
BCN Communications
Chicago (Illinois), USA
CREATIVES
Robert Mileham, Michael Neu,
Andy Goodwin, Verser Engelhard
CLIENT
May Dept. Stores Company

CREATIVE FIRM
Hershey Associates
Santa Monica (California), USA
CREATIVES
Lisa Joss, Christine Hershey
CLIENT
The California Wellness Foundation

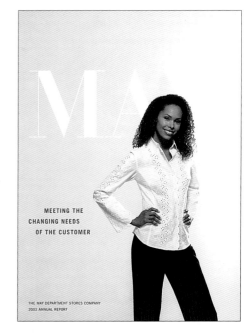

MEETING THE
CHANGING NEEDS
OF THE CUSTOMER

THE MAY DEPARTMENT STORES COMPANY
2002 ANNUAL REPORT

WELLSFORD REAL PROPERTIES, INC.

Annual Report 2002

PERSEVERANCE

CREATIVE FIRM
Bloch + Coulter Design Group
Los Angeles (California), USA
CREATIVES
Manna Wescott, Thomas Bloch,
Victoria Coulter, Francis Hurley,
Royal Geographical Courtesy Society,
London
CLIENT
Wellsford Real Properties, Inc.

CREATIVE FIRM
Epigram Pte Ltd
Singapore
CREATIVES
Beh Kayyi, Frank Pinckers
CLIENT
JTC Corporation

CREATIVE FIRM
LF Banks & Associates
Philadelphia (Pennsylvania), USA
CREATIVES
Lori Banks, Travis Schnupp
CLIENT
Rohm & Haas Company

SEE FOR YOURSELF: THE FUTURE IS NOW
imagine the possibilities™

Rohm and Haas Annual Report 2002

THE GEORGE GUND FOUNDATION ANNUAL REPORT 2002

INDUSTRIAL LANDSCAPE

CREATIVE FIRM
Nesnadny + Schwartz
Cleveland (Ohio), USA
CREATIVES
Mark Schwartz, Michelle Moehler,
Joyce Nesnadny, Andrew Borowiec
CLIENT
The George Gund Foundation

107

CREATIVE FIRM
Paragraphs Design
Chicago (Illinois), USA
CREATIVES
Jim Chilcutt, Rachel Radtke
CLIENT
FEMSA

FEMSA
Annual Report 2002

NATIONAL
fish AND
Wildlife
FOUNDATION
Annual Report
2002

CREATIVE FIRM
Dever Designs
Laurel (Maryland), USA
CREATIVES
Jeffrey L. Dever,
Byron Holly
CLIENT
National Fish and
Wildlife Foundation

CREATIVE FIRM
Dever Designs
Laurel (Maryland), USA
CREATIVES
Jeffrey L. Dever,
Kristin Deuel Duffy
CLIENT
National Air and Space Museum

CREATIVE FIRM
Howry Design Associates
San Francisco (California), USA
CREATIVES
Jill Howry, Todd Richards
CLIENT
Del Monte Foods

CREATIVE FIRM
Epigram Pte Ltd
Singapore
CREATIVES
Beh Kay Yi, Gerald Gay
CLIENT
National Arts Council

CREATIVE FIRM
Kan & Lau Design Consultants
Hong Kong, China
CREATIVES
Freeman Lau Stu Hong,
Pazu Lee
CLIENT
Roadshow Holdings Ltd.

108

CREATIVE FIRM
Lexicon Design
Singapore
CREATIVES
Jacqueline Thng, Yen Wee Liang,
Tom Tang
CLIENT
NTUC Fairprice Co-operative Ltd

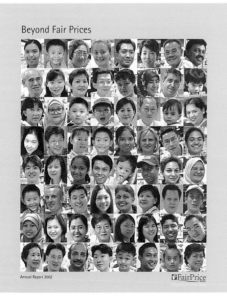

CREATIVE FIRM
The Jefferies Association
Los Angeles (California), USA
CREATIVES
Ron Jefferies, Hauchee Chung
CLIENT
Fidelity National Financial, Inc.

CREATIVE FIRM
Mires
San Diego (California), USA
CREATIVES
Scott Mires, Gale Spitzley,
Jody Hewgill, Mark Ulriksen
CLIENT
Arena Stage

stagestruck

CREATIVE FIRM
Franklin Design Group
Addison (Texas), USA
CREATIVES
Wendy Hanson
CLIENT
Southwest Corporate

BALANCE IT.

INNOVATIVE BUSINESS TECHNOLOGY
IT SIMPLIFIED. BY DESIGN.

CREATIVE FIRM
The Borenstein Group
Fairfax (Virginia), USA
CREATIVES
Brian Bowlin
CLIENT
IBT

109

CREATIVE FIRM
Health Sciences Relations
Iowa City (Iowa), USA
CREATIVES
Connie Peterson, Anne Duggan,
Liw Larson, Susan Green,
Daneite Angerer
CLIENT
University of Iowa

University of Iowa Roy J. and Lucille A. Carver College of Medicine | Medical Education and Research Facility

Promises
Fulfilled

inside
the box

cluttershrink

CREATIVE FIRM
no.e studios
Gaithersburg (Maryland), USA
CREATIVES
Chris Hays
CLIENT
Cluttershrink

CREATIVE FIRM
FCR Durban
Durban, South Africa
CREATIVES
Michael Bond, Paul Uosloo
CLIENT
Mondi Paper Ltd

CREATIVE FIRM
Gehl Design
Seattle (Washington), USA
CREATIVES
Joyce Gehl, Eric Junes,
Tracy Huddleson
CLIENT
Vulcan Inc.

CREATIVE FIRM
Cahan & Associates
San Francisco (California), USA
CREATIVES
Bill Cahan, Michael Braley
CLIENT
Stroock & Stroock & Lavan

CREATIVE FIRM
Kittner Design
Takoma Park (Maryland), USA
CREATIVES
Bobbi Kittner, Karen O'Hara,
Kristin Kaineg
CLIENT
Community Greens

CREATIVE FIRM
JA Design Solutions
Coppell (Texas), USA
CREATIVES
Jean Ashenfelter, Linda Capriotti,
Julie Schock, Jon Mosier
CLIENT
Timera-Kevin Schock

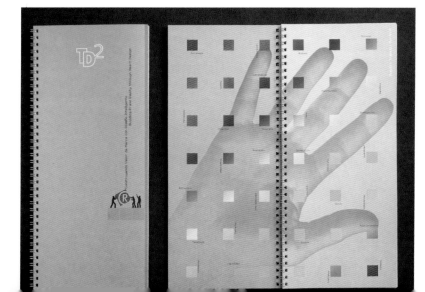

CREATIVE FIRM
TD2, S.C.
Mexico
CREATIVES
Rafael Treviño
CLIENT
TD2

downtown orlando

eola
south

CREATIVE FIRM
Fry Hammond Barr
Orlando (Florida), USA
CREATIVES
Tim Fisher, Sean Brunson,
Shannon Hallare, Ben Van Hook
CLIENT
Thornton Park Development

CREATIVE FIRM
Liquid Agency
San Jose (California), USA
CREATIVES
Joshua Swanbeck, Alfredo Muccino
CLIENT
Liquid Agency

liquid

spire

Your Partner in
Research

CREATIVE FIRM
atomzi! Pte Ltd
Singapore
CREATIVES
Patrick Lee, Sonia Che
CLIENT
Spire Research & Consulting

111

MAHLUM

CREATIVE FIRM
**Hornall Anderson
Design Works, Inc.**
Seattle (Washington), USA
CREATIVES
Jack Anderson,
Kathy Saito,
Sonja Max,
Alan Copeland
CLIENT
Mahlum Architects

Here's what to expect.

CORPORATION SERVICE COMPANY CSC

CREATIVE FIRM
RT & E, Inc.
Wilmington (Delaware), USA
CREATIVES
Randall Jones
CLIENT
CSC (Corporation Service Company)

bpTrinidad and Tobago
community
review 2002

...investing beyond petroleum

CREATIVE FIRM
All Media Projects Limited (AMPLE)
Trinidad & Tobago, West Indies
CREATIVES
Gary Clarke, Charmaine Daisley,
Nicole Jones
CLIENT
BP Trinidad and Tobago LLC (bpTT)

CREATIVE FIRM
Franke + Fiorella
Minneapolis (Minnesota), USA
CREATIVES
Craig Franke, Leslie McDougall
CLIENT
3M

RelyX™ Cements
A family of reliable cements you can trust.

RelyX

Easy to choose. Easy to use.

3M ESPE

CREATIVE FIRM
Sparkman + Associates, Inc.
Washington (D.C.), USA
CREATIVES
David Hazelton
CLIENT
Greenwald Associates

CREATIVE FIRM
Camarés Communications
Cedar Knolls (New Jersey), USA
CREATIVES
Deb Di Gregorio, Walter Clarke,
Dennis McCarthy
CLIENT
Amstat

112

CREATIVE FIRM
Don Schaaf & Friends, Inc.
Washington (D.C.), USA
CREATIVES
Don Schaaf, David Kammerdeiner
CLIENT
Digex

CREATIVE FIRM
The Dave and Alex Show
Redding (Connecticut), USA
CREATIVES
Alexander Isley, Dave Goldenberg,
Tracie Rosenkopf-Lissauer
CLIENT
Modem Media

Hosting Empowers Business™

CREATIVE FIRM
McGaughy Design
Centreville (Virginia), USA
CREATIVES
Malcolm McGaughy
CLIENT
National Postal Forum

MOVE ME

CREATIVE FIRM
Joseph Lover
St. Paul (Minnesota), USA
CREATIVES
Joseph Lover
CLIENT
Education Minnesota

CREATIVE FIRM
Sargent & Berman
Santa Monica (California), USA
CREATIVES
Barbara Chan, Peter Sargent
CLIENT
Viking River Cruises

CREATIVE FIRM
Weymouth Design/VICAM in-House
Watertown (Massachusetts), USA
CREATIVES
Bob Kellerman (Weymouth Design),
Jennifer Smith (VICAM)
CLIENT
VICAM

CREATIVE FIRM
3i Ltd.
Arlington (Virginia), USA
CREATIVES
Ron Harman, Kenn Speicher,
Cathy Kyle
CLIENT
Northrop Grumman IT

CREATIVE FIRM
Vavricka Juntti & Co.
Minneapolis (Minnesota), USA
CREATIVES
Lori Gerdts, Diane Allard,
Lisa Salsman, Cheryl Vavricka
CLIENT
Harvest States Foods

CREATIVE FIRM
Don Schaaf & Friends, Inc.
Washington (D.C.), USA
CREATIVES
Don Schaaf, David Kammerdeiner,
Sean Mullins
CLIENT
WorldCom Foundation

team
ble *group*

114

Everyday Values

The Harley-Davidson Code of Business Conduct

What can you expect
when you add RecordsCenter™
Compliance and Governance
to your corporate law office?

CORPORATION SERVICE COMPANY™ **CSC.**

CREATIVE FIRM
atomzi! Pte Ltd
Singapore
CREATIVES
Patrick Lee, Marvine Das
CLIENT
The WearHouse@SCENE
a division of People's
Association

CREATIVE FIRM
After Hours Creative
Phoenix (Arizona), USA
CREATIVES
After Hours Creative
CLIENT
U.S. Paralympics

CREATIVE FIRM
Teamwork Design Limited
Hong Kong, China
CREATIVES
Gary Tam, Wong Chi Kit
CLIENT
Teamwork Design Limited

115

CREATIVE FIRM
Davidoff Associates Inc.
New York (New York), USA
CREATIVES
Evelyn Jenkinson, Roger Davidoff,
Patrina Marino
CLIENT
Pepsi Bottling Group Inc.

CREATIVE FIRM
FirstEnergy
Akron (Ohio), USA
CREATIVES
Jeff Wilhelm
CLIENT
FirstEnergy

CREATIVE FIRM
Barbara Chan Design
Los Angeles (California), USA
CREATIVES
Barbara Chan, Darren Franks
CLIENT
Real Illusions, Inc.

CREATIVE FIRM
Watts Design
Victoria, Australia
CREATIVES
Peter Watts, Helen Watts,
James Vlahogiannis
CLIENT
Watts Design

CREATIVE FIRM
Gehl Design
Seattle (Washington), USA
CREATIVES
Joyce Gehl, Eric Junes,
Tracy Huddleson
CLIENT
Vulcan Inc.

CREATIVE FIRM
All Media Projects Limited (AMPLE)
Trinidad & Tobago, West Indies
CREATIVES
Glen Forte, Carl Harding,
Michael Loregnard, Julien Greenidge,
Caribbean Paper & Printed Products (1993)
Limited
CLIENT
Personnel Management Services Limited (PMSL)

HELPING PEOPLE TO IMPROVE
**ORGANISATIONAL
PERFORMANCE
AND PROFITS**

PMSL

CREATIVE FIRM
Arnold Sales Associates
New York (New York), USA
CREATIVES
Arnold Sales, Kevin Wines
CLIENT
Alcoa

Breath taking
The health effects of air pollution

Complete breath—a breath
exercise of even inhalation
and exhalation that involves
all respiratory muscles.
—American YOGA Association

CREATIVE FIRM
Barbara Brown Marketing & Design
Ventura (California), USA
CREATIVES
Barbara Brown, Jon A. Leslie,
Ventura Printing
CLIENT
VCAPCD

It all starts with dirt.

**The making
of aluminum
at Alcoa**

ALCOA

CREATIVE FIRM
VSA Partners
Chicago (Illinois),
USA
CREATIVES
Nichole Dillon,
Andy Blankenburg,
Geof Kern
CLIENT
Telwares
Communication, LLC.

···FIVE TRUTHS···

collected wisdom in telecom contract negotiation

URBAN LOFT LIVING AT
THE CENTER OF IT ALL

CREATIVE FIRM
The Garage
Birmingham (Michigan), USA
CREATIVES
Julie Pincus, Sue Levytsky,
Steve Magsig
CLIENT
Larson Realty Group

CREATIVE FIRM
**CA In-House
Creative Development**
Islandia (New York), USA
CREATIVES
Loren Moss Meyer, Franz and
Peter Edson
CLIENT
Computer Associates

For Internal Use Only

FlexSelect Licensing

{ Information for }
{ Better Selling }

(ca) Computer Associates™

STRENGTH THROUGH DIVERSITY

diversity@highmark

SUCCESS THROUGH INCLUSION

HIGHMARK.

CREATIVE FIRM
Highmark
Pittsburgh (Pennsylvania), USA
CREATIVES
Jay Hernishin
CLIENT
Diversity Workforce Initiatives

It's Your (Sex) Life
Your Guide to Safe & Responsible Sex

fight for your rights:
protect yourself

CREATIVE FIRM
MTV
New York (New York), USA
CREATIVES
Lance Rusoff, Jim de Barros,
Jeffrey Keyton, Scott Houston
CLIENT
MTV

Welcome to
Bright House Networks

bright
house
NETWORKS

CSC

HARVEST

EXECUTIVE SUMMARY

CREATIVE FIRM
First Marketing
Pompano Beach (California), USA
CREATIVES
Chad Shepard, Keith Johnson,
Kelley Plant
CLIENT
Bright House Networks

CREATIVE FIRM
CSC/P2 Communications
Falls Church (Virginia), USA
CREATIVES
Francois Fontaine, Bryann Farrar,
John Farquhar

CORPORATE OVERVIEW

GLOBAL LEADERS
IN MULTI-MANAGER INVESTING

Russell

CREATIVE FIRM
Russell-Creative Services
Tacoma (Washington), USA
CREATIVES
Jay Hember
CLIENT
Russell

CREATIVE FIRM
Graphicat Limited
Hong Kong, China
CREATIVES
Colin Tillyer
CLIENT
Noble Group Limited

Noble logistics

118

TOYS "R" US
Toys "R" Us Benefits Center
P.O. Box 785011
Orlando, FL 32878-5011

First Class Mail
U.S. Postage
PAID
Rochester, NY
Permit No. 1479

is for benefits

CREATIVE FIRM
Tom Fowler, Inc.
Norwalk (Connecticut), USA
CREATIVES
Thomas G. Fowler,
Brien O'Reilly,
Tod Bryant
CLIENT
Hewitt Associates LLC

CREATIVE FIRM
CA In-House Creative Development
Islandia (New York), USA
CREATIVES
Loren Moss Meyer
CLIENT
Computer Associates

quality + innovation
RAISING THE BAR

ca Computer Associates®

CREATIVE FIRM
GlaxoSmithKline Creative Services
Triangle Park (North Carolina), USA
CREATIVES
Kevin Dickerson, Todd Coats
CLIENT
GSK Community Affairs

GlaxoSmithKline 2002
Child Health Recognition Awards

CREATIVE FIRM
Highmark Blue Cross Blue Shield
Pittsburgh (Pennsylvania), USA
CREATIVES
Amy Davis
CLIENT
Highmark Life & Casualty

2002 FINANCIAL
Service that drives results
Profitable Growth
F O C U S
customer-first

HIGHMARK
LIFE & CASUALTY GROUP

CREATIVE FIRM
Highmark
Pittsburgh (Pennsylvania), USA
CREATIVES
Melanie Young
CLIENT
Highmark

Berkeley Lab HIGHLIGHTS

2002-2003

CREATIVE FIRM
Niza Hanany Design
St. Paul (Minnesota), USA
CREATIVES
Pam Patterson
CLIENT
Berkeley Lab

HIGHMARK
LIFE & CASUALTY GROUP

CREATIVE FIRM
Michael Orr + Associates, Inc.
Corning (New York), USA
CREATIVES
Michael R. Orr, Thomas Freeland
CLIENT
Corning Museum of Glass

119

NOBLE coffee

Noble coffee

CREATIVE FIRM
Graphicat Limited
Hong Kong, China
CREATIVES
Colin Tillyer
CLIENT
Noble Group Limited

Feldsott, Lee, Iger & Lew
REPRESENTING COMMUNITY
ASSOCIATIONS SINCE 1970

TRAVEL PR
Moving the market

CREATIVE FIRM
AdMarsh, inc.
Huntington Beach (California), USA
CREATIVES
Charlotte Marsh, Katy Krupp
CLIENT
Feldsott, Lee, Iger & Lew

CREATIVE FIRM
Penny Chuang Design
New York (New York), USA
CREATIVES
Penny Chuang
CLIENT
North American Precis Syndicate

CREATIVE FIRM
Hull Creative Group
Boston (Massachusetts), USA
CREATIVES
Amy Braddock, Carolyn Colonna,
Caryl Hull
CLIENT
MRO Software

CREATIVE FIRM
Mendes Publicidade
Belém, Brazil
CREATIVES
Oswaldo Mendes, Marcelo Amorim
CLIENT
Mendes Publicidade

CREATIVE FIRM
POP!
Seattle (Washington), USA
CREATIVES
Tan Le, Jeff Barlow
CLIENT
Sports Management International

CREATIVE FIRM
Warschawski Public Relations
Baltimore (Maryland), USA
CREATIVES
Warschawski Public Relations
CLIENT
U.S. Olympic Bid

CREATIVE FIRM
Firebox Media
San Francisco (California), USA
CREATIVES
Audrey Feely, Robert Balog,
The Writers Bloc
CLIENT
Carolynn Abst, Architects

CREATIVE FIRM
MYG Design
Denmark
CREATIVES
Marianne Fyhring
CLIENT
Strathconon Estate, Scotland

The world's best shopping is
in the heart of paradise.

CREATIVE FIRM
John Wingard Design
Honolulu (Hawaii), USA
CREATIVES
John Wingard
CLIENT
Ala Moana Center

CREATIVE FIRM
Kolbrener
Pittsburgh (Pennsylvania), USA
CREATIVES
Mike Kolbrener
CLIENT
Fukui Architects

BALANCE.

CREATIVE FIRM
Arista Advertising and Design
Timonium (Maryland), USA
CREATIVES
George Hoffman, Fanny Chakedis
CLIENT
Mercy Ridge Retirement Community

CREATIVE FIRM
Nesnadny + Schwartz
Cleveland (Ohio), USA
CREATIVES
Mark Schwartz, Michelle Moehler,
Greg Oznowich, Stacie Ross
CLIENT
Case Western Reserve University
and Weatherhead School of
Management

Initiatives

FOR A New Era

CREATIVE FIRM
Stan Gellman Graphic Design, Inc.
St. Louis (Missouri), USA
CREATIVES
Teresa Thompson, Jim Gobberdiel,
Bonnie Reiser
CLIENT
The American College

The POWER
of an IDEA

Celebrating Engineering Achievement

CREATIVE FIRM
TGD Communications
Alexandria (Virginia), USA
CREATIVES
Rochelle Gray, Jennifer Cedoz
CLIENT
National Academy of Engineering

{ the *New* math }

Think value.

THE CHRONICLE OF HIGHER EDUCATION'S
career network

CARPENTERS LEGISLATIVE CONFERENCE

UBC2002 STANDING UNITED

STANDING UNITED

THE UNITED BROTHERHOOD OF
CARPENTERS & JOINERS

This is a dictionary.

Genome Canada

CREATIVE FIRM
Greenfield Belser Ltd.
Washington (D.C.), USA
CREATIVES
Burkey Belser, Siobhan Davis,
Robyn McKenzie, Jill Sasser,
Kathryn Linde, Chris Atkin
CLIENT
Chronicle of Higher Education

CREATIVE FIRM
Levine & Associates
Washington (D.C.), USA
CREATIVES
Steve Ofner
CLIENT
United Brotherhood of Carpenters &
Joiners of America

CREATIVE FIRM
Iridium, a design agency
Ottawa (Ontario), Canada
CREATIVES
Mario L'Écuyer, Jean-Luc Denat,
Dwayne Brown, David Becker,
Lloyd Sutton, Diana Miller,
David Lockhart
CLIENT
Genome Canada

CASOLEIL

CREATIVE FIRM
Conover
San Diego (California), USA
CREATIVES
David Conover, Josh Higgins
CLIENT
Jmi Realty

CREATIVE FIRM
Pensaré Design Group, Ltd.
Washington (D.C.), USA
CREATIVES
Kundia D. Wood
CLIENT
Downtown DC Business Improvement District

TOWARD
the
NEW DOWNTOWN

A 45-MONTH TIMELINE OF
LANDMARK DEVELOPMENT IN THE
DOWNTOWN BUSINESS DISTRICT
OF WASHINGTON, DC

THE STORY OF THE revitalization of Downtown Washington, DC
as an entertainment, retail, dining and residential destination dates
back at least to 1997, when the 20,000-seat MCI Center opened
in Chinatown. Since then, commercial investment
in the city center has topped $3 billion. Long known as an
office market and tourism destination, DC's urban core has
matured into a 24/7 full-service Living Downtown.

In the past year alone, the Hotel Monaco, a 184-room boutique
operated by the Kimpton Group, opened after a $40 million
renovation of the historic 1839 Tariff Building, followed by the
opening of the 237-room Sofitel Hotel and the announcement of
plans for a 1,500-room headquarters hotel to open next to our
brand-new Convention Center. Perhaps more significant was the
opening in late 2002 of the 105-unit Summit Grand Parc apartment
building just two blocks from the White House, heralding an
explosion of Downtown residential development.

SERENA HILLS

CREATIVE FIRM
Mires
San Diego (California),
USA
CREATIVES
Jose Serrano,
Howard Weliver,
Paulina Monterrubio,
Eric La Brecque
CLIENT
Shea Homes

CREATIVE FIRM
Fry Hammond Barr
Orlando (Florida), USA
CREATIVES
Tim Fisher, Sean Brunson,
Shannon Hallare, Ben Van Hook
CLIENT
Thornton Park Development

CREATIVE FIRM
MYG Design
Denmark
CREATIVES
Marianne Fyhring
CLIENT
Red Cross-Copenhagen-dk.

CREATIVE FIRM
First Marketing
Pompano Beach (Florida), USA
CREATIVES
Peggy Preiser, Nicole Dalessio
CLIENT
Farmers' Financial Services

CREATIVE FIRM
Design Nut
Washington (D.C.), USA
CREATIVES
Brent M. Almond, Anne Boyle,
Executive Printing
CLIENT
Sutton Group/Ralph Lauren
Cancer Center

CREATIVE FIRM
Wilson-Lewis-Wilson Design
Palm Harbor (Florida), USA
CREATIVES
Bill Wilson, Jason Marsh
CLIENT
East Lake Community Library

CREATIVE FIRM
Dennis S. Juett & Associates
Pasadena (California), USA
CREATIVES
Dennis S. Juett, Dennis Scott Juett
CLIENT
Young & Healthy

CREATIVE FIRM
CSC/P2 Communications Services
Falls Church (Virginia), USA
CREATIVES
Bryn Farrar, Laurie Ann Tarkington

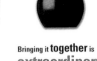

Being **unique**
is **beautiful.**

Bringing it **together** is
extraordinary.

It's Your Move.

CREATIVE FIRM
Carl Chiocca, Creative Designs
Pittsburgh (Pennsylvania), USA
CREATIVES
Ed Massery, JB Kreider Printing Co.
CLIENT
Denham Vitalie Design Associates

124

CREATIVE FIRM
**Greenfield
Belser Ltd.**
Washington (D.C.),
USA
CREATIVES
Burkey Belser,
Jill Sasser,
Lise Anne Schwartz,
Matt Lieppe
CLIENT
Chronicle of
Philanthropy

hard-to-fill shoes

THE CHRONICLE OF PHILANTHROPY'S
philanthropycareers.com

CREATIVE FIRM
BBK Studio
Grand Rapids (Michigan), USA
CREATIVES
Sharon Oleniczak, Michele Chartier,
Julie Ridl
CLIENT
Knoll

**Become
a Knoll it all.**

Online and On Site Product Training Resources

CREATIVE FIRM
**Hornall Anderson
Design Works, Inc.**
Seattle (Washington), USA
CREATIVES
Jack Anderson,
Bruce Stigler,
Holly Craven,
Elmer dela Cruz,
Don Stayner
CLIENT
Microsoft Corporation

(Read me.

Microsoft Office v. X

Microsoft

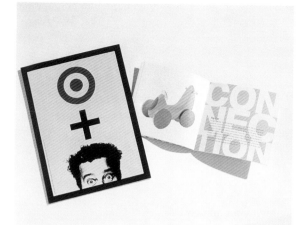

CREATIVE FIRM
Design Guys
Minneapolis (Minnesota), USA
CREATIVES
Steven Sikora, Jay Theige
CLIENT
Target Stores

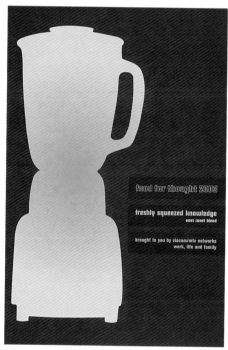

CREATIVE FIRM
Sparkman + Associates, Inc.
Washington (D.C.), USA
CREATIVES
Ryan Weible
CLIENT
NAIOP

CREATIVE FIRM
Graphicat Limited
Hong Kong, China
CREATIVES
Colin Tillyer
CLIENT
JPMorgan Private Bank

CREATIVE FIRM
MTV Networks Creative Services
New York (New York), USA
CREATIVES
Bjorn Ramberg, John Farrar, Ken Saji,
Patrick O'Sullivan, Stephen Borst,
Cheryl Family, Scott Wadler
CLIENT
Viacom

CREATIVE FIRM
Anjaro Designs
San Francisco (California), USA
CREATIVES
Jacques Rossouw, Annria Rossouw,
Mark Tuschman
CLIENT
The Palo Alto Medical Foundation

CREATIVE FIRM
The Star Group
Cherry Hill (New Jersey), USA
CREATIVES
Jan Talamo, Dave Gurgenti,
Rick Ender
CLIENT
David Michael Flavors

CREATIVE FIRM
Ilium Associates
Bellevue (Washington), USA
CREATIVES
Catherine Thompson, Jarod Baker
CLIENT
South Florida Commuter Service

Our Strength is People
Our Mission is Health

CREATIVE FIRM
Up Design, LLC
Montclair (New Jersey), USA
CREATIVES
Greg Gutbehzahl, Gary Underhill
CLIENT
Organon USA Pharmaceuticals Inc.

CREATIVE FIRM
Don Schaaf & Friends, Inc.
Washington (D.C.), USA
CREATIVES
Don Schaaf, Bram Meehan
CLIENT
CB Richard Ellis Law Firm Practice Group

126

CREATIVE FIRM
Conover
San Diego (California), USA
CREATIVES
David Conover, Josh Higgins,
John Bare, Owen McGoldrick
CLIENT
Eldorado Stone

CREATIVE FIRM
Hull Creative Group
Boston (Massachusetts), USA
CREATIVES
Amy Braddock, Carolyn Colonna,
Caryl Hull
CLIENT
Geac

CREATIVE FIRM
Kittner Design
Takoma Park (Maryland), USA
CREATIVES
Bobbi Kittner, Karen O'Hara,
Kristin Kaineg
CLIENT
Youth Venture

CREATIVE FIRM
Anjaro Designs
San Francisco (California), USA
CREATIVES
Jacques Roussouw, Cynthia Chiarappa,
Annria Rossouw, Dan Mills
CLIENT
California Pacific Medical Center

CREATIVE FIRM
Silver Communications Inc.
New York (New York), USA
CREATIVES
Christina Weissman
CLIENT
Thomson Financial

CREATIVE FIRM
Premier Communications Group
Royal Oak (Michigan), USA
CREATIVES
Randy Fossano, Patrick Hatfield
CLIENT
Marygrove College

CREATIVE FIRM
**SmileyHanchulak
Marketing Communications**
Akron (Ohio), USA
CREATIVES
Susan Breen, Jennifer Snider,
TRG Studios, ImageBank
CLIENT
Austin Printing Company

CREATIVE FIRM
atomzi! Pte Ltd
Singapore
CREATIVES
Patrick Lee, Lily Chia
CLIENT
Sembawang Kimtrans

CREATIVE FIRM
Anjaro Designs
San Francisco (California), USA
CREATIVES
Jacques Rossouw
CLIENT
California Pacific Medical Center

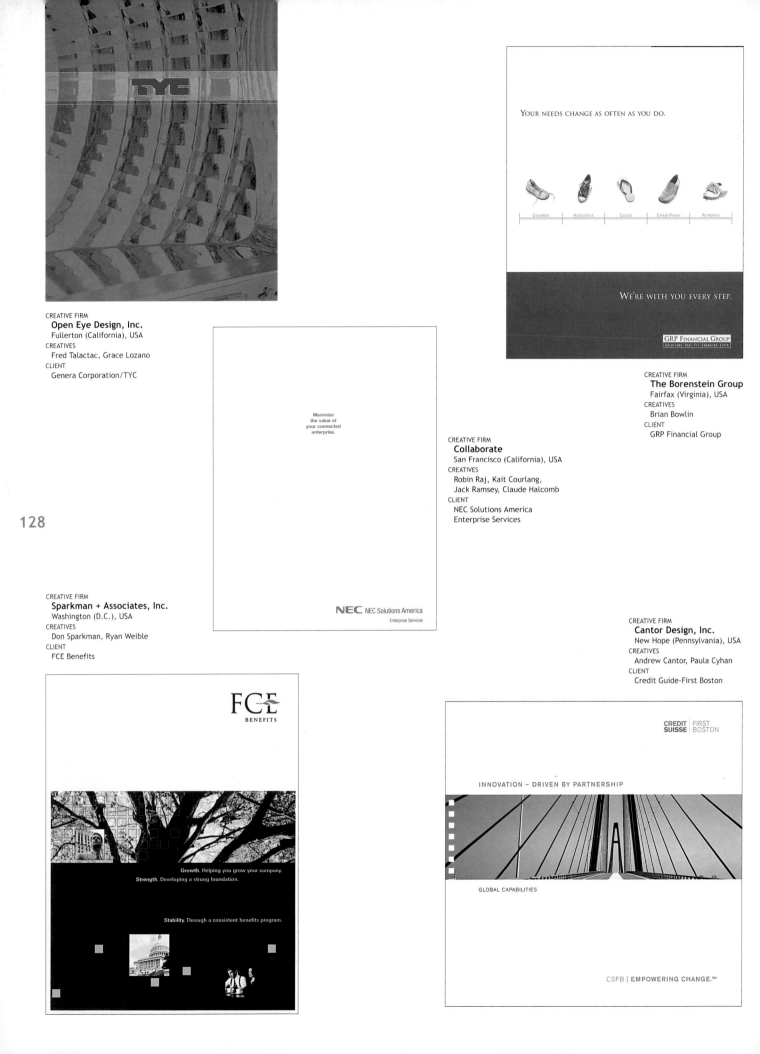

CREATIVE FIRM
Open Eye Design, Inc.
Fullerton (California), USA
CREATIVES
Fred Talactac, Grace Lozano
CLIENT
Genera Corporation/TYC

YOUR NEEDS CHANGE AS OFTEN AS YOU DO.

CHILDHOOD ADOLESCENCE COLLEGE CAREER/FAMILY RETIREMENT

WE'RE WITH YOU EVERY STEP.

GRP FINANCIAL GROUP
SOLUTIONS THAT FIT. CHANGING LIVES.

CREATIVE FIRM
The Borenstein Group
Fairfax (Virginia), USA
CREATIVES
Brian Bowlin
CLIENT
GRP Financial Group

Maximize
the value of
your connected
enterprise.

CREATIVE FIRM
Collaborate
San Francisco (California), USA
CREATIVES
Robin Raj, Kait Courlang,
Jack Ramsey, Claude Halcomb
CLIENT
NEC Solutions America
Enterprise Services

128

CREATIVE FIRM
Sparkman + Associates, Inc.
Washington (D.C.), USA
CREATIVES
Don Sparkman, Ryan Weible
CLIENT
FCE Benefits

NEC NEC Solutions America
Enterprise Services

CREATIVE FIRM
Cantor Design, Inc.
New Hope (Pennsylvania), USA
CREATIVES
Andrew Cantor, Paula Cyhan
CLIENT
Credit Guide-First Boston

FC E
BENEFITS

Growth. Helping you grow your company.
Strength. Developing a strong foundation.

Stability. Through a consistent benefits program.

CREDIT FIRST
SUISSE BOSTON

INNOVATION – DRIVEN BY PARTNERSHIP

GLOBAL CAPABILITIES

CSFB | EMPOWERING CHANGE.℠

CREATIVE FIRM
Diane Luger
 New York (New York), USA
CREATIVES
 Diane Luger, Daniel Pelavin
CLIENT
 Warner Books

CREATIVE FIRM
Design Club
 Tokyo, Japan
CREATIVES
 Hiroko Kondou,
 Akihiko Tsukamoto,
 Akiko Shiba
CLIENT
 P.I.E. Books

CREATIVE FIRM
MTV
 New York
 (New York), USA
CREATIVES
 Jeffrey Keyton,
 Stacy Drummond,
 Dewey Nicks,
 Stephanie Nicks
CLIENT
 MTV

129

CREATIVE FIRM
X-treme Advertising
 Mount Lavinia, Sri Lanka
CREATIVES
 Nishan Peiris, Mark R. Fonseka,
 Varuni Fernando, Anoj S. Fernando
CLIENT
 Softwave Printing & Packaging (Pvt) Ltd.

CREATIVE FIRM
Diane Luger
New York (New York), USA
CREATIVES
Diane Luger, Erik Rank,
Barnaby Hall
CLIENT
Warner Books

CREATIVE FIRM
Wendell Minor Design
Washington (Connecticut), USA
CREATIVES
Wendell Minor, Jill Breitbarth
CLIENT
Harvard University Press

130

CREATIVE FIRM
Allyn and Bacon Cover Dept.
Boston (Massachusetts), USA
CREATIVES
Susan Paradise,
Linda Knowles, Allen Garns
CLIENT
Allyn and Bacon

CREATIVE FIRM
Wendell Minor Design
Washington (Connecticut), USA
CREATIVES
Wendell Minor, Rich Hendel
CLIENT
University of North Carolina Press

CREATIVE FIRM
Red Canoe
Deer Lodge (Tennessee), USA
CREATIVES
Deb Koch, Vivien Sung,
Caroline Kavanagh, Neryl Walker
CLIENT
Chronicle Books

CREATIVE FIRM
Allyn and Bacon Cover Dept.
Boston (Massachusetts), USA
CREATIVES
Kristina Mose-Libon, Linda Knowles
Will Crocker
CLIENT
Allyn and Bacon

CREATIVE FIRM
**Shasti O'Leary Soudant
& Jackie Merri Meyer/
Flag**
New York (New York), USA
CREATIVES
Jackie Merri Meyer/Flag,
CLIENT
Warner Books

a novel

amanda bright@home

DANIELLE
CRITTENDEN

A BODY
TO DIE FOR

A BAILEY WEGGINS MYSTERY

KATE
WHITE

New York Times Bestselling Author of *If Looks Could Kill*

CREATIVE FIRM
**Shasti O'Leary Soudant
& Jackie Merri Meyer**
New York (New York), USA
CREATIVES
Jackie Merri Meyer,
CLIENT
Warner Books

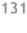

CREATIVE FIRM
Shasti O'Leary Soudant
New York (New York), USA
CREATIVES
Jackie Merri Meyer,
CLIENT
Warner Books

ORN TO
STEAL
When the Mafia
Hit Wall Street

GARY WEISS

CREATIVE FIRM
**Tom Tafuri &
Jackie Merri Meyer**
New York (New York), USA
CREATIVES
Jackie Merri Meyer,
Herman Estevez
CLIENT
Warner Books

IF LOOKS
COULD KILL

KATE
WHITE

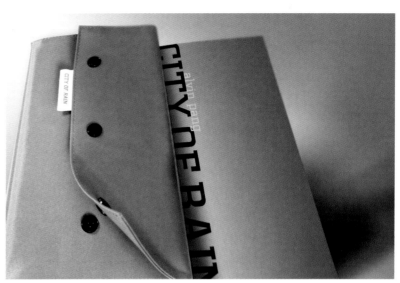

CREATIVE FIRM
Pagesetters Services Pte Ltd
Singapore
CREATIVES
Lee Shin Kee, Andrew Phang
CLIENT
Ethos Book

CREATIVE FIRM
Brigid Pearson
New York (New York), USA
CREATIVES
Jackie Merri Meyer,
Getty Images
CLIENT
Warner Books

CREATIVE FIRM
Jackie Merri Meyer
New York (New York), USA
CREATIVES
Jackie Merri Meyer
CLIENT
Warner Books

CREATIVE FIRM
Allyn and Bacon Cover Dept.
Boston (Massachusetts), USA
CREATIVES
Suzanne Harbison,
Linda Knowles,
Thomas Hoeffgen
CLIENT
Allyn and Bacon

CREATIVE FIRM
Roni Lagin
Graphic Design
Philadelphia
(Pennsylvania), USA
CLIENT
Fanfare Publishing, Inc.

133

Piotr Gliński
Polscy Zieloni

Ruch społeczny w okresie przemian

WYDAWNICTWO IFiS PAN

CREATIVE FIRM
KOREK Studio
Warsaw, Poland
CREATIVES
Wojtek Korkuc
CLIENT
IFiS PAN

CREATIVE FIRM
Pagesetters Services Pte Ltd
Singapore
CREATIVES
Lee Shin Kee, Christine Chua,
Sheryl Teo, Andrew Phang
CLIENT
ABN AMRO Bank

CREATIVE FIRM
Ukulele Brand Consultants Pte Ltd
Singapore
CREATIVES
Kim Chun-wei, Daphne Chan,
Lee Ann Wilson
CLIENT
National Parks Board, Singapore

134

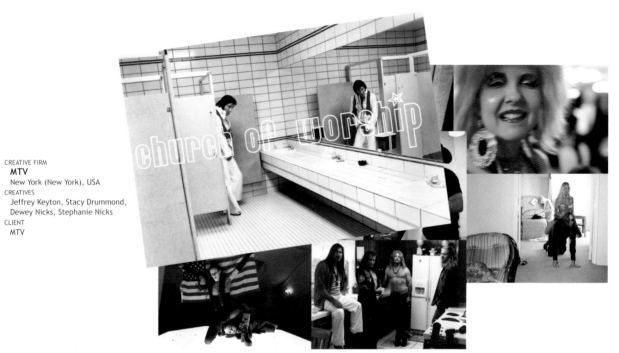

CREATIVE FIRM
MTV
New York (New York), USA
CREATIVES
Jeffrey Keyton, Stacy Drummond,
Dewey Nicks, Stephanie Nicks
CLIENT
MTV

CREATIVE FIRM
VH1 Off Air Creative
New York (New York), USA
CREATIVES
Nigel Cox Hagen, Phil DelBourbo,
Nancy Mazzei, Myriam Lopez,
Anne Marie Gilligan,
Traci Terrill, Shermalee Nicholson
CLIENT
VH1

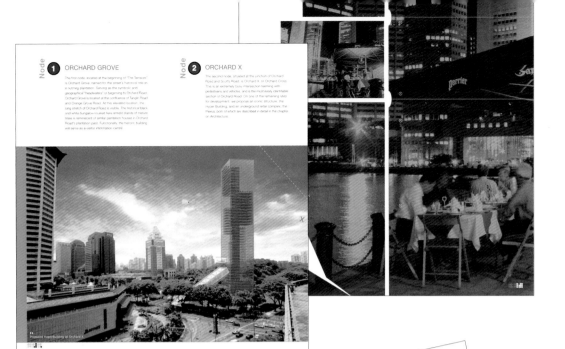

Node 1 ORCHARD GROVE

The first node, located at the beginning of "The Terraces" is Orchard Grove, named for the street's historical role as a nutmeg plantation. Serving as the symbolic and geographical "headwaters" or beginning to Orchard Road, Orchard Grove is located at the confluence of Tanglin Road and Orange Grove Road. At this elevated location, the long stretch of Orchard Road is visible. The historical black and white bungalow located here amidst islands of mature trees is reminiscent of similar plantation houses in Orchard Road's plantation past. Functionally, the historic building will serve as a visitor information centre.

Node 2 ORCHARD X

The second node, situated at the junction of Orchard Road and Scotts Road, is Orchard X, or Orchard Cross. This is an extremely busy intersection teeming with pedestrians and vehicles, and is the most easily identifiable section of Orchard Road. On one of the remaining sites for development, we propose an iconic structure, the Hyper Building, and an underground retail complex, the Hexus, both of which are described in detail in the chapter on Architecture.

CREATIVE FIRM
atomzi! Pte Ltd
Singapore
CREATIVES
Lily Chia, Patrick Lee,
Chiao-Wei Chang
CLIENT
Singapore Tourism Board

CREATIVE FIRM
Nesnadny + Schwartz
Cleveland (Ohio), USA
CREATIVES
Mark Schwartz,
Michelle Moehler
CLIENT
The Cleveland Museum of Arts
and The George Gund Foundation

135

CREATIVE FIRM
Design Club
Tokyo, Japan
CREATIVES
Michitaka Ota,
Akihiko Tsukamoto,
Chie Yasuda
CLIENT
Wides Shuppan Co., Ltd.

CREATIVE FIRM
Epigram Pte Ltd
Singapore
CREATIVES
Edmund Wee, Tay Chin Thiam,
Various at SAFRA
CLIENT
SAFRA

136

Grizz Lee
Goes to the
Hospital

The nice nurse gave Grizz Lee Johnnie's coat to wear.
He tried it on and found that you could
wear it two different ways.

CREATIVE FIRM
Tom Fowler, Inc.
Norwalk (Connecticut), USA
CREATIVES
Elizabeth P. Ball
CLIENT
Elizabeth P. Ball

:: MASTERWORKS AND ECCENTRICITIES ::

The Druckman Collection

CREATIVE FIRM
Kolbrener
Pittsburgh (Pennsylvania), USA
CREATIVES
Mike Kolbrener
CLIENT
Four Winds Gallery

as the Wind gently cradled it in its swirling current.

"You must never lose hope," whispered the Wind.

"But I have searched and searched,"
the tiny seed sobbed, "and there is no place
for me to grow. I will never find a home."

"For as long as time," whispered the Wind, "I have carried
all kinds of seeds across the earth. And one by one
each seed found its own special place to grow."

"But I'm not like other seeds,"
said the tiny seed with a sniffle.
"I'm a floater, not a grower."

"You are a grower," whispered the Wind,
"because that's what seeds do—they grow."

"You sound just like the old tree,"
said the tiny seed.

"That old tree was once a tiny seed and rode with me
just like you," whispered the Wind.
"Now it's time for you to float down
to the ground and look again."

"No, Wind!
I want to stay here with you!
Please don't let me go!" cried the tiny seed.

"Don't be afraid. You will find your place to grow and blossom.
And I will be there. I will always be there," whispered the Wind
and gently released the tiny seed from its airy embrace.

a place to grow
Written by Stephanie Bloom
Illustrated by Kelly Murphy

CREATIVE FIRM
Kiku Obata & Company
St. Louis (Missouri), USA
CREATIVES
Kiku Obata, Eleanor Safe,
Mel Lim-Keylon, Rich Nelson,
Amy Knopf, Dionna Raedeke
CLIENT
Bloom & Grow, Inc.

137

CREATIVE FIRM
VMA, Inc.
Dayton (Ohio), USA
CREATIVES
Al Hidalgo, Kenneth Botts
CLIENT
Montgomery County
Historical Society

CREATIVE FIRM
**Haase & Knels,
Atelier für Gestaltung**
Bremen, Germany
CREATIVES
Sibylle Haase,
Prof. Fritz Haase,
Katja Hirschfelder,
Simone Kattert
CLIENT
Wilhelm-Wagenfeld-
Stiftung-Gerhard-
Marcks-Haus

If Walls Could Talk...

CREATIVE FIRM
Maremar Graphic Design
Bayamón, Puerto Rico
CREATIVES
Marina Rivon, Stephanie McMahon,
Jan D'Esopo
CLIENT
Jan D'Esopo

138

CREATIVE FIRM
Wood Design
New York (New York), USA
CREATIVES
Tom Wood, Clint Bottoni
CLIENT
Louis Dreyfus

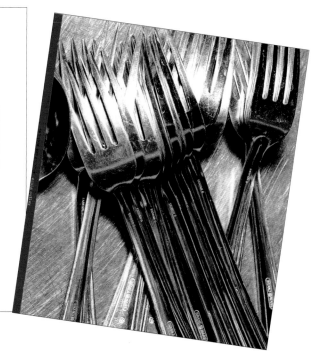

die organische form

1930 bis 1960: bildhauerkunst

CREATIVE FIRM
**Haase & Knels,
Atelier für Gestaltung**
Bremen, Germany
CREATIVES
Sibylle Haase,
Prof. Fritz Haase,
Katja Hirschfelder,
Simone Kattert
CLIENT
Wilhelm-Wagenfeld-
Stiftung-Gerhard-
Marcks-Haus

The Bridesmaid Guide

Etiquette,
Parties, and
Being Fabulous

BY KATE CHYNOWETH

Illustrations by Neryl Walker

ASTROBRIDE

Prepare for your job as bridesmaid by looking at her stars.

★ **The Aries Bride** March 21–April 19
The energetic, laugh-a-minute Ram bride will be a blast to work for—she'll generally keep her sense of humor and make sure those prewedding parties rock until dawn. But, be forewarned: her spontaneous, fiery nature means that she may change her mind at the last second about things you thought were written in stone.
Bridesmaid motto: Be prepared for anything.

★ **The Taurus Bride** April 20–May 20
Put away your glitter eye shadow: this classy, earthy lady has a healthy respect for tradition, and her wedding will be about simple elegance. She insists on high quality in every department, from classy gowns to gourmet food and drink. Lucky for you, you can count on the Bull bride to pick you a fabulous dress.
Bridesmaid motto: Put on the ritz.

★ **The Gemini Bride** May 21–June 21
A bride born under this mercurial sign will rarely take the traditional, well-trodden route to the altar, and her ceremony will be as creative and interesting as the guests. Ruled by the Twins, the Gemini bride may be indecisive when planning the details, so listen patiently to her myriad ideas and help her choose one path.
Bridesmaid motto: I am a rock.

★ **The Cancer Bride** June 22–July 22
The Crab bride prefers to lead—not be led—and will have very specific ideas about wedding details. She is very close to her mother and will want her to be involved in planning details. The slightest perceived criticism from a friend or mother-in-law-to-be will make the sensitive Cancerian retreat inside her shell. Encourage her to communicate her smallest concerns and troubleshoot when others act insensitively.
Bridesmaid motto: Don't worry; be happy.

★ **The Leo Bride** July 23–August 22
[...] get angry when this bride has moments of arrogance or vanity—she can't [...] them any more than she can deny her party-loving nature. Besides, few [...] appreciate loyalty and faithfulness in friends as much as the mighty Lion. [...] to plan a fabulous night out on the town with the ladies—with this bride at [...], the bachelorette party will be an extraordinary and outstanding evening.
Bridesmaid motto: Keep your eyes on the bride.

Being Fabulous | 47

CREATIVE FIRM
Red Canoe
Deer Lodge (Tennessee), USA
CREATIVES
Deb Koch,
Vivien Sung/Chronicle Books,
Caroline Kavanagh,
Neryl Walker
CLIENT
Chronicle Books

139

MTV PHOTOBOOTH

Over 200 celebrities. 61 sunglasses. 44 tongues. 28 goofy faces. 15 middle fingers. 14 blown kisses. 12 heavy metal signs. 8 threesomes. 5 nosepickings, 2 nipples, and 1 bare ass. Enter the secret space of MTV's world-famous Times Square studio photobooth and see what only the camera has as you stare straight into the faces—and some other body parts we can't mention here—of your favorite stars. You've seen them on *TRL, DFX* and other MTV programs, but you've never seen them like this, vamping, posing, giggling, and goofing in strip after outrageous four-photo strip. From Jennifer Lopez to Janet Jackson, Ozzy Osbourne to Blink 182, and Mike Myers to Madonna, *MTV Photobooth* brings you face-to-face with your favorite stars.

MTV Photobooth

Universe Publishing
A Division of Rizzoli International Publications, Inc.
300 Park Avenue South New York, NY 10010
Distributed to the U.S. trade by St. Martin's Press, New York, NY
Printed in Hong Kong.
©2002 MTV Networks. All Rights Reserved.

$17.95

MTV Photobooth

CREATIVE FIRM
MTV
New York (New York), USA

CREATIVES
Jacob Hoye, Walter Einenkel, Jeffrey Keyton,
Jim deBarros, Lance Rusoff, Christopher Truch,
Dave Sirulnick
CLIENT
MTV

AMERICAN SIGNS

Form and Meaning on Route 66

Lisa Mahar

THE MONACELLI PRESS

CREATIVE FIRM
Lisa Mahar
New York (New York), USA

CREATIVES
Lisa Mahar,
Ashley Sargent, Inc.
CLIENT
Lisa Mahar

CREATIVE FIRM
Warkulwiz Design Associates
Philadelphia (Pennsylvania), USA
CREATIVES
Robert Warkulwiz, Roni Lagin,
Michael Rogalski
CLIENT
Smart Papers

CREATIVE FIRM
Grafik Marketing Communications
Alexandria (Virginia), USA
CREATIVES
Kristin Goetz, Melba Black
CLIENT
McArdle Printing Co.

CREATIVE FIRM
Hull Creative Group
Boston (Massachusetts), USA
CREATIVES
Youn Park, Carolyn Colonna,
Caryl Hull
CLIENT
Justin, Charles & Co. Publishers

140

CREATIVE FIRM
Howry Design Associates
San Francisco (California), USA
CREATIVES
Jill Howry, Robert Williams,
Craig Williamson
CLIENT
Serbin Communications

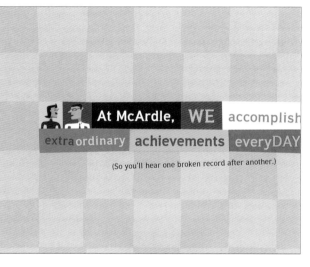

x5

2003

atedge / Marketing

PRE

CREATIVE FIRM
Q
Wiesbaden, Germany
CREATIVES
Laurenz Nielbock,
Matthias Frey, Christoph Kohl
CLIENT
Zanders Feinpapiere

Durable, solid, easy to maintain.

The Sweetwater Spas manufacturing process meets rigorous ISO 9001 requirements, the most demanding in the world, so your Sweetwater spa will last a long time and require minimal maintenance through the years. Two types of foam insulation are applied to every spa: high-density, heat-resistant foam surrounds the equipment bay, and lighter, more insulating foam fills the rest of the shell. This full-foam insulation conserves heat and provides additional plumbing support. A liner isolates the cabinetry from the foam insulation, protecting the insulation if the cabinetry is removed.

Comparing the "horsepower" of pumps is one way to gauge jet power, but measurement methods differ from one manufacturer to another. At Sweetwater Spas, we use solid plumbing, advanced jets and outstanding flow control for energy-efficient, high performance that stands up to any horsepower comparison.

Sweetwater's three-layer Dura Bond™ shell is a patented process. Shells are molded from one seamless piece of acrylic; there are no glued sections to delaminate, separate, or leak. The Dura Bond shell is eight times stronger than ordinary fiberglass resin shells, with a finish that is extremely long-lasting and weather-resistant.

The Sweetwater scrapbook.

BaslerPapermühl

CREATIVE FIRM
Kevershan Design/Quorum
San Diego (California), USA
CREATIVES
Patty Kevershan, Patti Testerman,
Michael Hetz
CLIENT
Sweetwater Spas

CREATIVE FIRM
**Albert Gomm Studio for Book
and Graphic Design**
Basel, Switzerland
CREATIVES
Albert Gomm, Markus Mueller, Stefan Meier
CLIENT
Swiss Museum of Paper Writing and Printing

CREATIVE FIRM
**Herman Miller
In House Design**
Zeeland (Michigan), USA
CREATIVES
Andrew Dull, Bill Holm
CLIENT
Herman Miller Inc.

For Internal Use Only

FlexSelect Licensing

{ Information for Better Selling }

Computer Associates™

CREATIVE FIRM
David Carter Design Assoc.
Dallas (Texas), USA
CREATIVES
Donna Aldridge,
Ashley Barron Mattocks
CLIENT
Lajitas-The Ultimate Hideout

CREATIVE FIRM
**CA In-House
Creative Development**
Islandia (New York), USA
CREATIVES
Loren Moss Meyer,
Franz Edson,
Peter Edson
CLIENT
Computer Associates

Ministry of Home Affairs

Home Affairs
Senior Executive

A Varied Career. Many Challenges.

CREATIVE FIRM
**Pagesetters Services
Pte Ltd**
Singapore
CREATIVES
Lee Shin Kee, Mark Lim,
Andrew Phang
CLIENT
Ministry of Home Affairs

CREATIVE FIRM
LTD Creative
Frederick (Maryland), USA
CREATIVES
Timothy Finnen, Louanne Welgoss,
Kimberly Dow
CLIENT
Hanley-Wood, LLC

CREATIVE FIRM
Ellen Bruss Design
Denver (Colorado), USA
CREATIVES
Ellen Bruss, Charles Carpenter,
Joseph Amram, Ron Pollard,
Bill Nelson
CLIENT
Eliav Nissan

ELIAV NISSAN

art with function

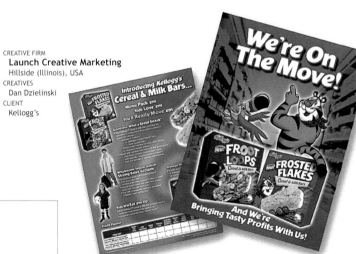

CREATIVE FIRM
flourish
Cleveland (Ohio), USA
CREATIVES
Christopher Ferranti, Charity Ewanko, Henry Frey,
Jing Lauengco, Larry Tuckman, David Hill,
Mike Hattaway, Jackson Bittle, Steve Shuman,
Lisa Fortuna, Michael Rogers
CLIENT
Arhaus Furniture

142

CREATIVE FIRM
Launch Creative Marketing
Hillside (Illinois), USA
CREATIVES
Dan Dzielinski
CLIENT
Kellogg's

CREATIVE FIRM
John Wingard Design
Honolulu (Hawaii), USA
CREATIVES
John Wingard
CLIENT
Ian L. Mattoch

CREATIVE FIRM
Jensen Design Associates
Long Beach (California), USA
CREATIVES
David Jensen, Virginia Teager,
Joel Penos, Julio Escalante
CLIENT
Kenwood U.S.A.

143

CREATIVE FIRM
Hult Fritz Matuszak Inc.
Peoria (Illinois), USA
CREATIVES
Dave Wiggins, Chantel Cradduck-Jones,
Judi Jones, Jane Wells
CLIENT
Maui Jim, Inc.

CREATIVE FIRM
Besser Design Group
Santa Monica (California), USA
CREATIVES
Rik Besser
CLIENT
The Raymond Group

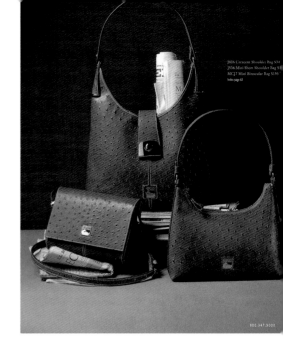

CREATIVE FIRM
Millyard Design Assoc. Ltd.
Dover (Massachusetts), USA
CREATIVES
Marjorie Millyard, Phyllis Dooney, Kristen Burns,
Marian Courie, Jason Penny, Frank Rapp
CLIENT
Dooney & Bourke

144

CREATIVE FIRM
Recipe
Hong Kong, China
CREATIVES
Ben Lai
CLIENT
LSDS

CREATIVE FIRM
TGD Communications
Alexandria (Virginia), USA
CREATIVES
Rochelle Gray,
Jennifer Cedoz,
Ivy Lamanna,
Tracy Walker
CLIENT
American Association of
Pharmaceutical Scientists

CREATIVE FIRM
Mitten Design
San Francisco (California), USA
CREATIVES
Marianne Mitten
CLIENT
Robert Mondavi Corporation

CREATIVE FIRM
Brooks-Jeffrey Marketing, Inc.
Mountain Home (Arkansas), USA
CREATIVES
Brooks-Jeffrey Marketing
Creative Team
CLIENT
Mountain Home Area
Chamber of Commerce

CREATIVE FIRM
Croxson Design
Houston (Texas), USA
CREATIVES
Stephen Croxson, Richard Byrd
CLIENT
Weatherford International

CREATIVE FIRM
Herman Miller In House Design
Zeeland (Michigan), USA
CREATIVES
Kathy Stanton, Sharon Boehm, Bill Holm,
Nick Merrick, Herman Miller Virtual Lab
CLIENT
Herman Miller Inc.

145

CREATIVE FIRM
**Grafik Marketing
Communications**
Alexandria (Virginia), USA
CREATIVES
Melissa Wilets, Lynn Umemoto,
Gregg Glaviano, Judy Kirpich
CLIENT
Tidewater Jewish Community

CREATIVE FIRM
**Whitney Edwards
Design**
Easton (Maryland), USA
CREATIVES
Barbara J. Christopher,
Charlene Whitney Edwards,
Debbie Collison
CLIENT
Campbell's Boatyards

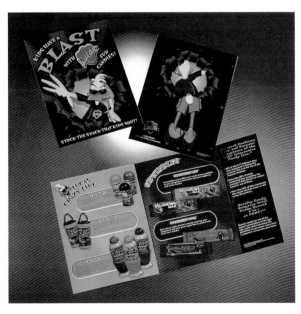

CREATIVE FIRM
CAG Design
Hackettstown (New Jersey), USA
CREATIVES
Alison Black, Eileen LaGrecca
CLIENT
Masterfoods, USA

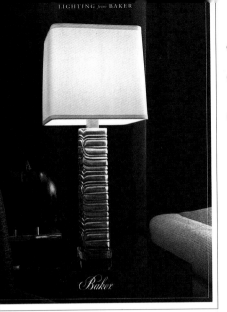

CREATIVE FIRM
VSA Partners
Chicago (Illinois), USA
CREATIVES
James Koval, Dan
Knuckey,
Katie Heit
CLIENT
Baker Furniture

CREATIVE FIRM
Hull Creative Group
Boston (Massachusetts), USA
CREATIVES
Youn Park, Carolyn Colonna,
Caryl Hull
CLIENT
Allyn & Bacon Publishers

CREATIVE FIRM
Sherman Advertising
New York (New York), USA
CREATIVES
Sharon Lloyd McLaughlin,
William Touchet
CLIENT
Applied Development Company

146

CREATIVE FIRM
Herman Miller In house design
Zeeland (Michigan), USA
CREATIVES
Brian Edlefson, Dick Holm,
Nick Merrick, Jody Williams
CLIENT
Herman Miller Inc.

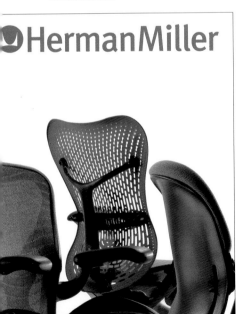

CREATIVE FIRM
Tangram Strategic Design
Novara, Italy
CREATIVES
Enrico Sempi, Alberto Baccari, Anna
Grimaldi, Maria Vittoria Backhaus
CLIENT
Davide Cenci

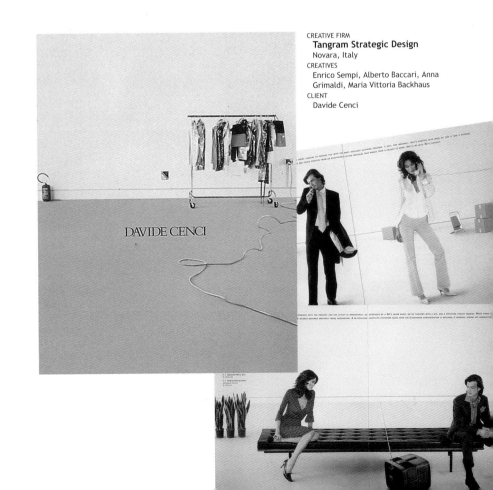

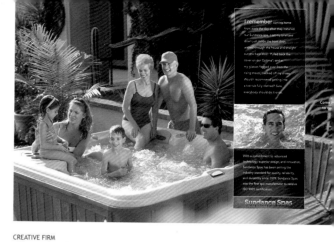

CREATIVE FIRM
Sherman Advertising
New York (New York), USA
CREATIVES
Sharon Lloyd McLaughlin, Diana Weaton, William Touchet
CLIENT
Roseland Property Company

CREATIVE FIRM
Kevershan Design/Quorum
San Diego (California), USA
CREATIVES
Patty Kevershan, Patti Testerman,
Michael Hetz
CLIENT
Sundance Spas

CREATIVE FIRM
Noevir USA, Inc.
Irvine (California), USA
CREATIVES
Joseph Gaydos,
Rene Armenta
CLIENT
Noevir USA, Inc.

CREATIVE FIRM
Gehl Design
Seattle (Washington),
USA
CREATIVES
Joyce Gehl,
Eric Junes,
Jennifer Lakeman,
Sarah Hersack
CLIENT
Highwire

CREATIVE FIRM
Gehl Design
Seattle (Washington), USA
CREATIVES
Joyce Gehl, Eric Junes, Jennifer Lakeman,
Janet Pankow, Anita Lehman, Students &
Faculty
CLIENT
Cornish College of the Arts

CREATIVE FIRM
The Marketing Formula
Dayton (Ohio), USA
CREATIVES
Errin Hahn, Pam Zajovits, Mary Ann Chang
CLIENT
Cityfolk

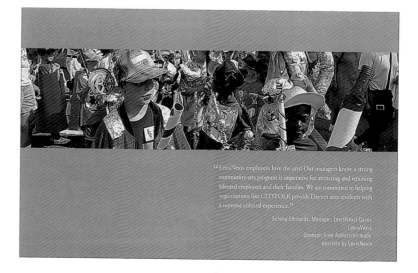

CREATIVE FIRM
David Carter Design Assoc.
Dallas (Texas), USA
CREATIVES
Stephanie Burt,
Ashley Barron Mattocks
CLIENT
Watermark Hotel & Spa

CREATIVE FIRM
Ukulele Brand Consultants Pte Ltd
Singapore
CREATIVES
Kim Chun-wei, Roger Hiew,
Lynn Lim
CLIENT
Cathay Organisation Holdings Ltd

CREATIVE FIRM
Primary Design, Inc.
Haverhill (Maryland), USA
CREATIVES
Jules Epstein, Allison Davis
CLIENT
Abbott Development

CREATIVE FIRM
Decker Design, Inc.
New York (New York),
USA
CREATIVES
Lynda Decker,
John Medere
CLIENT
St. John's University

CREATIVE FIRM
Gary Taylor Creative Group
Los Angeles (California), USA
CREATIVES
Gary Taylor, Mike Gonzales,
Phil Warth
CLIENT
Kawasaki Motors

CREATIVE FIRM
FCB Durban
Durban, South Africa
CREATIVES
Michael Bond, Paul Voslo
CLIENT
Mondi Paper Ltd

CREATIVE FIRM
5D Studio
Malibu (California), USA
CREATIVES
Maggie Van Oppen, Jane Kobayashi
CLIENT
Walker Zanger

CREATIVE FIRM
Catalyst Studios
Minneapolis (Minnesota), USA
CREATIVES
Jason Rysavy, Beth Mueller,
Jodi Eckes,
Sherwin Schwartzrock
(BlackRock Graphics)
CLIENT
The Wehmann Agency

CREATIVE FIRM
Nassar Design
Brookline (Massachusetts), USA
CREATIVES
Nelida Nassar, Margarita Encomignda
CLIENT
Mireille Honeïn

149

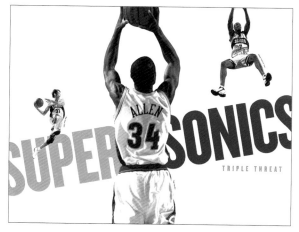

CREATIVE FIRM
**Gary Taylor
Creative Group**
Los Angeles
(California), USA
CREATIVES
Gary Taylor,
Mike Gonzales,
Phil Warth
CLIENT
Kawasaki Motors

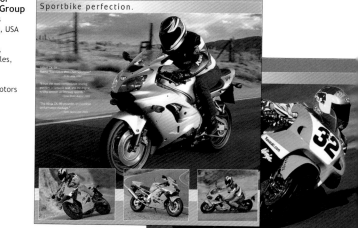

CREATIVE FIRM
Hornall Anderson Design Works, Inc.
Seattle (Washington), USA
CREATIVES
Jack Anderson, Andrew Wicklund,
Ed Lee
CLIENT
Seattle SuperSonics

CREATIVE FIRM
Design Guys
Minneapolis (Minnesota), USA
CREATIVES
Steven Sikora, Jay Theige
CLIENT
Theatre de la Jeune Lune

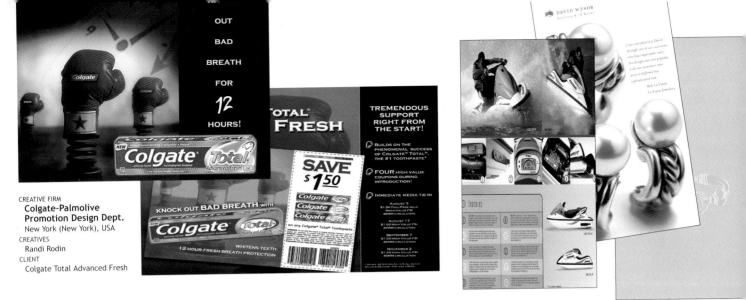

CREATIVE FIRM
**Colgate-Palmolive
Promotion Design Dept.**
New York (New York), USA
CREATIVES
Randi Rodin
CLIENT
Colgate Total Advanced Fresh

CREATIVE FIRM
Warkulwiz Design Assoc.
Philadelphia (Pennsylvania), USA
CREATIVES
Robert Warkulwiz, Michael Rogalski
CLIENT
David Wysor Jeweler

CREATIVE FIRM
Lee Reedy Creative
Denver (Colorado), USA
CREATIVES
Patrick Gill, Sam Mobley,
Lee Reedy, Kelly Reedy
CLIENT
Nocerino Editions

150

CREATIVE FIRM
**In One Advertising
& Design**
Scottsdale (Arizona), USA
CREATIVES
Jaci Scully, Kim Allison,
D² Productions
CLIENT
Marbella Country Club

CREATIVE FIRM
**Hornall Anderson Design
Works, Inc.**
Seattle (Washington), USA
CREATIVES
Jack Anderson, Andrew Wicklund,
Mark Popich
CLIENT
Seattle SuperSonics

CREATIVE FIRM
Gammon Ragonesi Associates
New York (New York), USA
CREATIVES
J.P. Forbes, Mary Ragonesi
CLIENT
Nestle Ice Cream Company

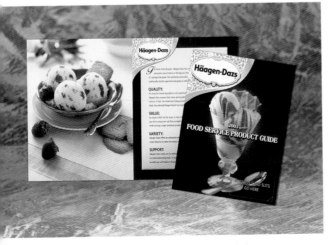

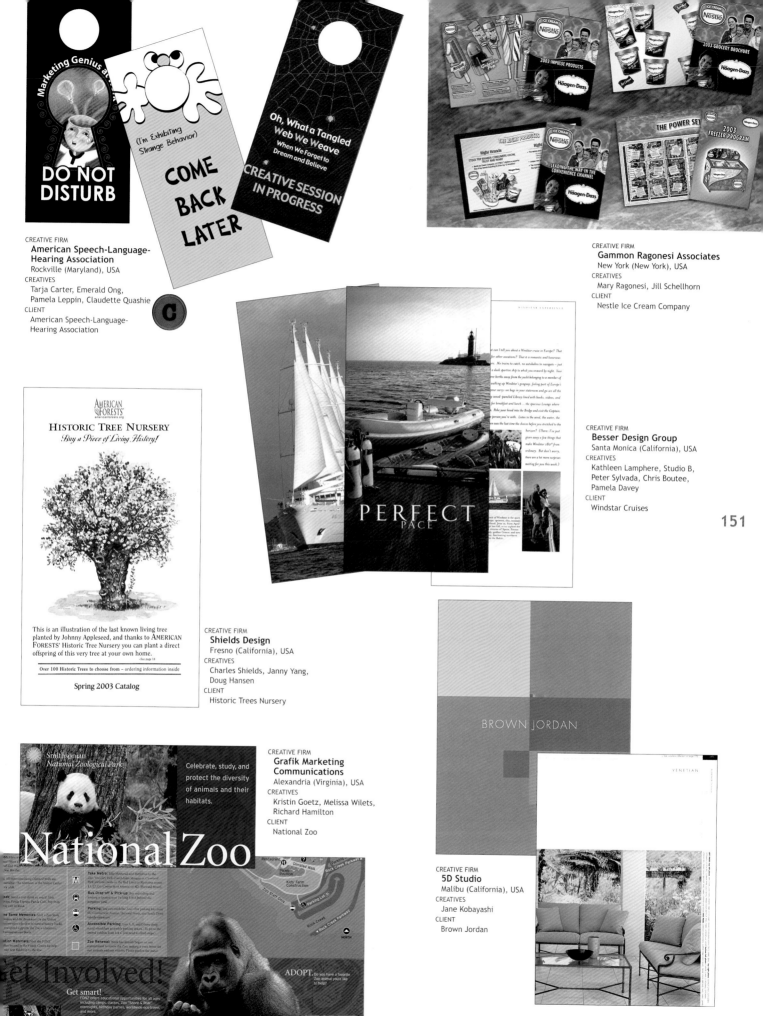

CREATIVE FIRM
American Speech-Language-Hearing Association
Rockville (Maryland), USA
CREATIVES
Tarja Carter, Emerald Ong,
Pamela Leppin, Claudette Quashie
CLIENT
American Speech-Language-Hearing Association

CREATIVE FIRM
Gammon Ragonesi Associates
New York (New York), USA
CREATIVES
Mary Ragonesi, Jill Schellhorn
CLIENT
Nestle Ice Cream Company

CREATIVE FIRM
Besser Design Group
Santa Monica (California), USA
CREATIVES
Kathleen Lamphere, Studio B,
Peter Sylvada, Chris Boutee,
Pamela Davey
CLIENT
Windstar Cruises

151

CREATIVE FIRM
Shields Design
Fresno (California), USA
CREATIVES
Charles Shields, Janny Yang,
Doug Hansen
CLIENT
Historic Trees Nursery

CREATIVE FIRM
Grafik Marketing Communications
Alexandria (Virginia), USA
CREATIVES
Kristin Goetz, Melissa Wilets,
Richard Hamilton
CLIENT
National Zoo

CREATIVE FIRM
5D Studio
Malibu (California), USA
CREATIVES
Jane Kobayashi
CLIENT
Brown Jordan

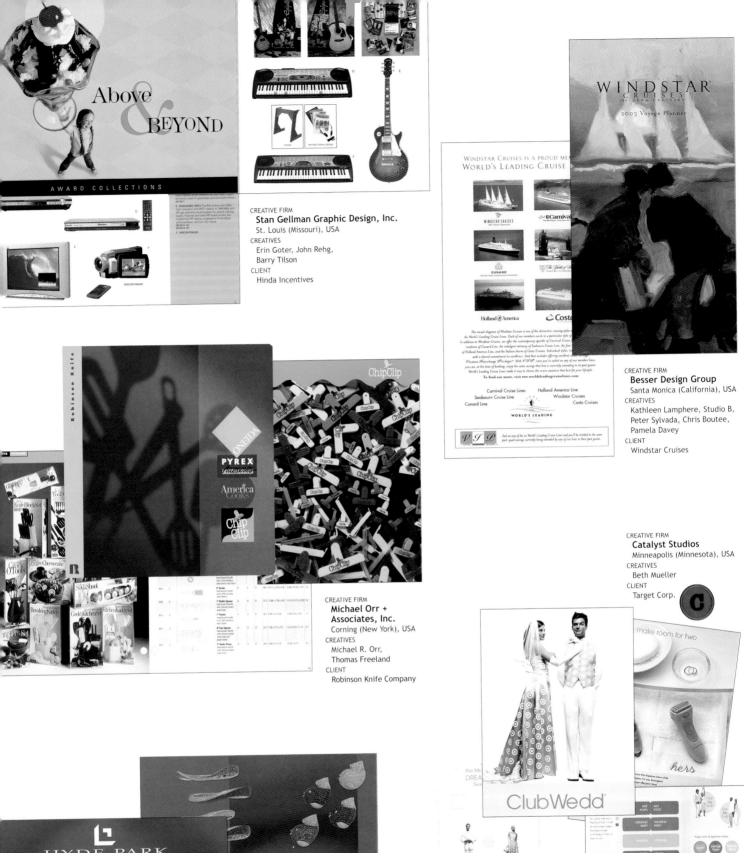

CREATIVE FIRM
Stan Gellman Graphic Design, Inc.
St. Louis (Missouri), USA
CREATIVES
Erin Goter, John Rehg,
Barry Tilson
CLIENT
Hinda Incentives

CREATIVE FIRM
Besser Design Group
Santa Monica (California), USA
CREATIVES
Kathleen Lamphere, Studio B,
Peter Sylvada, Chris Boutee,
Pamela Davey
CLIENT
Windstar Cruises

CREATIVE FIRM
**Michael Orr +
Associates, Inc.**
Corning (New York), USA
CREATIVES
Michael R. Orr,
Thomas Freeland
CLIENT
Robinson Knife Company

CREATIVE FIRM
Catalyst Studios
Minneapolis (Minnesota), USA
CREATIVES
Beth Mueller
CLIENT
Target Corp.

CREATIVE FIRM
Ellen Bruss Design
Denver (Colorado), USA
CREATIVES
Ellen Bruss, Charles Carpenter,
Greg Christman
CLIENT
Hyde Park

CREATIVE FIRM
Watts Design
South Melbourne, Australia
CREATIVES
Peter Watts
CLIENT
Water Wheel Vineyards

CREATIVE FIRM
**Grafik Marketing
Communications**
Alexandria (Virginia), USA
CREATIVES
Kristin Goetz,
Alysia Orrel
CLIENT
EastBanc

CREATIVE FIRM
Sherman Advertising
New York (New York), USA
CREATIVES
Sharon Loyd McLaughlin,
William Touchet
CLIENT
The Dermot Company, Inc.

153

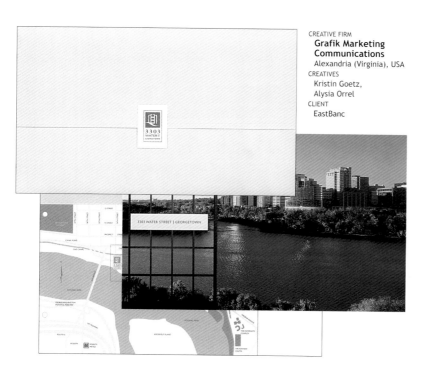

CREATIVE FIRM
Besser Design Group
Santa Monica (California),
USA
CREATIVES
Kathleen Lamphere,
Studio B,
Peter Sylvada,
Chris Boutee,
Pamela Davey
CLIENT
Windstar Cruises

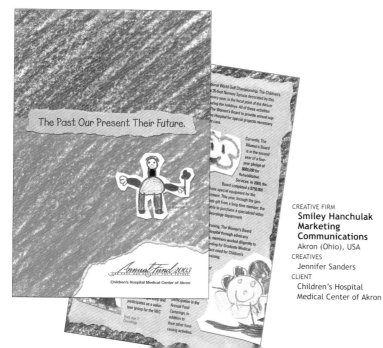

The Past. Our Present. Their Future.

Annual Fund 2003

Children's Hospital Medical Center of Akron

CREATIVE FIRM
**Smiley Hanchulak
Marketing
Communications**
Akron (Ohio), USA
CREATIVES
Jennifer Sanders
CLIENT
Children's Hospital
Medical Center of Akron

CREATIVE FIRM
Sherman Advertising
New York (New York), USA
CREATIVES
Sharon Lloyd McLaughlin,
William Touchet
CLIENT
Jack Resnick and Sons, Inc.

154

CREATIVE FIRM
Besser Design Group
Santa Monica (California), USA
CREATIVES
Kathleen Lamphere, Studio B,
Peter Sylvada, Chris Boutee,
Pamela Davey
CLIENT
Windstar Cruises

CREATIVE FIRM
Herman Miller In house design
Zeeland (Michigan), USA
CREATIVES
Kathy Stanton, Sharon Boehm,
Clark Malcolm
CLIENT
Herman Miller Inc.

CREATIVE FIRM
VSA Partners
Chicago (Illinois), USA
CREATIVES
James Koval, Thom Wolfe,
Brock Conrad
CLIENT
Baker Furniture

CREATIVE FIRM
Sherman Advertising
New York (New York), USA
CREATIVES
Sharon Lloyd McLaughlin,
William Touchet
CLIENT
Bozzuto Management

CREATIVE FIRM
Designski
Toledo (Ohio), USA
CREATIVES
Denny Kreger, Mike Clark,
Jim Gibson, Josh Cooper
CLIENT
Jim Gibson

CREATIVE FIRM
Jeff Gilligan
New York (New York), USA
CREATIVES
Jeff Gilligan, Alex Ostroy
CLIENT
KOCH Records

155

CREATIVE FIRM
3i Ltd.
Arlington (Virginia), USA
CREATIVES
Ron Harman, Hugh Feeley,
Kenn Speicher
CLIENT
Hugh Feeley & Talk is Cheap

CREATIVE FIRM
Nexus Design & Marketing Inc.
Cardiff (California), USA
CREATIVES
Craig Calsbeek
CLIENT
Bill Ratner Primetime Voice-Overs

CREATIVE FIRM
EPOS, Inc.
Santa Monica (California), USA
CREATIVES
Eric Martinez
CLIENT
Walt Disney Records

156

CREATIVE FIRM
HBO
New York (New York), USA
CREATIVES
Gary Dueno
CLIENT
HBO

CREATIVE FIRM
Microsoft Studios
Redmond (Washington), USA
CREATIVES
Jeannine Frazier
CLIENT
Adam Rosenblatt, Kelly Weadlock

CREATIVE FIRM
Blackburn's LTD
London, England
CREATIVES
John Blackburn,
Matt Thompson,
Anand Choudhry
CLIENT
Taisho Pharmaceutical

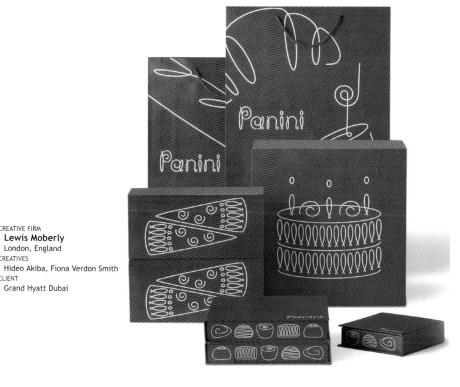

CREATIVE FIRM
Lewis Moberly
London, England
CREATIVES
Hideo Akiba, Fiona Verdon Smith
CLIENT
Grand Hyatt Dubai

CREATIVE FIRM
Launch Creative Marketing
Hillside (Illinois), USA
CREATIVES
Michelle Morales
CLIENT
Kellogg's

CREATIVE FIRM
Karacters design group
Vancouver (British Columbia), Canada
CREATIVES
Maria Kennedy, Matthew Clark
CLIENT
Sun-Rype Products Ltd.

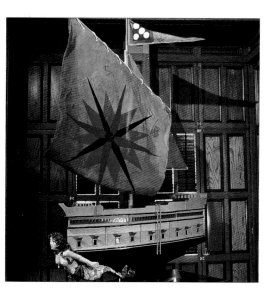

CREATIVE FIRM
WINDIGO
Morristown (New Jersey), USA
CREATIVES
Lia DiStefano,
Mark Friedlander/Future Scopes
CLIENT
Newport Art Museum

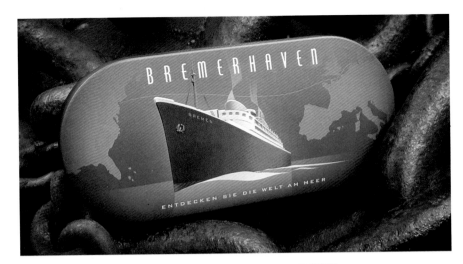

CREATIVE FIRM
Blackburn's LTD
London, England
CREATIVES
John Blackburn, Matt Thompson,
Anand Choudhry
CLIENT
PLB Group

CREATIVE FIRM
Braue, Branding & Corporate Design
Bremerhaven, Germany
CREATIVES
Kai Braue, Marcel Robbers
CLIENT
BIS Bremerhaven

158

CREATIVE FIRM
Launch Creative Marketing
Hillside (Illinois), USA
CREATIVES
Don Dzielinski
CLIENT
Keebler

CREATIVE FIRM
Corporate Design & Vsability
Rochester (New York), USA
CREATIVES
Michelle Demeyer, Tim McCann,
Alan Farkas
CLIENT
Kodak Professional

CREATIVE FIRM
Karacters design group
Vancouver (British Columbia), Canada
CREATIVES
Maria Kennedy, Michelle Melenchuk,
Marsha Kupsch
CLIENT
Caboodles Cosmetics

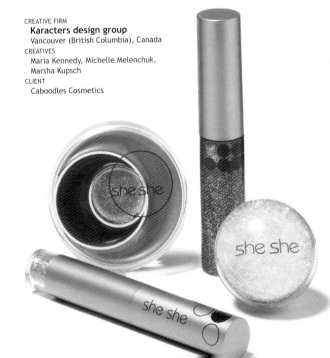

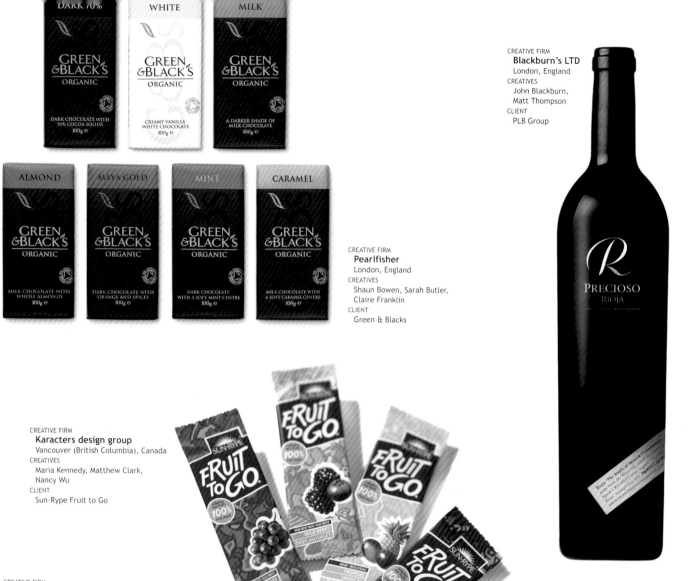

CREATIVE FIRM
Blackburn's LTD
London, England
CREATIVES
John Blackburn,
Matt Thompson
CLIENT
PLB Group

CREATIVE FIRM
Pearlfisher
London, England
CREATIVES
Shaun Bowen, Sarah Butler,
Claire Franklin
CLIENT
Green & Blacks

CREATIVE FIRM
Karacters design group
Vancouver (British Columbia), Canada
CREATIVES
Maria Kennedy, Matthew Clark,
Nancy Wu
CLIENT
Sun-Rype Fruit to Go

CREATIVE FIRM
Whitney Design Works
St. Louis (Missouri), USA
CREATIVES
Mike Whitney
CLIENT
Hershey Import Co.

CREATIVE FIRM
Cornerstone
New York (New York), USA
CREATIVES
Keith Steimel, Sally Clarke,
Julia Smith
CLIENT
Swedish Match

159

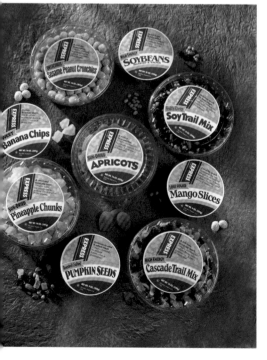

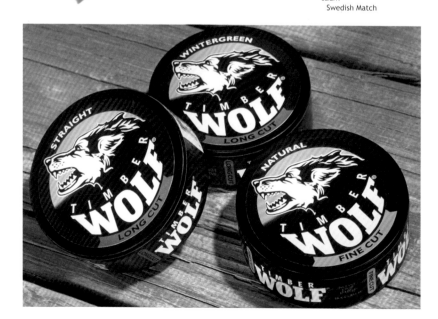

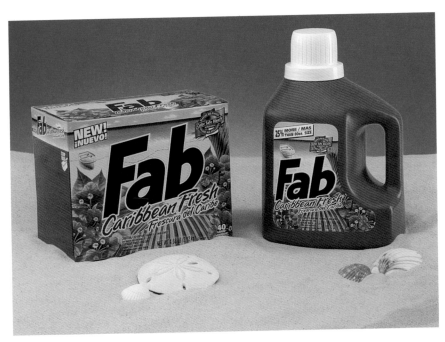

CREATIVE FIRM
Sterling Group
New York (New York),
USA
CREATIVES
Jean Nordlan,
Yana Rodin-Tracy,
Hal Brooks,
Bob Santomarco,
Fisher Design
CLIENT
Colgate-Palmolive

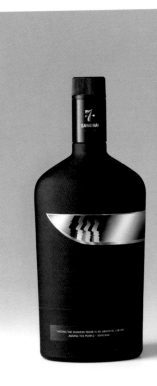

CREATIVE FIRM
Philippe Becker Design
San Francisco (California), USA
CREATIVES
Philippe Becker, Scott Sawyer
CLIENT
Buddy Rhodes Studio

CREATIVE FIRM
Lewis Moberly
London, England
CREATIVES
Mary Lewis, Wesley Anson
CLIENT
Mercury

160

CREATIVE FIRM
Alternatives
New York (New York), USA
CREATIVES
Barbara-Kimball-Walker,
Julie Koch-Beinke
CLIENT
Kiss My Face

CREATIVE FIRM
Cornerstone
New York (New York), USA
CREATIVES
Sally Clarke, Martin Yeo
CLIENT
Ambev-Brazil

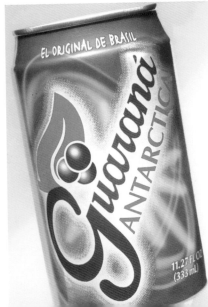

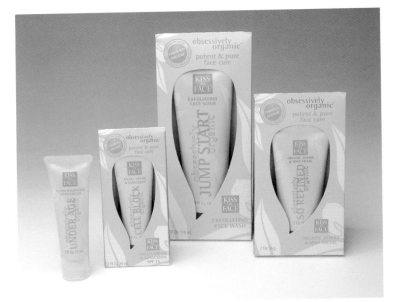

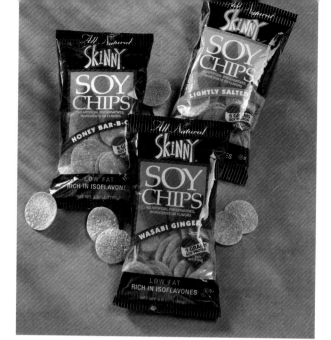

CREATIVE FIRM
Whitney Stinger, Inc.
St. Louis (Missouri), USA
CREATIVES
Mike Whitney, Karl Stinger
CLIENT
nSpired Natural Foods

CREATIVE FIRM
Philippe Becker Design
San Francisco (California), USA
CREATIVES
Philippe Becker
CLIENT
Crabapple Vineyards

161

CREATIVE FIRM
Pearlfisher
London, England
CREATIVES
Sarah Butler, Darren Foley
CLIENT
Michael Van Clarke

CREATIVE FIRM
Corporate Design & Vsability
Rochester (New York), USA
CREATIVES
Michelle Demeyer, Tim McCann,
Steve Kelly
CLIENT
Kodak Professional

CREATIVE FIRM
Moby Dick Warszawa
Warsaw, Poland
CREATIVES
Malgorzata Ciepielak,
Anna Bal
CLIENT
Perla Browary Lubelskie SA

CREATIVE FIRM
H. Montgomery Strategic Design, Inc.
S. Norwalk (Connecticut), USA
CREATIVES
Jenna Goguen, Lucy Raia
CLIENT
Snapple Beverage Group

CREATIVE FIRM
Cornerstone
New York (New York), USA
CREATIVES
Keith Steimel, Sally Clarke,
Martin Yeo, David O'Neil
CLIENT
Coca-Cola

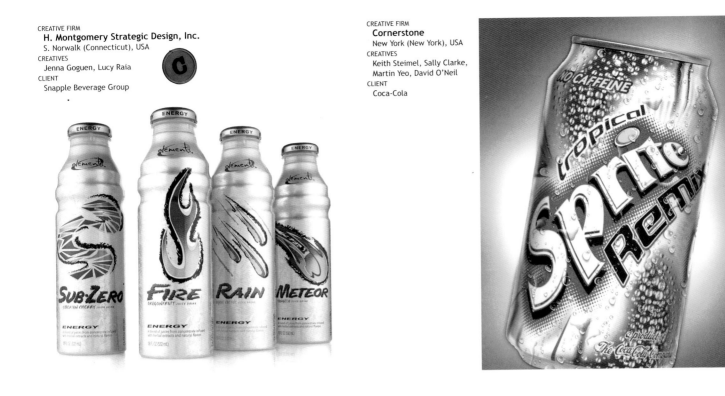

162

CREATIVE FIRM
Pearlfisher
London, England
CREATIVES
Karen Welman, Darren Foley
CLIENT
The Purbeck Chocolate Co.

CREATIVE FIRM
Sterling Group
New York (New York), USA
CREATIVES
Marcus Hewitt, Paula Patricola
CLIENT
Unilever PLC

CREATIVE FIRM
Blackburn's LTD
London, England
CREATIVES
John Blackburn,
Matt Thompson,
CLIENT
PLB Group

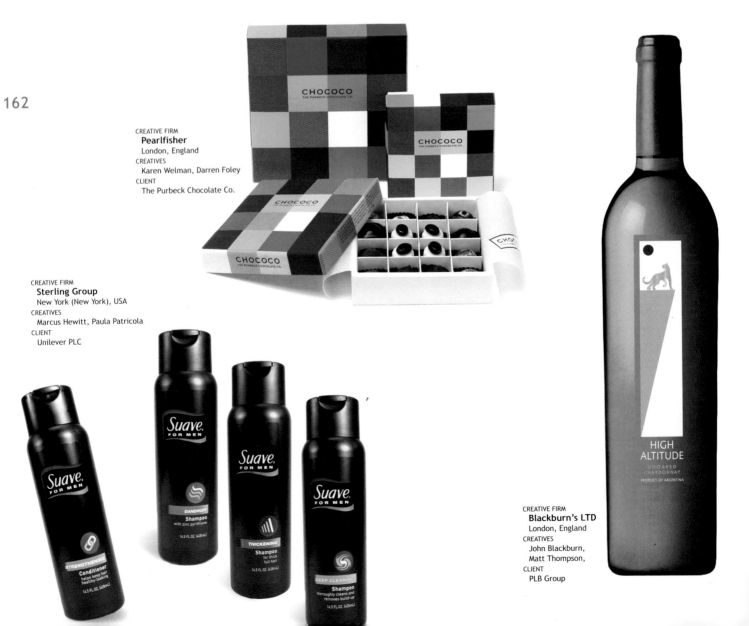

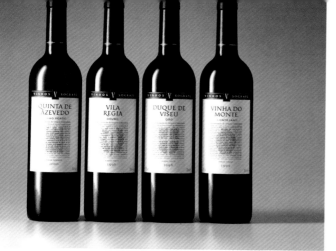

CREATIVE FIRM
Lewis Moberly
London, England
CREATIVES
Mary Lewis, Ann Marshall
CLIENT
Vinhos Sogrape

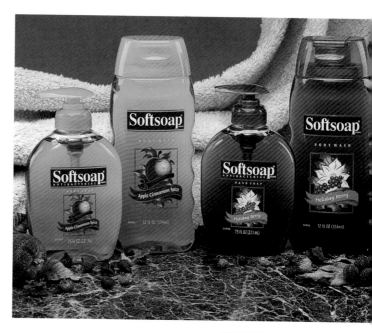

CREATIVE FIRM
**Colgate-Palmolive
In-House Design Studio**
New York (New York), USA
CREATIVES
Sabrina Black, Marjorie Wood,
Nancy Pearson, Gyeong Lee,
Robin Wallace
CLIENT
Colgate-Palmolive

CREATIVE FIRM
Karacters Design Group
Vancouver (British Columbia), Canada
CREATIVES
Maria Kennedy, Matthew Clark
CLIENT
Clearly Canadian Beverage Corp.

163

CREATIVE FIRM
Michael Orr + Associates, Inc.
Corning (New York), USA
CREATIVES
Michael R. Orr, Thomas Freeland
CLIENT
Robinson Knife Company

CREATIVE FIRM
Philippe Becker Design
San Francisco (California), USA
CREATIVES
Philippe Becker
CLIENT
Whole Foods Market

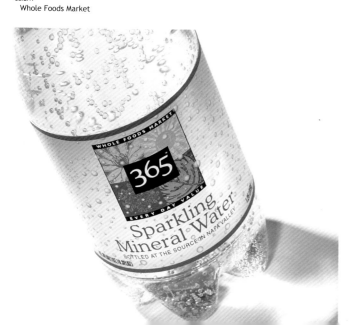

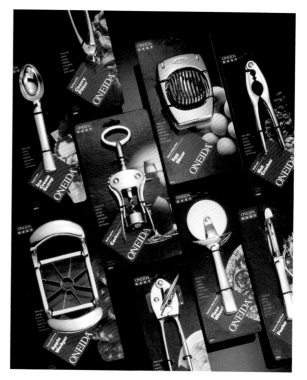

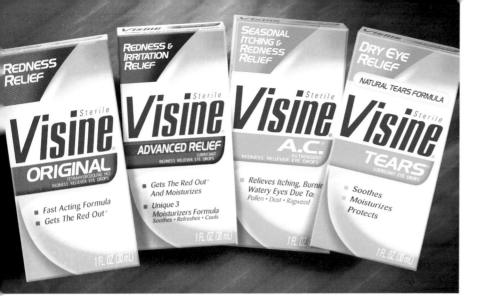

CREATIVE FIRM
Cornerstone
New York (New York), USA
CREATIVES
Keith Steimel, Martin Yeo
CLIENT
Pfizer

CREATIVE FIRM
Philippe Becker Design
San Francisco (California), USA
CREATIVES
Philippe Becker
CLIENT
Frantoio

164

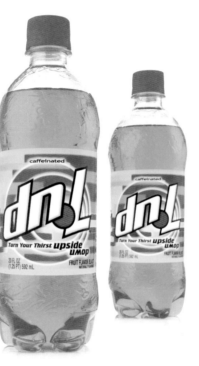

CREATIVE FIRM
H. Montgomery Strategic Design, Inc.
S. Norwalk (Connecticut), USA
CREATIVES
Inga Ekgaus
CLIENT
Cadbury Schweppes

CREATIVE FIRM
Lewis Moberly
London, England
CREATIVES
Bryan Clark, Sarah Cruz
CLIENT
Cafedirect Ltd

CREATIVE FIRM
Erbe Design
South Pasadena (California), USA
CREATIVES
Maureen Erbe, Rita Sowins
CLIENT
Altman Plants

CREATIVE FIRM
Lime Design
New York (New York), USA
CREATIVES
Jean Nordlane, John Harwood,
Bob Santomarco, Fisher Design
CLIENT
Colgate-Palmolive

CREATIVE FIRM
Stormhouse Partners
New York (New York), USA
CREATIVES
Rodney Durso, R. Berger
CLIENT
Elenis New York

CREATIVE FIRM
Sterling Group
New York (New York), USA
CREATIVES
Marcus Hewitt, Simm Lince
CLIENT
Hoegaarden

165

CREATIVE FIRM
Philippe Becker Design
San Francisco (California), USA
CREATIVES
Coco Yan Qiu, Philippe Becker
CLIENT
Whole Foods Market

CREATIVE FIRM
Deutsch Design Works
San Francisco (California), USA
CREATIVES
Barry Deutsch, Jess Giambroni,
Lori Wynn, Mike Kunisaki
CLIENT
Infinite Spirits

CREATIVE FIRM
Pearlfisher
London, England
CREATIVES
Sarah Butler, Claire Franklin
CLIENT
Fima Portugal

CREATIVE FIRM
Design North, Inc.
Racine (Wisconsin), USA
CREATIVES
Pat Cowan, Art Grebetz,
Allan Knox
CLIENT
Palermo's

CREATIVE FIRM
Addax Design (Canada)
Richmond Hill (Ontario), Canada
CREATIVES
Elena Kraynov
CLIENT
Tasty Cheese Inc.
(Cheesecake to Go)

166

CREATIVE FIRM
Goldforest
Miami (Florida), USA
CREATIVES
Lauren Gold, Michael Gold,
Carolyn Redi, Roger Xavier,
Jim Roldan, Steven Noble,
Ray Garcia
CLIENT
Nino Salvaggio International Marketplace

CREATIVE FIRM
S² design Group
New York (New York), USA
CREATIVES
Eileen Strauss, Sabrina Black, Nancy Pearson,
Tom Montini, Paul Bochko
CLIENT
Colgate-Palmolive

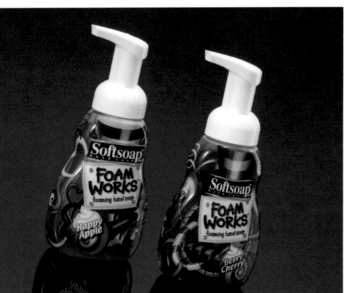

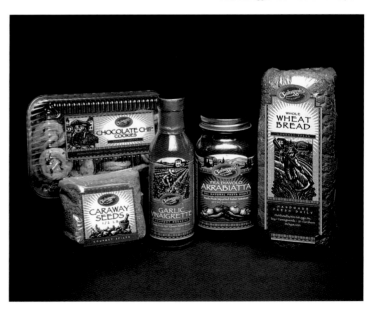

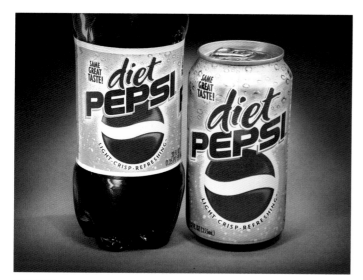

CREATIVE FIRM
Deutsch Design Works
San Francisco (California), USA
CREATIVES
Barry Deutsch, Eric Pino,
Pepsi-Cola Design Group
CLIENT
Pepsi-Cola

CREATIVE FIRM
Colgate-Palmolive
In-House Design Studio
New York (New York), USA
CREATIVES
Veronica Gagliardi, Marjorie Wood,
Elaine Casey, Gyeong Lee, Robin Wallace,
Janet Cunniffe-Chieffo, Tom Montini,
Raphael Bostic
CLIENT
Colgate-Palmolive

167

CREATIVE FIRM
Pearlfisher
London, England
CREATIVES
Shaun Bowen, Lisa Simpson,
Eva Dieker, Darren Foley
CLIENT
The Absolut Company

CREATIVE FIRM
RGB Graphic Design
Rio Janeiro, Brazil
CREATIVES
Maria Luiza Goncalves Veiga Brito
CLIENT
De Millus ind. E com. S.A.

CREATIVE FIRM
TD2, S.C.
Mexico City, Mexico
CREATIVES
Alejandra Urbina, Edgar Medina,
Javier Sánchez
CLIENT
UDV

CREATIVE FIRM
TD2, S.C.
Mexico City, Mexico
CREATIVES
Rafael Treviño, Rafael Rodrigo Cordova,
Gabriel Martinez M.
CLIENT
Nestle

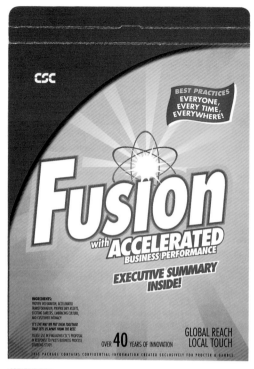

CREATIVE FIRM
**CSC/P2 Communications
Services**
Falls Church (Virginia), USA
CREATIVES
Francois Fontaine, Bryn Farrar,
Bill Baldiga

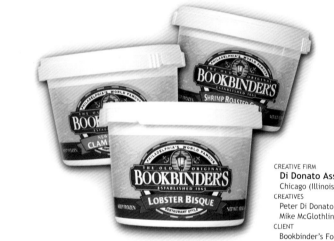

168

CREATIVE FIRM
Di Donato Associates
Chicago (Illinois), USA
CREATIVES
Peter Di Donato,
Mike McGlothlin, Doug Miller
CLIENT
Bookbinder's Food Products

CREATIVE FIRM
PrimoAngeli:Fitch
San Francisco (California), USA
CREATIVES
Richard Scheve, Peter Matsukawa,
Kelson Mau, Kate Buddenbaum
CLIENT
Reckitt Benckiser

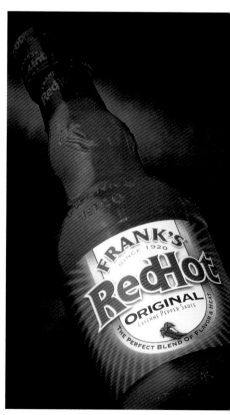

CREATIVE FIRM
Hornall Anderson Design Works, Inc.
Seattle (Washington), USA
CREATIVES
Jack Anderson, Larry Anderson, Jay Hilburn,
Elmer dela Cruz, Don Stayner, Bruce Stigler,
Dorothee Soechting
CLIENT
Widmer Brothers

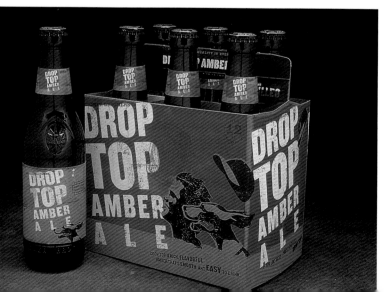

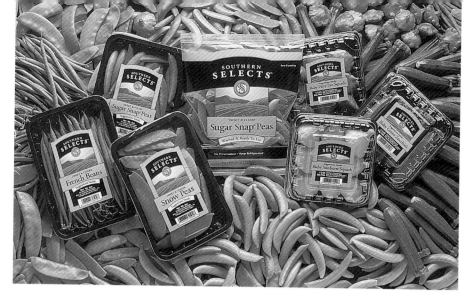

CREATIVE FIRM
Cave Images, Inc.
Boca Raton (Florida), USA
CREATIVES
David Edmundson, Matt Cave
CLIENT
Southern Selects

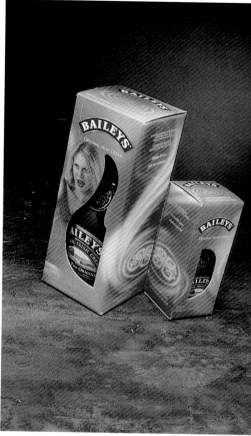

CREATIVE FIRM
Sterling Group
New York (New York), USA
CREATIVES
Marcus Hewitt,
Stephanie Godkin
CLIENT
Origins

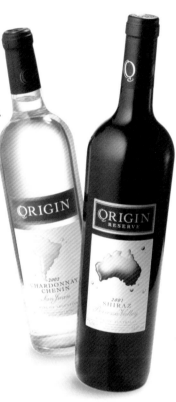

CREATIVE FIRM
TD2, S.C.
Mexico City, Mexico
CREATIVES
Rafael Treviño,
Rafael Rodrigo Cordova
CLIENT
Nestle

169

CREATIVE FIRM
Hornall Anderson Design Works, Inc.
Seattle (Washington), USA
CREATIVES
Debra McCloskey, Steffanie Lorig,
Andrew Wicklund, Beckon Wyld
CLIENT
Nordstrom

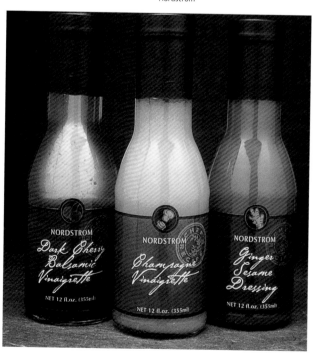

CREATIVE FIRM
RGB Graphic Design
Rio Janeiro, Brazil
CREATIVES
Maria Luiza Goncalves Veiga Brito
CLIENT
De Millus ind. E com. S.A.

CREATIVE FIRM
Lime Design
New York (New York), USA
CREATIVES
Jean Nordlano, Julianne Brown,
Bob Santomarco, Fisher Design
CLIENT
Colgate-Palmolive

CREATIVE FIRM
Zunda Design Group
South Norwalk (Connecticut), USA
CREATIVES
Charles Zunda, Todd Nickel
CLIENT
Boehringer Ingelhiem

CREATIVE FIRM
Zunda Design Group
South Norwalk (Connecticut), USA
CREATIVES
Charles Zunda, Mark Isenhard,
Todd Nickel
CLIENT
Hill's Pet Nutrition, Inc.

170

CREATIVE FIRM
Brian J. Ganton & Associates
Cedar Grove (New Jersey), USA
CREATIVES
Christopher Ganton,
Brian Ganton, Jr.,
Pat Palmieri
CLIENT
U.S. Cigar Sales, Inc.

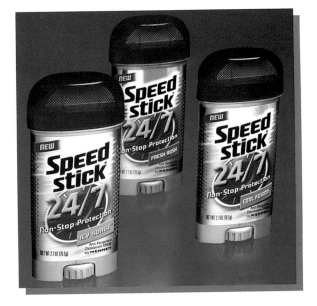

CREATIVE FIRM
S² Design Group
New York (New York), USA
CREATIVES
Eileen Strauss
CLIENT
Colgate-Palmolive

CREATIVE FIRM
Watts Design
South Melbourne, Australia
CREATIVES
Peter Watts, Alex Supurmus,
Helen Watts
CLIENT
Zed Snack Foods

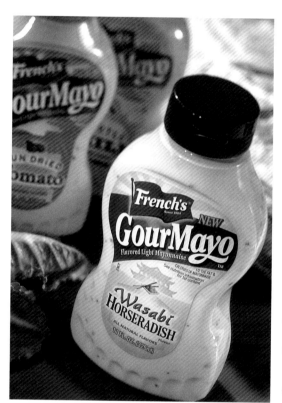

CREATIVE FIRM
Hughes Design Group
Norwalk (Connecticut), USA
CREATIVES
Hughes Design Staff
CLIENT
Jaret International

171

CREATIVE FIRM
PrimoAngeli:Fitch
San Francisco (California), USA
CREATIVES
Lynn Ritts, Kelson Mau,
Toby Sudduth, Kate Buddenbaum,
Robert Evans, Kelson Mau
CLIENT
Reckitt Benckiser

CREATIVE FIRM
Dunn and Rice Design, Inc.
Rochester (New York), USA
CREATIVES
John Dunn, Darlene Kocher
CLIENT
Milton Bradley/Hasbro

CREATIVE FIRM
Laura Coe Design Assoc.
San Diego (California), USA
CREATIVES
Tracy Castle,
Laura Coe Wright
CLIENT
Prima Pharm

CREATIVE FIRM
Szylinski Associates, Inc.
New York (New York), USA
CREATIVES
Ed Szylinski
CLIENT
Bayer Healthcare, LLC

CREATIVE FIRM
Allen Bell Solutions
Agoura Hills (California), USA
CREATIVES
Allen Weideman, Bruce Bell
CLIENT
Hydrovera LLC.

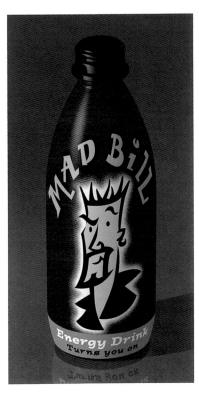

CREATIVE FIRM
Sabingrafik, Inc.
Carlsbad (California), USA
CREATIVES
Karim Amiryani, Tracy Sabin
CLIENT
TamanSari Beverage

172

CREATIVE FIRM
Mark Oliver, Inc.
Solvang (California), USA
CREATIVES
Mark Oliver, Allicen Jacqua
CLIENT
Shima Corporation

CREATIVE FIRM
Hornall Anderson Design Works, Inc.
Seattle (Washington), USA
CREATIVES
Jack Anderson, Julie Lock,
Jana Wilson Esser
CLIENT
Okamoto Corporation

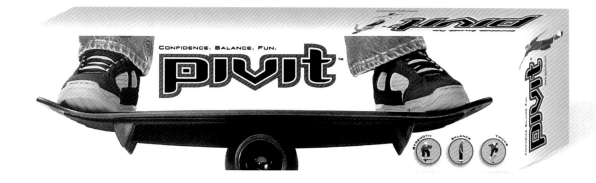

CREATIVE FIRM
Jensen Design Associates
Long Beach (California), USA
CREATIVES
David Jensen, Jerome Calleja,
Joel Penos
CLIENT
Pivit

CREATIVE FIRM
**Logos Identity
By Design Ltd.**
Toronto (Ontario),
Canada
CREATIVES
Brian Smith,
Franca DiNardo,
Anna Volpentesta
CLIENT
Parmalat Canada

173

CREATIVE FIRM
Hughes Design Group
Norwalk (Connecticut), USA
CREATIVES
Hughes Design Staff
CLIENT
Castrol N.A. Automotive

CREATIVE FIRM
Mark Oliver, Inc.
Solvang (California), USA
CREATIVES
Mark Oliver, Patty Driskel,
Debra Denker
CLIENT
Organic Milling

CREATIVE FIRM
**McElveney & Palozzi
Design Group, Inc.**
Rochester (New York), USA
CREATIVES
Steve Palozzi, Chad Pattison
CLIENT
Nalge Nunc International

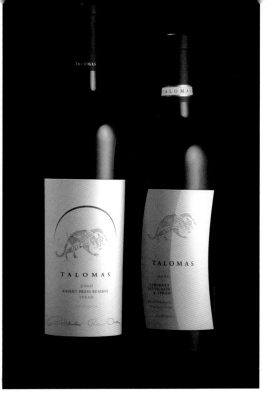

CREATIVE FIRM
Philippe Becker Design
San Francisco (California), USA
CREATIVES
Philippe Becker, Wil Nelson,
Brody Hartman
CLIENT
Stremick's Heritage Foods

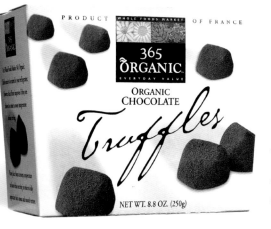

CREATIVE FIRM
Deutsch Design Works
San Francisco (California), USA
CREATIVES
Barry Deutsch, Jess Giambroni,
Lori Wynn, Lorraine Tuson
CLIENT
Robert Mondavi Winery

174

CREATIVE FIRM
Philippe Becker Design
San Francisco (California), USA
CREATIVES
Philippe Becker
CLIENT
Whole Foods Market

CREATIVE FIRM
**Kan & Lau Design
Consultants**
Hong Kong, China
CREATIVES
Freeman Lau, Sin Hong,
Karen Li
CLIENT
Watson's Water

CREATIVE FIRM
Tom Fowler, Inc.
Norwalk (Connecticut), USA
CREATIVES
Mary Ellen Butkus, Brien O'Reilly
CLIENT
Honyewell Consumer
Products Group/Prestone

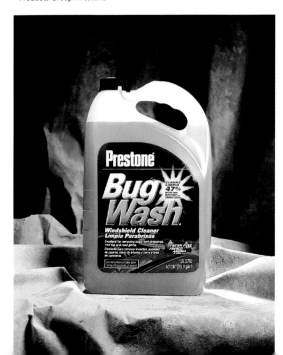

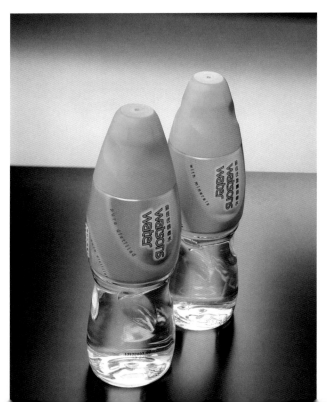

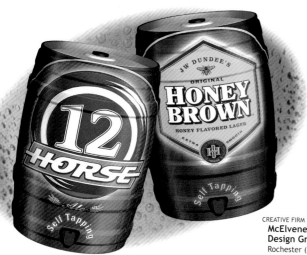

CREATIVE FIRM
**McElveney & Palozzi
Design Group, Inc.**
Rochester (New York), USA
CREATIVES
Steve Palozzi, Paul Reisinger
CLIENT
High Falls Brewery

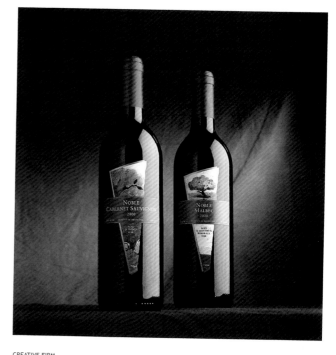

CREATIVE FIRM
Graphicat Limited
Hong Kong, China
CREATIVES
Colin Tillyer
CLIENT
Noble Group Limited

175

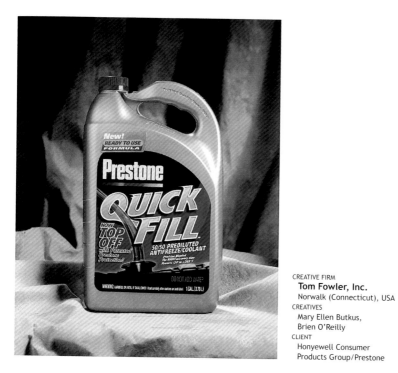

CREATIVE FIRM
Tom Fowler, Inc.
Norwalk (Connecticut), USA
CREATIVES
Mary Ellen Butkus,
Brien O'Reilly
CLIENT
Honeywell Consumer
Products Group/Prestone

CREATIVE FIRM
Triple 888 Studios
Parramatta, Australia
CREATIVES
Alberto Estanislao
CLIENT
Sheldon and Hammond Pty. Ltd.

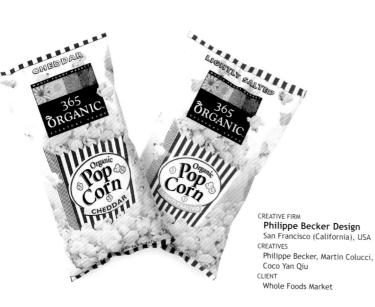

CREATIVE FIRM
Philippe Becker Design
San Francisco (California), USA
CREATIVES
Philippe Becker, Martin Colucci,
Coco Yan Qiu
CLIENT
Whole Foods Market

CREATIVE FIRM
Szylinski Associates, Inc.
New York (New York), USA
CREATIVES
Ed Szylinski
CLIENT
Bayer HealthCare, LLC

CREATIVE FIRM
Lime Design
New York (New York), USA
CREATIVES
Jean Nordland, Julianne Brown,
Bob Santomarco, Fisher Design
CLIENT
Colgate-Palmolive

CREATIVE FIRM
Ukulele Brand Consultants Pte Ltd
Singapore
CREATIVES
Kim Chun-wei, Tee Siew Lin
CLIENT
Yeo Hiap Seng Limited

176

CREATIVE FIRM
Mires
San Diego (California), USA
CREATIVES
Scott Mires, Jennifer Cadam,
Eric LaBrecque, Gerald Bustante
CLIENT
Woods Lithographics

CREATIVE FIRM
Gammon Ragonesi Associates
New York (New York), USA
CREATIVES
J.P. Forbes, Mary Ragonesi
CLIENT
Pet Dairy

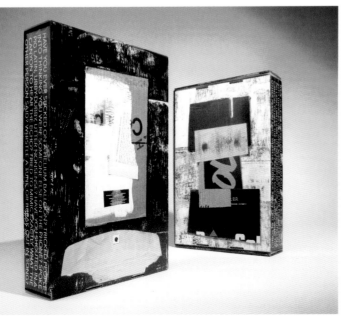

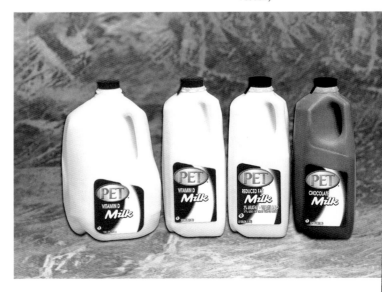

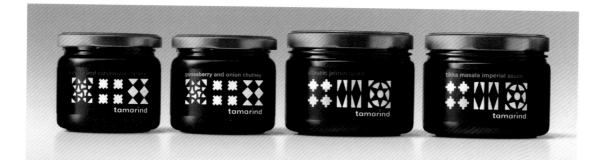

CREATIVE FIRM
Lewis Moberly
London, England
CREATIVES
Mary Lewis
CLIENT
Tamarind

CREATIVE FIRM
Praxis Diseñadores S.C.
Mexico City, Mexico
CREATIVES
Lucia Perez Lira,
Cristina Martinez,
Barbara Kirschner
CLIENT
Procter & Gamble
Latin America

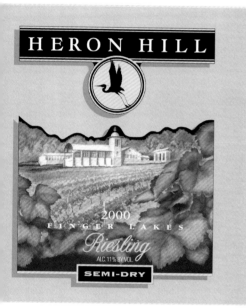

CREATIVE FIRM
**McElveney & Palozzi
Design Group, Inc.**
Rochester (New York), USA
CREATIVES
Steve Palozzi, M&P Design Group
CLIENT
Heron Hill Winery

CREATIVE FIRM
Dunn and Rice Design, Inc.
Rochester (New York), USA
CREATIVES
John Dunn, Clay Girouard
CLIENT
Milton Bradley/Hasbro

CREATIVE FIRM
Colgate-Palmolive In-House Design Studio
New York (New York), USA
CREATIVES
Veronica Gagliordi, Marjorie Wood, Elaine Casey,
CP Design Studio, Raphael Bostic
CLIENT
Colgate-Palmolive

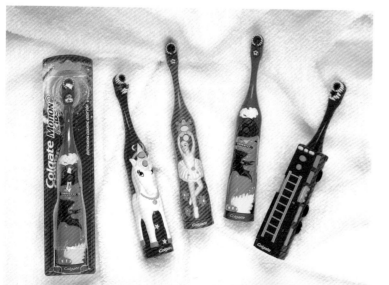

CREATIVE FIRM
Philippe Becker Design
San Francisco, (California), USA
CREATIVES
Philippe Becker, Jay Cabalquinto
CLIENT
Napa Valley Vintners Association

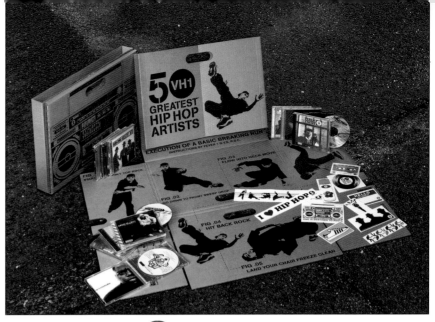

CREATIVE FIRM
VH1 Off Air Creative
New York (New York), USA
CREATIVES
Nigel Cox Hagen, Phil Del Bourgo, Nancy Mazzei,
Julie Ruiz, Traci Terrill, Fever, Christine Howedges
CLIENT
VH1

178

CREATIVE FIRM
**Lōgos Identity By
Design Ltd.**
Toronto (Ontario),
Canada
CREATIVES
Franca DiNardo,
Brian Smith,
Denise Barac,
Teric Lieu
CLIENT
The Great Atlantic &
Pacific Co. of Canada

CREATIVE FIRM
Tom Fowler, Inc.
Norwalk (Connecticut), USA
CREATIVES
Mary Ellen Butkus, Brien O'Reilly
CLIENT
Honyewell Consumer Products Group/Prestone

CREATIVE FIRM
Sabingrafik, Inc.
Carlsbad (California), USA
CREATIVES
Paul Friedman, Tracy Sabin
CLIENT
Adra Soaps

CREATIVE FIRM
The Thompson Design Group
San Francisco (California), USA
CREATIVES
Dennis Thompson, Patrick Fraser,
Dennis Mosner
CLIENT
Nestlé Purina PetCare Company

CREATIVE FIRM
Hornall Anderson Design Works, Inc.
Seattle (Washington), USA
CREATIVES
Jana Nishi, Henry Yiu
CLIENT
Sticky Fingers Bakery

CREATIVE FIRM
Cahan & Associates
San Francisco (California), USA
CREATIVES
Bill Cahan,
Michael Braley,
Todd Simmons
CLIENT
jstar Brands

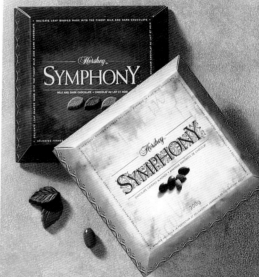

CREATIVE FIRM
Logos Identity By Design Ltd.
Toronto (Ontario), Canada
CREATIVES
Franca DiNardo, Brian Smith,
Anna Volpentesta, Kris Wei
CLIENT
Hershey Canada Inc.

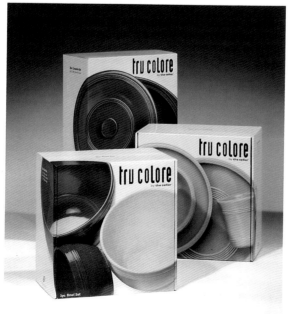

CREATIVE FIRM
**Federated Marketing Services
(In-House)**
New York (New York), USA
CREATIVES
Elizabeth Prinz, Anthony Ranieri
CLIENT
Federated Merchandising Group
(A division of Federated Department Stores)

CREATIVE FIRM
Haase & Knels, Atelier für Gestaltung
Bremen, Germany
CREATIVES
Sibylle Haase, Prof. Fritz Haase, Judith Heinemann
CLIENT
Stanwell Vertriebs-Gesellschaft mbH

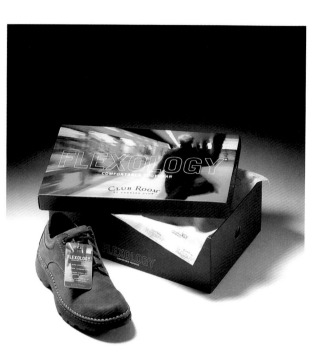

CREATIVE FIRM
Federated Marketing Services (In-House)
New York (New York), USA
CREATIVES
Vicky Wan
CLIENT
Federated Merchandising Group (A division of Federated Department Stores)

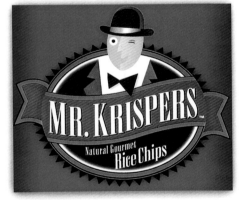

180

CREATIVE FIRM
Teamwork Design Limited
Hong Kong, China
CREATIVES
Gary Tam, Hong Chi Kit
CLIENT
Le Sommet

CREATIVE FIRM
Di Donato Associates
Chicago (Illinois), USA
CREATIVES
Peter Di Donato, Doug Miller
CLIENT
Terra Harvest Foods, Inc.

CREATIVE FIRM
Praxis Diseñadores S.C.
Mexico City, Mexico
CREATIVES
Florencia Gutierrez, Victor Hernandez, Janet Wolpert
CLIENT
Procter & Gamble Mexico

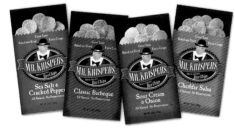

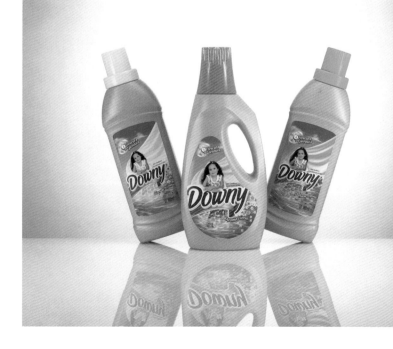

CREATIVE FIRM
Creaxis Design Pte Ltd
Singapore
CREATIVES
Yang Qiao'e
CLIENT
Canon Singapore Pte Ltd

CREATIVE FIRM
Smith Design Associates
Glen Ridge (New Jersey), USA
CREATIVES
Eileen Berezni, James C. Smith
CLIENT
Saputo Cheese USA

CREATIVE FIRM
Zunda Design Group
South Norwalk (Connecticut), USA
CREATIVES
Charles Zunda, Todd Nickel
CLIENT
Pinnacle Foods

181

CREATIVE FIRM
The Thompson Design Group
San Francisco (California), USA
CREATIVES
Dennis Thompson, Felicia Utomo
CLIENT
Freemark Abbey

CREATIVE FIRM
Joe Cuticone Design & S² Design Group
New York (New York), USA
CREATIVES
Veronica Gagliard, Mark Connelly,
Pat McDarby, Phil Venticinque,
Eileen Strauss
CLIENT
Colgate-Palmolive

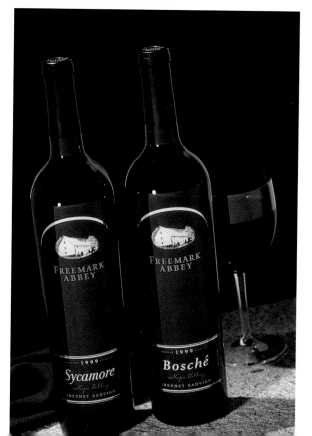

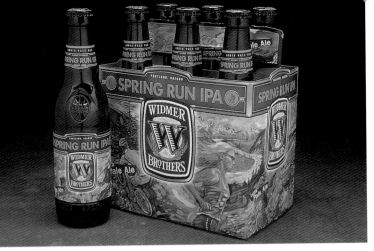

CREATIVE FIRM
Gammon Ragonesi Associates
New York (New York), USA
CREATIVES
Jill Schellhorn, Mary Ragonesi,
Alison Marston
CLIENT
Nestlé Ice Cream Company

CREATIVE FIRM
Hornall Anderson Design Works, Inc.
Seattle (Washington), USA
CREATIVES
Jack Anderson, Larry Anderson, Jay Hilburn,
Elmer dela Cruz, Don Stayner, Bruce Stigler,
Dorothee Soechting
CLIENT
Widmer Brothers

CREATIVE FIRM
Mark Oliver, Inc.
Solvang (California), USA
CREATIVES
Mark Oliver, Patty Driskel,
Grace DeVito, Burke/Triolo
CLIENT
Organic Milling

182

CREATIVE FIRM
Logos Identity By Design Ltd.
Toronto (Ontario), Canada
CREATIVES
Franca DiNardo, Brian Smith,
Terry Moss
CLIENT
Hershey Canada Inc.

CREATIVE FIRM
Mark Oliver, Inc.
Solvang (California), USA
CREATIVES
Mark Oliver, Patty Driskel
CLIENT
Organic Milling

CREATIVE FIRM
RGB Graphic Design
Rio Janeiro, Brazil
CREATIVES
Maria Luiza Goncalves Veiga Brito
CLIENT
DeMillus ind. E com. S.A.

CREATIVE FIRM
Smith Design Associates
Glen Ridge (New Jersey), USA
CREATIVES
Laura Markley, James C. Smith,
Martha Gelber, Angel Sauto
CLIENT
Arla Foods

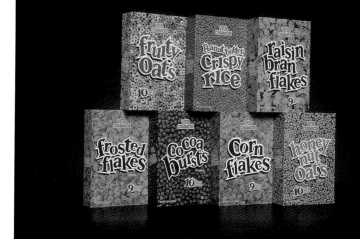

CREATIVE FIRM
Mark Oliver, Inc.
Solvang (California), USA
CREATIVES
Mark Oliver, Eric Gordon
CLIENT
Organic Milling

CREATIVE FIRM
Gammon Ragonesi Associates
New York (New York), USA
CREATIVES
Mary Ragonesi, Jill Schellhorn
CLIENT
Beer Nuts

183

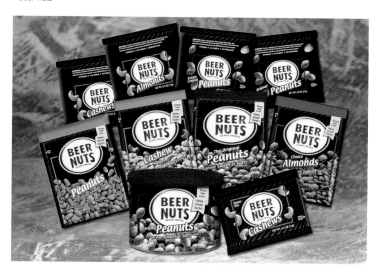

CREATIVE FIRM
Hornall Anderson Design Works, Inc.
Seattle (Washington), USA
CREATIVES
Jack Anderson, Andrew Wicklund, Henry Yiu,
Andrew Smith, Bruce Branson-Meyer
CLIENT
PMI

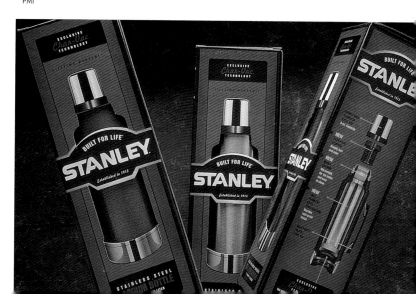

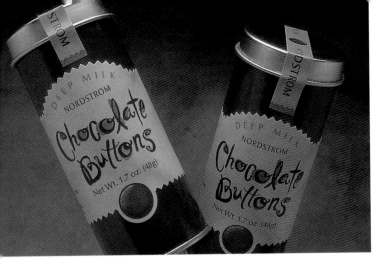

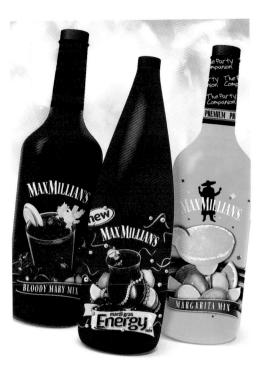

CREATIVE FIRM
Hornall Anderson Design Works, Inc.
Seattle (Washington), USA
CREATIVES
Debra McCloskey, Steffanie Lorig,
Beckon Wyld
CLIENT
Nordstrom

CREATIVE FIRM
Smith Design Associates
Glen Ridge (New Jersey), USA
CREATIVES
L. Markley, C. Konkowski,
E. Bereznit, Lynn Vaughan,
Angel Sauto, Jon Rosenbaum
CLIENT
Unilever Bestfoods

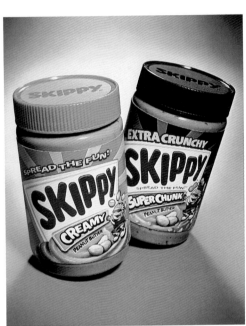

184

CREATIVE FIRM
Zunda Design Group
South Norwalk (Connecticut), USA
CREATIVES
Charles Zunda, Pat Sullivan
CLIENT
MaxMillian's Mixers, LLC

CREATIVE FIRM
Ukulele Brand Consultants Pte Ltd
Singapore
CREATIVES
Kim Chun-wei, Jessica Ang,
Yvonne Lee
CLIENT
Yeo Hiap Seng Limited

CREATIVE FIRM
Alternatives
New York (New York), USA
CREATIVES
Christina Baute, Lynn Marfey,
Julie Koch-Beinke
CLIENT
Sudz

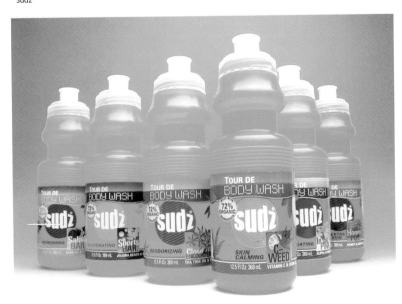

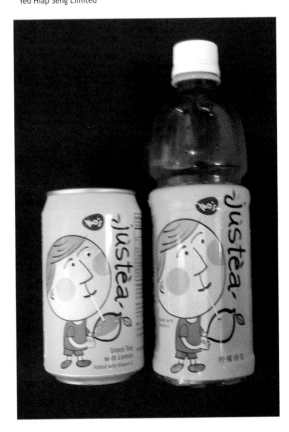

CREATIVE FIRM
Logos Identity By Design.com
Toronto (Ontario), Canada
CREATIVES
Brian Smith, Gabriella Sousa
CLIENT
Hershey Canada Inc.

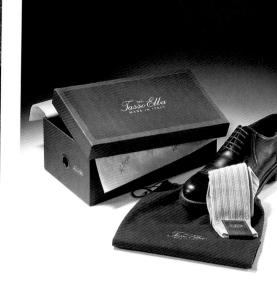

CREATIVE FIRM
**Federated Marketing Services
(In-House)**
New York (New York), USA
CREATIVES
Caryle Cruz
CLIENT
Federated Merchandising Group
(A division of Federated Department Stores)

185

CREATIVE FIRM
**Hornall Anderson
Design Works, Inc.**
Seattle (Washington),
USA
CREATIVES
Jack Anderson,
James Tee,
Gretchen Cook,
Elmer dela Cruz,
Andrew Wicklund
CLIENT
Jack in the Box

CREATIVE FIRM
**Logos Identity By
Design Ltd.**
Toronto (Ontario), Canada
CREATIVES
Brian Smith, Ryan Spencer
CLIENT
Irwin Toys

CREATIVE FIRM
Deutsch Design Works
San Francisco (California), USA
CREATIVES
Barry Deutsch, John Marota,
Eric Pino
CLIENT
Anheuser-Busch

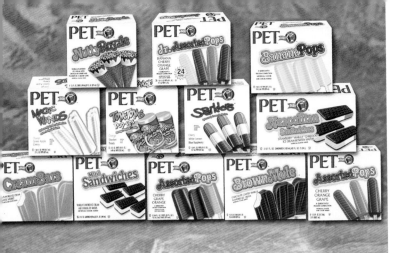

CREATIVE FIRM
Gammon Ragonesi Associates
New York (New York), USA
CREATIVES
Jill Schellhorn, Mary Ragonesi,
Grace Wu
CLIENT
Pet Dairy

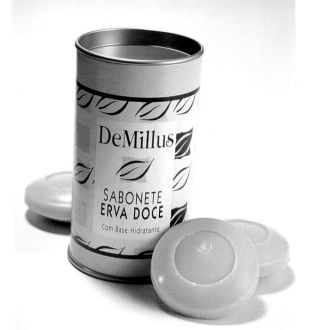

CREATIVE FIRM
RGB Graphic Design
Rio de Janeiro, Brazil
CREATIVES
Maria Luiza Goncalves
Veiga Brito
CLIENT
DeMillus ind E com. S.A.

CREATIVE FIRM
Watts Design
South Melbourne,
Australia
CREATIVES
David Fry, Helen Watts
CLIENT
Pod Organics

CREATIVE FIRM
Gammon Ragonesi Associates
New York (New York), USA
CREATIVES
Jill Schellhorn, Mary Ragonesi
CLIENT
Giant Eagle

CREATIVE FIRM
Shimokochi-Reeves
Beverly Hills (California), USA
CREATIVES
Mamoru Shimokochi
CLIENT
Breeder's Choice Pet Foods Inc.

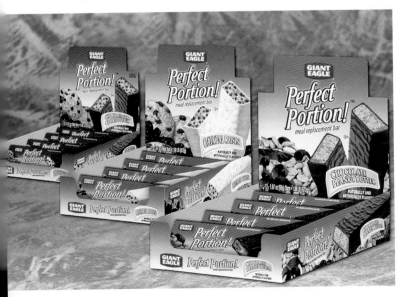

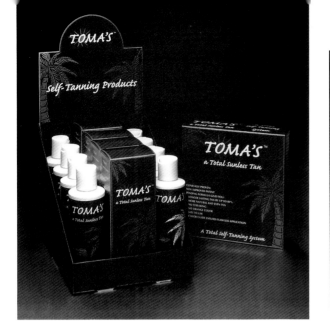

CREATIVE FIRM
Franklin Design Group
Addison (Texas), USA
CREATIVES
Amy Migliore
CLIENT
Tomas LLC

CREATIVE FIRM
Luis R. Lee & Associates
Suffield (Connecticut), USA
CREATIVES
Luis R. Lee, Heather VanLoan,
Mark Gerber, Alan Epstein
CLIENT
Friendly Ice Cream Corporation

CREATIVE FIRM
Yellobee Studio
Atlanta (Georgia), USA
CREATIVES
Alison Scheel
CLIENT
Saralyn's Shortbread

187

CREATIVE FIRM
MTV Networks Creative Services
New York (New York), USA
CREATIVES
Bjorn Ramberg, Nok Acharee,
Scott Wadler, Ken Saji,
Cynara Webb, Cheryl Family
CLIENT
Noggin/The N

CREATIVE FIRM
Zunda Design Group
South Norwalk (Connecticut), USA
CREATIVES
Charles Zunda, Todd Nickel
CLIENT
World Finer Foods, Inc.

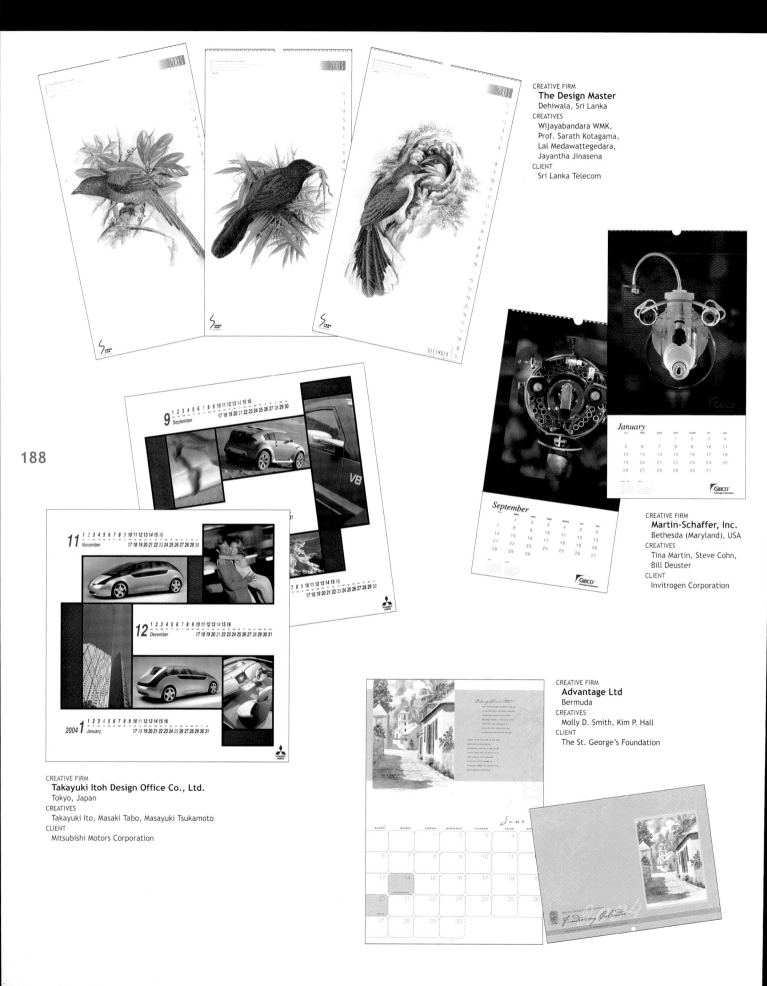

CREATIVE FIRM
The Design Master
Dehiwala, Sri Lanka
CREATIVES
Wijayabandara WMK,
Prof. Sarath Kotagama,
Lal Medawattegedara,
Jayantha Jinasena
CLIENT
Sri Lanka Telecom

CREATIVE FIRM
Martin-Schaffer, Inc.
Bethesda (Maryland), USA
CREATIVES
Tina Martin, Steve Cohn,
Bill Deuster
CLIENT
Invitrogen Corporation

CREATIVE FIRM
Advantage Ltd
Bermuda
CREATIVES
Molly D. Smith, Kim P. Hall
CLIENT
The St. George's Foundation

CREATIVE FIRM
Takayuki Itoh Design Office Co., Ltd.
Tokyo, Japan
CREATIVES
Takayuki Ito, Masaki Tabo, Masayuki Tsukamoto
CLIENT
Mitsubishi Motors Corporation

188

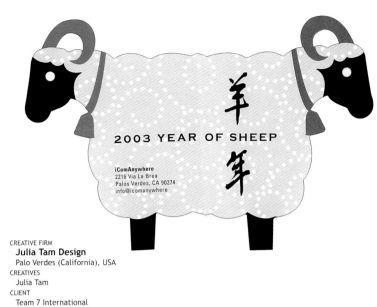

2003 YEAR OF SHEEP

羊年

iComAnywhere
2216 Via La Brea
Palos Verdes, CA 90274
info@icomanywhere

CREATIVE FIRM
Julia Tam Design
Palo Verdes (California), USA
CREATIVES
Julia Tam
CLIENT
Team 7 International

CREATIVE FIRM
The Star Group
Cherry Hill (New Jersey), USA
CREATIVES
Jan Talamo, Dave Girgenti,
Zave Smith
CLIENT
David Michael Flavors

1-800-DM-FLAVORS www.DMFlavors.com

Sure, we can do that.

CREATIVE FIRM
BBK Studio
Grand Rapids
(Michigan), USA
CREATIVES
Yang Kim,
Michele Chartier,
Bob Neumann,
Julie Ridl,
Jason Kalajainen,
Elizabeth Ebihara
CLIENT
Holland Area
Arts Council

189

FEBRUARY

CREATIVE FIRM
QCCG
San Diego (California), USA
CREATIVES
Christopher Lee, Grant Kroeger,
Steve Lim, Frank Bernas,
Dave Korinek
CLIENT
QCCG

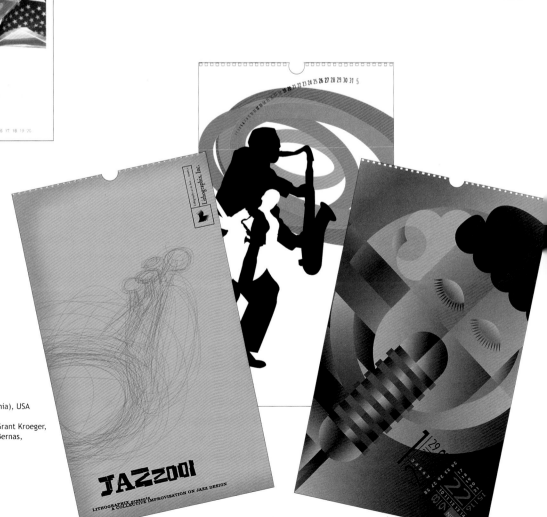

JAZZ001
LITHOGRAPHIX PRESENTS
A COLLECTIVE IMPROVISATION ON JAZZ DESIGN

Animal trainer

| JANUARY |
|1|2|3|4|5|6|7|8|9|10|11|12|13|14|15|16|17|18|19|20|21|22|23|24|25|26|

| FEBRUARY |
|1|2|3|4|5|6|7|8|9|10|11|12|13|14|15|16|17|18|19|20|21|22|23|24|25|26|27|

CREATIVE FIRM
Leo Burnett
Rome, Italy
CLIENT
Studio Universal Italy

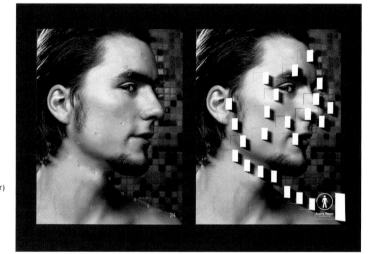

CREATIVE FIRM
Scanad
Denmark
CREATIVES
Henry Rasmussen,
Per Klixbüll,
Kim Michael
CLIENT
Mens Room
(men's beauty parlour)

190

CREATIVE FIRM
Tangram Strategic Design
Novara, Italy
CREATIVES
Enrico Sempi, Andrea Sempi,
Anna Grimaldi
CLIENT
Tangram Strategic Design/A.De Pedrini
Tipolitografia Cugini Pagani

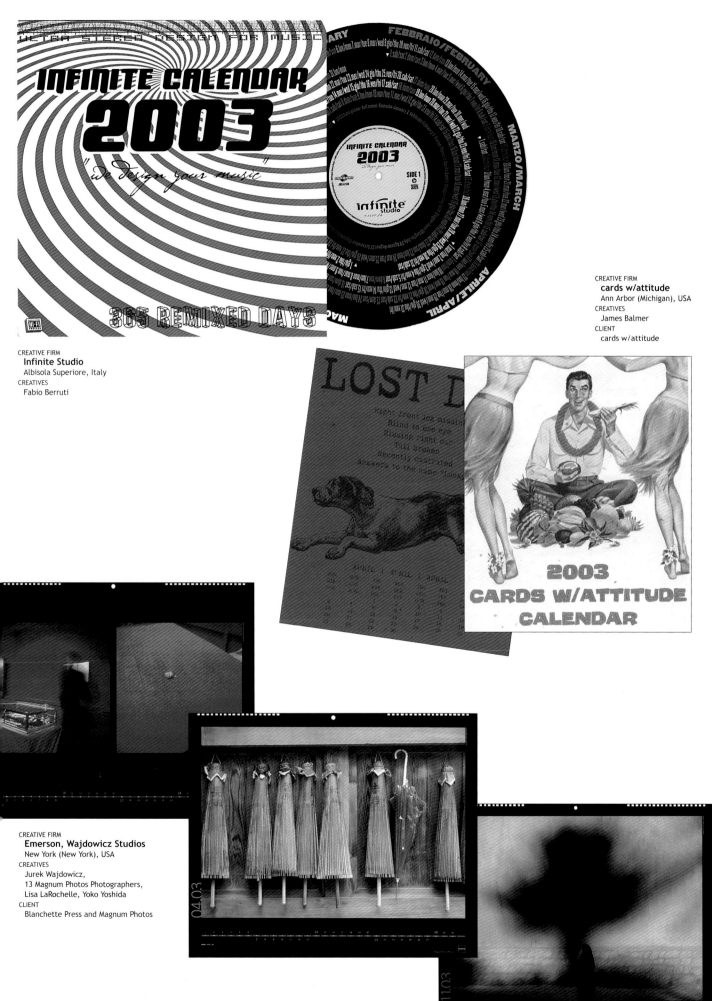

INFINITE CALENDAR 2003
"we design your music"
365 REMIXED DAYS

INFINITE CALENDAR 2003
SIDE 1

CREATIVE FIRM
Infinite Studio
Albisola Superiore, Italy
CREATIVES
Fabio Berruti

CREATIVE FIRM
cards w/attitude
Ann Arbor (Michigan), USA
CREATIVES
James Balmer
CLIENT
cards w/attitude

2003
CARDS W/ATTITUDE
CALENDAR

191

CREATIVE FIRM
Emerson, Wajdowicz Studios
New York (New York), USA
CREATIVES
Jurek Wajdowicz,
13 Magnum Photos Photographers,
Lisa LaRochelle, Yoko Yoshida
CLIENT
Blanchette Press and Magnum Photos

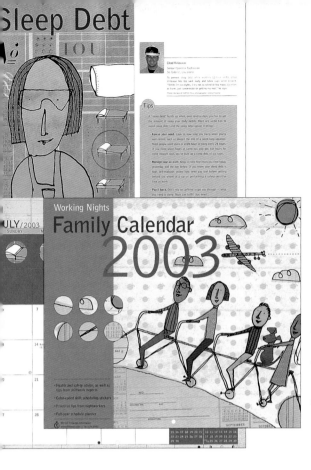

Sleep Debt

IOU

Working Nights
Family Calendar
2003

- Health and safety advice, as well as tips from shiftwork experts
- Color-coded shift scheduling stickers
- Practical tips for nightworkers
- Full-year schedule planner

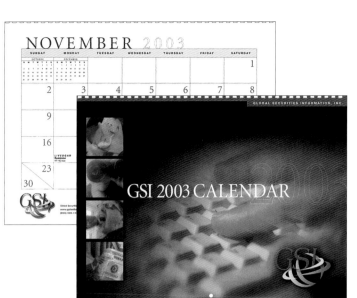

NOVEMBER 2003

SUNDAY	MONDAY	TUESDAY	WEDNESDAY	THURSDAY	FRIDAY	SATURDAY
						1
2	3	4	5	6	7	8
9						
16						
23						
30						

GSI 2003 CALENDAR

GLOBAL SECURITIES INFORMATION, INC.

CREATIVE FIRM
Hull Creative Group
 Boston (Massachusetts), USA
CREATIVES
 Youn Park,
 Carolyn Colonna,
 Caryl Hull
CLIENT
 Circadian Technologies

CREATIVE FIRM
Don Schaaf & Friends, Inc.
 Washington (D.C.), USA
CREATIVES
 Don Schaaf, David Kammerdeiner,
 Jane Burkhalter
CLIENT
 GSI

CREATIVE FIRM
Armando Testa
 Torino, Italy
CREATIVES
 Guido Avigdor,
 Andrea Lantelme,
 Teresa Gennuso,
 Jean-Baptiste Mondino
CLIENT
 Lavazza
 "Expresso and Glamour"

192

CREATIVE FIRM
Rule29
 Elgin (Illinois), USA
CREATIVES
 Justin Ahrens, Jim Bobovci,
 Jon McGrath, Elecia Gilstrap,
 Brian MacDonald
CLIENT
 Rule29, O'Neil Printing,
 MacDonald Photography

COFFEE

THE ANNUAL
MAGAZINE
THAT SPEAKS
FOR ESPRESSO
AND GLAMOUR

PHOTOS BY
JEAN-BAPTISTE
MONDINO.
LIMITED EDITION,
ISSUED
BY LAVAZZA,
ITALY'S
FAVOURITE COFFEE

CREATIVE FIRM
Jack Nadel, Inc.
Los Angeles (California), USA
CREATIVES
Scott Brown, Tawny Thuy Le
CLIENT
Jack Nadel, Inc.

CREATIVE FIRM
Sudler & Hennessey
North Sydney, Australia
CREATIVES
Peter Ryan,
Nathalie Garcia
CLIENT
Sanofi-Synthelabo

CREATIVE FIRM
Design Club
Tokyo, Japan
CREATIVES
Akihiko Tsukamoto, Frank Viva
CLIENT
Arjo Wiggins Canson KK

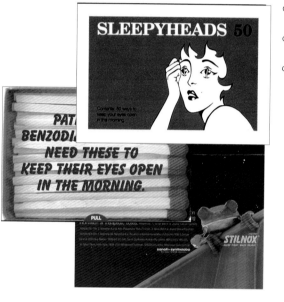

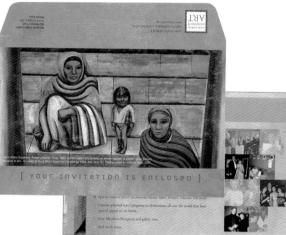

CREATIVE FIRM
Barbara Brown Marketing & Design
Ventura (California), USA
CREATIVES
Barbara Brown, Jon A. Leslie, Holden Color,
RP Printing
CLIENT
SBMA

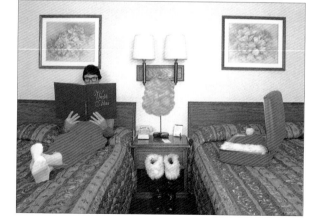

CREATIVE FIRM
Erbe Design
South Pasadena (California), USA
CREATIVES
Maureen Erbe, Henry Blackham
CLIENT
Erbe Design

CREATIVE FIRM
Rodgers Townsend
St. Louis (Missouri), USA
CREATIVES
Erik Mathre, Michelle Vesth,
Tom Hudder
CLIENT
Maritz Inc.

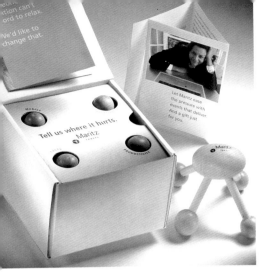

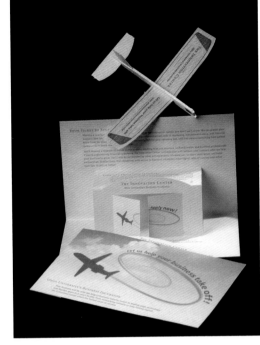

CREATIVE FIRM
Russell-Creative Services
Tacoma (Washington), USA
CREATIVES
Lance Kagey
CLIENT
Russell

CREATIVE FIRM
Rodgers Townsend
St. Louis (Missouri), USA
CREATIVES
Susan Schultz, Dawn Sorgea,
Erik Mathre, Tom Hudder
CLIENT
Maritz Inc.

CREATIVE FIRM
**University Communications
& Marketing**
Athens (Ohio), USA
CREATIVES
Stacey Riley Pugh, Mary C. Dillon,
Sally Linder
CLIENT
The Innovation Center

194

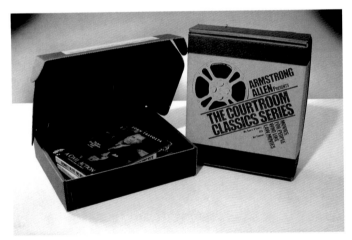

CREATIVE FIRM
Thompson & Company
Memphis (Tennessee), USA
CREATIVES
Andrew Macris,
Phillip Livingston,
Dave Smith
CLIENT
Armstrong Allen

CREATIVE FIRM
Paragraph's Design
Chicago (Illinolis), USA
CREATIVES
Mcow Vatanatumrak,
Bonnie Simon
CLIENT
Unisource

CREATIVE FIRM
WKSP
Ramat Gan, Israel
CREATIVES
Ori Livny, Shuki Berg, Alon Zaid
CLIENT
AMPA

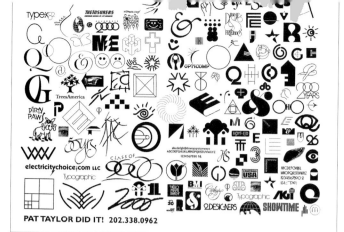

CREATIVE FIRM
Pat Taylor Inc.
Washington (D.C.), USA
CREATIVES
Pat Taylor
CLIENT
Pat Taylor Inc.

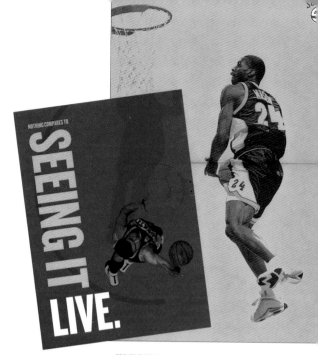

CREATIVE FIRM
Hornall Anderson Design Works, Inc.
Seattle (Washington), USA
CREATIVES
Jack Anderson, Andrew Wicklund,
Mark Popich
CLIENT
Seattle SuperSonics

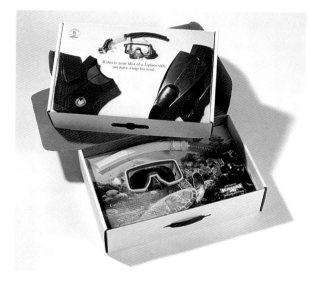

CREATIVE FIRM
Jack Nadel, Inc.
Los Angeles (California),
USA
CREATIVES
Scott Brown,
Tawny Thuy Le
CLIENT
Jack Nadel, Inc.

CREATIVE FIRM
Karacters design group
Vancouver (British Columbia), Canada
CREATIVES
Maria Kennedy, Matthew Clark, Ken Therrien
CLIENT
BC Hydro

CREATIVE FIRM
VH1 Off Air Creative
New York (New York), USA
CREATIVES
Nigel Cox Hagen, Phil Deubargo,
Nancy Mazzei,Shayne Ivy,
Travis Spangler, Vinny Cecouni,
Traci Terril, Shermalee Nichason,
CLIENT
VH1

CREATIVE FIRM
Nolen & Associates, Inc.
Atlanta (Georgia), USA
CREATIVES
Ed Young, David Harrell
CLIENT
Mead Westvaco Coated Board

CREATIVE FIRM
CAG Design
Hackettstown (New Jersey), USA
CREATIVES
Allison Black, Nanci DeDiego,
Laura Dudes
CLIENT
Binney & Smith

CREATIVE FIRM
Rottman Creative Group, LLC
La Plata (Maryland), USA
CREATIVES
Gary Rottman
CLIENT
The Production Center Inc.

CREATIVE FIRM
Randi Wolf Design
Glassboro (New Jersey), USA
CREATIVES
Randi Wolf, Dennis Dougherty
CLIENT
Rowan University

196

CREATIVE FIRM
Kircher, Inc.
Washington (D.C.),
USA
CREATIVES
Bruce E. Morgan,
Rich Gilroy,
Tina Williams
CLIENT
International
Association of
Amusement Parks
and Attractions

The measure of success.

2003 Exchange Privileges
Accommodations Currency Program

FOUR SEASONS
RESIDENCE CLUBS

CREATIVE FIRM
Zeesman Communications, Inc.
Culver City (California), USA
CREATIVES
Katie Mickey, Trish Abbot
CLIENT
Four Seasons Residence Clubs-Aviara

Oh, What a Tangled
Web We Weave
When We Forget to
Dream and Believe

CREATIVE SESSION
IN PROGRESS

CREATIVE FIRM
**American Speech-Language-
Hearing Association**
Rockville (Maryland), USA
CREATIVES
Pamela Leppin, Tarja Carter,
Emerald Ong,
Claudette Quashie,
Brent Jacobs
CLIENT
American Speech-Language-
Hearing Association

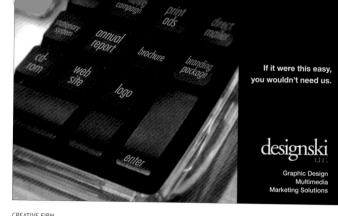

If it were this easy,
you wouldn't need us.

designski
LLC

Graphic Design
Multimedia
Marketing Solutions

CREATIVE FIRM
Designski
Toledo (Ohio), USA
CREATIVES
Denny Kreger, Chris Sniegowski
CLIENT
Designski

You're doing
all the groundwork ...

CREATIVE FIRM
First Marketing
Pompano Beach (Florida), USA
CREATIVES
Kim Ryan, Jeff Carter,
Yamile Chontow, Debbie Harris
CLIENT
Progressive Communications Int'l

take a shower

wash your car

boil some pasta

flush the toilet

What would
you do
without it?

your lawn

fill the ice trays

put out a fire

CREATIVE FIRM
Pool Design Group
Englewood (California), USA
CREATIVES
Jeanna Pool, Penny Banks,
Diane Bowen
CLIENT
Texas Agricultural Extension Service

197

JAUTZ NEGATIVE REINFORCEMENT

CREATIVE FIRM
3i Ltd.
Arlington (Virginia), USA
CREATIVES
Ron Harman, Ron Jautz,
Ron Lucky, Jack Lucky
CLIENT
Ron Jautz Photography

CREATIVE FIRM
Team One Advertising
El Segundo (California), USA
CREATIVES
Laureen Zaccheo, Susanna Leighton,
Gabrielle Mayeur, Bill Day, Ede Schweizer
CLIENT
Lexus

CREATIVE FIRM
Graphics 2 LLC
Scottsdale (Arizona), USA
CREATIVES
Colleen Steinberg
CLIENT
Objects

TECHNOLOGY
THE COMPETITION'S OBSERVATION: THE TECHNOLOGY LEAVES US BEHIND. FAR BEHIND.

CREATIVE FIRM
Levine & Associates
Washington (D.C.), USA
CREATIVES
Lena Markley
CLIENT
Printing & Graphic
Communications Association

CREATIVE FIRM
**Perkins & Will/Eva Maddox
Branded Environments**
Chicago (Illinois), USA
CREATIVES
Eileen Jones, Emily Neville,
Maron Demissie, Ron Stelmarski,
Carly Cannell
CLIENT
DuPont™ Antron®

CREATIVE FIRM
**CA In-House
Creative
Department**
Islandia (New York),
USA
CREATIVES
Loren Moss Meyer,
Franz Edson,
Peter Edson,
Structural Graphics
CLIENT
Computer Associates

198

CREATIVE FIRM
The Ashway Group
Hoboken (New Jersey), USA
CREATIVES
Nader Ashway
CLIENT
BMW of Manhattan

CREATIVE FIRM
Griffith Phillips Creative
Dallas (Texas), USA
CREATIVES
Bo McCord
CLIENT
Verizon

CREATIVE FIRM
Rodgers Townsend
St. Louis (Missouri),
USA
CREATIVES
Susan Schultz,
Martha Koenig,
Erik Mathre,
Tom Hudder
CLIENT
St. Louis Effort
For AIDS

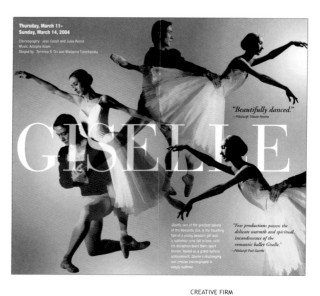

CREATIVE FIRM
Lee Reedy Creative
Denver (Colorado), USA
CREATIVES
Lee Reedy, Kelly Reedy,
Jamie Reedy, Patrick Gill
CLIENT
Frederic Printing

CREATIVE FIRM
Agnew Moyer Smith
Pittsburgh (Pennsylvania), USA
CREATIVES
John Sotirakis, Jack Kelley,
Melissa Neely
CLIENT
Pittsburgh Ballet Theatre

CREATIVE FIRM
Team One Advertising
El Segundo (California), USA
CREATIVES
Sandra Flores,
Susanna Leighton,
Gabrielle Mayeur,
Jon Pearce,
Nikki Shea
CLIENT
Lexus

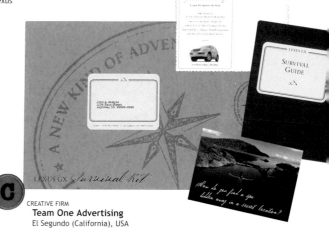

CREATIVE FIRM
The Ashway Group
Hoboken (New Jersey), USA
CREATIVES
Mike Azzarone,
Dorothy Maver,
Nader Ashway,
CLIENT
American Business Media

CREATIVE FIRM
Team One Advertising
El Segundo (California), USA
CREATIVES
Susan Lee, Susanna Leighton,
Gabrielle Mayeur
CLIENT
Lexus

CREATIVE FIRM
Bertz Design Group
Middletown (Connecticut), USA
CREATIVES
Chris Hyde, Ted Bertz
CLIENT
Bertz Design Group

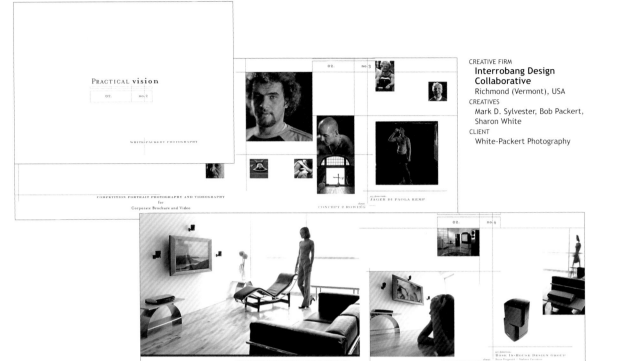

CREATIVE FIRM
Interrobang Design Collaborative
Richmond (Vermont), USA
CREATIVES
Mark D. Sylvester, Bob Packert,
Sharon White
CLIENT
White-Packert Photography

CREATIVE FIRM
Lee Reedy Creative
Denver (Colorado), USA
CREATIVES
Lee Reedy, Kelly Reedy,
Jamie Reedy, Patrick Gill
CLIENT
Frederic Printing

200

CREATIVE FIRM
Jill Tanenbaum Graphic Design & Advertising Inc.
Bethesda (Maryland), USA
CREATIVES
Jill Tanenbaum, Sue Sprinkle
CLIENT
Johns Hopkins University

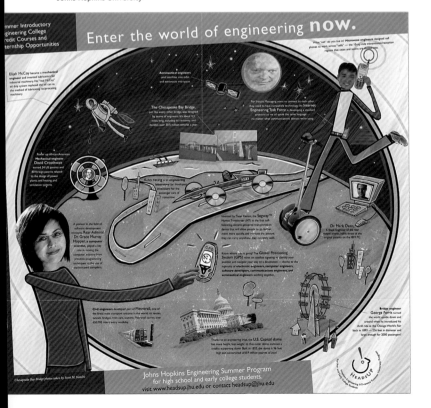

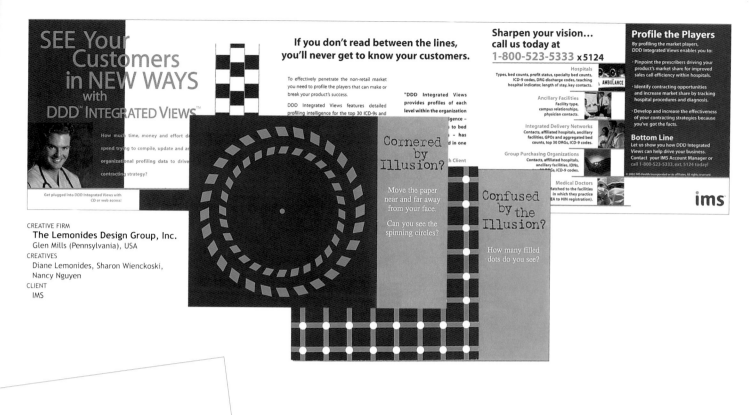

SEE Your Customers in NEW WAYS with DDD™ INTEGRATED VIEWS™

How much time, money and effort do you spend trying to compile, update and maintain organizational profiling data to drive your contracting strategy?

Get plugged into DDD Integrated Views with CD or web access!

If you don't read between the lines, you'll never get to know your customers.

To effectively penetrate the non-retail market you need to profile the players that can make or break your product's success.

DDD Integrated Views features detailed profiling intelligence for the top 30 ICD-9s and

"DDD Integrated Views provides profiles of each level within the organization

Cornered by Illusion?

Move the paper near and far away from your face.

Can you see the spinning circles?

Confused by the Illusion?

How many filled dots do you see?

Sharpen your vision... call us today at 1-800-523-5333 x5124

Hospitals
Types, bed counts, profit status, specialty bed counts, ICD-9 codes, DRG discharge codes, teaching hospital indicator, length of stay, key contacts.

Ancillary Facilities
Facility type, campus relationships, physician contacts.

Integrated Delivery Networks
Contacts, affiliated hospitals, ancillary facilities, GPOs and aggregated bed counts, top 30 DRGs, ICD-9 codes.

Group Purchasing Organizations
Contacts, affiliated hospitals, ancillary facilities, IDNs, DRGs, ICD-9 codes.

Medical Doctors
Matched to the facilities in which they practice (DEA to HIN registration).

Profile the Players
By profiling the market players, DDD Integrated Views enables you to:

- Pinpoint the prescribers driving your product's market share for improved sales call efficiency within hospitals.
- Identify contracting opportunities and increase market share by tracking hospital procedures and diagnosis.
- Develop and increase the effectiveness of your contracting strategies because you've got the facts.

Bottom Line
Let us show you how DDD Integrated Views can help drive your business. Contact your IMS Account Manager or call 1-800-523-5333, ext; 5124 today!

© 2002 IMS Health Incorporated or its affiliates. All rights reserved.

ims

CREATIVE FIRM
The Lemonides Design Group, Inc.
Glen Mills (Pennsylvania), USA
CREATIVES
Diane Lemonides, Sharon Wienckoski,
Nancy Nguyen
CLIENT
IMS

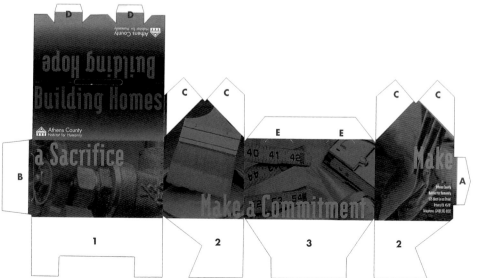

McKesson is everywhere.

Everywhere in healthcare.

CREATIVE FIRM
Cahan & Associates
San Francisco (California), USA
CREATIVES
Bill Cahan, Sharrie Brooks
CLIENT
McKesson Corporation

CREATIVE FIRM
**University Communications
& Marketing**
Athens (Ohio), USA
CREATIVES
Mary C. Dillon, Mark Krumel
CLIENT
Athens County Habitat for Humanity

CREATIVE FIRM
Red Canoe
Deer Lodge (Tennessee), USA
CREATIVES
Deb Koch, Caroline Kavanagh,
Brian Cronin
CLIENT
Renée Rhyner and Company

202

CREATIVE FIRM
TD2, S.C.
Mexico City, Mexico
CREATIVES
Rafael Treviño,
Rafael Rodrigo Cordova
CLIENT
TD2

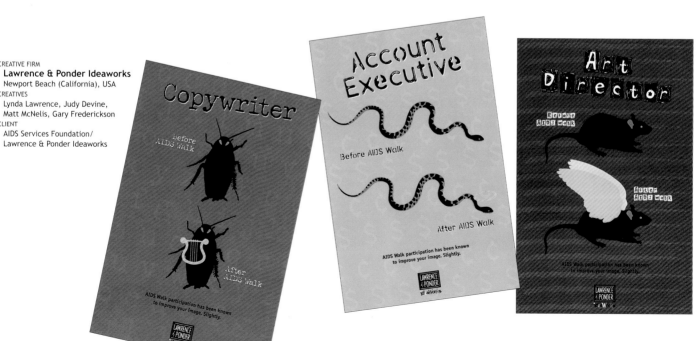

CREATIVE FIRM
Lawrence & Ponder Ideaworks
Newport Beach (California), USA
CREATIVES
Lynda Lawrence, Judy Devine,
Matt McNelis, Gary Frederickson
CLIENT
AIDS Services Foundation/
Lawrence & Ponder Ideaworks

CREATIVE FIRM
Willis Advertising
Laguna Hills (California), USA
CREATIVES
Bud Willis, Stephanie Rigney,
Cami Keyes
CLIENT
Westec Interactive

IS YOUR GUARD POSITIONED FOR AN EMERGENCY?

... guards are? How ... them? Most of the nation's more ... guards are unlicensed, untrained and not subject to background checks. Companies invest thousands of dollars in their guards and often spend millions of dollars in lawsuit payouts when they mishandle situations.

You can be assured you are receiving the best security for your money by using Westec InterActive services. With Westec, you get a sophisticated two-way audio and digital video monitoring service staffed by highly-trained Intervention Specialists with more than 200 hours of crisis management training.

Our team watches, listens, and when necessary, uses voice intervention techniques to improve safety and decrease criminal activity. We have established the industry's most demanding training program, including situation analysis, pathological typing and police academy schooling. And unlike other security companies, our specialists are licensed and highly qualified.

Westec InterActive security has a proven, extraordinary impact on your company's bottom line and, in a short period of time, more than pays for itself. Time and again, Westec InterActive has been shown to reduce internal and external shrink and frivolous worker's compensation claims. Employees and customers feel safer, increasing employee satisfaction and reducing costly turnover. All of this adds up to a tremendous return on investment and improvement to your bottom line.

Don't trust the safety and security of your business to just anyone. Call Westec InterActive today at 888-947-8110.

Westec InterActive
The Power Of Presence

16842 Von Karman Avenue, Suite 150
Irvine, California 92606
(888) 947-8110 www.westecnow.com

When compared with security guards Westec InterActive offers:
- Overall reduced expenses
- Assurance of 24/7 coverage
- Reduction in shrink
- Immediate crisis response
- Extraordinary return on investment

☐ Yes, I want to find out more about Westec InterActive Security Solutions.

Please contact me by:
☐ Telephone ☐ E-Mail

Name: _____
Company: _____
Phone: _____ E-mail: _____

203

One world company vision
SCHAWK

SCHAWK
Vision 2020 and You

How can you make a difference? Every time you go above and beyond what was required or asked for, every time you go out of your way to solve a problem, each time you catch someone doing something right and recognize it, you make a difference. Every single employee can make a difference—to our clients, to Schawk, to each other and to themselves. I believe that every employee has the ability to shape their own future as well as Schawk's. How? By taking this idea to work with you every day.

③ Embrace the change that new technology brings to develop innovative solutions for our clients. It's human nature to be uncomfortable with change. It disrupts our regular routines. It requires that we do the same things in new ways. Or that we do completely new things. To the fearful, change is threatening. But to the confident, change is inspiring. Be confident. Be inspired by change. Inspire others. Change creates new possibilities and is fertile ground for great breakthroughs and innovative solutions. Never be intimidated by new technology. Whether it's a new version of software or a new piece of equipment, or a new process, look at it as an opportunity to learn; to add to your professional skill set. Challenge it. Use it to discover new solutions for the way we do business internally, and with the world outside of Schawk. Always think about how it can benefit our clients.

Challenge technology. Embrace change. Make a difference. Technology is only as good as the people using it. And I am confident that Schawk has the best people in the industry. With people like you doing your very best to make Schawk more useful for our clients than anyone ever intended it to be, we simply cannot be beat.

Thank You,

David Schawk
President & CEO

CREATIVE FIRM
Anthem Group
Hackettstown (New Jersey), USA
CREATIVES
Patti Soldavini,
Barbara Krouse
CLIENT
Schawk, Inc.

CREATIVE FIRM
Rodgers Townsend
St. Louis (Missouri), USA
CREATIVES
Erik Mathre, Michelle Vesth,
Tom Hudder
CLIENT
Humane Society of Missouri

Some pets actually can't wait to see us.

PATIENT: Slash
CONDITION: broken leg

The place for surgery, checkups, vaccinations and more.

We offer more than just adoptions.

At the Humane Society of Missouri, pets are also patients. Our Maryland Heights veterinary facility treats pets from homes all over St. Louis County. And we welcome them for all kinds of reasons, even if they haven't been adopted from us.

- Spaying and neutering
- Surgery
- Medical treatments for diseases
- Lab tests
- Heartworm and flea preventatives
- Annual exams and vaccinations
- Dental checkups/cleanings
- Prescription medicines

We're in the neighborhood. Come visit our newly remodeled building where there's more room for everyone — our many vets and, of course, animals waiting for a good home.

Get $5 off your next visit.
Bring this postcard to our Maryland Heights facility and we'll take off $5 for any veterinary service, medical exam or pet adoptions.
For veterinary appointments, call 314-951-1590.
For adoptions, call 314-951-1598.
Email: info@hsmo.org Web: hsmo.org

Humane Society of Missouri
1201 Macklind Avenue
St. Louis, MO 63110

NON-PROFIT
U.S. POSTAGE
PAID
ST. LOUIS, MO
PERMIT NO. 1381

Sample Q. Sample
123 Anystreet
Anytown, USA 67890

2400 Drilling Service Drive
(off Dorsett, two miles east of I-270)

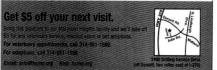

Rescued from frequent bouts of bad breath.

PATIENT: Zsa-Zsa
CONDITION: tooth decay

Humane Society of Missouri

The place for dental cleanings, exams, vaccinations and more.

Our neighborhood has the freshest fish this side of Montauk.

Hudson Crossing

Our neighborhood has great buns.

Hudson Crossing

CREATIVE FIRM
Sherman Advertising
New York (New York), USA
CREATIVES
Sharon Lloyd McLaughlin,
William Touchet
CLIENT
The Dermont Company, Inc.

style

next

happiness

CREATIVE FIRM
Fry Hammond Barr
Orlando (Florida), USA
CREATIVES
Tim Fisher, Sean Brunson,
Shannon Hallare, Ben Van Hook
CLIENT
Thornton Park Development

JUST IN

WHA

FIRST CLASS
DELIVERY

SPECIAL
DELIVERY

AIR
MAIL

SONICS UPDATE

CREATIVE FIRM
Hornall Anderson Design Works, Inc.
Seattle (Washington), USA
CREATIVES
Jack Anderson, Andrew Wicklund,
Mark Popich
CLIENT
Seattle SuperSonics

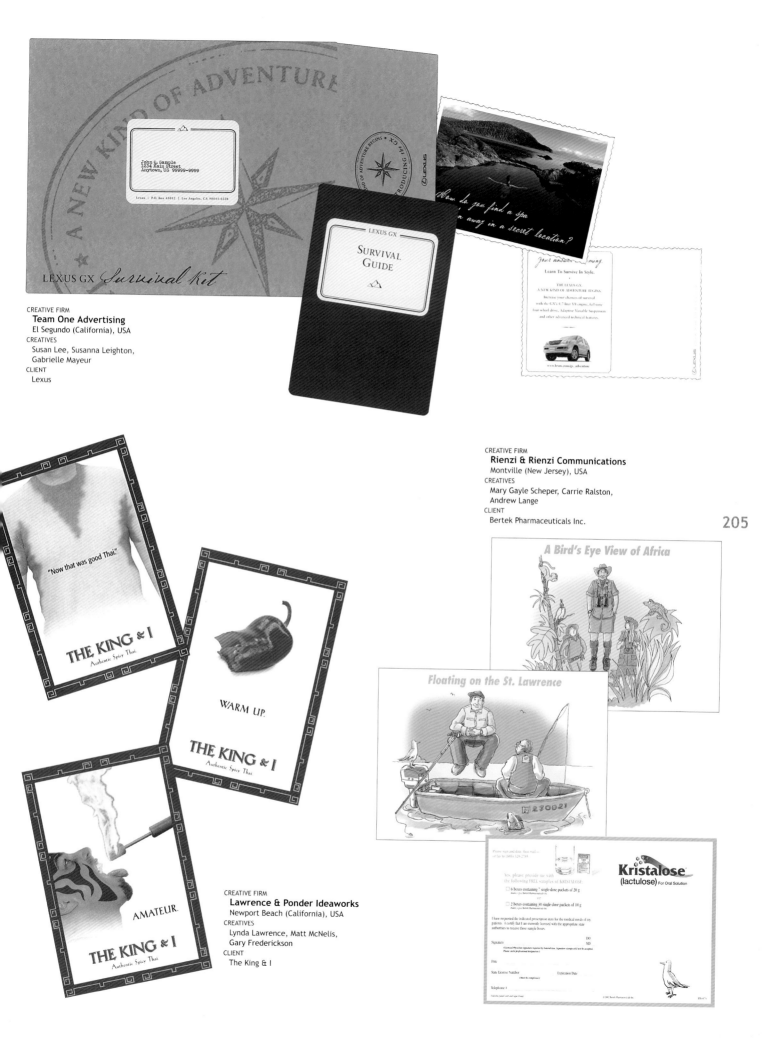

CREATIVE FIRM
Team One Advertising
El Segundo (California), USA
CREATIVES
Susan Lee, Susanna Leighton,
Gabrielle Mayeur
CLIENT
Lexus

CREATIVE FIRM
Rienzi & Rienzi Communications
Montville (New Jersey), USA
CREATIVES
Mary Gayle Scheper, Carrie Ralston,
Andrew Lange
CLIENT
Bertek Pharmaceuticals Inc.

205

CREATIVE FIRM
Lawrence & Ponder Ideaworks
Newport Beach (California), USA
CREATIVES
Lynda Lawrence, Matt McNelis,
Gary Frederickson
CLIENT
The King & I

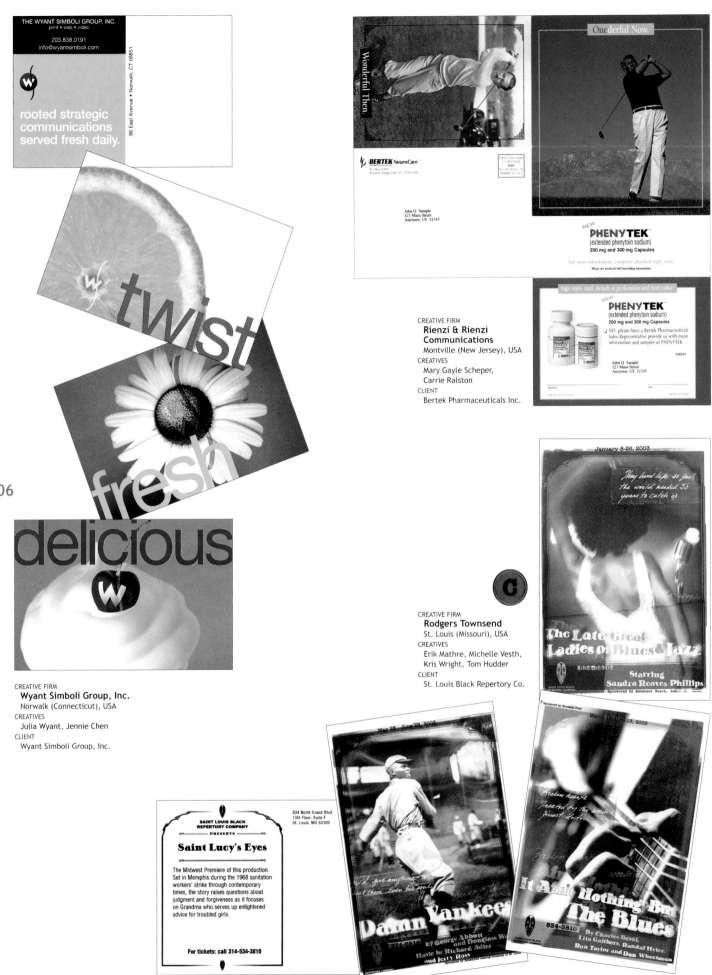

THE WYANT SIMBOLI GROUP, INC.
print • web • video

203.838.0191
info@wyantsimboli.com

96 East Avenue • Norwalk, CT 06851

rooted strategic
communications
served fresh daily.

twist

fresh

delicious

206

One**derful** Now.

Wonderful Then.

BERTEK NeuroCare

NEW
PHENY**TEK**
(extended phenytoin sodium)
200 mg and 300 mg Capsules

For more information, complete attached reply card.
Please see enclosed full Prescribing Information.

John Q. Sample
123 Main Street
Anytown, US 12345

Sign reply card, detach at perforation and mail today!

NEW
PHENY**TEK**
(extended phenytoin sodium)
200 mg and 300 mg Capsules

☐ YES, please have a Bertek Pharmaceuticals
Sales Representative provide us with more
information and samples of PHENYTEK.

John Q. Sample
123 Main Street
Anytown, US 12345

CREATIVE FIRM
**Rienzi & Rienzi
Communications**
Montville (New Jersey), USA
CREATIVES
Mary Gayle Scheper,
Carrie Ralston
CLIENT
Bertek Pharmaceuticals Inc.

January 8-26, 2003

The Late Great
Ladies of Blues & Jazz

Starring
Sandra Reaves-Phillips

Sponsored by Anheuser-Busch, Inc.

CREATIVE FIRM
Rodgers Townsend
St. Louis (Missouri), USA
CREATIVES
Erik Mathre, Michelle Vesth,
Kris Wright, Tom Hudder
CLIENT
St. Louis Black Repertory Co.

CREATIVE FIRM
Wyant Simboli Group, Inc.
Norwalk (Connecticut), USA
CREATIVES
Julia Wyant, Jennie Chen
CLIENT
Wyant Simboli Group, Inc.

634 North Grand Blvd.
10th Floor, Suite F
St. Louis, MO 63103

SAINT LOUIS BLACK
REPERTORY COMPANY
PRESENTS

Saint Lucy's Eyes

The Midwest Premiere of this production.
Set in Memphis during the 1968 sanitation
workers' strike through contemporary
times, the story raises questions about
judgment and forgiveness as it focuses
on Grandma who serves up enlightened
advice for troubled girls.

For tickets: call 314-534-3810

Damn Yankees

by George Abbott
and Douglass Wallop
Music by Richard Adler
and Jerry Ross

It Aint Nothing But
The Blues

By Charles Bevel,
Lita Gaithers, Randal Myler,
Ron Taylor and Dan Wheetman

634-3810

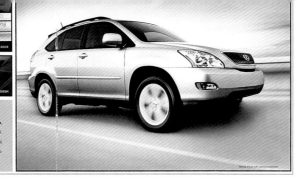

TECHNOLOGY

THE COMPETITION'S OBSERVATION: THE TECHNOLOGY LEAVES US BEHIND. FAR BEHIND.

It is difficult to know where to start when addressing the technical achievements represented in the new RX. It has optional features like the Adaptive Front Lighting System (AFS) that follows the contours of the road, Dynamic Laser Cruise Control* to help keep a safe distance from cars ahead and a Rear Backup Camera* to help see what's behind. We must start adapting this technology for our vehicles immediately.

CREATIVE FIRM
Team One Advertising
El Segundo (California), USA
CREATIVES
Laureen Zaccheo, Susanna Leighton,
Gabrielle Mayeur, Bill Day,
Ede Schweizer
CLIENT
Lexus

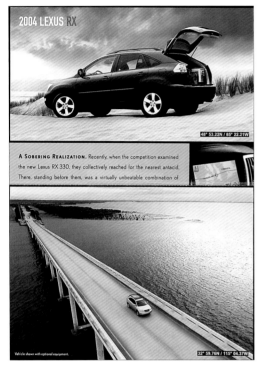

2004 LEXUS RX

48° 53.22N / 85° 22.21W

A SOBERING REALIZATION. Recently, when the competition examined the new Lexus RX 330, they collectively reached for the nearest antacid. There, standing before them, was a virtually unbeatable combination of

Vehicle shown with optional equipment.

32° 59.76N / 115° 04.37W

CREATIVE FIRM
BarrettLaidlawGervais
Coral Gables (Florida), USA
CREATIVES
David Laidlaw
CLIENT
Continental Real Estate Companies

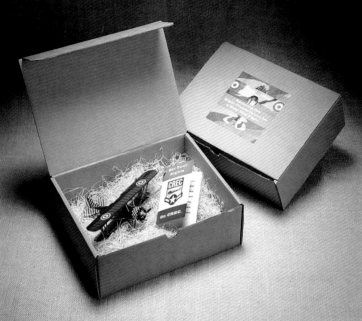

207

CREATIVE FIRM
Nassar Design
Brookline (Massachusetts), USA
CREATIVES
Nelida Nassar, Margarita Encomienda
CLIENT
The Stubbins Associates RMC

Grand Prize Auditoriums

Illumination Design Award New England Section

Honor Award

The Stubbins Associates, Inc The Stubbins Associates, Inc The Stubbins Associates, Inc The Stubbins Associates, Inc

onorable Mention

Associates, Inc The Stubbins Associates, Inc The Stubbins Associates, Inc The Stubbins Associates, Inc

and Prize

The Stubbins Associates, Inc The Stubbins Associates, Inc The Stubbins Associates, Inc The Stubbins Associates, Inc

Illumination Design Award

208

CREATIVE FIRM
VH1 Off Air Creative
New York (New York), USA
CREATIVES
Nigel Cox Hagen, Phil Delbourbo,
Nancy Mazzei, Shayne Ivy,
Christine Halwedell
CLIENT
VH1

CREATIVE FIRM
**Herman Miller
In-House Design**
Zeeland (Michigan), USA
CREATIVES
Steve Frykholm, Martin Burch
CLIENT
Herman Miller Inc.

CREATIVE FIRM
Martin-Schaffer, Inc.
Bethesda (Maryland), USA
CREATIVES
Tina Martin, Steve Cohn,
Kelly Fraczek
CLIENT
Gene Logic Inc.

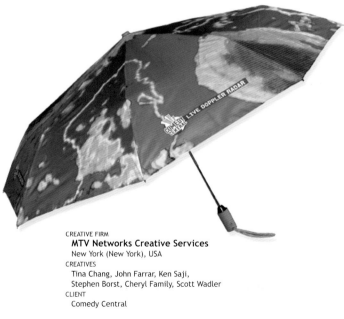

CREATIVE FIRM
MTV Networks Creative Services
New York (New York), USA
CREATIVES
Tina Chang, John Farrar, Ken Saji,
Stephen Borst, Cheryl Family, Scott Wadler
CLIENT
Comedy Central

CREATIVE FIRM
Creaxis design Pte Ltd
 Singapore
CREATIVES
 Yang Qiao'e, Hui Jing
CLIENT
 Canon Singapore Pte Ltd

CREATIVE FIRM
Wood Design
 New York (New York), USA
CREATIVES
 Tom Wood, Clint Bottoni,
 Rachel Totora
CLIENT
 Louis Dreyfus

209

CREATIVE FIRM
"Smiley" Kato
 Nagoya, Japan
CREATIVES
 "Smiley" Kato
CLIENT
 Linda & The Big King Jive Daddies

CREATIVE FIRM
The Ashway Group
 Hoboken (New Jersey), USA
CREATIVES
 Mike Azzarone, Nader Ashway
CLIENT
 MG—Escape from Alcatraz Triathlon

210

CREATIVE FIRM
p3
Farmington (Connecticut), USA
CREATIVES
James Pettus, Patricia Pettus
CLIENT
James & Patricia Pettus

CREATIVE FIRM
@radical.media
New York (New York), USA
CREATIVES
Wendy Wen, Gregory Gross, Heike Sperber,
Jay Miolla, Jorg Scheuerpflug, Nadia Vertlib,
Joe Prestino, Rafael Esquer
CLIENT
@radical.media

CREATIVE FIRM
AMP
Costa Mesa (California), USA
CREATIVES
Luis Camano, Lucas Risé,
Cameron Young
CLIENT
Johnny Rockets

CREATIVE FIRM
Crabtree + Co.
Falls Church (Virginia), USA
CREATIVES
Nisha Nair, Tamera Finn
CLIENT
Honda Corp. of America

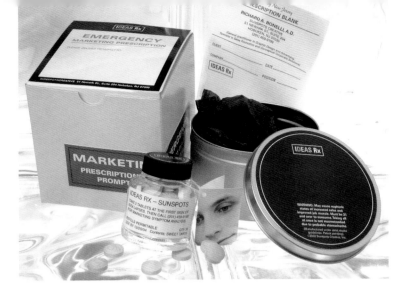

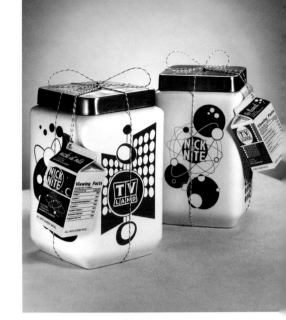

CREATIVE FIRM
Sunspots Creative
Hoboken (New Jersey), USA
CREATIVES
Rick Bonelli, Deena Hartley
CLIENT
Sunspots Creative

 CREATIVE FIRM
TV Land/NAN
New York (New York), USA
CREATIVES
Dom Vitali, Tracey Bobb

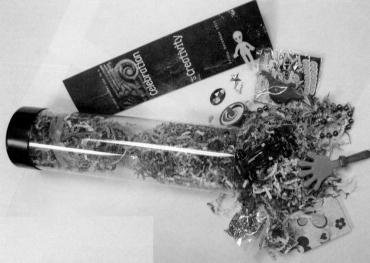

CREATIVE FIRM
Arista Advertising and Design
Timonium (Maryland), USA
CREATIVES
Fanny Chakedis, David Walper,
Ed Armstrong, Wes Hughes
CLIENT
Arista Advertising and Design

212

CREATIVE FIRM
Red Canoe
Deer Lodge (Tennessee), USA
CREATIVES
Deb Koch, Caroline Kavanagh,
Diana Marye Huff
CLIENT
Diana Marye Huff

CREATIVE FIRM
QCCG
San Diego (California), USA
CREATIVES
Christopher Lee, Grant Kroeger
CLIENT
The Kroeger Family

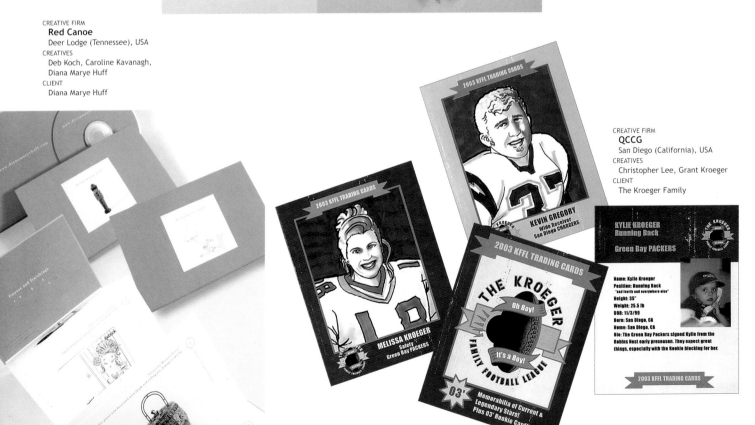

CREATIVE FIRM
Sunspots Creative
Hoboken (New Jersey), USA
CREATIVES
Rick Bonelli, Deena Hartley,
Ab Sesay
CLIENT
Premium Color Graphics

CREATIVE FIRM
LTD Creative
Frederick (Maryland), USA
CREATIVES
Timothy Finnen, Louanne Welgoss,
Kimberly Dow
CLIENT
Hanley-Wood, LLC

213

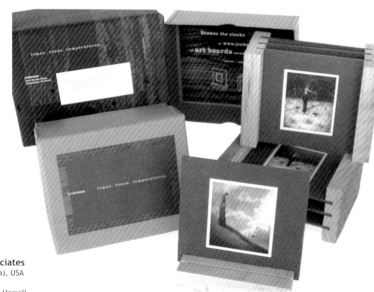

CREATIVE FIRM
Red Canoe
Deer Lodge (Tennessee), USA
CREATIVES
Deb Koch, Caroline Kavanagh,
John Krause, Nick Warner
CLIENT
Jon Krause

CREATIVE FIRM
Nolen & Associates
Atlanta (Georgia), USA
CREATIVES
Ed Young, David Harrell
CLIENT
Mead Westvaco Coated Board

CREATIVE FIRM
**American Speech-Language-
Hearing Association**
Rockville (Maryland), USA
CREATIVES
Pamela Leppin, Tarja Carter,
Emerald Ong, Claudette Quashie,
Brent Jacocks
CLIENT
American Speech-Language-
Hearing Association

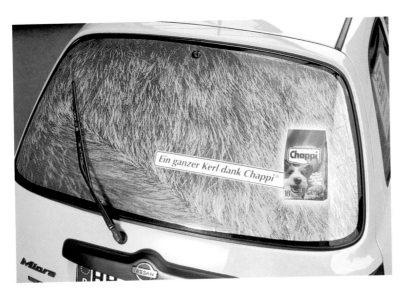

CREATIVE FIRM
Heye & Partner
Bavaria, Germany
CREATIVES
Andreas Forberger, Wolfgang Biebach,
Florian Ege, Gunnar Immisch
CLIENT
Masterfoods GmbH

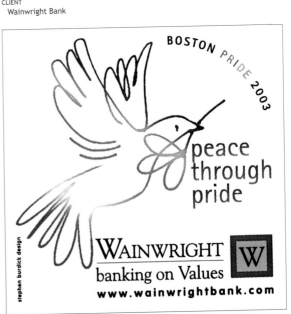

CREATIVE FIRM
5D Studio
Malibu (California), USA
CREATIVES
Jane Kobayashi, Anne Coates
CLIENT
5D Studio

214

CREATIVE FIRM
Mitten Design
San Francisco (California), USA
CREATIVES
Marianne Mitten
CLIENT
Mitten Design

CREATIVE FIRM
Stephen Burdick Design
Boston (Massachusetts), USA
CREATIVES
Stephen Burdick
CLIENT
Wainwright Bank

THE AXE WEARER'S HANDBOOK · **SELF-DEFENSE** THE AXE WEARER'S HANDBOOK · **SELF-DEFENSE**

HOW TO AVOID CHAFING

It's a simple fact, when the fairer sex takes a liking to something, she'll rub up against it uncontrollably. The force of this rubbing can range from mild to industrial-strength belt sander. So watch out — if you're not careful, a trip out onto the dance floor could result in a serious rash or chafing. To avoid five-alarm chafing, the most severe of chafing injuries, follow these steps:

1 Hang in there as long as you can.

2 In the event of "heavy grinding", have an escape route planned. Be cool, escape with style.

3 Redirect women's "grinding" attention.*

*A pole also works well.

15

HOW TO AVOID A BAD CASE OF RUG BURN

One of the hidden dangers in the home is that soft flooring you call a rug. It hides tacks, staples and other sharp objects. You could skin your knees so badly you might not be able to walk normally or wear pants for a week. And you won't always be somewhere you know is knee-friendly when the mood strikes. Keep in mind, nothing ruins a nice romantic moment on the rug in front of a roaring fire quicker than knees that look like a bloody alligator. To prevent that from happening to you, or your special lady friend, simply:

1 **2** **3**

16

CREATIVE FIRM
Bartle Bogle Hegarty
New York (New York), USA
CREATIVES
William Gelner, Brian Friedrich, Jeff Church, Gianfranco Arena, Peter Kain
CLIENT
Unilever

3 sanitary towels = 1/99 pair of shoes

FEET ME
Addicted to shoes

CREATIVE FIRM
Scanad
Denmark
CREATIVES
Henry Rasmussen, Per Klixbüll, Kim Michael, Mari-Louise Jonsson
CLIENT
Feet Me

215

4-H Afterschool
EXTRAORDINARY LEARNING OPPORTUNITIES

4-H Afterschool
IN A BOX

JCPenney Afterschool Fund
NATIONAL PRESENTING SPONSOR

CREATIVE FIRM
Lawrence & Ponder Ideaworks
Newport Beach (California), USA
CREATIVES
Lynda Lawrence, Gary Frederickson, Matt McNelis
CLIENT
California Department of Alcohol and Drug Programs

CREATIVE FIRM
Pensáre Design Group, Ltd.
Washington (D.C.), USA
CREATIVES
Amy E. Billingham
CLIENT
National 4-H Council

CREATIVE FIRM
Jack Nadel, Inc.
Los Angeles (California), USA
CREATIVES
Scott Brown, Tawny Thuy Le
CLIENT
Jack Nadel, Inc.

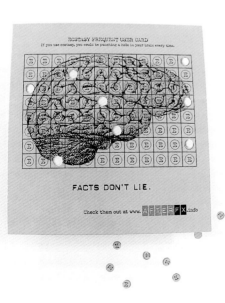

ECSTASY FREQUENT USER CARD
If you use ecstasy, you could be punching a hole in your brain every time.

FACTS DON'T LIE.

Check them out at www.AFTERFX.info

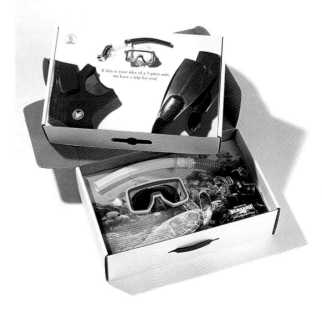

If this is your idea of a 3-piece suit, we have a trip for you!

CREATIVE FIRM
Pisarkiewicz Mazur & Co.
New York (New York), USA
CREATIVES
Candice Waddell, Michelle Zulauf,
Mary Pisarkiewicz
CLIENT
PM & Co

C

CREATIVE FIRM
Rottman Creative Group, LLC
La Plata (Maryland), USA
CREATIVES
Gary Rottman, Kelly Gammon, Lisa Pressley,
Mary Rottman
CLIENT
Andrews Federal Credit Union

216

CREATIVE FIRM
30sixty design inc.
Los Angeles (California), USA
CREATIVES
Henry Vizcarra, David Fuscellaro,
Duy Nguyen
CLIENT
30sixty design, inc.

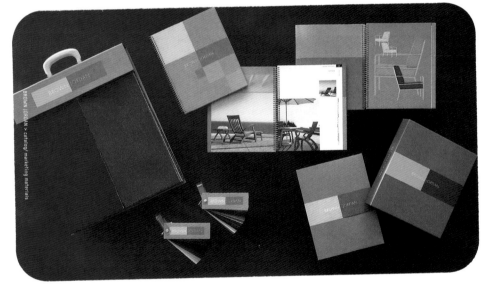

CREATIVE FIRM
5D Studio
Malibu (California), USA
CREATIVES
Jane Kobayashi
CLIENT
Brown Jordan

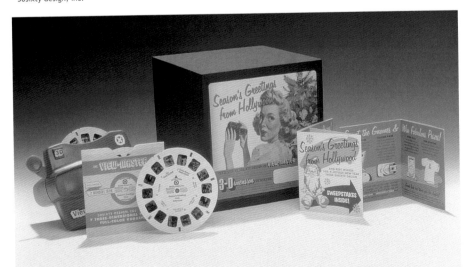

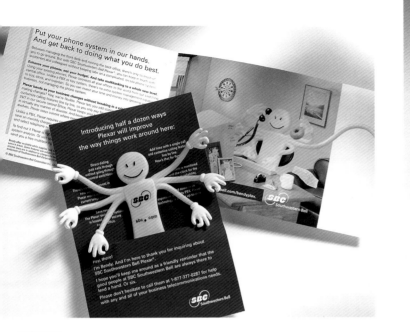

CREATIVE FIRM
Rodgers Townsend
St. Louis (Missouri), USA
CREATIVES
Susan Schultz, Dawn Sorgea,
Erik Mathre, Tom Hudder
CLIENT
SBC Properties, L.P.

CREATIVE FIRM
The Sloan Group
New York (New York), USA
CREATIVES
Rita Arifin, Jay Sandusky
CLIENT
Scholastic

Promote natural
girth control.

CREATIVE FIRM
Sudler & Hennessey
North Sydney, Australia
CREATIVES
Peter Ryan, Adam Taor
CLIENT
Meat & Livestock Australia

217

CREATIVE FIRM
Nesnadny + Schwartz
Cleveland (Ohio), USA
CREATIVES
Mark Schwartz, Michelle Moehler,
Greg Oznowich, Stacie Ross
CLIENT
Case Western Reserve University and
Weatherhead School of Management

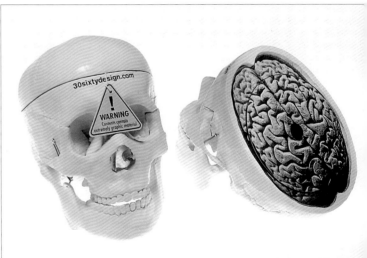

CREATIVE FIRM
30sixty design, inc.
Los Angeles (California), USA
CREATIVES
Henry Vizcarra, David Fuscellaro,
Rickard Olsson
CLIENT
30sixty design, inc.

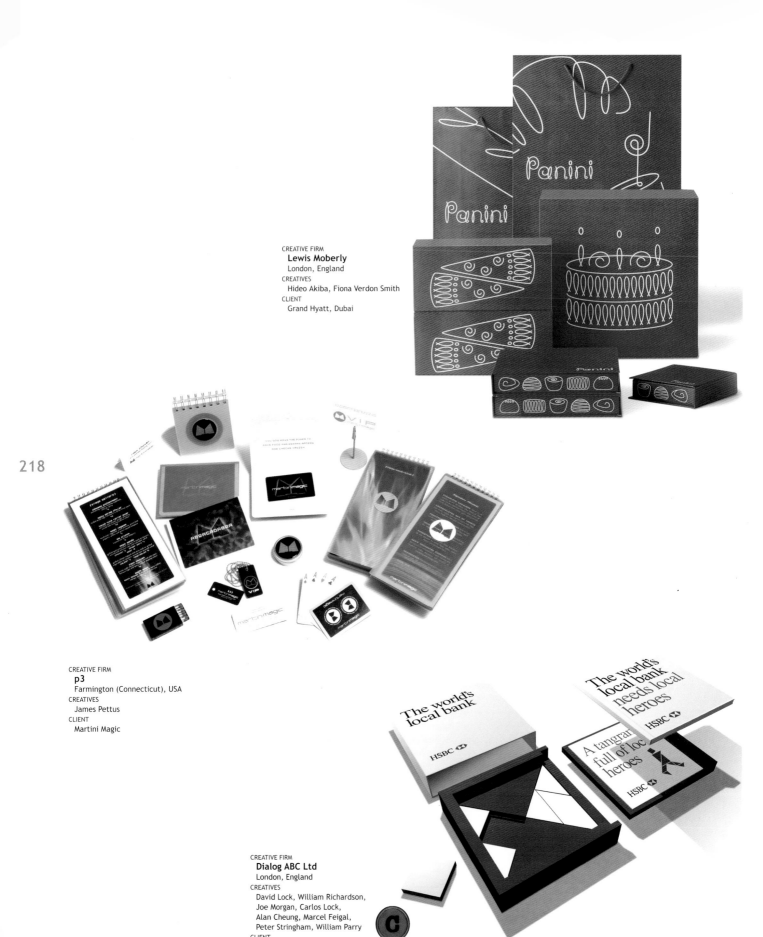

CREATIVE FIRM
Lewis Moberly
London, England
CREATIVES
Hideo Akiba, Fiona Verdon Smith
CLIENT
Grand Hyatt, Dubai

218

CREATIVE FIRM
p3
Farmington (Connecticut), USA
CREATIVES
James Pettus
CLIENT
Martini Magic

CREATIVE FIRM
Dialog ABC Ltd
London, England
CREATIVES
David Lock, William Richardson,
Joe Morgan, Carlos Lock,
Alan Cheung, Marcel Feigal,
Peter Stringham, William Parry
CLIENT
HSBC Group PLC

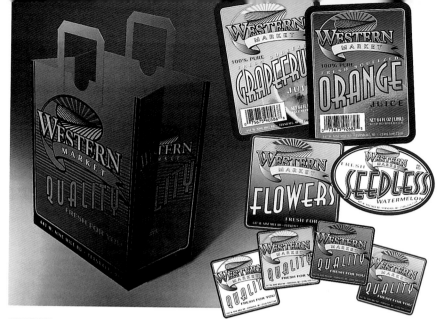

CREATIVE FIRM
Premier Communications Group
Royal Oak (Michigan), USA
CREATIVES
Randy Fossano, Pete Pultz
CLIENT
Western Market

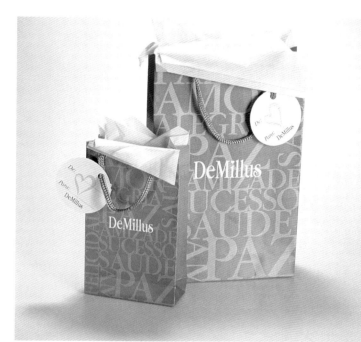

CREATIVE FIRM
RGB Graphic Design
Rio, Brazil
CREATIVES
Maria Luiza Goncalves
Veiga Brito
CLIENT
DeMillus Ind. E Com. S.A.

219

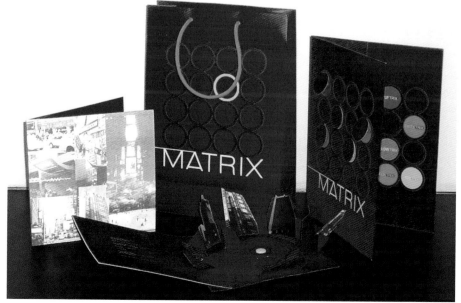

CREATIVE FIRM
Dente + Cristina, Inc.
New York (New York), USA
CREATIVES
Barbara Dente
CLIENT
Matrix

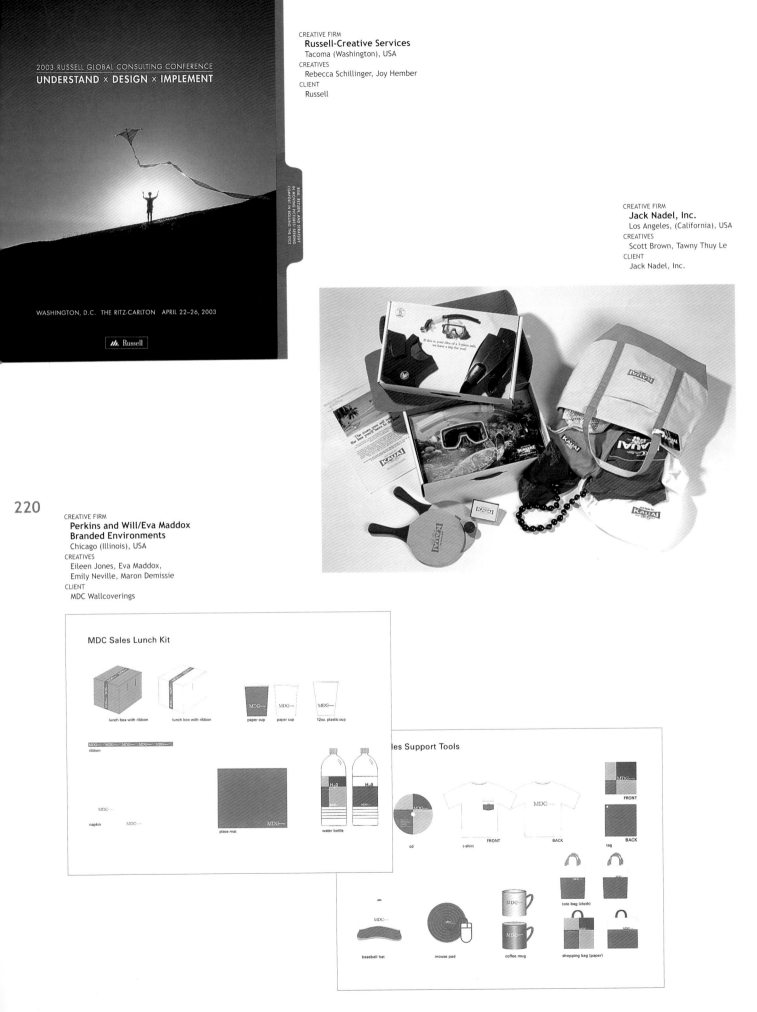

CREATIVE FIRM
Russell-Creative Services
Tacoma (Washington), USA
CREATIVES
Rebecca Schillinger, Joy Hember
CLIENT
Russell

2003 RUSSELL GLOBAL CONSULTING CONFERENCE
UNDERSTAND × DESIGN × IMPLEMENT

WASHINGTON, D.C. THE RITZ-CARLTON APRIL 22–26, 2003

Russell

CREATIVE FIRM
Jack Nadel, Inc.
Los Angeles, (California), USA
CREATIVES
Scott Brown, Tawny Thuy Le
CLIENT
Jack Nadel, Inc.

CREATIVE FIRM
**Perkins and Will/Eva Maddox
Branded Environments**
Chicago (Illinois), USA
CREATIVES
Eileen Jones, Eva Maddox,
Emily Neville, Maron Demissie
CLIENT
MDC Wallcoverings

MDC Sales Lunch Kit

lunch box with ribbon lunch box with ribbon paper cup paper cup 12oz. plastic cup

ribbon

MDC

napkin MDC place mat water bottle

les Support Tools

cd t-shirt FRONT BACK tag FRONT BACK

tote bag (cloth)

baseball hat mouse pad coffee mug shopping bag (paper)

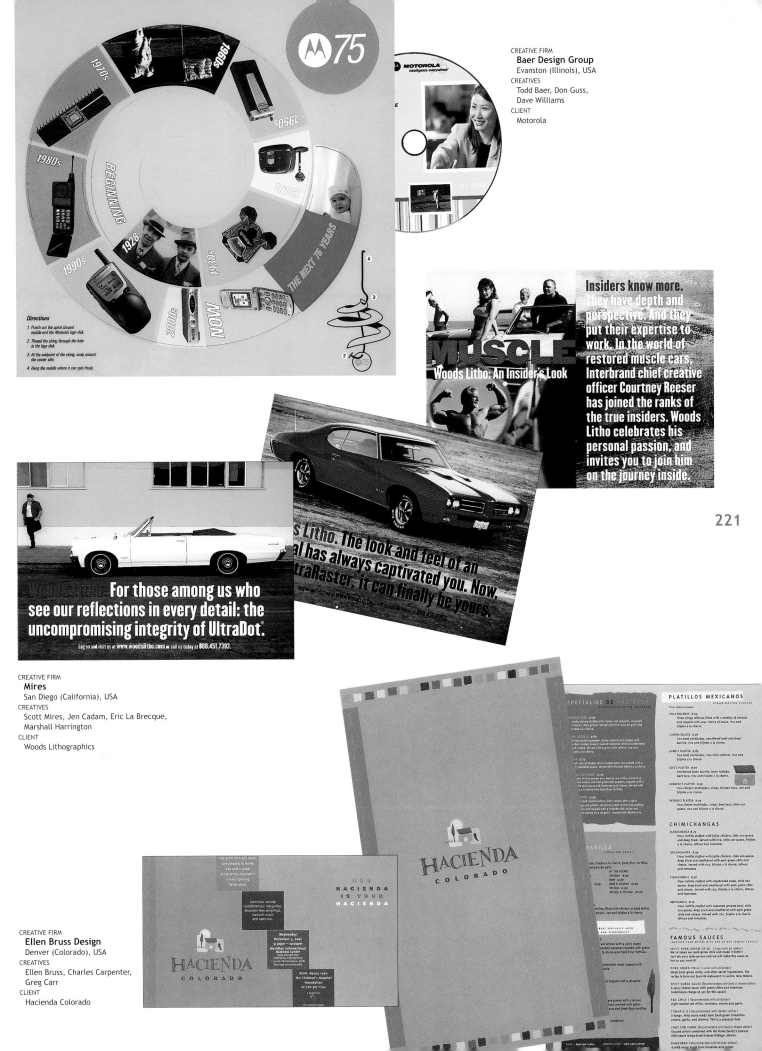

CREATIVE FIRM
Baer Design Group
Evanston (Illinois), USA
CREATIVES
Todd Baer, Don Guss,
Dave Williams
CLIENT
Motorola

Insiders know more. They have depth and perspective. And they put their expertise to work. In the world of restored muscle cars, Interbrand chief creative officer Courtney Reeser has joined the ranks of the true insiders. Woods Litho celebrates his personal passion, and invites you to join him on the journey inside.

Woods Litho: An Insider's Look

MUSCLE

For those among us who see our reflections in every detail: the uncompromising integrity of UltraDot.

Log on and visit us at www.woodslitho.com or call us today at 800.451.7393.

CREATIVE FIRM
Mires
San Diego (California), USA
CREATIVES
Scott Mires, Jen Cadam, Eric La Brecque,
Marshall Harrington
CLIENT
Woods Lithographics

CREATIVE FIRM
Ellen Bruss Design
Denver (Colorado), USA
CREATIVES
Ellen Bruss, Charles Carpenter,
Greg Carr
CLIENT
Hacienda Colorado

CREATIVE FIRM
AdVantage Ltd.
Hamilton, Bermuda
CREATIVES
Kim P. Hall
CLIENT
Bermuda Electric
Light Company Ltd.

222

CREATIVE FIRM
Watts Design
South Melbourne, Australia
CREATIVES
Helen Watts
CLIENT
Watts Design

CREATIVE FIRM
Wa Mu Creative Services
Seattle (Washington), USA
CREATIVES
Stuart Dunn, Terrie Shattuck,
Tim Pearson, Kevin Brockschmidt
CLIENT
Wa Mu School Savings

CREATIVE FIRM
Gee + Chung Design
San Francisco (California), USA
CREATIVES
Earl Gee, Fani Chung, Kevin Ng
CLIENT
Applied Materials

indochine

CREATIVE FIRM
Lewis Moberly
London, England
CREATIVES
Bryan Clark, Graham Evernden
CLIENT
Grand Hyatt, Dubai

224

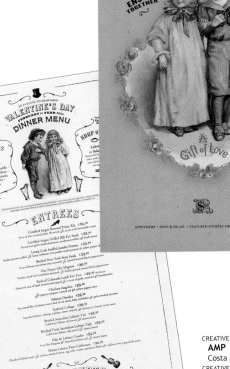

CREATIVE FIRM
AMP
Costa Mesa (California), USA
CREATIVES
Luis Camano, Phil Buck,
Lucas Risé
CLIENT
Specialty Restaurants Corp.

CREATIVE FIRM
**Patrick Henry
Creative Promotions**
Stafford (Texas), USA
CREATIVES
Julia Austin Church,
Nephele Papadopoulos
CLIENT
Consolidated Restaurant
Operations, Inc./El Chico

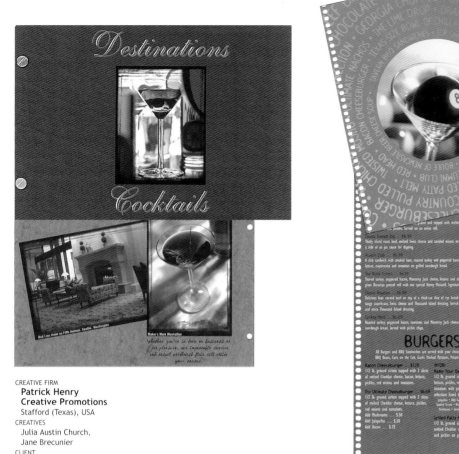

CREATIVE FIRM
**Patrick Henry
Creative Promotions**
Stafford (Texas), USA
CREATIVES
Julia Austin Church,
Jane Brecunier
CLIENT
Westcoast Family of Hotels

CREATIVE FIRM
**Patrick Henry
Creative Promotions**
Stafford (Texas), USA
CREATIVES
Summer Simmons,
Annie Barbee-Akin
CLIENT
Total Entertainment

225

CREATIVE FIRM
**Patrick Henry
Creative Promotions**
Stafford (Texas), USA
CREATIVES
Julia Austin Church,
Nephele Papadopoulos
CLIENT
Lone Star Steakhouse & Saloon

CREATIVE FIRM
**Patrick Henry
Creative Promotions**
Stafford (Texas), USA
CREATIVES
Rodney Allen,
Christy Jones
CLIENT
Ground Round

CREATIVE FIRM
Creative Force
Auckland, New Zealand
CREATIVES
Emma Mann
CLIENT
Luna-Fashion Designer

LUNA
WINTER 2003 COLLECTION
L'OREAL
FASHION
11AM TUESDAY 22 OCTOBER
THE GREAT HALL
AUCKLAND TOWN HALL

BE THERE OR BE SQUARE!

CREATIVE FIRM
Karacters design group
Vancouver (British Columbia), USA
CREATIVES
Maria Kennedy, Matthew Clark
CLIENT
Palmer Jarvis DDB

226

From your friends at
Computer Associates

Strong partnerships... make for smooth sailing. Have a happy holiday and a prosperous new year.

Season's Greetings · Egökernt On · Buon Natale e Felice Anno Nuovo
God Jul och Gott Nytt Ar · PRUMERNE SVATKY · Gleidileg jól og farsælt komandi ár
GRUCNE MRAZANIC · Prettige kerstdagen en een voorspoedig nieuwjaar
God Jul og en Godt Nyttår · Bon Nadal · PRUMERNE SVATKY · Happy Holidays
Feliz Natal e Bom Ano Novo · WESOŁYCH ŚWIĄT · KELLEMES ÜNNEPEKET
Feliz Navidad y Próspero Año Nuevo · Schöni Fäschttäg
Frohe Weihnachten und ein glückliches Neues Jahr · Selamat Menyambut Tahun Baru
Joyeux Noël et Bonne Année
新年快樂 · BUCURIE DRAG · God ul og godt nytår
Maligayang Pasko at Maligyang Bagong Taon · SRECNE PRAZNIKE
恭 禧 發 財 · MUTLU YILLAR

ca
Computer Associates

CREATIVE FIRM
**Computer Associates
In House Design**
Islandia, (New York), USA
CREATIVES
Malia Vrooman

CREATIVE FIRM
Sterling Group
New York (New York), USA
CREATIVES
Marcus Hewitt, Clay Pullen
CLIENT
Sterling Group

CREATIVE FIRM
Emspace Design Group
Omaha (Nebraska), USA
CREATIVES
Gail Snodgrass, Elizebeth Murphy
CLIENT
First National Merchant Solutions

JOY

FIRST NATIONAL MERCHANT SOLUTIONS
EXECUTIVE SUMMIT 2002

CREATIVE FIRM
Design Nut
Washington (D.C.), USA
CREATIVES
Jacques Coughlin, Brent M. Almond
CLIENT
National Public Radio

springtime with addy

Get a fresh impression of the best of Baltimore advertising.
At the 2003 Addy Awards Show.

ADONNA AND CHILD WITH ADDY

You're invited to a divine celebration of advertising's
immaculate conceptions.
At the 30th Annual Addy Awards Show.

CREATIVE FIRM
Crosby Marketing Communications
Annapolis (Maryland), USA
CREATIVES
Ron Ordansa, Mark Walston
CLIENT
Advertising Association of Baltimore

CREATIVE FIRM
Creative Network, Inc.
Overland Park (Kansas), USA
CREATIVES
Tim McNamara, Steve Minshull, Corey Shulda,
Sean Nelson, Jake Lord, Nancy King
CLIENT
Creative Network, Inc.

227

CREATIVE FIRM
Primary Design, Inc.
Haverhill (Massachusetts), USA
CREATIVES
Jules Epstein, Jennifer Dickert
CLIENT
Avalon Bay

CREATIVE FIRM
Ellen Bruss Design
Denver (Colorado), USA
CREATIVES
Ellen Bruss, Charles Carpenter,
Greg Carr
CLIENT
Denver Zoo

CREATIVE FIRM
Mendes Publicidade
Belém, Brazil
CREATIVES
Oswaldo Mendes,
Cláudia Vinagre
CLIENT
Mendes Publicidade

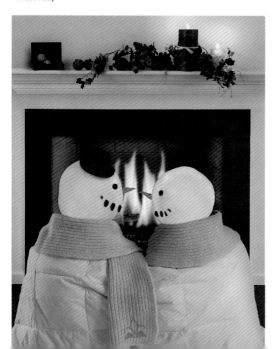

CREATIVE FIRM
Kellum McClain Inc.
New York (New York), USA
CREATIVES
Ron Kellum
CLIENT
The Museum of Modern Art

CREATIVE FIRM
Wendell Minor Design
Washington (Connecticut), USA
CREATIVES
Wendell Minor
CLIENT
UCONN (University of Connecticut)

Our entertainment for the evening is the
Magician and Comedian, Roger Burget.
You will delight in his humor and sleight-of-hand, while enjoying dinner and cocktails.
Dinner will be served at 6:30 PM and the show will begin at 7:15 PM.
Please RSVP to the Argosy Host Office by Tuesday, April 15th
at 816.746.3322 or 816.746.3323.

Offer nontransferable. No cash value. Must be 21. Gambling Problem? 1.888.BETS.OFF

Argosy Casino
BECAUSE EVERYONE LOVES A WINNER!

[HERE WE GO AGAIN.]

CREATIVE FIRM
The Star Group
Cherry Hill (New Jersey), USA
CREATIVES
Jan Talamo, Maria Bompensa, Brandon Dalton
CLIENT
Argosy

228

CREATIVE FIRM
ZGraphics, Ltd.
East Dundee (Illinois), USA
CREATIVES
Renee Clark, Joe Zeller
CLIENT
Studio C

You are Cordially Invited to Experience

Sal & Carvão
CHURRASCARIA
601 East Algonquin Road · Schaumburg, IL 60173

How Brazilians Say "FEAST"!
VIP INVITATION
YES PLEASE
SIM POR FAVOR

How Brazilians Say "FEAST"!

CREATIVE FIRM
HBO
New York (New York), USA
CREATIVES
Anna Racelis, Mary Tcjorbajian, Venus Dennison
CLIENT
HBO

CREATIVE FIRM
Stephen Burdick Design
Boston (Massachusetts), USA
CREATIVES
Stephen Burdick
CLIENT
Stephen Burdick Design

Millions of lives.

Many nations.

One dream.

HOME BOX OFFICE
and the
INTERNATIONAL AIDS TRUST

Cordially Invite You and A Guest
to attend the Atlanta Premiere of

PANDEMIC
FACING AIDS

An HBO Documentary Series

With Special Guests:
Rory Kennedy, Producer & Director, "PANDEMIC: FACING
Sandra Thurman, President, International AIDS Trust
es W. Curran, Dean, Rollins School of Public Health, Emo

THURSDAY, MAY 15, 2003

The Carter Presidential Center
One Copenhill
Atlanta, Georgia

6:30 p.m. Cocktail Reception in Ivan Allen III Pavilion
7:30 p.m. Screening in Day Chapel

RSVPs are required. Call toll free: 866-573-8334

This invitation is nontransferable
and will admit the invitee and one guest only.

Complimentary valet parking will be provided.

stephen
burdick
design

www.stephenburdickdesign.com
617.695.1400

CREATIVE FIRM
p3
Farmington (Connecticut), USA
CREATIVES
James Pettus, Mandy Rohde
CLIENT
MartiniMagic

CREATIVE FIRM
bonatodesign
Brooklyn (New York), USA
CREATIVES
Donna Bonato, Ashley
Geoffroy,
Rebecca Uberti
CLIENT
Zullo Communications/Yohay

CREATIVE FIRM
Martin-Schaffer, Inc.
Bethesda (Maryland), USA
CREATIVES
Tina Martin, Steve Cohn,
Kelly Fraczek, Herrmann + Starke
CLIENT
Montgomery County Executive's Ball

229

CREATIVE FIRM
Emerson, Wajdowicz Studios
New York (New York), USA
CREATIVES
Jurek Wajdowicz, Manuel Mendez
CLIENT
Emerson, Wajdowicz Studios

CREATIVE FIRM
Sterrett Dymond Stewart
Charlotte (North Carolina), USA
CREATIVES
Russ Dymond, Eric Rochvon Rochsburg
CLIENT
Sterrett Dymond Stewart

CREATIVE FIRM
Sara Bernstein Design
Brooklyn (New York), USA
CREATIVES
Sara Bernstein
CLIENT
American Museum of Natural History

MAY THE SPIRIT OF THE SEASON LIGHT YOUR SOUL.

MAY THE BLESSINGS OF THE SEASON SURROUND YOU.

MAY THE JOY AND PEACE OF THE SEASON BE WITH YOU.

MAY THE MAGIC OF THE SEASON LIVE WITHIN YOUR HEART.

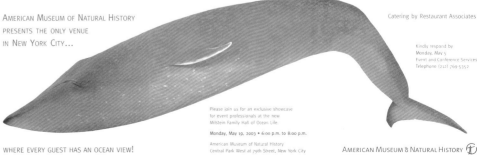

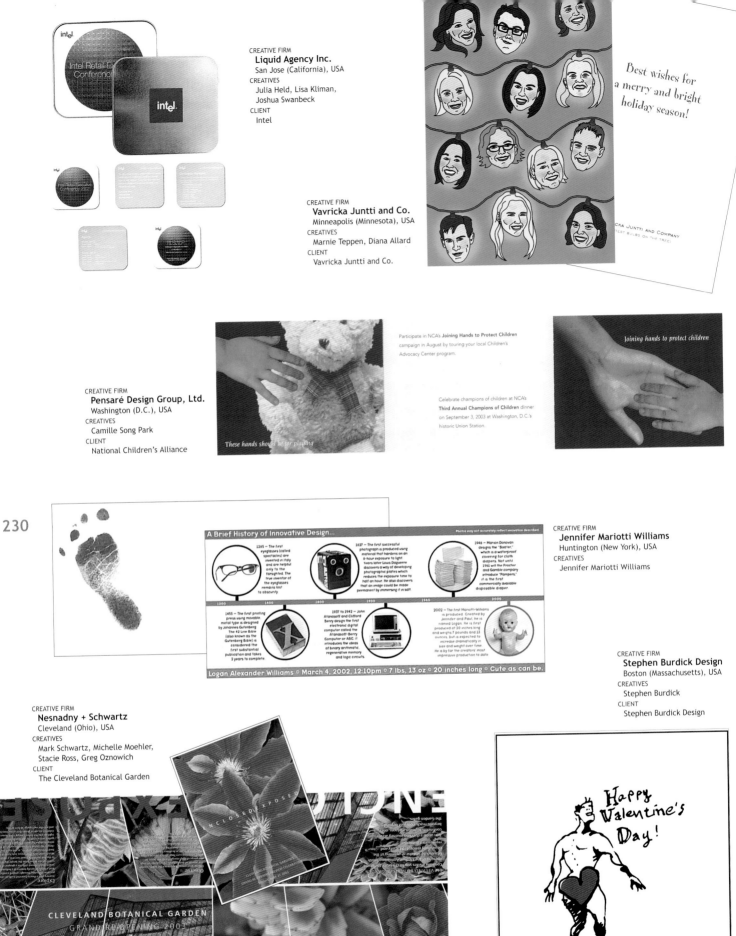

CREATIVE FIRM
Liquid Agency Inc.
San Jose (California), USA
CREATIVES
Julia Held, Lisa Kliman,
Joshua Swanbeck
CLIENT
Intel

CREATIVE FIRM
Vavricka Juntti and Co.
Minneapolis (Minnesota), USA
CREATIVES
Marnie Teppen, Diana Allard
CLIENT
Vavricka Juntti and Co.

Best wishes for
a merry and bright
holiday season!

CREATIVE FIRM
Pensaré Design Group, Ltd.
Washington (D.C.), USA
CREATIVES
Camille Song Park
CLIENT
National Children's Alliance

Participate in NCA's **Joining Hands to Protect Children** campaign in August by touring your local Children's Advocacy Center program.

Celebrate champions of children at NCA's **Third Annual Champions of Children** dinner on September 3, 2003 at Washington, D.C.'s historic Union Station.

These hands should be for playing

Joining hands to protect children

230

A Brief History of Innovative Design...

CREATIVE FIRM
Jennifer Mariotti Williams
Huntington (New York), USA
CREATIVES
Jennifer Mariotti Williams

CREATIVE FIRM
Stephen Burdick Design
Boston (Massachusetts), USA
CREATIVES
Stephen Burdick
CLIENT
Stephen Burdick Design

CREATIVE FIRM
Nesnadny + Schwartz
Cleveland (Ohio), USA
CREATIVES
Mark Schwartz, Michelle Moehler,
Stacie Ross, Greg Oznowich
CLIENT
The Cleveland Botanical Garden

CLEVELAND BOTANICAL GARDEN
GRAND RE-OPENING 2003

EXPOSED

Happy Valentine's Day!

stephen burdick design

www.stephenburdickdesign.com

231

CREATIVE FIRM
Catalyst Studios
Minneapolis (Minnesota), USA
CREATIVES
Jason Rysavy,
Ben Levitz
CLIENT
Chef Kevin Cullen,
Goodfellow's Restaurant

CREATIVE FIRM
MTV Networks Creative Services
New York (New York), USA
CREATIVES
Bjorn Ramberg, Nok Acharee, Scott Wadler,
Ken Saji, Cynara Webb, Cheryl Family
CLIENT
Noggin/The N

CREATIVE FIRM
Lynn Cyr Design
Franklin (Massachusetts), USA
CREATIVES
Lynn Cyr
CLIENT
Lynn Cyr Design

232

CREATIVE FIRM
Gee + Chung Design
San Francisco (California), USA
CREATIVES
Earl Gee, Fani Chung, Kevin Ng
CLIENT
Applied Materials

CREATIVE FIRM
**Computer Associates In-house
Creative Development**
Islandia (New York), USA
CREATIVES
Kristi M. Latuso
CLIENT
Computer Associates International, Inc.

CREATIVE FIRM
**Wendell Minor
Design**
Washington
(Connecticut), USA
CREATIVES
Wendell Minor,
Caitlyn Dlouhy
CLIENT
Atheneum

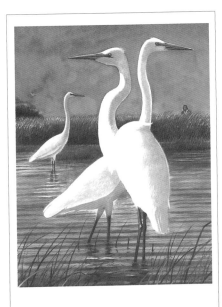

233

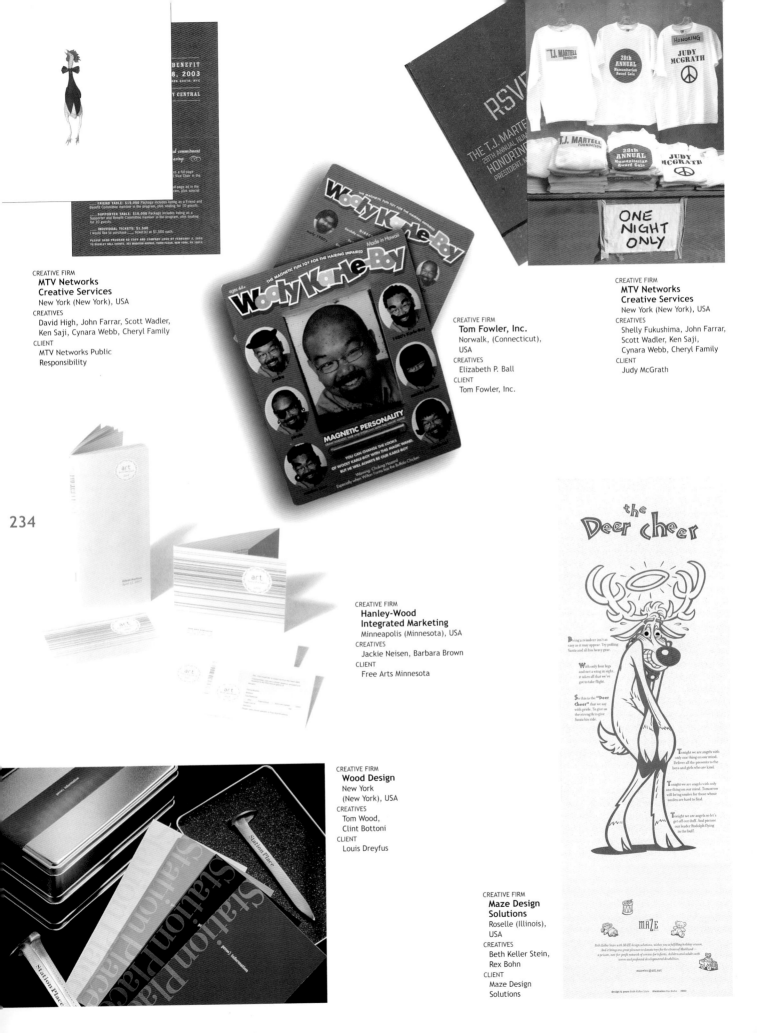

CREATIVE FIRM
**MTV Networks
Creative Services**
New York (New York), USA
CREATIVES
David High, John Farrar, Scott Wadler,
Ken Saji, Cynara Webb, Cheryl Family
CLIENT
MTV Networks Public
Responsibility

CREATIVE FIRM
Tom Fowler, Inc.
Norwalk, (Connecticut),
USA
CREATIVES
Elizabeth P. Ball
CLIENT
Tom Fowler, Inc.

CREATIVE FIRM
**MTV Networks
Creative Services**
New York (New York), USA
CREATIVES
Shelly Fukushima, John Farrar,
Scott Wadler, Ken Saji,
Cynara Webb, Cheryl Family
CLIENT
Judy McGrath

234

CREATIVE FIRM
**Hanley-Wood
Integrated Marketing**
Minneapolis (Minnesota), USA
CREATIVES
Jackie Neisen, Barbara Brown
CLIENT
Free Arts Minnesota

CREATIVE FIRM
Wood Design
New York
(New York), USA
CREATIVES
Tom Wood,
Clint Bottoni
CLIENT
Louis Dreyfus

CREATIVE FIRM
**Maze Design
Solutions**
Roselle (Illinois),
USA
CREATIVES
Beth Keller Stein,
Rex Bohn
CLIENT
Maze Design
Solutions

CREATIVE FIRM
Hornall Anderson Design Works, Inc.
Seattle (Washington), USA
CREATIVES
Jack Anderson, Katha Dalton, Gretchen Cook, Sonja Max
CLIENT
Lincoln Square

CREATIVE FIRM
McGaughy Design
Centreville (Virginia), USA
CREATIVES
Malcolm McGaughy
CLIENT
McGaughy Design

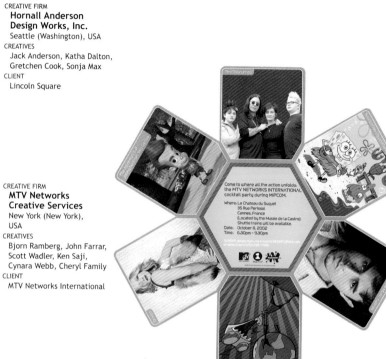

CREATIVE FIRM
MTV Networks Creative Services
New York (New York), USA
CREATIVES
Bjorn Ramberg, John Farrar, Scott Wadler, Ken Saji, Cynara Webb, Cheryl Family
CLIENT
MTV Networks International

235

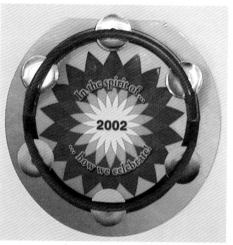

CREATIVE FIRM
HBO
New York (New York), USA
CREATIVES
Carlos Tejeda, Venus Dennison
CLIENT
HBO

CREATIVE FIRM
All Media Projects Limited (Ample)
Trinidad & Tobago, West Indies
CREATIVES
Alfred Aguiton, Astra Da Costa, Camille Durham, Julien Greenidge, Nicole Jones, Geraldo Vieria, Scrip-J Printers Ltd.
CLIENT
BP Trinidad and Tobago LLC (bpTT)

CREATIVE FIRM
IE Design
Manhattan Beach (California), USA
CREATIVES
Marcie Carson, Amy Klass
CLIENT
Davita, Inc.

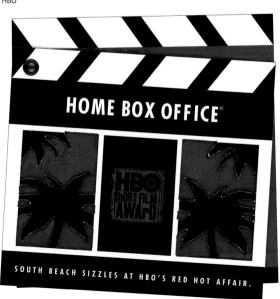

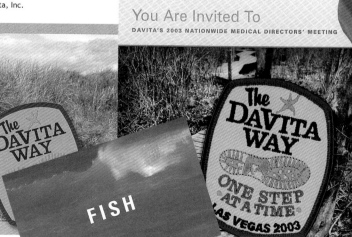

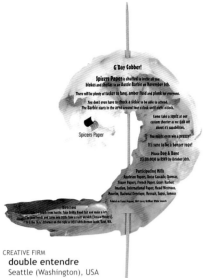

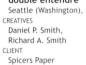

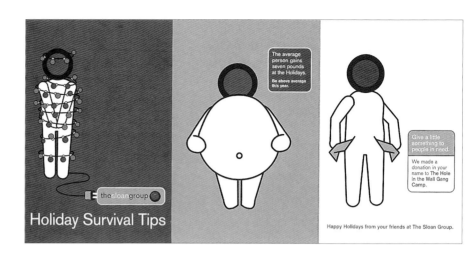

CREATIVE FIRM
double entendre
Seattle (Washington), USA
CREATIVES
Daniel P. Smith,
Richard A. Smith
CLIENT
Spicers Paper

CREATIVE FIRM
The Sloan Group
New York (New York), USA
CREATIVES
Wyndy Wilder, Rita Arifin,
Jay Sandusky
CLIENT
The Sloan Group

CREATIVE FIRM
After Hours Creative
Phoenix (Arizona), USA
CREATIVES
After Hours Creative
CLIENT
Max & Lucy

CREATIVE FIRM
Design Objectives Pte Ltd
Singapore
CREATIVES
Ronnie S C Tan
CLIENT
A-Star

CREATIVE FIRM
**MTV Networks
Creative Services**
New York (New York), USA
CREATIVES
Bjorn Ramberg, John Farrar,
Scott Wadler, Ken Saji, Cynara Webb,
Cheryl Family
CLIENT
MTV Networks

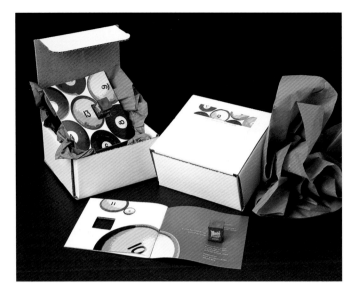

CREATIVE FIRM
BarrettLaidlawGervais
Coral Gables (Florida), USA
CREATIVES
David Laidlaw
CLIENT
Everett Laidlaw

CREATIVE FIRM
Sudler & Hennessey
North Sydney, Australia
CREATIVES
Bob Lallamant, Peter Ryan,
Huw Edwards
CLIENT
Sudler & Hennessey

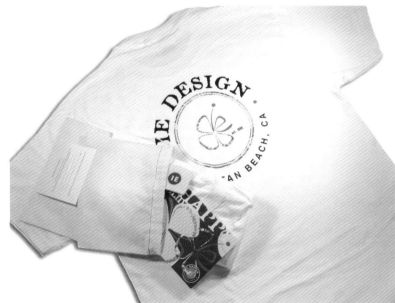

CREATIVE FIRM
IE Design
Manhattan Beach (California), USA
CREATIVES
Amy Klass, Marcie Carson
CLIENT
I E Design

237

CREATIVE FIRM
Mires
San Diego (California), USA
CREATIVES
John Ball, Miguel Perez
CLIENT
Mires

peace

CREATIVE FIRM
**MTV Networks
Creative Services**
New York (New York),
USA
CREATIVES
Tina Chang,
John Farrar,
Scott Wadler,
Ken Saji,
Cynara Webb,
Cheryl Family
CLIENT
Besla

CREATIVE FIRM
Cave Images, Inc.
Boca Raton (Florida), USA
CREATIVES
Matt Cave, David Edmundson
CLIENT
Intellibrands

CREATIVE FIRM
David Carter Design Assoc.
Dallas (Texas), USA
CREATIVES
Donna Aldridge, Stephanie Burt,
Ashley Barron Mattocks
CLIENT
St. Joe/Arvida

CREATIVE FIRM
Mark Oliver, Inc.
Solvang (California), USA
CREATIVES
Mark Oliver
CLIENT
AYSO Soccer

CREATIVE FIRM
Capstone Studios
Coto de Caza (California), USA
CREATIVES
John T. Dismukes, Peter Greco,
Morgan Tomaiolo
CLIENT
Infogrames

CREATIVE FIRM
Sterling Group
New York (New York), USA
CREATIVES
Marcus Hewitt
CLIENT
Thresher Group

238

CREATIVE FIRM
Hull Creative Group
Boston (Massachusetts), USA
CREATIVES
Carolyn Colonna, Caryl Hull
CLIENT
Inmagic

CREATIVE FIRM
Capstone Studios, Inc.
Coto de Caza (California), USA
CREATIVES
John T. Dismukes
CLIENT
TheArtRocks.com

CREATIVE FIRM
McElveney & Palozzi Design Group, Inc.
Rochester (New York), USA
CREATIVES
Gloria Kreitzberg
CLIENT
McElveney & Palozzi Design Group, Inc.

CREATIVE FIRM
Recipe
Hong Kong, China
CREATIVES
Ben Lai
CLIENT
Ben Lai Creative

CREATIVE FIRM
David Carter Design Assoc.
Dallas (Texas), USA
CREATIVES
Stephanie Burt, Ashley Barron Mattocks
CLIENT
Hyatt Regency Huntington Beach

CREATIVE FIRM
Peg Faimon Design
Cincinnati (Ohio), USA
CREATIVES
Peg Faimon
CLIENT
Cincinnati Hill Christian Academy

CREATIVE FIRM
Hull Creative Group
Boston (Massachusetts), USA
CREATIVES
Amy Braddock, Carolyn Colonna,
Caryl Hull
CLIENT
Geac

CREATIVE FIRM
Mark Oliver, Inc.
Solvang (California), USA
CREATIVES
Mark Oliver, Tom Hennessy
CLIENT
Ocean Beauty Seafood

CREATIVE FIRM
Watts Design
South Melbourne, Australia
CREATIVES
Natasha Iskandar
CLIENT
Ancient Grains

239

CREATIVE FIRM
Page by Page Publishing
Katy (Texas), USA
CREATIVES
Carey Handley
CLIENT
A Personal Touch Errand Service

CREATIVE FIRM
Cave Images, Inc.
Boca Raton (Florida), USA
CREATIVES
David Edmundson, Matt Cave
CLIENT
Questinghound Technology

CREATIVE FIRM
Acme Communications, Inc.
New York (New York), USA
CREATIVES
Kiki Boucher
CLIENT
Michael Rubin Architects

CREATIVE FIRM
Acme Communications, Inc.
New York (New York), USA
CREATIVES
Kiki Boucher, Jon Livingston,
Jean Tuttle
CLIENT
The Roosevelt Investment Group

CREATIVE FIRM
Grafik Marketing Communication
Alexandria (Virginia), USA
CREATIVES
Michelle Mar, Lynn Umemoto
CLIENT
EastBanc

CREATIVE FIRM
Moby Dick Warszawa
Warsaw, Poland
CREATIVES
Marcin Kosiorowski, Sawomir Czyz
CLIENT
Nova Group

CREATIVE FIRM
Design Objectives Pte Ltd
Singapore
CREATIVES
Ronnie S C Tan
CLIENT
Asia Consulting Pte Ltd

CREATIVE FIRM
Denise Bosler Design
Phoenixville (Pennsylvania), USA
CREATIVES
Denise Bosler
CLIENT
Denise Bosler Design

CREATIVE FIRM
Brown
Regina (Saskatchewan), Canada
CREATIVES
Chris Anderson, Mike Woroniak
CLIENT
Caffeine Commercial Products

240

CREATIVE FIRM
Capstone Studios
Coto de Caza (California), USA
CREATIVES
John T. Dismukes, Paul Sherstobitoff
CLIENT
Harley-Davidson

CREATIVE FIRM
Design Guys
Minneapolis (Minnesota), USA
CREATIVES
Steven Sikora, Jerry Stenback
CLIENT
Leggett & Platt

CREATIVE FIRM
Arte-Final, Design & Pub. LDA
Lisbon, Portugal
CREATIVES
Autguio Autunes, Fernando Feiteiro
CLIENT
Dominó-Industrias Ceramics, S.A.

CREATIVE FIRM
Grafik Marketing Communication
Alexandria (Virginia), USA
CREATIVES
Michelle Mar, Judy Kirpich
CLIENT
USA Football

CREATIVE FIRM
Lazarus Design
Rockville (Maryland), USA
CREATIVES
Robin Lazarus Berlin
CLIENT
Commercial Windows Initiative

CREATIVE FIRM
Design Systemat
Philippines
CREATIVES
Belandre Nepomuceno
CLIENT
Lifestyle Engineering

CREATIVE FIRM
KOREK Studio
Warsaw, Poland
CREATIVES
Wojtek Korkuc
CLIENT
Funny Models Ltd.

CREATIVE FIRM
Sumo
Newcastle Upon Tyne, England
CREATIVES
Daniel Plant, Jim Richardson
CLIENT
Home Interactive

CREATIVE FIRM
Kiku Obata and Company
St. Louis (Missouri), USA
CREATIVES
Rich Nelson, Todd Mayberry
CLIENT
Faison

CREATIVE FIRM
Stan Gellman Graphic Design Inc.
St. Louis (Missouri), USA
CREATIVES
Jill Lampen, David Kendall,
Barry Tilson
CLIENT
St. Louis Regional Chamber & Growth Association

CREATIVE FIRM
Acme Communications, Inc.
New York (New York), USA
CREATIVES
Kiki Boucher, Andrea Ross Boyle
CLIENT
Mayflower National
Life Insurance Co.

CREATIVE FIRM
Pixallure Design
Mobile (Alabama), USA
CREATIVES
Joel Lamascus, Terry Edeker
CLIENT
Spanish Fort United Methodist Church

CREATIVE FIRM
Wolken Communica
Seattle (Washington), USA
CREATIVES
Kurt Wolken
CLIENT
Motivo

CREATIVE FIRM
Philippe Becker Design
San Francisco (California), USA
CREATIVES
Philippe Becker
CLIENT
Whole Foods Market

CREATIVE FIRM
Maremar Graphic Design
Bayamón (Puerto Rico), USA
CREATIVES
Marina Rivón
CLIENT
Ikon Benefits Group

motivo

CREATIVE FIRM
Sumo
Newcastle Upon Tyne, England
CREATIVES
Daniel Plant, Jim Richardson
CLIENT
Superkrush

CREATIVE FIRM
Kiku Obata and Company
St. Louis (Missouri), USA
CREATIVES
Amy Knopf
CLIENT
Body Aesthetic Identity

CREATIVE FIRM
KOREK Studio
Warsaw, Poland
CREATIVES
Wojtek Korkuc
CLIENT
Planet Book Ltd.

242

Superkrush

bodyaesthetic
plastic surgery & skincare center

CREATIVE FIRM
Interrobang Design Collabrative
Richmond (Vermont), USA
CREATIVES
Mark D. Sylvester
CLIENT
Repro Digital

CREATIVE FIRM
Design Objectives Pte Ltd
Singapore
CREATIVES
Ronnie S C Tan
CLIENT
Comfort Delgro Ltd

CREATIVE FIRM
Steven Skaggs
Louisville (Kentucky), USA
CREATIVES
Steven Skaggs
CLIENT
evensong/Classical Vocal Ensemble

REPRO
DIGITAL

COMFORTDELGRO

evensong

CREATIVE FIRM
Design Objectives Pte Ltd
Singapore
CREATIVES
Ronnie S C Tan
CLIENT
Singapore Post Ltd

CREATIVE FIRM
Tom Fowler, Inc.
Norwalk (Connecticut), USA
CREATIVES
Thomas G. Fowler
CLIENT
Gideon Cardozo Communications

CREATIVE FIRM
Sumo
Newcastle Upon Tyne, England
CREATIVES
Suzanne Evans, Daniel Plant
CLIENT
Premier Gardens

CREATIVE FIRM
**CA In-House
Creative Development**
Islandia (New York), USA
CREATIVES
Loren Moss Meyer, Paul Young
CLIENT
Computer Associates

CREATIVE FIRM
Wolken Communica
Seattle (Washington), USA
CREATIVES
Andrea Simons, Kurt Wolken
CLIENT
Oobas Mexican Grill

**going
p/aces
with ca**
Real Solutions.
Real Results.

CREATIVE FIRM
Kenneth Diseño
Michoacan, Mexico
CREATIVES
Kenneth Treviño
CLIENT
El Pedal Bicycle Shop

CREATIVE FIRM
Oakley Design Studios
Portland (Oregon), USA
CREATIVES
Tim Oakley
CLIENT
Russ Auto Group

CREATIVE FIRM
Yellobee Studio
Atlanta, (Georgia), USA
CREATIVES
Alison Scheel
CLIENT
Center for Puppetry Arts

CREATIVE FIRM
Philippe Becker Design
San Francisco (California), USA
CREATIVES
Scott Sawyer, Philippe Becker
CLIENT
Buddy Rhodes Studio

CREATIVE FIRM
x_ design
Mexico
CREATIVES
Pilar Muñoz
CLIENT
Cafe Gourmet

CREATIVE FIRM
The Star Group
Cherry Hill (New Jersey), USA
CREATIVES
Jan Talamo, Dave Girgenti
CLIENT
American Federal Mortgage

CREATIVE FIRM
Purdue University
West Lafayette (Indiana), USA
CREATIVES
Li Zhang
CLIENT
Purdue University

CREATIVE FIRM
Grafik Marketing Communications
Alexandria (Virginia), USA
CREATIVES
Michelle Mar, Judy Kirpich
CLIENT
Market Salamander

244

CREATIVE FIRM
Design Objectives Pte Ltd
Singapore
CREATIVES
Ronnie S C Tan
CLIENT
Grace Baptist Church

CREATIVE FIRM
Thompson & Company
Memphis (Tennessee), USA
CREATIVES
Michael Thompson, Conroy Lam
CLIENT
713 Ducks Club

CREATIVE FIRM
TD2, S.C.
Mexico
CREATIVES
Rafael Treviño, Rafael Rodrigo Cordova
CLIENT
Printegra

CREATIVE FIRM
Gunnar Swanson Design Office
Ventura (California), USA
CREATIVES
Gunnar Swanson
CLIENT
California State Polytechnic
University Pomona

CREATIVE FIRM
Richard Zeid Design
Evanston (Illinois), USA
CREATIVES
Richard Zeid
CLIENT
Red Spade

CREATIVE FIRM
Acme Communications, Inc.
New York (New York), USA
CREATIVES
Kiki Boucher, Jon Livingston
CLIENT
Dirtworks, PC

RED SPADE™

DIRTWORKS, PC

LANDSCAPE ARCHITECTURE

CREATIVE FIRM
Octavo Designs
Frederick (Maryland), USA
CREATIVES
Sue Hough, Mark Burrier
CLIENT
National Association of School Psychologists

CREATIVE FIRM
Oakley Design Studios
Portland (Oregon), USA
CREATIVES
Tim Oakley
CLIENT
Angela Bates • Massage

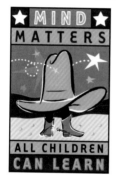

245

CREATIVE FIRM
Sumo
Newcastle Upon Tyne, England
CREATIVES
Daniel Plant, Suzanne Evans
CLIENT
EA Events

CREATIVE FIRM
Moby Dick Warszawa
Warsaw, Poland
CREATIVES
Malgorzata Ciepielak, Sawomir Czyz
CLIENT
Polska Zegluga Baltycka SA

CREATIVE FIRM
Kenneth Diseño
Michoacan, Mexico
CREATIVES
Kenneth Treviño
CLIENT
Avocado Exporters Assoc. of Michoacan

Polferries

CREATIVE FIRM
Acme Communications, Inc.
New York (New York), USA
CREATIVES
Kiki Boucher
CLIENT
Crew Construction Corp.

CREATIVE FIRM
Cannonball Adv. & Design
Fremont (California), USA
CREATIVES
Patrick Doyle, Jason Carter
CLIENT
Jason Carter

CREATIVE FIRM
Denise Bosler Design
Phoenixville (Pennsylvania), USA
CREATIVES
Denise Bosler
CLIENT
Tsunami Dragons Dragon Boat
Racing Team

CREATIVE FIRM
Brown
Regina (Saskatchewan), Canada
CREATIVES
Dean Fleck, Mike Woroniak
CLIENT
Bennett Dunlop Ford

CREATIVE FIRM
Design Objectives Pte Ltd
Singapore
CREATIVES
Ronnie S C Tan
CLIENT
Singapore Post Ltd

246

CREATIVE FIRM
Wolken Communica
Seattle (Washington), USA
CREATIVES
Kurt Wolken
CLIENT
Spa Del Lago

CREATIVE FIRM
Kenneth Diseño
Michoacan, Mexico
CREATIVES
Kenneth Treviño
CLIENT
Industrial Mulsa Sa

CREATIVE FIRM
Kenneth Diseño
Michoacan, Mexico
CREATIVES
Kenneth Treviño
CLIENT
Dennis Pizza Restaurant

CREATIVE FIRM
Hornall Anderson Design Works, Inc.
Seattle (Washington), USA
CREATIVES
Jack Anderson, John Hornall, Henry Yiu,
Andrew Wicklund, Mark Popich
CLIENT
Hornall Anderson Design Works, Inc.

CREATIVE FIRM
Kellum McClain Inc.
New York (New York), USA
CREATIVES
Ron Kellum
CLIENT
Domus

CREATIVE FIRM
Lawrence & Ponder Ideaworks
Newport Beach (California), USA
CREATIVES
Lynda Lawrence, Marvie Blair
CLIENT
Western Growers Association

CREATIVE FIRM
Liquid Agency Inc.
San Jose (California), USA
CREATIVES
Robert Wong, Lance Kitagawa,
Alfredo Muccino
CLIENT
Rosa Pharmaceuticals

CREATIVE FIRM
Nucleus Designs
Bergenfield (New Jersey), USA
CREATIVES
Mike Azzarone
CLIENT
Dynasty Contracting Inc.

247

CREATIVE FIRM
Nesnadny + Schwartz
Cleveland (Ohio), USA
CREATIVES
Michelle Moehler, Mark Schwartz,
Teresa Snow, Joyce Nesnadny
CLIENT
Museum of Contemporary Art Cleveland

CREATIVE FIRM
Mortensen Design, Inc.
Mountain View (California), USA
CREATIVES
Helena Seo, Gordon Mortensen
CLIENT
CPP, Inc.

CREATIVE FIRM
Mike Salisbury, LLC
Venice (California), USA
CREATIVES
Mike Salisbury, Matt Bright
CLIENT
AMA

CREATIVE FIRM
Hornall Anderson Design Works, Inc.
Seattle (Washington), USA
CREATIVES
Jack Anderson, Kathy Saito, Henry Yiu,
Sonja Max, Gretchen Cook
CLIENT
aQuantive Corporation

CREATIVE FIRM
Methodologie
Seattle (Washington), USA
CREATIVES
Dale Hart, Mary Weisnewski
CLIENT
Entranco

CREATIVE FIRM
Capstone Studios, Inc.
Coto de Caza (California), USA
CREATIVES
John T. Dismukes, Paul Anselmi
CLIENT
Infogrames

aQuantive entranco.

CREATIVE FIRM
McElveney & Palozzi Design Group, Inc.
Rochester (New York), USA
CREATIVES
Gloria Kreitzberg, Studio Artists
CLIENT
McElveney & Palozzi Design Group, Inc.

CREATIVE FIRM
Liquid Agency Inc.
San Jose (California), USA
CREATIVES
Joshua Swanbeck, Charlotte Jones,
Alfredo Muccino
CLIENT
Business Inc.

248

SILICON VALLEY

biz
ink

CREATIVE FIRM
Penny Chuang Design
New York (New York), USA
CREATIVES
Penny Chuang
CLIENT
Upstairs Salon

CREATIVE FIRM
Pat Taylor Inc.
Washington (D.C.), USA
CREATIVES
Pat Taylor, GLM Design
CLIENT
Owens Optical Co.

CREATIVE FIRM
Seventwenty Group Advertising & Design
Indianapolis (Indiana), USA
CREATIVES
Eric Scudder, Dominic Jannazzo
CLIENT
Stutz Business Centers

CREATIVE FIRM
Kellum McClain Inc.
New York (New York), USA
CREATIVES
Ron Kellum
CLIENT
Creative Insurance Marketing

CREATIVE FIRM
Recipe
Hong Kong, China
CREATIVES
Ben Lai
CLIENT
Virtual Game

CREATIVE FIRM
Rassman Design
Denver (Colorado), USA
CREATIVES
John Rassman, Glen Hobbs
CLIENT
Denver Young Artists Orchestra

Schinnerer

CREATIVE FIRM
Prologix, Inc.
Aurora (Colorado), USA
CREATIVES
Pamela Cisneros, Christopher Cisneros
CLIENT
Prologix, Inc.

CREATIVE FIRM
Arte-Final, Design E Pub, LDA
Lisbon, Portugal
CREATIVES
António Antunes, Cristina Farinha,
Nuno Duque
CLIENT
Fazenda Amaragi-Recife-Brasil

249

CREATIVE FIRM
Recipe
Hong Kong, China
CREATIVES
Ben Lai
CLIENT
Explore (IT Business)

CREATIVE FIRM
www.clubfreelance.com
Beau Bassin, Mauritius
CREATIVES
Avinash Ramsurrun
CLIENT
Alzato

CREATIVE FIRM
Pisarkiewicz Mazur & Co.
New York (New York), USA
CREATIVES
Somsara Rielly, Michelle Zuláuf,
Mary Pisarkiewicz
CLIENT
Library of American Broadcasting

CREATIVE FIRM
Methodologie
Seattle (Washington), USA
CREATIVES
Leo Raymundo, Paul Nasenbeny,
Dale Hart, Sonja Brisson
CLIENT
SSA Marine

CREATIVE FIRM
Oakley Design Studios
Portland (Oregon), USA
CREATIVES
Tim Oakley
CLIENT
Physical Element

CREATIVE FIRM
Kellum McClain Inc.
New York (New York), USA
CREATIVES
Ron Kellum
CLIENT
Robin Road Software

250

CREATIVE FIRM
Parker/White
Carlsbad (California), USA
CREATIVES
Dylan T. Jones, Tracy Sabin
CLIENT
Centerpulse

CREATIVE FIRM
Rodgers Townsend
St. Louis (Missouri), USA
CREATIVES
Luke Partridge
CLIENT
Silver Mountain

CREATIVE FIRM
Recipe
Hong Kong, China
CREATIVES
Ben Lai
CLIENT
UNO

CREATIVE FIRM
Rubin Cordaro Design
Minneapolis (Minnesota), USA
CREATIVES
Jim Cordaro, Bruce Rubin
CLIENT
Rubin Cordaro Design

CREATIVE FIRM
Lee Design
San Diego (California), USA
CREATIVES
Christopher Lee
CLIENT
San Diego Asian
Film Festival

CREATIVE FIRM
Bobco Design Inc.
Aliso Viego (California), USA
CREATIVES
Bob Nenninger, Jay Gaylen
CLIENT
Imagine That. Picture This.
Advertising

CREATIVE FIRM
Mark Oliver, Inc.
Solvang (California), USA
CREATIVES
Mark Oliver, Harry Bates
CLIENT
Ocean Beauty Seafood

CREATIVE FIRM
Rassman Design
Denver (Colorado), USA
CREATIVES
John Rassman, Glen Hobbs
CLIENT
National Pro Fast Pitch

CREATIVE FIRM
Substance 151
Baltimore (Maryland), USA
CREATIVES
Ida Cheinman, Rick Salzman
CLIENT
d3cg

CREATIVE FIRM
Kellum McClain Inc.
New York (New York), USA
CREATIVES
Ron Kellum, Russell Hicks
CLIENT
Nickelodeon

251

CREATIVE FIRM
Rassman Design
Denver (Colorado), USA
CREATIVES
John Rassman, Glen Hobbs
CLIENT
Water World/STORM

CREATIVE FIRM
Parker/White
Carlsbad (California), USA
CREATIVES
Dylan T. Jones, Tracy Sabin
CLIENT
Centerpulse

CREATIVE FIRM
QCCG
San Diego (California), USA
CREATIVES
Christopher Lee, Grant Kroeger,
Steve Lim, Frank Bernas, Kathy Lopez
CLIENT
Qualcomm

CREATIVE FIRM
Roni Hicks & Associates
Carlsbad (California), USA
CREATIVES
Stephen Sharp, Tracy Sabin
CLIENT
Water Ridge

CREATIVE FIRM
Kellum McClain Inc.
New York (New York), USA
CREATIVES
Ron Kellum, Lisa Lloyd
CLIENT
HBO Network

CREATIVE FIRM
Rodgers Townsend
St. Louis (Missouri), USA
CREATIVES
Luke Partridge
CLIENT
Persona Non Grata

CREATIVE FIRM
Lawrence & Ponder Ideaworks
Newport Beach (California), USA
CREATIVES
Lynda Lawrence, Christina Bogussian,
Marvie Blair, Jim Bell, Bil Dicks
CLIENT
California Department of Alcohol
and Drug Programs

CREATIVE FIRM
Hornall Anderson Design Works, Inc.
Seattle (Washington), USA
CREATIVES
Jack Anderson, Gretchen Cook,
Kathy Saito
CLIENT
Truck Trax

252

CREATIVE FIRM
Sabingrafik, Inc.
Carlsbad (California), USA
CREATIVES
Tracy Sabin
CLIENT
San Pacifico

CREATIVE FIRM
Wa Mu Creative Services
Seattle (Washington), USA
CREATIVES
Brett Gadbois
CLIENT
Washington Mutual

CREATIVE FIRM
Tom Ventress Design
Nashville (Tennessee), USA
CREATIVES
Tom Ventress
CLIENT
Walker Foods

CREATIVE FIRM
Roni Hicks & Associates
Carlsbad (California), USA
CREATIVES
Stephen Sharp, Tracy Sabin
CLIENT
La Costa Greens

CREATIVE FIRM
D&W Studio
Szczecin, Poland
CREATIVES
Waldemar Wojciechowski
CLIENT
MW Bearings

CREATIVE FIRM
no.e studios
Gaithersburg (Maryland), USA
CREATIVES
Chris Hays
CLIENT
Cluttershrink

CREATIVE FIRM
David Carter Design Assoc.
Dallas (Texas), USA
CREATIVES
Stephanie Burt, Ashley Barron Mattocks
CLIENT
Hyatt Regency Huntington Beach

CREATIVE FIRM
Hornall Anderson Design Works, Inc.
Seattle (Washington), USA
CREATIVES
Jack Anderson, Andrew Wicklund,
Henry Yiu
CLIENT
Orivo

253

CREATIVE FIRM
flourish
Cleveland (Ohio), USA
CREATIVES
Steve Shuman, Christopher Ferranti,
Jing Lauengco, Henry Frey
CLIENT
AODK

CREATIVE FIRM
Liska + Associates, Inc.
Chicago (Illinois), USA
CREATIVES
Steve Liska
CLIENT
Creatas

CREATIVE FIRM
Franke + Fiorella
Minneapolis (Minnesota), USA
CREATIVES
Craig Franke, Leslie McDougall
CLIENT
Cargill

CREATIVE FIRM
Oakley Design Studios
Portland (Oregon), USA
CREATIVES
Tim Oakley, Gene Gratton
CLIENT
Metro Computerworks

CREATIVE FIRM
Design Systemat
Makati City, Philippines
CREATIVES
Belandre Nepomuceno
CLIENT
Phil. Townships, Inc. /
Fairways Tower

CREATIVE FIRM
Tangram Strategic Design
Novara, Italy
CREATIVES
Gianluca Barbero
CLIENT
Telecom & Capital Express

CREATIVE FIRM
Moby Dick Warszawa
Warsaw, Poland
CREATIVES
Marcin Kosiorowski, Slawomir Czyz
CLIENT
Arteria

CREATIVE FIRM
www.huthdesigns.com
Berne (New York), USA
CREATIVES
Jeffrey Huth
CLIENT
Jeffrey Huth

254

jeffrey huth

CREATIVE FIRM
Anjaro Designs
San Francisco (California), USA
CREATIVES
Jacques Rossouw, Annria Rossouw,
Kobie Swart
CLIENT
Annria Rossouw

CREATIVE FIRM
Greenhaus
Carlsbad (California), USA
CREATIVES
Craig Fuller, Tracy Sabin
CLIENT
Woodbury

CREATIVE FIRM
Hornall Anderson Design Works, Inc.
Seattle (Washington), USA
CREATIVES
Jack Anderson, Sonja Max,
Andrew Smith, Kathy Saito
CLIENT
Pace International

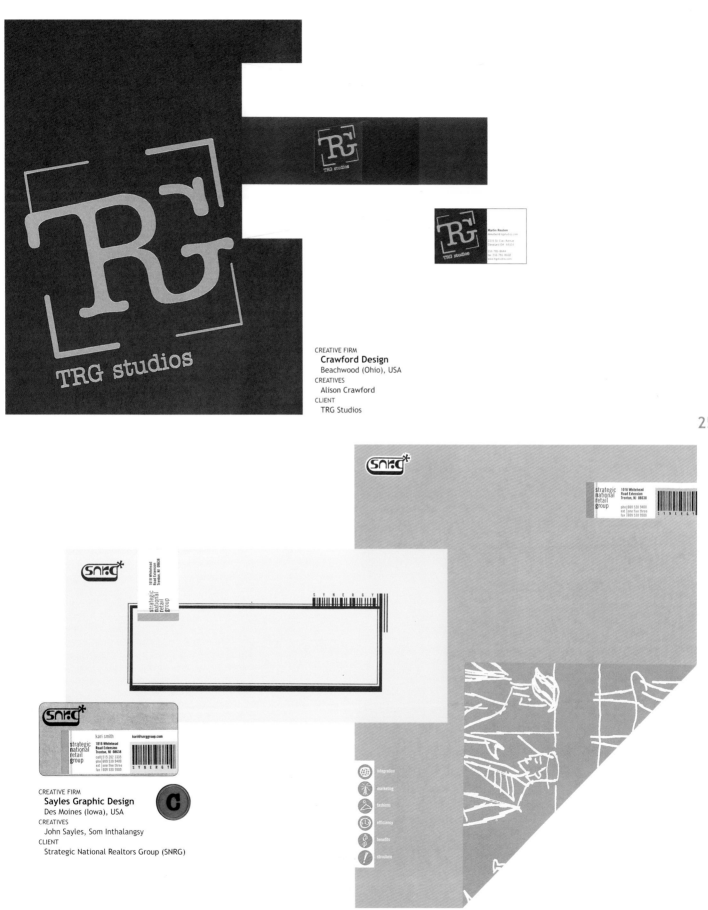

CREATIVE FIRM
Crawford Design
Beachwood (Ohio), USA
CREATIVES
Alison Crawford
CLIENT
TRG Studios

255

CREATIVE FIRM
Sayles Graphic Design
Des Moines (Iowa), USA
CREATIVES
John Sayles, Som Inthalangsy
CLIENT
Strategic National Realtors Group (SNRG)

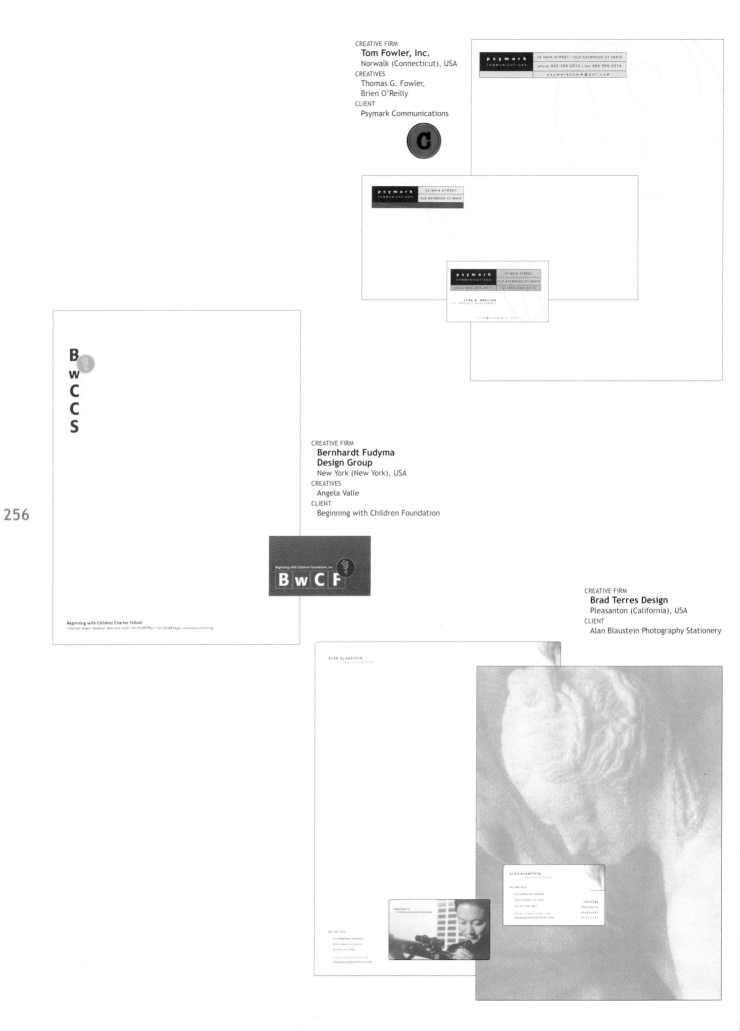

CREATIVE FIRM
Tom Fowler, Inc.
Norwalk (Connecticut), USA
CREATIVES
Thomas G. Fowler,
Brien O'Reilly
CLIENT
Psymark Communications

CREATIVE FIRM
**Bernhardt Fudyma
Design Group**
New York (New York), USA
CREATIVES
Angela Valle
CLIENT
Beginning with Children Foundation

CREATIVE FIRM
Brad Terres Design
Pleasanton (California), USA
CLIENT
Alan Blaustein Photography Stationery

256

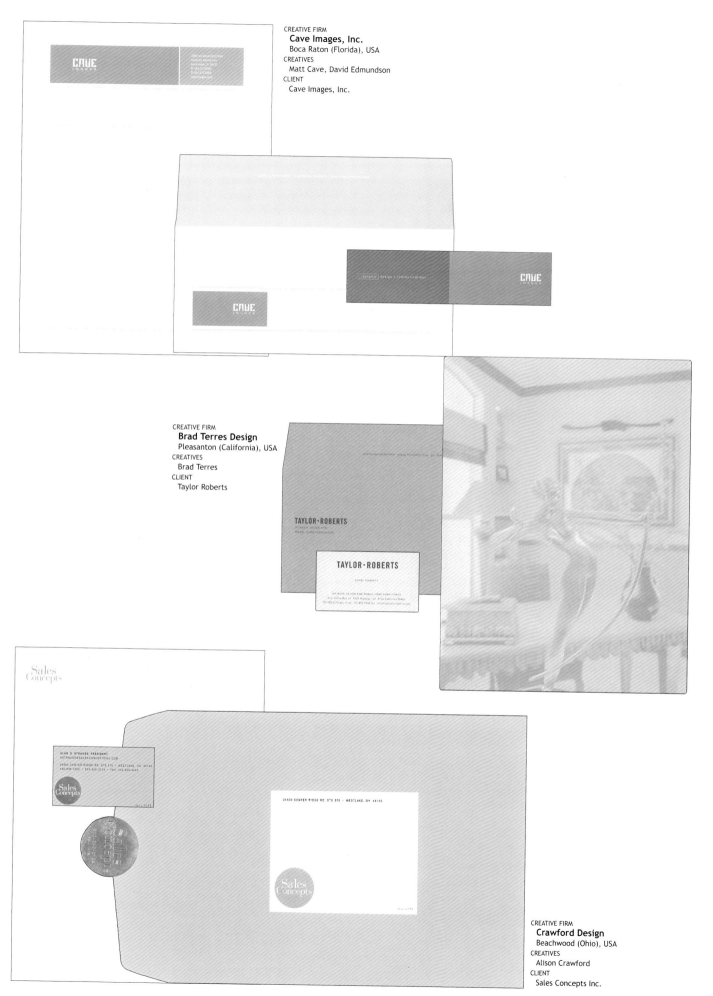

CREATIVE FIRM
Cave Images, Inc.
Boca Raton (Florida), USA
CREATIVES
Matt Cave, David Edmundson
CLIENT
Cave Images, Inc.

CREATIVE FIRM
Brad Terres Design
Pleasanton (California), USA
CREATIVES
Brad Terres
CLIENT
Taylor Roberts

257

CREATIVE FIRM
Crawford Design
Beachwood (Ohio), USA
CREATIVES
Alison Crawford
CLIENT
Sales Concepts Inc.

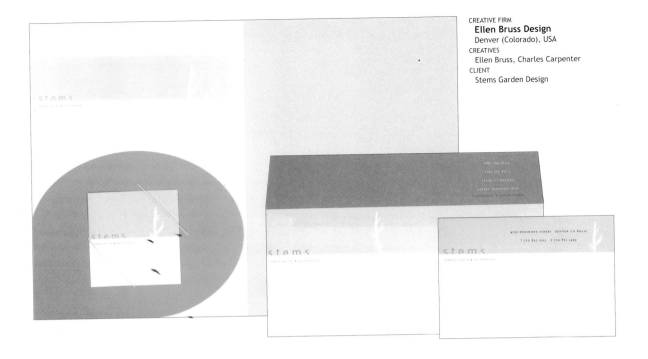

CREATIVE FIRM
Ellen Bruss Design
Denver (Colorado), USA
CREATIVES
Ellen Bruss, Charles Carpenter
CLIENT
Stems Garden Design

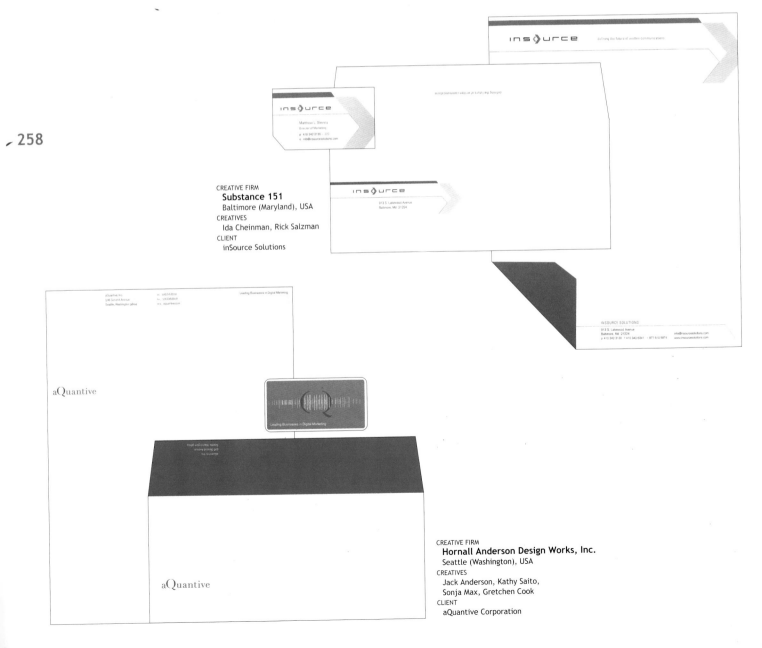

CREATIVE FIRM
Substance 151
Baltimore (Maryland), USA
CREATIVES
Ida Cheinman, Rick Salzman
CLIENT
inSource Solutions

CREATIVE FIRM
Hornall Anderson Design Works, Inc.
Seattle (Washington), USA
CREATIVES
Jack Anderson, Kathy Saito,
Sonja Max, Gretchen Cook
CLIENT
aQuantive Corporation

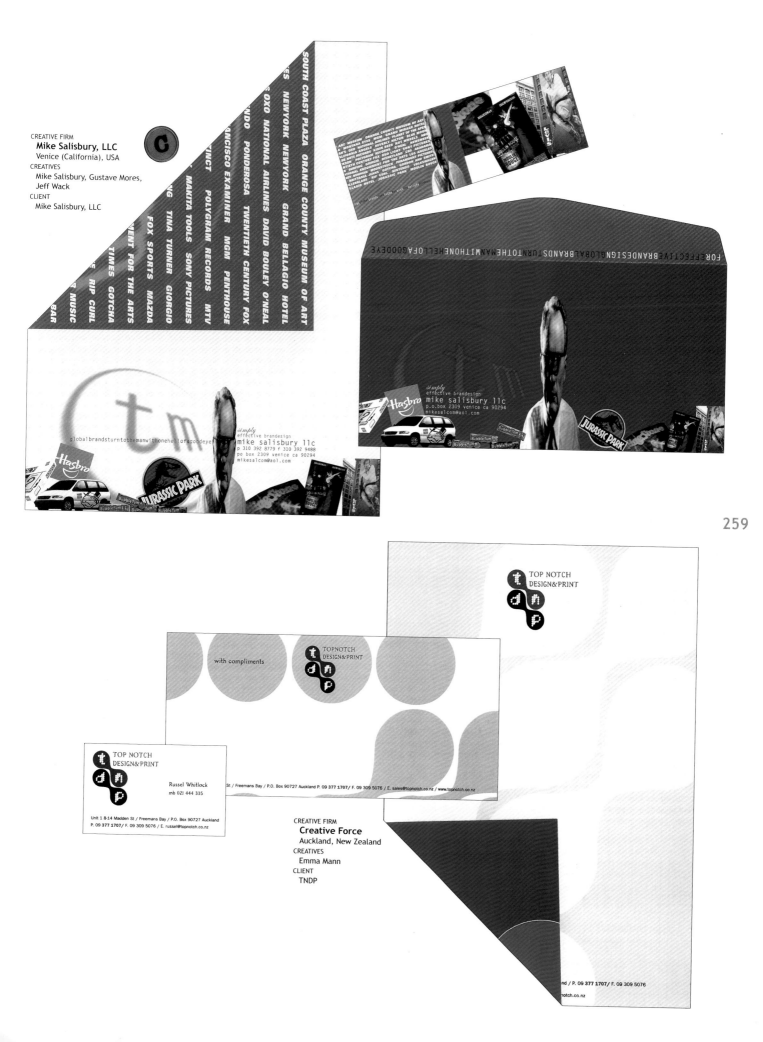

259

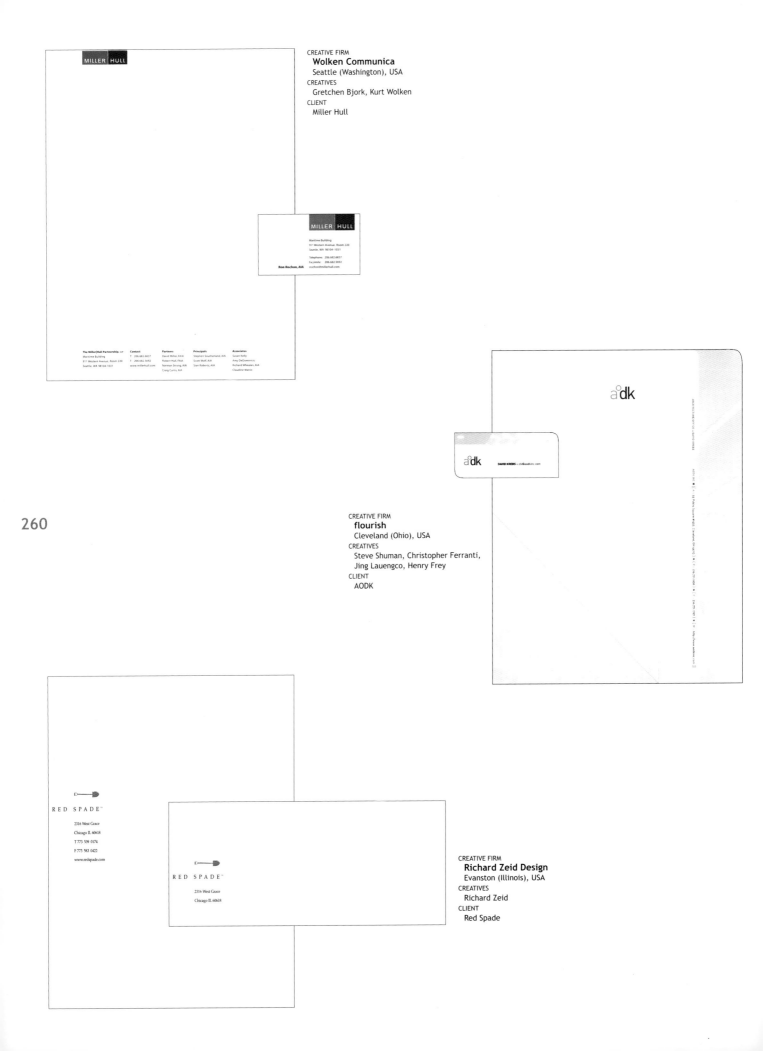

CREATIVE FIRM
Wolken Communica
Seattle (Washington), USA
CREATIVES
Gretchen Bjork, Kurt Wolken
CLIENT
Miller Hull

260

CREATIVE FIRM
flourish
Cleveland (Ohio), USA
CREATIVES
Steve Shuman, Christopher Ferranti,
Jing Lauengco, Henry Frey
CLIENT
AODK

CREATIVE FIRM
Richard Zeid Design
Evanston (Illinois), USA
CREATIVES
Richard Zeid
CLIENT
Red Spade

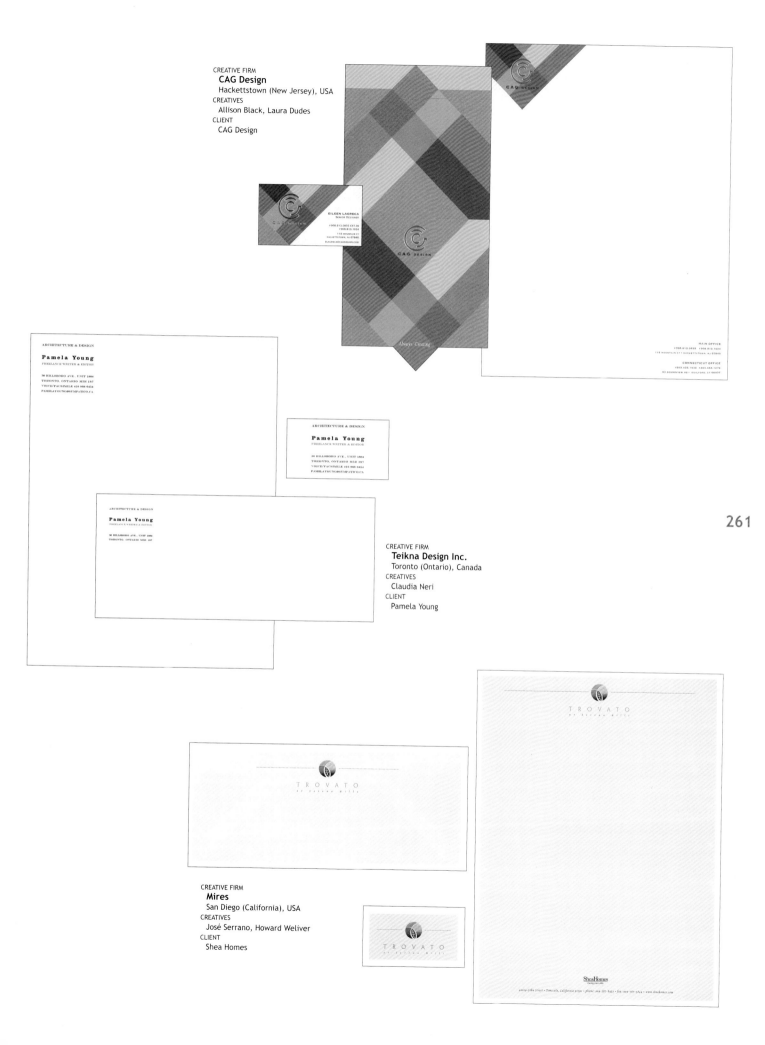

CREATIVE FIRM
CAG Design
Hackettstown (New Jersey), USA
CREATIVES
Allison Black, Laura Dudes
CLIENT
CAG Design

261

CREATIVE FIRM
Teikna Design Inc.
Toronto (Ontario), Canada
CREATIVES
Claudia Neri
CLIENT
Pamela Young

CREATIVE FIRM
Mires
San Diego (California), USA
CREATIVES
José Serrano, Howard Weliver
CLIENT
Shea Homes

CREATIVE FIRM
Mires
San Diego (California), USA
CREATIVES
Scott Mires, Jennifer Cadam,
Dan Thoner, Miguel Perez
CLIENT
Neill Archer Roan

3500 Q Street, #451, NW
Neill
Washington, DC 20007
Archer
archerroan@aol.com
Roan
202 338 0486

Neill
3500 Q Street, #451, NW
Archer
Washington, DC 20007
Roan

7979 Wisconsin Ave, Ste. 300
Neill
Bethesda, MD 20814
Archer
neill@neillarcherroan.com
Roan
301 654 0008

CREATIVE FIRM
Substance 151
Baltimore (Maryland), USA
CREATIVES
Ida Cheinman, Rick Salzman
CLIENT
Apex Search Engine
Marketing

Holland Area Arts Council
150 East 8th Street
Holland Michigan 49423
616 396 3278 fax 616 396 6298
www.hollandarts.org

HAAC Holland Area Arts Council
150 East 8th Street
Holland Michigan 49423
616 396 3278 fax 616 396 6298
www.hollandarts.org

CREATIVE FIRM
BBK Studio
Grand Rapids (Michigan), USA
CREATIVES
Kevin Budelmann, Alison Popp
CLIENT
Holland Area Arts Council (HAAC)

CREATIVE FIRM
Gouthier Design
Fort Lauderdale (Florida), USA
CREATIVES
Jonathan Gouthier, Kiley Del Valle
CLIENT
Gouthier Design

CREATIVE FIRM
Sherman Advertising
New York (New York), USA
CREATIVES
Sharon Lloyd McLaughlin,
William Touchet
CLIENT
Bozzuto Management

263

CREATIVE FIRM
The Garage
Birmingham (Michigan), USA
CREATIVES
Julie Pincus
CLIENT
McManamon Design
Consultants

CREATIVE FIRM
Mires
San Diego (California), USA
CREATIVES
José Serrano, Gale Spitzley,
Tavo Galindo, Anito Olmos
CLIENT
J.F. Shea Company

264

CREATIVE FIRM
**Hornall Anderson
Design Works, Inc.**
Seattle (Washington), USA
CREATIVES
John Hornall, Kathy Saito,
Henry Yiu
CLIENT
Erickson McGovern

CREATIVE FIRM
Wolken Communica
Seattle (Washington), USA
CREATIVES
Ryan Burlinson, Kurt Wolken
CLIENT
Bellevue Art Museum

CREATIVE FIRM
Anjaro Designs
San Francisco (California), USA
CREATIVES
Jacques Rossouw
CLIENT
Spirit of Life Institute

CREATIVE FIRM
AMP
Costa Mesa (California), USA
CREATIVES
Luis Camano, Carlos Musquez,
Lucas Risé
CLIENT
Beta Benefits Insurance

CREATIVE FIRM
Red Canoe
Deer Lodge (Tennessee), USA
CREATIVES
Deb Koch, Caroline Kavanagh,
Diana Marye Huff
CLIENT
The Catering Company

265

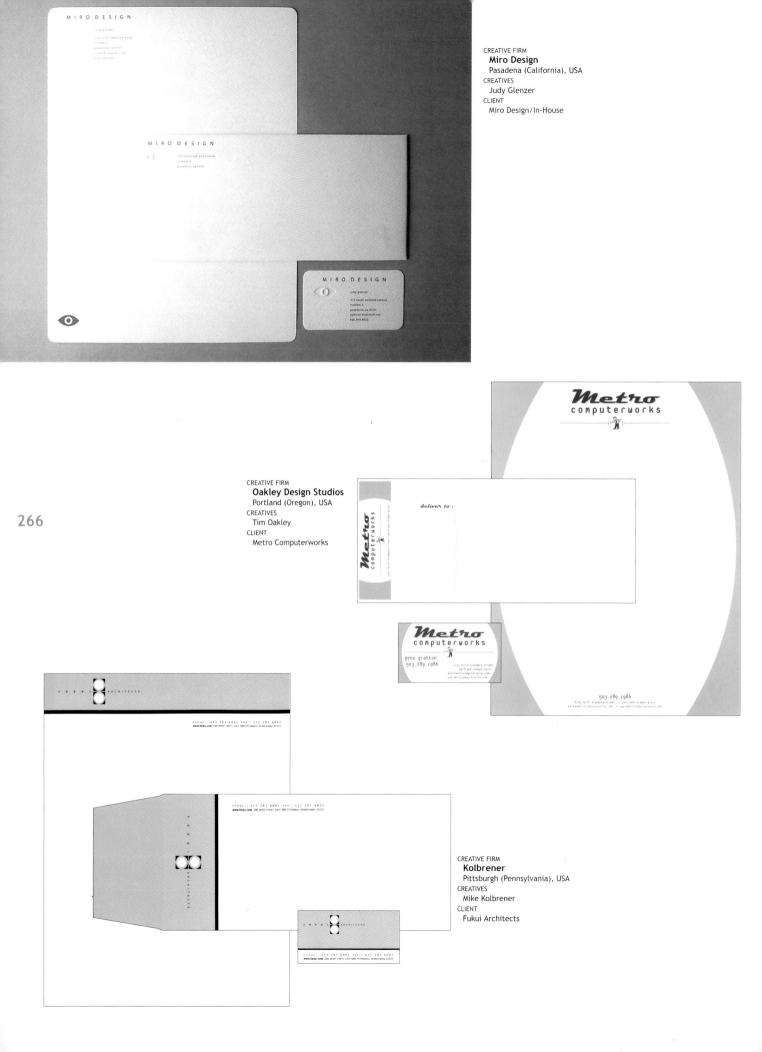

CREATIVE FIRM
Miro Design
Pasadena (California), USA
CREATIVES
Judy Glenzer
CLIENT
Miro Design/In-House

CREATIVE FIRM
Oakley Design Studios
Portland (Oregon), USA
CREATIVES
Tim Oakley
CLIENT
Metro Computerworks

266

CREATIVE FIRM
Kolbrener
Pittsburgh (Pennsylvania), USA
CREATIVES
Mike Kolbrener
CLIENT
Fukui Architects

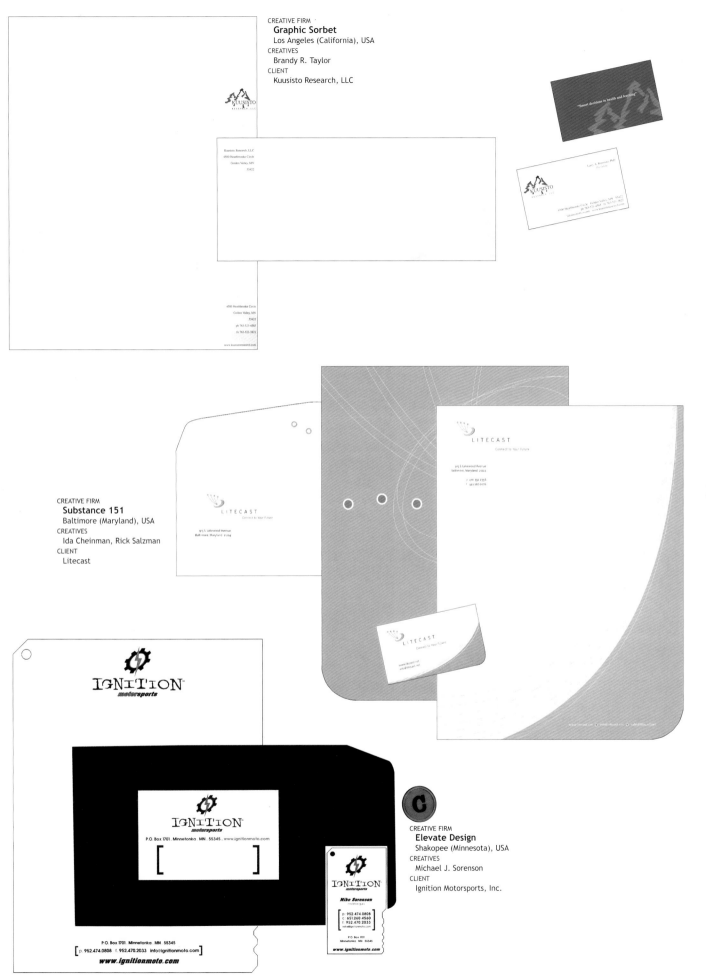

CREATIVE FIRM
Graphic Sorbet
Los Angeles (California), USA
CREATIVES
Brandy R. Taylor
CLIENT
Kuusisto Research, LLC

CREATIVE FIRM
Substance 151
Baltimore (Maryland), USA
CREATIVES
Ida Cheinman, Rick Salzman
CLIENT
Litecast

CREATIVE FIRM
Elevate Design
Shakopee (Minnesota), USA
CREATIVES
Michael J. Sorenson
CLIENT
Ignition Motorsports, Inc.

267

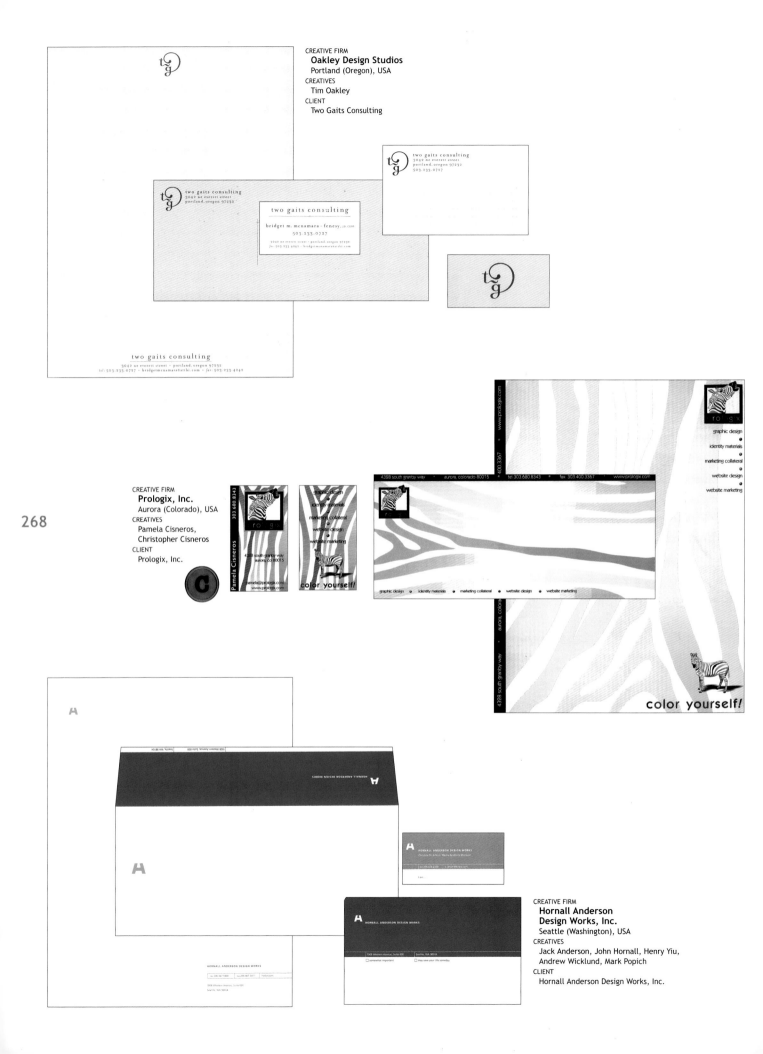

CREATIVE FIRM
Oakley Design Studios
Portland (Oregon), USA
CREATIVES
Tim Oakley
CLIENT
Two Gaits Consulting

two gaits consulting
3042 ne everett street
portland, oregon 97232
503.233.0727

two gaits consulting
3042 ne everett street
portland, oregon 97232

two gaits consulting

bridget m. mcnamara - fenesy, JD-CDFS

503.233.0727

3042 ne everett street · portland, oregon 97232
tel: 503.233.4247 · bridgetmcnamara@attbi.com

two gaits consulting
3042 ne everett street · portland, oregon 97232
tel: 503.233.0727 · bridgetmcnamara@attbi.com · fax: 503.233.4247

268

CREATIVE FIRM
Prologix, Inc.
Aurora (Colorado), USA
CREATIVES
Pamela Cisneros,
Christopher Cisneros
CLIENT
Prologix, Inc.

303.680.8343

graphic design
identity materials
marketing collateral
website design
website marketing

Pamela Cisneros

4328 south granby way
aurora, co 80015

pamela@prologix.com
www.prologix.com

color yourself!

www.prologix.com

303.400.3367

graphic design
identity materials
marketing collateral
website design
website marketing

4328 south granby way aurora, colorado 80015 tel: 303.680.8343 fax: 303.400.3367 www.prologix.com

graphic design ● identity materials ● marketing collateral ● website design ● website marketing

color yourself!

CREATIVE FIRM
Hornall Anderson
Design Works, Inc.
Seattle (Washington), USA
CREATIVES
Jack Anderson, John Hornall, Henry Yiu,
Andrew Wicklund, Mark Popich
CLIENT
Hornall Anderson Design Works, Inc.

HORNALL ANDERSON DESIGN WORKS

HORNALL ANDERSON DESIGN WORKS

HORNALL ANDERSON DESIGN WORKS

1008 Western Avenue, Suite 600
Seattle, WA 98104

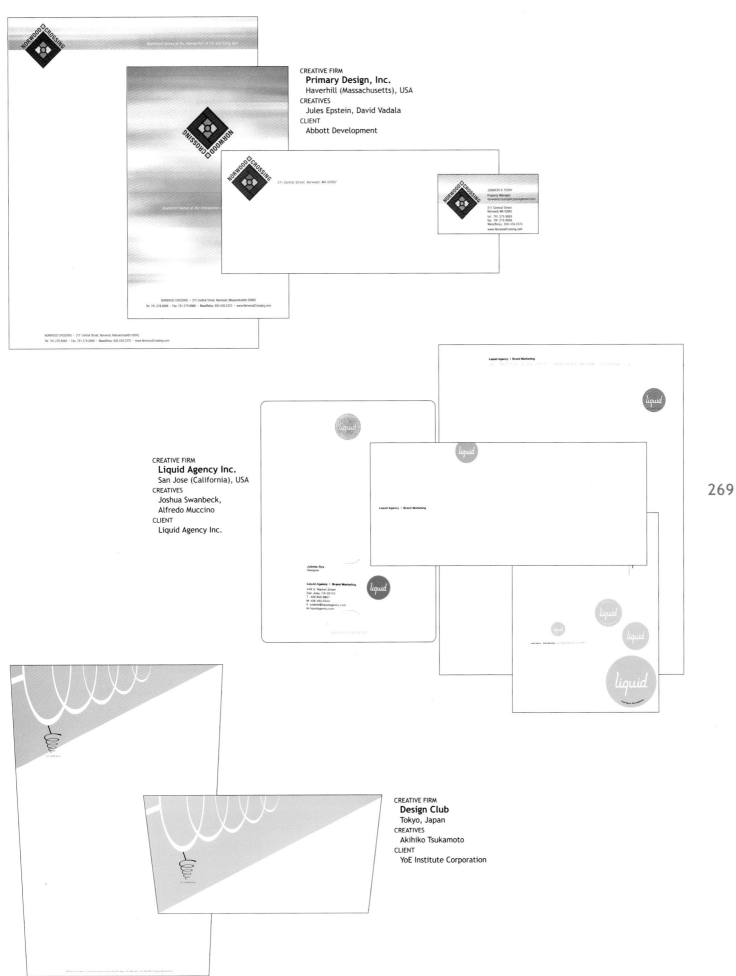

CREATIVE FIRM
Primary Design, Inc.
Haverhill (Massachusetts), USA
CREATIVES
Jules Epstein, David Vadala
CLIENT
Abbott Development

269

CREATIVE FIRM
Liquid Agency Inc.
San Jose (California), USA
CREATIVES
Joshua Swanbeck,
Alfredo Muccino
CLIENT
Liquid Agency Inc.

CREATIVE FIRM
Design Club
Tokyo, Japan
CREATIVES
Akihiko Tsukamoto
CLIENT
YoE Institute Corporation

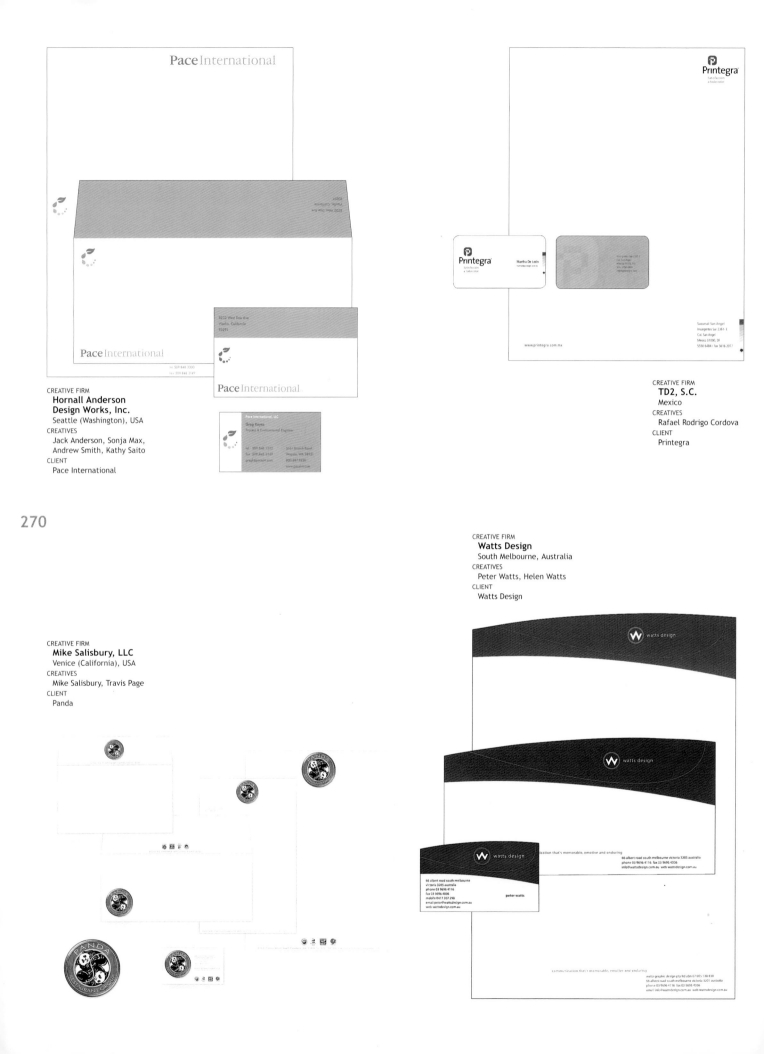

CREATIVE FIRM
**Hornall Anderson
Design Works, Inc.**
Seattle (Washington), USA
CREATIVES
Jack Anderson, Sonja Max,
Andrew Smith, Kathy Saito
CLIENT
Pace International

270

CREATIVE FIRM
TD2, S.C.
Mexico
CREATIVES
Rafael Rodrigo Cordova
CLIENT
Printegra

CREATIVE FIRM
Mike Salisbury, LLC
Venice (California), USA
CREATIVES
Mike Salisbury, Travis Page
CLIENT
Panda

CREATIVE FIRM
Watts Design
South Melbourne, Australia
CREATIVES
Peter Watts, Helen Watts
CLIENT
Watts Design

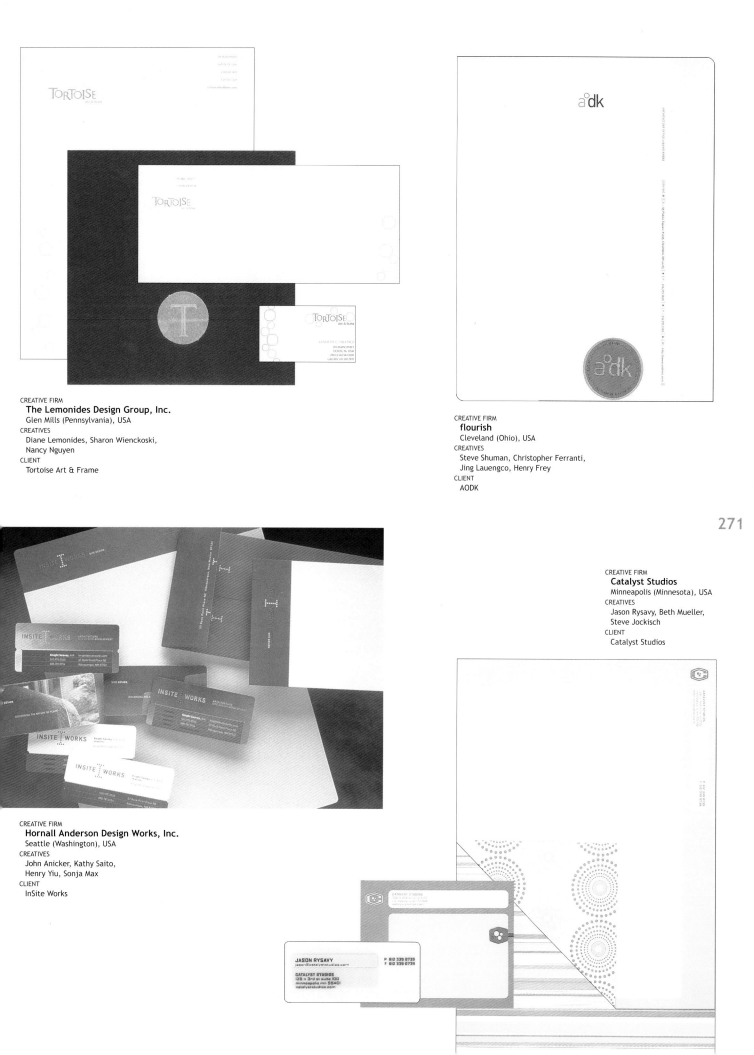

CREATIVE FIRM
The Lemonides Design Group, Inc.
Glen Mills (Pennsylvania), USA
CREATIVES
Diane Lemonides, Sharon Wienckoski,
Nancy Nguyen
CLIENT
Tortoise Art & Frame

CREATIVE FIRM
flourish
Cleveland (Ohio), USA
CREATIVES
Steve Shuman, Christopher Ferranti,
Jing Lauengco, Henry Frey
CLIENT
AODK

271

CREATIVE FIRM
Catalyst Studios
Minneapolis (Minnesota), USA
CREATIVES
Jason Rysavy, Beth Mueller,
Steve Jockisch
CLIENT
Catalyst Studios

CREATIVE FIRM
Hornall Anderson Design Works, Inc.
Seattle (Washington), USA
CREATIVES
John Anicker, Kathy Saito,
Henry Yiu, Sonja Max
CLIENT
InSite Works

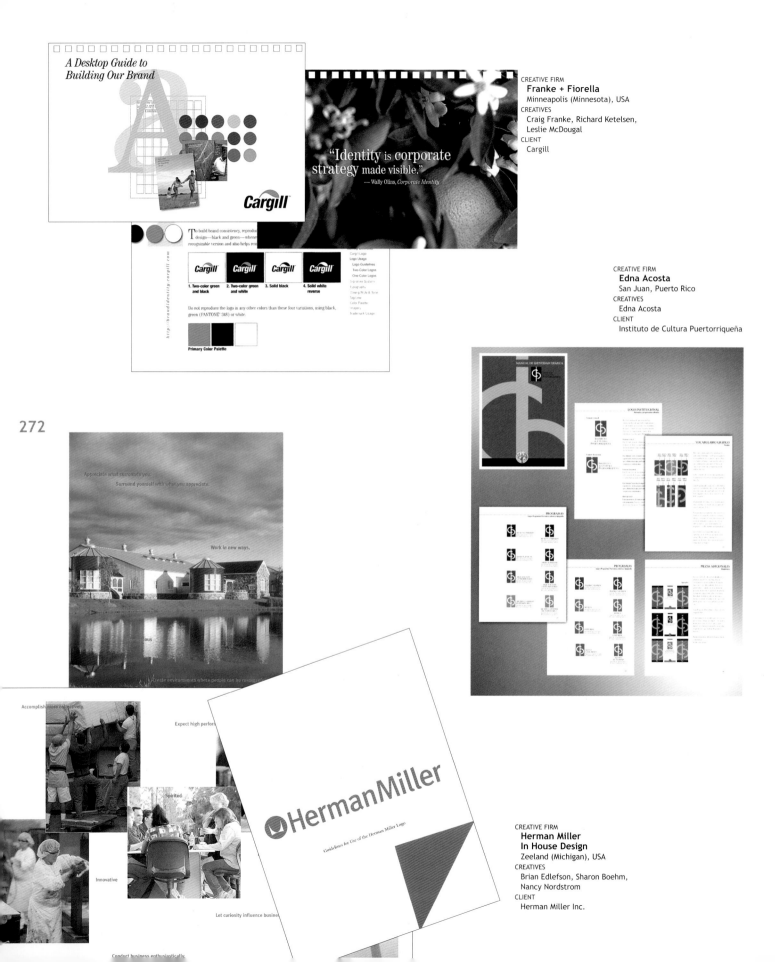

A Desktop Guide to
Building Our Brand

Cargill™

"Identity is corporate
strategy made visible."
— Wally Olins, *Corporate Identity*

To build brand consistency, reproduce the design—black and green—wherever possible. The recognizable version and also helps reinforce...

Cargill Cargill Cargill Cargill

1. Two-color green and black
2. Two-color green and white
3. Solid black
4. Solid white reverse

Do not reproduce the logo in any other colors than these four variations, using black, green (PANTONE® 348) or white.

Primary Color Palette

CREATIVE FIRM
Franke + Fiorella
Minneapolis (Minnesota), USA
CREATIVES
Craig Franke, Richard Ketelsen,
Leslie McDougal
CLIENT
Cargill

CREATIVE FIRM
Edna Acosta
San Juan, Puerto Rico
CREATIVES
Edna Acosta
CLIENT
Instituto de Cultura Puertorriqueña

272

Appreciate what surrounds you.
Surround yourself with what you appreciate.

Work in new ways.

Accomplish more collectively.

Expect high perfor...

Spirited

Innovative

Let curiosity influence busine...

Conduct business enthusiastically.

HermanMiller
Guidelines for Use of the Herman Miller Logo

CREATIVE FIRM
**Herman Miller
In House Design**
Zeeland (Michigan), USA
CREATIVES
Brian Edlefson, Sharon Boehm,
Nancy Nordstrom
CLIENT
Herman Miller Inc.

CREATIVE FIRM
Addison Whitney
Charlotte (North Carolina), USA
CREATIVES
Kimberlee Davis, David Houk,
Lisa Johnston
CLIENT
Net Bank

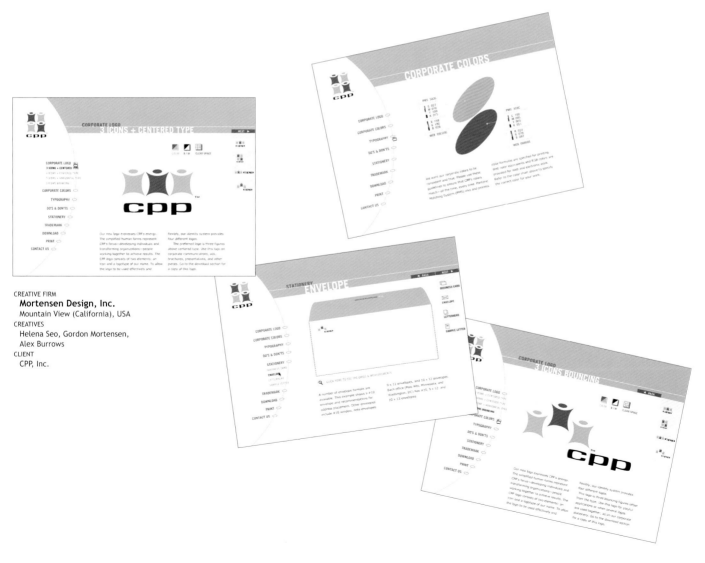

CREATIVE FIRM
Mortensen Design, Inc.
Mountain View (California), USA
CREATIVES
Helena Seo, Gordon Mortensen,
Alex Burrows
CLIENT
CPP, Inc.

274

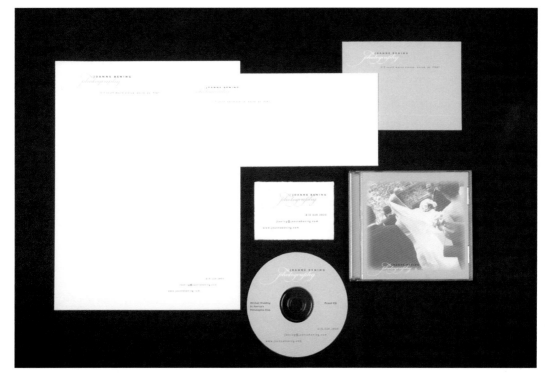

CREATIVE FIRM
Miro Design
Pasadena (California), USA
CREATIVES
Judy Glenzer, Joanne Bening,
Rick Wong/jmp design
CLIENT
Joanne Bening Photography

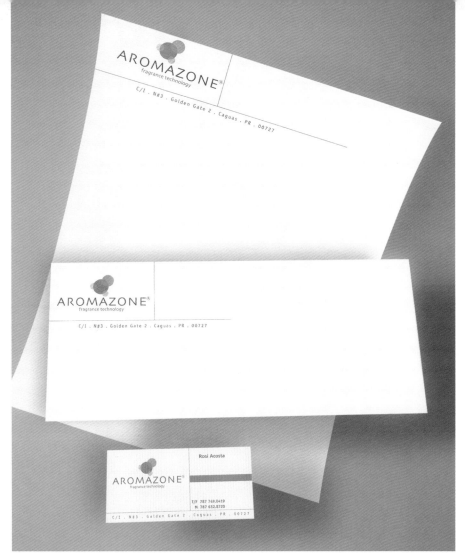

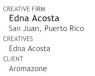

CREATIVE FIRM
Edna Acosta
San Juan, Puerto Rico
CREATIVES
Edna Acosta
CLIENT
Aromazone

275

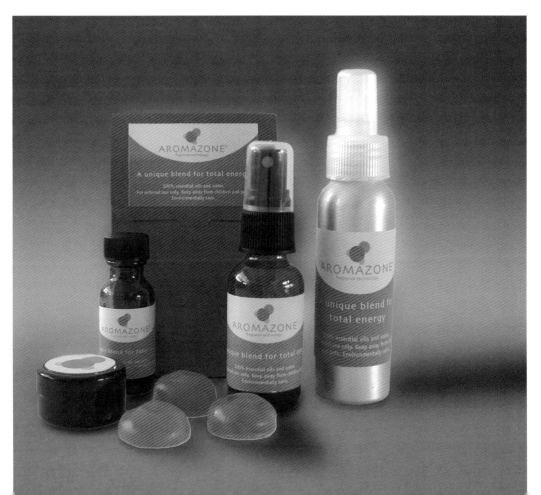

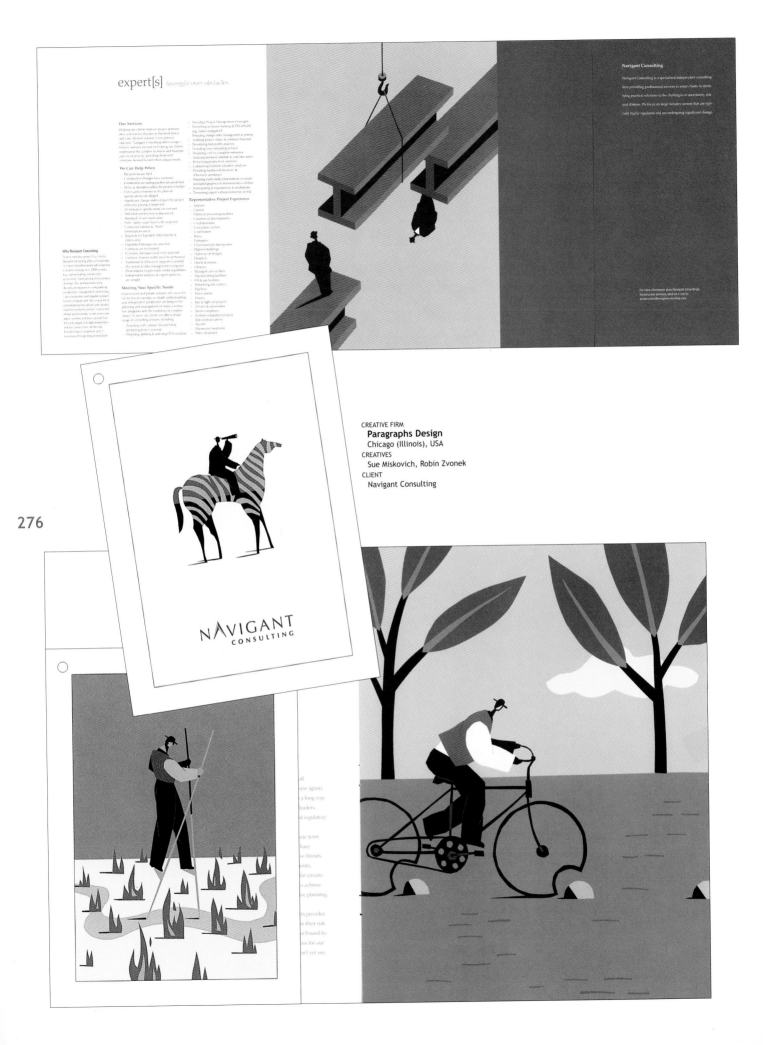

CREATIVE FIRM
Paragraphs Design
Chicago (Illinois), USA
CREATIVES
Sue Miskovich, Robin Zvonek
CLIENT
Navigant Consulting

276

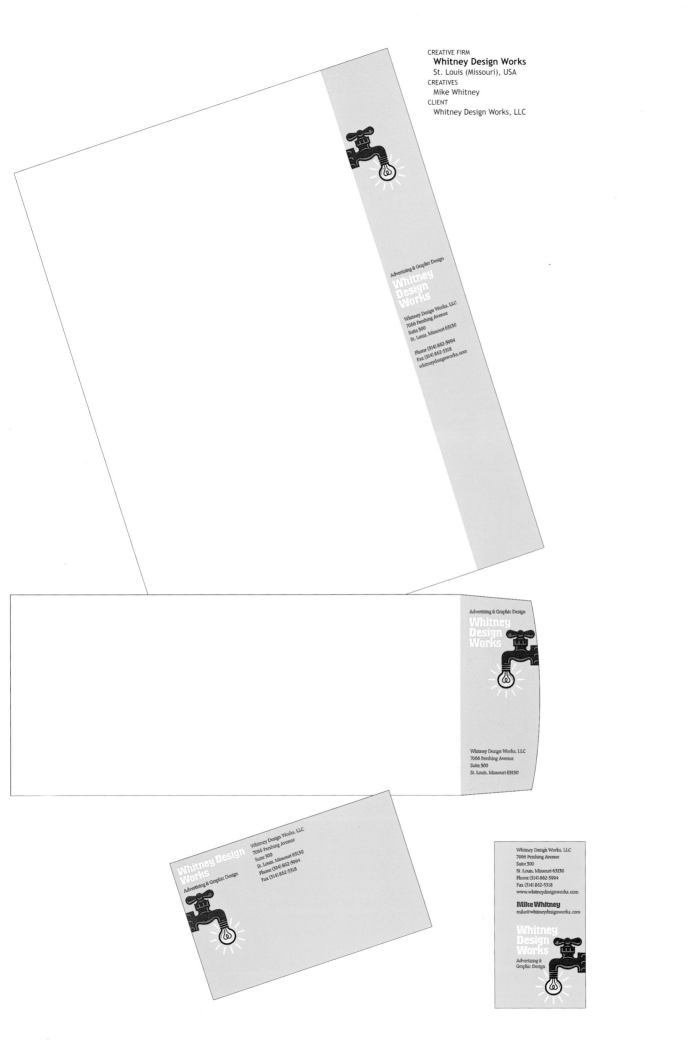

CREATIVE FIRM
Whitney Design Works
St. Louis (Missouri), USA
CREATIVES
Mike Whitney
CLIENT
Whitney Design Works, LLC

277

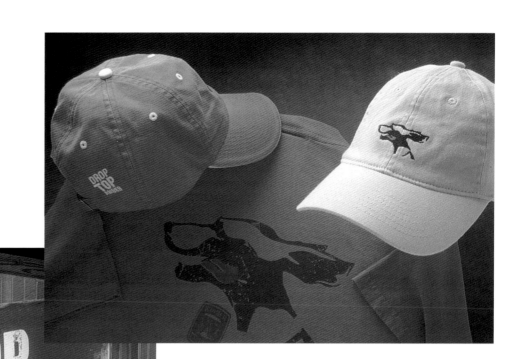

CREATIVE FIRM
Hornall Anderson Design Works, Inc.
Seattle (Washington), USA
CREATIVES
Jack Anderson, Larry Anderson, Jay Hilburn,
Elmer dela Cruz, Don Stayner, Bruce Stigler,
Dorothee Soechting
CLIENT
Widmer Brothers

278

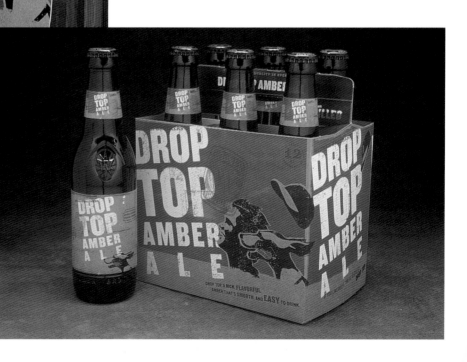

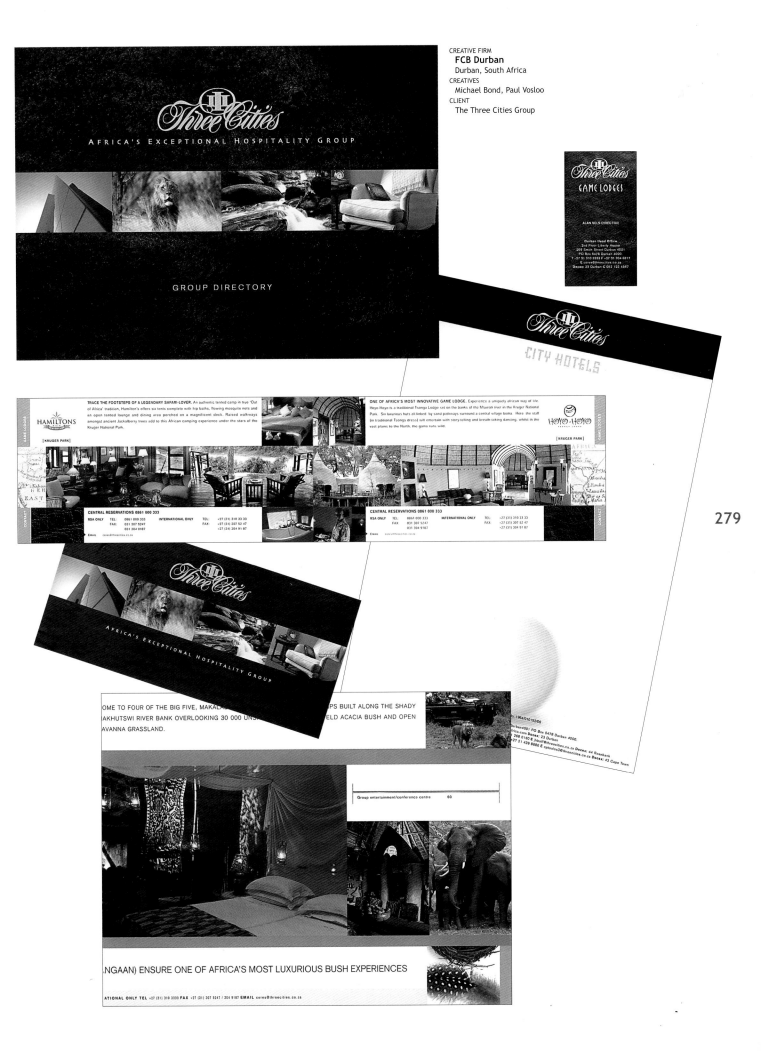

CREATIVE FIRM
FCB Durban
Durban, South Africa
CREATIVES
Michael Bond, Paul Vosloo
CLIENT
The Three Cities Group

GROUP DIRECTORY

279

TRACE THE FOOTSTEPS OF A LEGENDARY SAFARI-LOVER. An authentic tented camp in true 'Out of Africa' tradition, Hamilton's offers six tents complete with hip baths, flowing mosquito nets and an open tented lounge and dining area perched on a magnificent deck. Raised walkways amongst ancient Jackalberry trees add to this African camping experience under the stars of the Kruger National Park.

[KRUGER PARK]

ONE OF AFRICA'S MOST INNOVATIVE GAME LODGE. Experience a uniquely african way of life. Hoyo-Hoyo is a traditional Tsonga Lodge set on the banks of the Mluwati river in the Kruger National Park. Six luxurious huts all linked by sand pathways surround a central village boma. Here the staff (in traditional Tsonga dress) will entertain with story-telling and breath-taking dancing, whilst in the vast plains to the North, the game runs wild.

[KRUGER PARK]

CENTRAL RESERVATIONS 0861 000 333

RSA ONLY	TEL:	0861 000 333	INTERNATIONAL ONLY	TEL:	+27 (31) 310 33 33
	FAX:	031 307 5247		FAX:	+27 (31) 307 52 47
		031 304 9187			+27 (31) 304 91 87

EMAIL ceres@threecities.co.za

CENTRAL RESERVATIONS 0861 000 333

RSA ONLY	TEL:	0861 000 333	INTERNATIONAL ONLY	TEL:	+27 (31) 310 33 33
	FAX:	031 307 5247		FAX:	+27 (31) 307 52 47
		031 304 9187			+27 (31) 304 91 87

EMAIL ceres@threecities.co.za

OME TO FOUR OF THE BIG FIVE, MAKALA... ...PS BUILT ALONG THE SHADY
AKHUTSWI RIVER BANK OVERLOOKING 30 000 UNS... ...ELD ACACIA BUSH AND OPEN
AVANNA GRASSLAND.

| Group entertainment/conference centre | 60 |

...NGAAN) ENSURE ONE OF AFRICA'S MOST LUXURIOUS BUSH EXPERIENCES

...ATIONAL ONLY TEL +27 (31) 310 3333 FAX +27 (31) 307 5247 / 304 9187 EMAIL ceres@threecities.co.za

CREATIVE FIRM
Sayles Graphic Design
Des Moines (Iowa), USA
CREATIVES
John Sayles, Som Inthalangsy
CLIENT
Kirke Financial Services

280

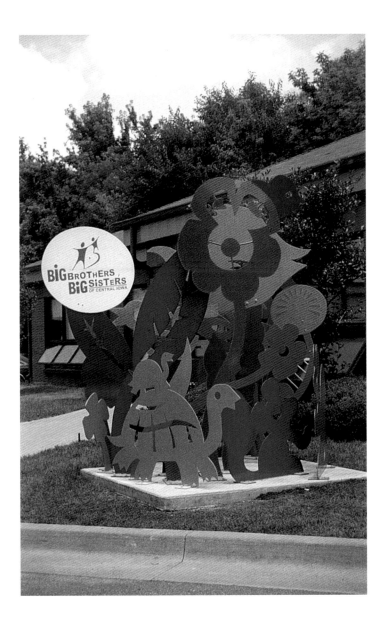

CREATIVE FIRM
Sayles Graphic Design
Des Moines (Iowa), USA
CREATIVES
John Sayles, Som Inthalangsy
CLIENT
Big Brothers Big Sisters of
Central Iowa

281

CREATIVE FIRM
Hornall Anderson Design Works, Inc.
Seattle (Washington), USA
CREATIVES
Jack Anderson, Larry Anderson, Jay Hilburn,
Elmer dela Cruz, Don Stayner, Bruce Stigler,
Dorothee Soechting
CLIENT
Widmer Brothers

282

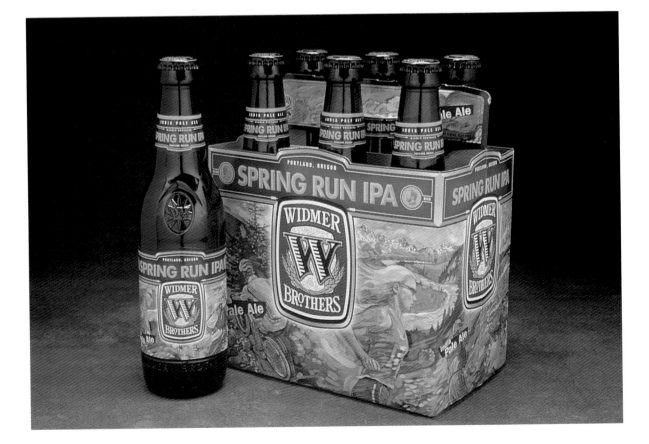

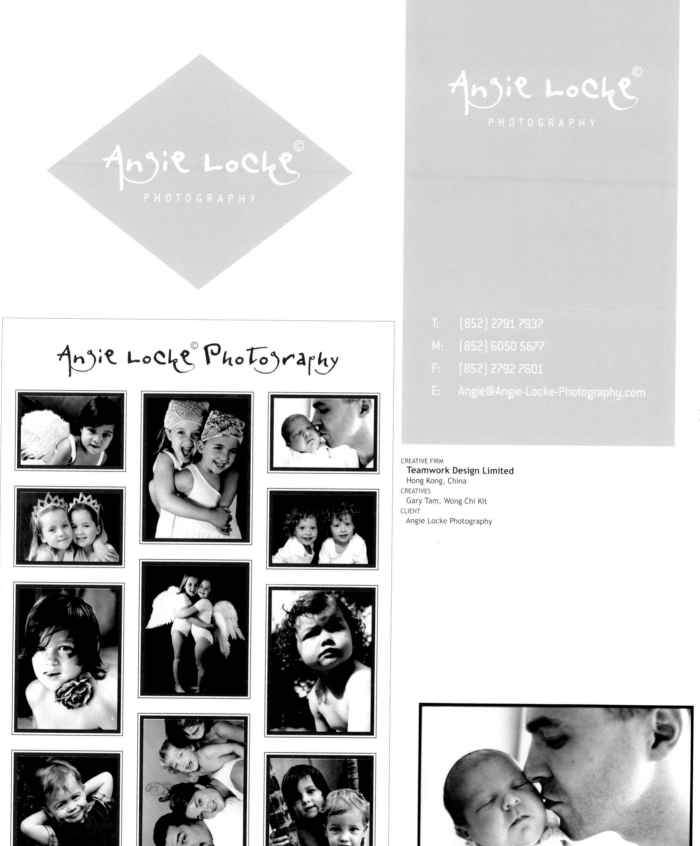

T: (852) 2791 7937
M: (852) 6050 5677
F: (852) 2792 7601
E: Angie@Angie-Locke-Photography.com

283

CREATIVE FIRM
Teamwork Design Limited
Hong Kong, China
CREATIVES
Gary Tam, Wong Chi Kit
CLIENT
Angie Locke Photography

284

CREATIVE FIRM
Federated Marketing Services (In-House)
New York (New York), USA
CREATIVES
Elizabeth Prinz, Hilda Wong
CLIENT
Federated Merchandising Group
(A division of Federated Department Stores)

285

CREATIVE FIRM
Lewis Moberly
London, England
CREATIVES
Mary Lewis, Paul Cilia La Corte
CLIENT
NABS

286

CREATIVE FIRM
Gouthier Design
Fort Lauderdale (Florida), USA
CREATIVES
Jonathan J. Gouthier, Kiltsy Del Valle
CLIENT
Saskia Ltd.

CREATIVE FIRM
Whitney Stinger, Inc.
St. Louis (Missouri), USA
CREATIVES
Mike Whitney, Karl Stinger
CLIENT
Hershey Import Co.

287

CREATIVE FIRM
Franke + Fiorella
Minneapolis (Minnesota), USA
CREATIVES
Craig Franke, Leslie McDougall,
Richard Ketelsen, Todd Monge
CLIENT
Cargill

CREATIVE FIRM
Whitney Stinger, Inc.
St. Louis (Missouri), USA
CREATIVES
Mike Whitney
CLIENT
Testa Renovations

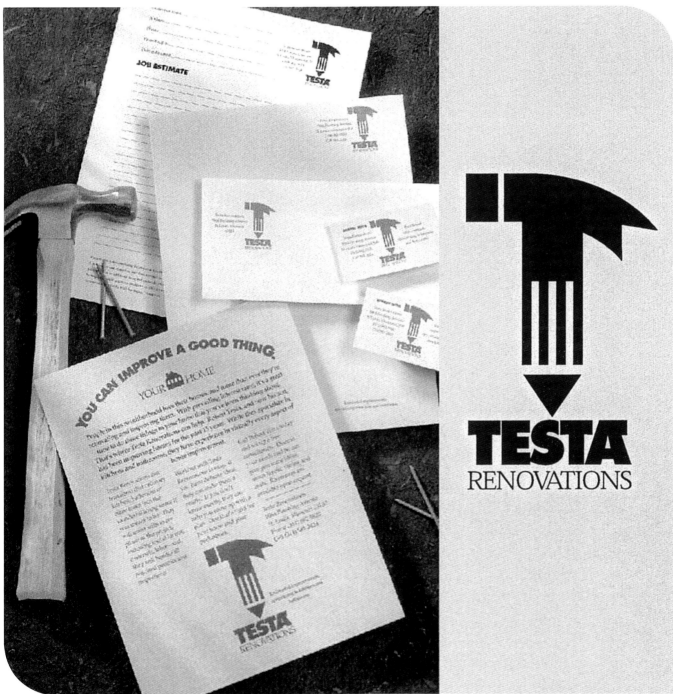

289

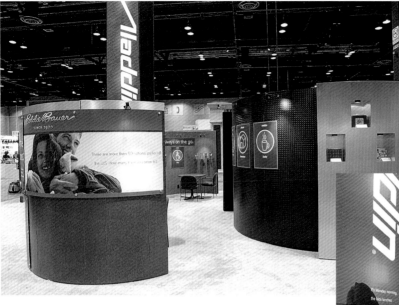

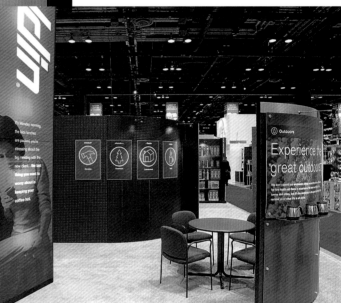

CREATIVE FIRM
Hornall Anderson Design Works, Inc.
Seattle (Washington), USA
CREATIVES
Jack Anderson, Andrew Wicklund,
Henry Yiu
CLIENT
PMI

290

CREATIVE FIRM
Shea, Inc.
Minneapolis (Minnesota), USA
CREATIVES
Holly Robbins, Mark Whitenack,
Jane Mjolsness
CLIENT
Marshall Field's

CREATIVE FIRM
The Star Group
Cherry Hill (New Jersey), USA
CREATIVES
Jan Talamo, Dave Girgenti
CLIENT
Bucks County Coffee Co.

CREATIVE FIRM
Wood Design
New York (New York), USA
CREATIVES
Tom Wood, Clint Bottoni
CLIENT
Louis Dreyfus

291

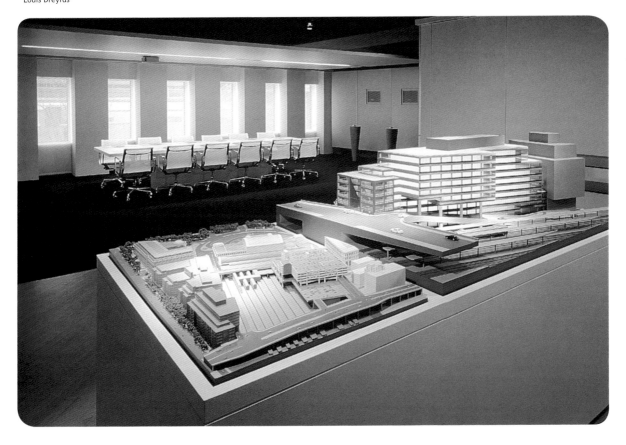

CREATIVE FIRM
Kiku Obata and Company
St. Louis (Missouri), USA
CREATIVES
Kiku Obata, Todd Mayberry, Rich Nelson, Troy Guzman,
Amber Elli, Denise Fuehne
CLIENT
Faison

CREATIVE FIRM
Octavo Designs
Frederick (Maryland), USA
CREATIVES
Sue Hough, Mark Burrier
CLIENT
OmnEssence

CREATIVE FIRM
Karen Skunta & Company
Cleveland (Ohio), USA
CREATIVES
Karen A. Skunta,
Christopher Suster,
Christopher D. Oldham
CLIENT
Town Hall of Cleveland

CREATIVE FIRM
Wallach Glass Studio
Santa Rosa (California), USA
CREATIVES
Christina Wallach, Eric Zammitt
CLIENT
Baylor College of Medicine

293

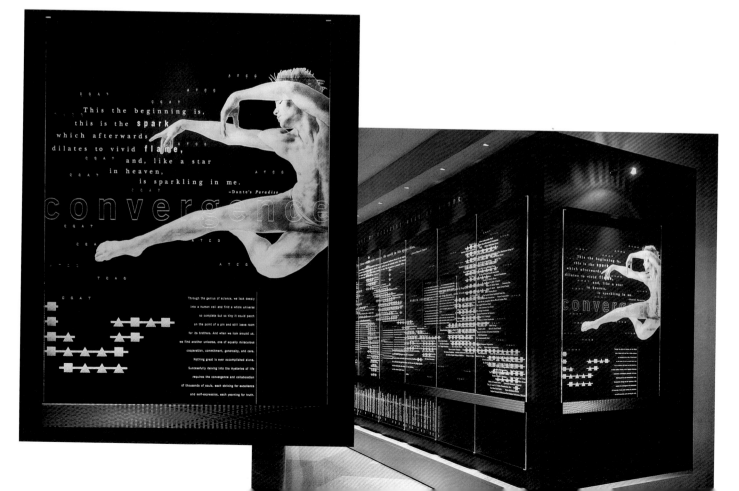

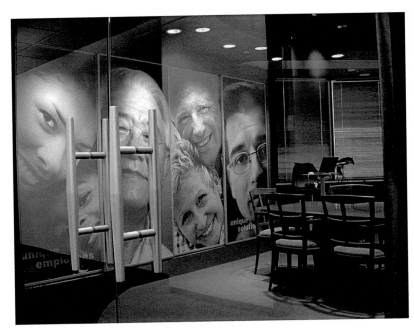

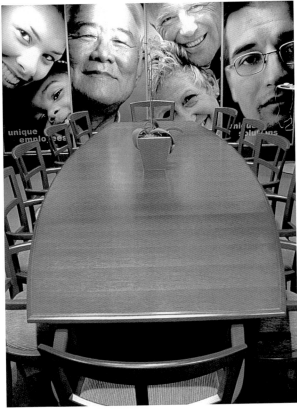

CREATIVE FIRM
flourish
Cleveland (Ohio), USA
CREATIVES
Christopher Ferranti, Henry Frey,
Les Kovach
CLIENT
Charles Schwab

294

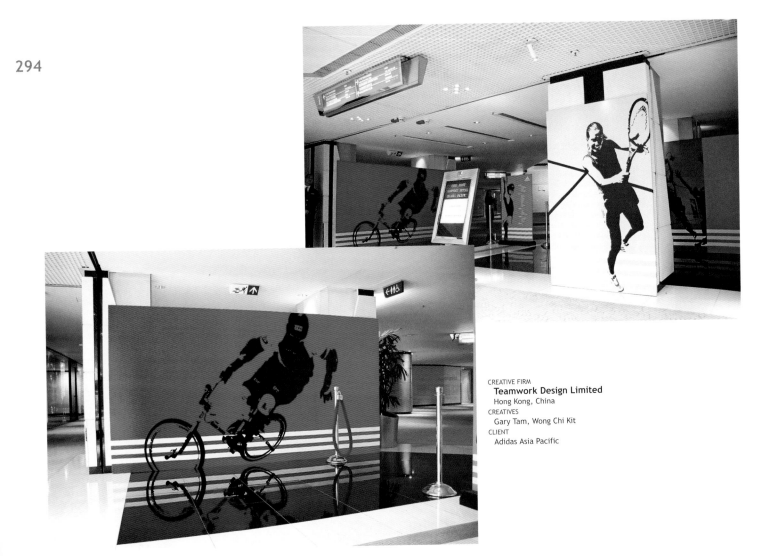

CREATIVE FIRM
Teamwork Design Limited
Hong Kong, China
CREATIVES
Gary Tam, Wong Chi Kit
CLIENT
Adidas Asia Pacific

CREATIVE FIRM
Ilium Associates
Bellevue (Washington), USA
CREATIVES
Chris Sandbeck, Lisa Lindsay,
Don Sellars
CLIENT
Trammell Crow Residential

295

CREATIVE FIRM
The Thompson Design Group
San Francisco (California), USA
CREATIVES
Dennis Thompson, Trevor Thompson,
Robert Evans, Gene Dupont
CLIENT
Nestlé USA, Inc.

CREATIVE FIRM
Dennis S. Juett & Associates
Pasadena (California), USA
CREATIVES
Dennis Scott Juett
CLIENT
Child & Family Center

296

CREATIVE FIRM
Teamwork Design Limited
Hong Kong, China
CREATIVES
Gary Tam, Wong Chi Kit
CLIENT
Adidas Asia Pacific

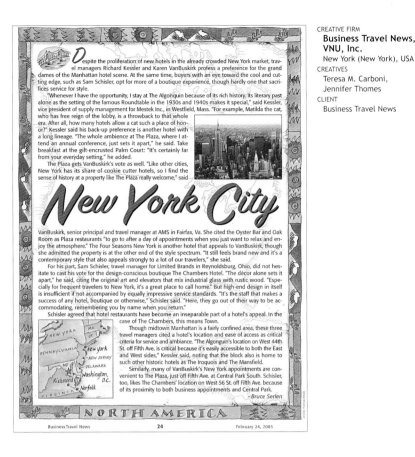

Despite the proliferation of new hotels in the already crowded New York market, travel managers Richard Kessler and Karen VanBuskirk profess a preference for the grand dames of the Manhattan hotel scene. At the same time, buyers with an eye toward the cool and cutting edge, such as Sam Schisler, opt for more of a boutique experience, though hardly one that sacrifices service for style.

"Whenever I have the opportunity, I stay at The Algonquin because of its rich history. Its literary past alone as the setting of the famous Roundtable in the 1930s and 1940s makes it special," said Kessler, vice president of supply management for Mestek Inc., in Westfield, Mass. "For example, Matilda the cat, who has free reign of the lobby, is a throwback to that whole era. After all, how many hotels allow a cat such a place of honor?" Kessler said his back-up preference is another hotel with a long lineage. "The whole ambience at The Plaza, where I attend an annual conference, just sets it apart," he said. Take breakfast at the gilt-encrusted Palm Court: "It's certainly far from your everyday setting," he added.

The Plaza gets VanBuskirk's vote as well. "Like other cities, New York has its share of cookie cutter hotels, so I find the sense of history at a property like The Plaza really welcome," said

New York City

VanBuskirk, senior principal and travel manager at AMS in Fairfax, Va. She cited the Oyster Bar and Oak Room as Plaza restaurants "to go to after a day of appointments when you just want to relax and enjoy the atmosphere." The Four Seasons New York is another hotel that appeals to VanBuskirk, though she admitted the property is at the other end of the style spectrum. "It's still feels brand new and it's a contemporary style that also appeals strongly to a lot of our travelers," she said.

For his part, Sam Schisler, travel manager for Limited Brands in Reynoldsburg, Ohio, did not hesitate to cast his vote for the design-conscious boutique The Chambers Hotel. "The décor alone sets it apart," he said, citing the original art and elevators that mix industrial glass with rustic wood. "Especially for frequent travelers to New York, it's a great place to call home." But high-end design in itself is insufficient if not accompanied by equally impressive service standards. "It's the staff that makes a success of any hotel, boutique or otherwise," Schisler said. "Here, they go out of their way to be accommodating, remembering you by name when you return."

Schisler agreed that hotel restaurants have become an inseparable part of a hotel's appeal. In the case of The Chambers, this means Town.

Though midtown Manhattan is a fairly confined area, these three travel managers cited a hotel's location and ease of access as critical criteria for service and ambiance. "The Algonquin's location on West 44th St. off Fifth Ave. is critical because it's easily accessible to both the East and West sides," Kessler said, noting that the block also is home to such other historic hotels as The Iroquois and The Mansfield.

Similarly, many of VanBuskirk's New York appointments are convenient to The Plaza, just off Fifth Ave. at Central Park South. Schisler, too, likes The Chambers' location on West 56 St. off Fifth Ave. because of its proximity to both business appointments and Central Park.

– Bruce Serlen

CREATIVE FIRM
Business Travel News, VNU, Inc.
New York (New York), USA
CREATIVES
Teresa M. Carboni, Jennifer Thomes
CLIENT
Business Travel News

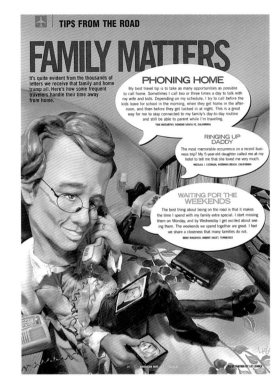

FAMILY MATTERS

It's quite evident from the thousands of letters we receive that family and home trump all. Here's how some frequent travelers handle their time away from home.

PHONING HOME

My best travel tip is to take as many opportunities as possible to call home. Sometimes I call two or three times a day to talk with my wife and kids. Depending on my schedule, I try to call before the kids leave for school in the morning, when they get home in the afternoon, and then before they get tucked in at night. This is a great way for me to stay connected to my family's day-to-day routine and still be able to parent while I'm traveling.
TOM MCCARTHY, RANCHO SANTA FE, CALIFORNIA

RINGING UP DADDY

The most memorable occurrence on a recent business trip? My 5-year-old daughter called me at my hotel to tell me that she loved me very much.
NICOLAS J. ESTRADA, REDONDO BEACH, CALIFORNIA

WAITING FOR THE WEEKENDS

The best thing about being on the road is that it makes the time I spend with my family extra special. I start missing them on Monday, and by Wednesday I get excited about seeing them. The weekends we spend together are great. I feel we share a closeness that many families do not.
BRAD WAGGONER, MOUNT JULIET, TENNESSEE

CREATIVE FIRM
American Way Magazine
Ft. Worth (Texas), USA
CREATIVES
Gilberto Mejia, Charles Stone, Liz Lomax
CLIENT
American Airlines Publishing

297

CREATIVE FIRM
Business Travel News, VNU, Inc.
New York (New York), USA
CREATIVES
Teresa M. Carboni, Mark Tuchman
CLIENT
Business Travel News

Let Me Count The Ways

This frequent traveler offers 10 reasons why Road Warriors stand out from the pack. Recognize a few?

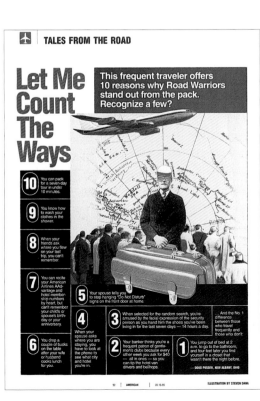

10 You can pack for a seven-day tour in under 10 minutes.

9 You know how to wash your clothes in the shower.

8 When your friends ask where you flew on your last trip, you can't remember.

7 You can recite your American AAdvantage and hotel membership numbers by heart, but can't remember your child's or spouse's birthday or your anniversary.

6 You drop a couple of bucks on the table after your wife or husband cooks your lunch for you.

5 Your spouse tells you to stop hanging "Do Not Disturb" signs on the front door at home.

4 When your spouse asks where you are staying, you have to look at the phone to see what city you are in.

3 When selected for the random search, you're amused by the facial expression of the security person as you hand him the shoes you've been living in for the last seven days — 14 hours a day.

2 Your banker thinks you're a frequent patron of gentlemen's clubs because every other week you ask for $40 — still in ones — so you can tip the van drivers and bellhops.

... And the No. 1 difference between those who travel frequently and those who don't:

1 You jump out of bed at 2 a.m. to go to the bathroom, and four feet later you find yourself in a closet that wasn't there the night before.

— DOUG PUSSER, NEW ALBANY, OHIO

CREATIVE FIRM
American Way Magazine
Ft. Worth (Texas), USA
CREATIVES
Gilberto Mejia, Marilyn Calley, Steven Dana
CLIENT
American Airlines Publishing

CREATIVE FIRM
Business Travel News
New York (New York), USA
CREATIVES
Teresa M. Carboni,
Glenn Mitsui
CLIENT
Business Travel News

298

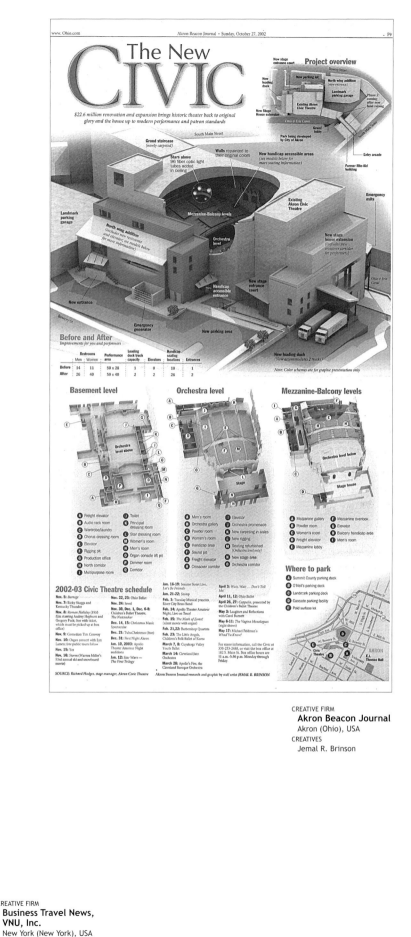

CREATIVE FIRM
Akron Beacon Journal
Akron (Ohio), USA
CREATIVES
Jemal R. Brinson

Situated north of what used to be Johannesburg's central business district and about 30 minutes away by car from Johannesburg International Airport, Sandton has emerged as the business hub of the city. The Johannesburg Stock Exchange is in Sandton, as are all the major local and foreign banking groups, such as Deutsche Bank, HSBC and Citibank.

While most of the hotels in and around Sandton are mid to upper upscale, the relative weakness of the South African currency—the rand, which is about 10:1 to both the dollar and the euro—makes them affordable for most overseas travelers.

Some of the best hotels in terms of location, state of the hotel and standard of living for the guest in and around Sandton are the Hilton-Sandton, Holiday Inn Crowne Plaza, Michelangelo, Protea Hotel Balalaika, Courtyard and the Sandton Sun and Towers InterContinental.

The old, but hip, suburb of Rosebank is about a five-minute drive from Sandton and boasts some of the best mid to upscale hotels in the whole of South Africa, including: the Park Hyatt Johannesburg, Grace Inn, Rosebank Hotel, Courtyard and the Don Rosebank.

The area that includes both Sandton and Rosebank is also where travelers will find most of the city's best restaurants, including: Assagi, which specializes in Italian food; Alexander's Deli, a kosher eatery in the trendy neighborhood of Norwood; Browns of Rivonia, which boasts an amazing wine list; and Cornutis, which serves some of the best pizza in town.

For ambiance, travelers should go to Cranks, a Thai-Vietnamese eatery whose decor will be as entertaining as the food will be delicious. For the best Joburg culinary experience, nothing beats Grama-doelas, which offers an exotic pan-African cuisine in the heart of Johannesburg's theatre district. Icon, a Greek restaurant, offers some refreshingly modern twists to Greek cuisine, while Karma offers the best in Indian food. The Butcher Shop and Grill offers the best steaks in the whole of Johannesburg.

For a slightly different, but more local culinary experience, travelers should try Wandi's Place, one of the most famous meeting places in Johannesburg, as the signatures and business cards on the walls of this popular joint attest. Situated in Soweto—Africa's largest township—Wandi's serves strictly traditional local African fare in a place free from pretension and airs.

Johannesburg does not have an excellent public transport system, but the city is well-served by a network of both public and private taxis. Public taxis are best left to the locals. Travelers will not be able to hail a cab on the street, but they can call a central number that their hotel will provide. Visitors also can rent a car if they so choose, but should always bear in mind that South Africa's driving rules are very similar to those of the United Kingdom, including on which side of the road to drive.

On the whole, South Africans tend to dress smart casual, meaning they will wear suits and shirts to business meetings, but not ties.

~Jacob Dlamini

Johannesburg

AFRICA

CREATIVE FIRM
**Business Travel News,
VNU, Inc.**
New York (New York), USA
CREATIVES
Teresa M. Carboni, Jennifer Thomes
CLIENT
Business Travel News

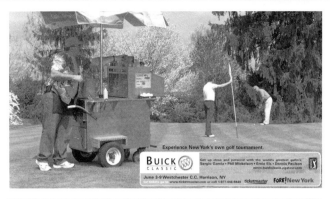

CREATIVE FIRM
Grey Worldwide N.Y.
New York (New York), USA
CREATIVES
Robert Skollar, Mark Catalina,
Brian Fallon
CLIENT
Buick Classics-Golf

CREATIVE FIRM
Graphiculture
Minneapolis (Minnesota), USA
CREATIVES
Cheryl Watson, Kevin White
CLIENT
Target

299

CREATIVE FIRM
MTV Networks Creative Services
New York (New York), USA
CREATIVES
David High, John Farrar, Scott Wadler,
Ken Saji, Cynara Webb, Cheryl Family
CLIENT
MTV Networks Public Responsibility

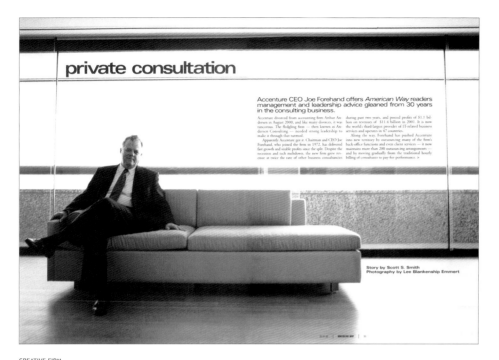

private consultation

Accenture CEO Joe Forehand offers *American Way* readers management and leadership advice gleaned from 30 years in the consulting business.

Accenture divested from accounting firm Arthur Andersen in August 2000, and like many divorces, it was rancorous. The fledgling firm — then known as Andersen Consulting — needed strong leadership to make it through that turmoil.

Apparently Accenture got it. Chairman and CEO Joe Forehand, who joined the firm in 1972, has delivered fast growth and sizable profits since the split. Despite the recession and tech meltdown, the new firm grew revenue at twice the rate of other business consultancies during past two years, and posted profits of $3.1 billion on revenues of $11.4 billion in 2001. It is now the world's third-largest provider of IT-related business services and operates in 47 countries.

Along the way, Forehand has pushed Accenture into new territory by outsourcing many of the firm's back-office functions and even client services — it now maintains more than 200 outsourcing arrangements — and by moving gradually from the traditional hourly billing of consultants to pay-for-performance. >

Story by Scott S. Smith
Photography by Lee Blankenship Emmert

CREATIVE FIRM
American Way Magazine
Ft. Worth (Texas), USA
CREATIVES
Gilberto Mejia, Betsy Semple,
Lee Emmert
CLIENT
American Airlines Publishing

300

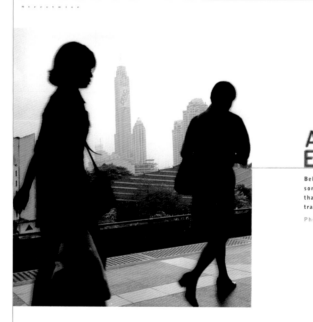

A Moving Experience

Believe it or not, Bangkok gets around, sometimes it just takes a little longer than it would elsewhere. That said, the transportation options are endless

Photography by Palani Mohan

CREATIVE FIRM
Popular Mechanics
New York (New York), USA
CREATIVES
Bryan Canniff
CLIENT
Popular Mechanics

CREATIVE FIRM
Emphasis Media Ltd.
Hong Kong, China
CREATIVES
Teresita Khaw, Davide Butson
CLIENT
Thai Airways

SCIENCE

New cameras
aboard the
Hubble Space
Telescope
reveal the
artistry that is
the universe.
BY JIM WILSON

CELESTIAL BEAUTY

If an incredible accident of time and space were to deposit Galileo Galilei in the 21st century, we would suggest he pay a visit to Keith Noll so that he could see how beautifully his pioneering work with telescopes has paid off. Noll heads NASA's Hubble Heritage Project. "The Hubble Space Telescope is a research tool dedicated to scientific studies of nature," he explains. "The Hubble Heritage Project sees this instrument also as a tool for extending human vision, one that is capable of building a bridge between the endeavors of scientists and the public." For nearly a decade, Hubble has been expanding our imaginations with spectacular images from the farthest reaches of space. Riding high above the **ASTRONOMY** light-distorting atmosphere that gives the stars their twinkle, Hubble is a key research tool for astronomers from around the world. Competition for telescope time is fierce and for some the wait has been years. But, as the colorized images here show, the payoff is stunning. "By emphasizing compelling Hubble images distilled from scientific data, we hope to pique curiosity about our astrophysical understanding of the universe we all inhabit," says Noll. You can see the

PLANETARY NEBULA
IC 418 *The Spirograph
Nebula is about 2000
light-years from Earth
in the direction of the
constellation Lepus. This
image was captured by
Hubble's Wide Field
Planetary Camera 2.*

HEART OF THE CRAB
NEBULA *In C.E. 1054,
Chinese astronomers
and American Indians
were startled by a new
star so bright it was visible
in daylight. Located about
6500 light-years from
Earth in the direction of
the constellation Taurus,
the object was the rem-
nant of a star that had
gone supernova.*

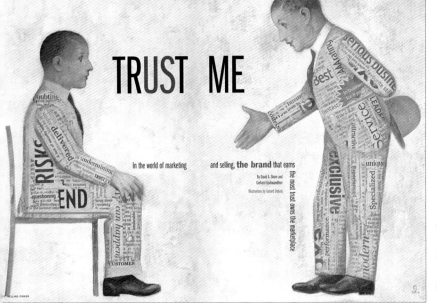

TRUST ME

In the world of marketing and selling, **the brand** that earns the most trust owns the marketplace

By David A. Shore and Gerhard Gschwandtner

Illustrations by Gerard DuBois

CREATIVE FIRM
Selling Power Magazine
Fredericksburg (Virginia), USA
CREATIVES
Colleen Quinnell, Tarver Harris,
Gerard DuBois
CLIENT
Selling Power Magazine

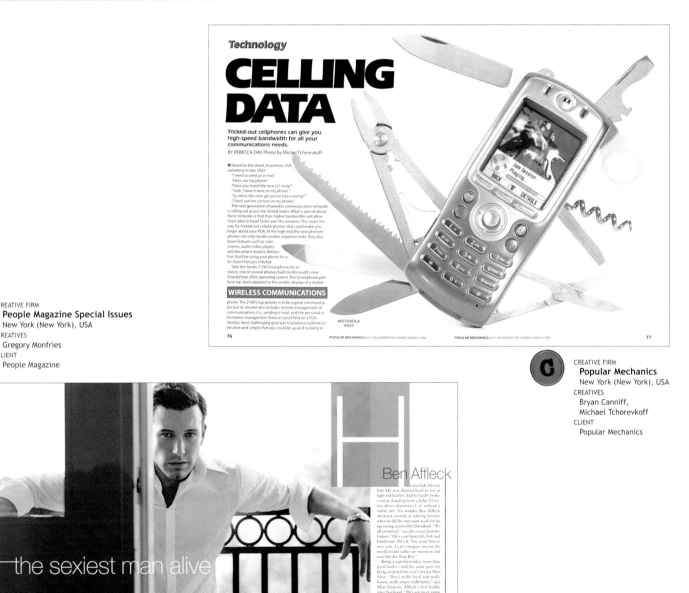

Technology

CELLING DATA

Tricked-out cellphones can give you high-speed bandwidth for all your communications needs.

BY REBECCA DAY, Photo by Michel Tcherevkoff

■ Heard on the street, Anywhere, USA, sometime in late 2002:
"I need to send an e-mail."
"Here, use my phone."
"Have you heard the new U2 song?"
"Yeah, I have it here on my phone."
"So who's this new gel you've been seeing?"
"Check out her picture on my phone."

The next generation of wireless communication networks is rolling out across the United States. What is special about these networks is that their higher bandwidths will allow more data to travel faster over the airwaves. This clears the way for tricked-out cellular phones that could make you forget about your PDA. At the high end, the new phenom phones not only handle routine organizer tasks, they also boast features such as color screens, audio/video players, and document readers. Bottom line: You'll be using your phone for a lot more than just chitchat.

Take the Sendo Z100 Smartphone, for instance, one of several phones built on Microsoft's new Smartphone 2002 operating system. The Smartphone platform has been adapted to the smaller display of a mobile

WIRELESS COMMUNICATIONS

phone. The Z100's top priority is to be a great communicator, but its resumé also includes remote management of communications (i.e., sending e-mail) and the personal information management features you'd find on a PDA. Sendo's most challenging goal was to produce a phone so intuitive and simple that you could be up and running in

MOTOROLA A820

POPULAR MECHANICS•JULY 2002•WWW.POPULARMECHANICS.COM 76

POPULAR MECHANICS•JULY 2002•WWW.POPULARMECHANICS.COM 77

CREATIVE FIRM
People Magazine Special Issues
New York (New York), USA
CREATIVES
Gregory Monfries
CLIENT
People Magazine

CREATIVE FIRM
Popular Mechanics
New York (New York), USA
CREATIVES
Bryan Canniff,
Michael Tchorevkoff
CLIENT
Popular Mechanics

Ben Affleck

the sexiest man alive

e was buff. He was bad. He was dressed head to toe in tight red leather. And he hardly broke a sweat dangling from a ledge 10 stories above downtown L.A. without a safety net. No wonder Ben Affleck attracted crowds of adoring females when he did his own stunt work for his upcoming action film *Daredevil*. "We all swooned," says his costar Jennifer Garner. "He's over basic tall, dark and handsome. He's it. You want him to save you. I can't imagine anyone the world would rather see swoop in and save the day than Ben."

Being a superhero takes more than good looks—and the same goes for being crowned this year's Sexiest Man Alive. "Ben's really loyal and really honest, really smart, really funny," says Matt Damon, Affleck's best buddy since boyhood. "He's got more going for him than just about anyone I've ever met."

The 30-year-old actor is also intriguingly complex. In private that big-screen big lunk (he's 6'2") displays impressive range: An easygoing charmer. A passionate political activist. An Oscar winner. A devoted son. A self-aware grown-up. A flirt. A brainiac. A goofball. A head-over-heels romantic.

And—perhaps you've heard—husband-to-be to a certain Jennifer Lopez. Despite the hullabaloo over the joined-at-the-lips stars' flashy four-month courtship—and much public clucking over Lopez's short-lived pair of previous marriages—those close to Affleck

Photographs by Tony Duran

74

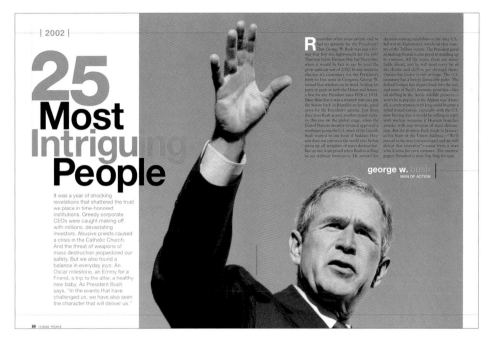

25 Most Intriguing People

It was a year of shocking revelations that shattered the trust we place in time-honored institutions. Greedy corporate CEOs were caught making off with millions, devastating investors. Abusive priests caused a crisis in the Catholic Church. And the threat of weapons of mass destruction jeopardized our safety. But we also found a balance in everyday joys: An Oscar milestone, an Emmy for a Friend, a trip to the altar, a healthy new baby. As President Bush says, "In the events that have challenged us, we have also seen the character that will deliver us."

george w. bush
MAN OF ACTION

CREATIVE FIRM
People Magazine Special Issues
New York (New York), USA
CREATIVES
David Schlow, Gregory Monfries
CLIENT
People Magazine

302

What a Nightmare

Think back on all the sales calls you've experienced. If you're like most salespeople, there's at least one call that sticks out in your mind as an event that you'd never want to repeat. Every sales professional has calls that don't go exactly as planned, but let's face it, some sales calls are so spectacularly awful that they ought to be the stuff of legend. *Selling Power* asked a variety of sales professionals about their worst sales-call experiences. Then we asked a panel of sales experts how salespeople can recover when things go wrong and, even better, how to prevent call disasters before they happen. By Geoffrey James · Illustrations by Rick Sealock

CREATIVE FIRM
American Way Magazine
Ft. Worth (Texas), USA
CREATIVES
Gilberto Mejia, Betsy Semple,
Tim Bower
CLIENT
American Airlines Publishing

CREATIVE FIRM
Selling Power Magazine
Fredericksburg (Virginia), USA
CREATIVES
Colleen Quinnell,
Michael Aubrecht,
Rick Sealock
CLIENT
Selling Power Magazine

Business in Paradise

Caribbean efforts to diversify mean vacation heaven could also be nirvana for your company.

All over the Caribbean region, countries have made a decision: The traditional staples of the region's business community — tourism and commodities such as coffee, sugar cane, and tobacco — aren't enough anymore for stable, growing economies. They are opening their borders to foreign investment by liberalizing trade, passing laws to modernize accounting and financial reporting, privatizing government-held industry, and establishing tax breaks and other incentives.

What this means is that the Caribbean paradise of lush tropical jungles, white sand, and crystal aqua waters is now a paradise for business, too. Here are reports from three of the region's rising economic stars.

DOMINICAN REPUBLIC
Fast becoming the economic star of the Caribbean.
Candidates for president in the Dominican Republic don't usually make campaign stops on the floor of the New York Stock Exchange. This island nation of 8.5 million people has, in modern times, been leery of foreign economic involvement. Until now. Times have changed enough that the two leading candidates for the Dominican presidency — Danilo Medina and the eventual winner, Hipolito Mejia — made pilgrimages to Wall Street, the epicenter of the world's capital markets.

The candidates' visit, sponsored by Tricom, S.A., the country's only NYSE-listed company, was symbolic of the country's recent efforts to diversify its economy beyond the traditional staples of tourism and commodities like sugar and tobacco. "Tourism is still important, but the leaders of the country know that to have stability and growth, the economy must be diversified," says John Schroder of Ascot Advisory Services, a Santo Domingo-based firm that offers investment and consulting services for companies doing business in the Dominican Republic.

By Chris Warren, Charles L. Leary, Vaughn J. Perret, and Bobby McGill
Illustration by Tim Bower

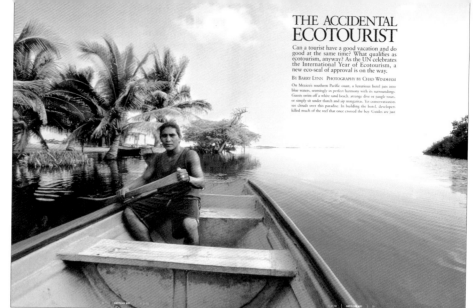

THE ACCIDENTAL ECOTOURIST

Can a tourist have a good vacation and do good at the same time? What qualifies as ecotourism, anyway? As the UN celebrates the International Year of Ecotourism, a new eco-seal of approval is on the way.

BY BARRY LYNN PHOTOGRAPHY BY CHAD WINDHAM

On Mexico's southern Pacific coast, a luxurious hotel juts into blue waters, seemingly in perfect harmony with its surroundings. Guests swim off a white sand beach, arrange dive or jungle tours, or simply sit under thatch and sip margaritas. Yet conservationists see clouds over this paradise. In building the hotel, developers killed much of the reef that once crossed the bay. Guides are just

CREATIVE FIRM
American Way Magazine
Ft. Worth (Texas), USA
CREATIVES
Gilberto Mejia, Betsy Semple,
Chad Windham
CLIENT
American Airlines Publishing

Text by Malcolm Fleschner Illustrations by Serge Bloch

Motivational experts and top sales performers weigh in on what it takes to send your achievement levels soaring

Inspect the average sales rep's shelves, bookseat or file cabinet and you're bound to run across an assortment of cassettes, books, pamphlets and other paraphernalia all dedicated to one subject - achieving success. Salespeople are legendary for building veritable arsenals of motivational materials. Yet despite absorbing the collected wisdom of many of the nation's top success gurus, the average sales rep remains just that average. So why is it that so many sales professionals become stifled in their achievement levels or plateau before reaching the rarefied air of success they aspire to? Part of the problem, experts agree, is that too frequently people define success exclusively in financial

destined for **success**

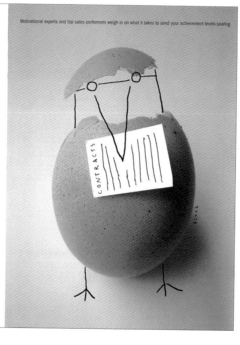

terms, while giving short shrift to the other critical dimensions that make up a successful life. This focus is generally supported by many of our cultural values - consider how often we hear revelations of the disastrous private lives of otherwise "successful" business professionals or celebrities. • As a result, explains Dr. Jan Gault, psychologist and author of The Mighty Power of Your Beliefs (Ocean Manor Pub. 2000), people who operate within such a narrow definition of success often find themselves ill-equipped to handle financial setbacks. • "Say you have a string of rejections, you lose a big sale, or you have to file for bankruptcy," she says. "You're going to feel like a failure if you're just hanging success on that one dimension of your life. If we can't put these unwanted outcomes into perspective with the rest of our lives and values - family, health, personal relationships and so forth - this can throw us into a state of depression." • Gault adds that, while we don't always control outcomes and economic conditions, we do always have control over how we perceive and interpret these outcomes. "That's why our definitions of success are critical, for our mental health as well as for our ongoing success," she says. **curb your dogma** Noah St. John, an inspirational speaker and the author of Permission to Succeed: Unlocking The Mystery of Success Anorexia (Health Communications, 1999), argues that many people have been misled by the traditional success dogma that offers overly simple answers to complex issues. He says that when he criticizes some of the sacred cows of success literature he often taps into a wellspring of disaffection with the strategies that have proven fruitless for many. • "One thing I work hard at," he says, "is to take the cliches we hear all the time and go underneath them. One is 'Persistence is the key to success.' Well, what does that mean? Where does persistence come from? What is it? Another one we frequently hear is 'You've got to set your goals.' 'Well, why is that? And when I get in front of people and say these things they start nodding to themselves saying, 'Yeah, that's what I've been wondering too.' • "Relying on these cliches to motivate you is like depending on Snickers bars for nutrition - they give you a lot of energy, but only briefly. That's why people walk out of motivational seminars all pumped up, but pretty soon the system breaks down, and they're left without anything to keep them going for the long haul." **what's your purpose?** Few would dispute that persistence and goal setting play a role in achieving success, particularly in sales. But instead of focusing on goals and persistence as the primary factors leading to success, Gault suggests beginning at the true source - a sense of purpose. • "People need to be clear about their purpose in life," she says. "Your purpose is what you feel compelled to do or to accomplish, and it's what keeps you on course. It's what gives meaning and direction to your life. So the first step is not to come up with a string of goals, but to clarify your purpose and then get more specific. Everyone should have a personal mission statement. Your goals need to be consistent with that purpose, otherwise you're not going to

CREATIVE FIRM
Selling Power Magazine
Fredericksburg (Virginia), USA
CREATIVES
Colleen Quinnell, Serge Bloch
CLIENT
Selling Power Magazine

303

52 APRIL 2002 SELLING POWER

ASHTON KUTCHER

ACTOR WHEN ASHTON KUTCHER WAS growing up in Homestead, Iowa, his older sister Tausha liked messing with him. "I would fall asleep and wake up in full makeup!" he says. "Can you imagine how scary that was for a little kid, to wake up with lipstick, eye shadow and mascara?" There were no lasting effects. "I'm a guy's guy," says Kutcher, 25, who now makes his own mischief playing pranks on celebrities in MTV's Punk'd. "I don't comb my hair unless I have to, and I don't use lotions or fancy shampoos. My mom used to work at Procter & Gamble, and we used to get free shampoo. I was never picky about that stuff. So why start changing things now?" Even when he does try to change, things don't always work out for the 6'3" star of That '70s Show. "I lifted weights for about two months," he says. "I thought I'd get all beefed up, but my friends were like, 'Dude, you look just the same.'" He has been equally unsuccessful growing a beard, which he had to do for his upcoming film The Butterfly Effect. "I had patchy holes on the side of my face," he says. "But it still ended up in the movie, so you'll see when it comes out in September." His diet could also use a little filling in. "I don't eat my vegetables and I don't take my vitamins unless I'm sick," he says, admitting that he subsists on "tons of taffy." Single again after breaking up with Just Married costar Brittany Murphy last month, Kutcher says there's a lot more to him than a healthy metabolism, though. "I don't think my physical attributes are my best attributes," he says. "But people do say I have nice eyelashes. I have a double row."

Photograph by TONY DURAN

79

CREATIVE FIRM
People Magazine Special Issues
New York (New York), USA
CREATIVES
Brian Anstey, Gregery Monfries
CLIENT
People Magazine

HALLE BERRY

ACTRESS

THERE ARE KISSES AND THEN THERE ARE kisses—rock-your-world, paperback-romance kisses that set hearts aflutter and make knees buckle under. Such was the case when surprise Best Actor winner Adrien Brody leapt onstage at this year's Oscars and embraced presenter Halle Berry for what seemed like forever. "He's a wet kisser," says Berry. "I didn't kiss back at all." Of course, "I didn't stop him either." Later that night, Brody explained his impulsive move. "If you ever have an excuse to do something like that, that was it," he declared. "I took my shot."

Who can blame him? One year after her historic Best Actress win for her gritty portrayal of a struggling waitress in *Monster's Ball*, the star with the silk-pie skin and to-die-for body says she has "evolved into this woman that feels very confident in who she is." It shows. Berry, 36, a former catalog model and Miss USA first runner-up (Note to judges: Oops!), seems to get more gorgeous with every passing year. Slipping into a tight bodysuit as mutant weather girl Storm in *X2: X-Men United*, the new sequel to the '00 megahit, she even manages to make a white wig look sexy. "It's bad enough I've got to wear white hair with my dark skin," she says. "But the style is more layered this time. I welcomed the softening change."

Now is definitely prime time for Halle. "Boy, does she know how to work with what she has, and she's got a lot," says producer Joel Silver, who has worked with her on four films. Adds Pierce Brosnan, her leading man in last year's Bond offering, *Die Another Day*: "She's got the most gorgeous face that you just want to dive into, the most gorgeous body that you just want to embrace." And John Travolta, Berry's costar in the '01 thriller *Swordfish*, says, "Her talent is equal to her beauty. Halle is completely real, and you immediately want to support her survival. She's strong but very vulnerable at the same time."

Berry capitalizes on those contradictions to glide between just-for-fun roles and art-house Oscar bait. Now in Montreal filming the horror flick *Gothika* with Robert Downey Jr., "she has

Photograph by CLIFF WATTS

50 MOST BEAUTIFUL PEOPLE

CREATIVE FIRM
People Magazine Special Issues
New York (New York), USA
CREATIVES
Ronnie Brandwein-Keats,
Gregery Monfries
CLIENT
People Magazine

HEIDI KLUM'S GERMANY

ENJOY A WHIRLWIND WEEKEND IN FIVE CHARMING CITIES WITH THE RAVISHING DEUTSCHLAND-BORN MODEL, ACTRESS, AND ENTREPRENEUR.

What better way to spend the holidays than with supermodel Heidi Klum in her mother country of Germany. Born and raised in Bergisch Gladbach, a storybook town outside of Cologne, Klum skyrocketed to international fame after appearing on the cover of *Sports Illustrated*'s 1998 swimsuit issue. In addition to appearing on hundreds of other magazine covers since then, she's acted on TV and in movies, and now has her own fragrance, her own postage stamp (the nation of Granada), and a brand new multiyear deal in which she will design shoes for the noted German company Birkenstock. Now based in New York, Klum returns regularly to her homeland for business and to visit family. She suggests the following itinerary: "First, fly to Frankfurt for a day. Then take the train two hours to Cologne. After experiencing Cologne, take the train to Hamburg. Then take the train to Berlin, then to Munich. From Munich, you go back to Frankfurt and fly home. You're doing a circle of Germany." How do you manage all that in a single weekend? Make it a long one and be sure to pack a sense of adventure. Here's Heidi Klum's whirlwind tour of Germany.

BY MARK SEAL PHOTOGRAPH BY ALEX SARGINSON

CREATIVE FIRM
The American Lawyer
New York (New York), USA
CREATIVES
Joan Ferrell, Polly Becker
CLIENT
The American Lawyer

CREATIVE FIRM
American Way Magazine
Ft. Worth (Texas), USA
CREATIVES
Gilberto Mejia, Marilyn Calley,
Alex Sarginson
CLIENT
American Airlines Publishing

Sexual harassment is one of the most devastating forms of workplace misconduct because of its potential for liability and its drain on morale, productivity and trust. Though liability for sexual harassment can result from the actions of any employee, such misconduct by high-level executives carries the greatest risk and the most severe consequences.

—FROM THE PROGRAM FOR A SEMINAR ON "EMPLOYMENT LIABILITY IN THE WORKPLACE" PRESENTED IN MAY BY JACKSON, LEWIS SCHNITZLER & KRUPMAN

man handled

Jackson Lewis has a long history defending management against charges such as sexual harassment. Should it take its own advice?

By Paul Braverman

Illustration by Polly Becker

IN JANUARY 2000 THERESA GALLION, THEN A PARTNER IN THE CHICAGO office of Jackson Lewis Schnitzler & Krupman, was giving a ride to her friend Kathryn Ditmars, an associate in the office who was pregnant at the time. Ditmars was crying. She was upset about an incident the previous day involving Michael Petkovich, the office's managing partner. When deposed last winter, Gallion recounted how Ditmars told her that the 6-foot-5-inch Petkovich had put his hands on her shoulders, pushed her into the corner of his office, and screamed at her. Ditmars "was just terrified, just terrified, and shocked at his physically menacing conduct," testified Gallion. "[S]he just cried and cried."

Shortly afterwards, Gallion said, she called William Krupman, the firm's chairman, and reported the incident. Gallion testified that she had previously told Krupman that Petkovich was "abusive" to the female associates in the office. In addition, Petkovich was rumored to be having an affair with an associate in the office; the people's interaction was "suggestive of some kind of favoritism," Gallion says she told Krupman. She made a similar call to Gregory Raun, the firm's national director of litigation, concluding, "It's a likely gender issue."

The phrase should have set off alarm bells. Jackson Lewis is one of the country's top labor and employment firms, with a national reputation that has attracted a roster of Fortune 500 clients. (American Lawyer Media, Inc., the parent company of *The American Lawyer*, is also a client.) The firm has about 350 lawyers in 20 offices

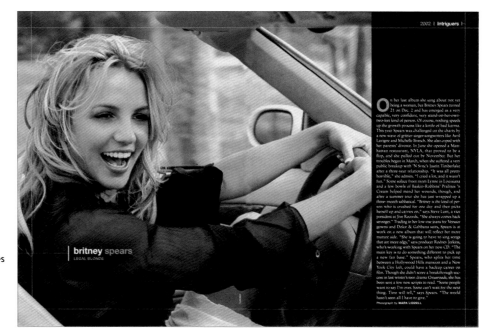

britney spears
LEGAL BLONDE

On her last album she sang about not yet being a woman, but Britney Spears turned 21 on Dec. 2 and has emerged as a very capable, very confident, very stand-on-her-own-two-feet kind of person. Of course, nothing speeds up the growth process like a kettle of bad karma. This year Spears was challenged on the charts by a new wave of grittier singer-songwriters like Avril Lavigne and Michelle Branch. She also coped with her parents' divorce. In June she opened a Manhattan restaurant, NYLA, that proved to be a flop, and she pulled out by November. But her troubles began in March, when she suffered a very public breakup with 'N Sync's Justin Timberlake after a three-year relationship. "It was all pretty horrible," she admits. "I cried a lot, and it wasn't fun." Some solace from mom Lynne in Louisiana and a few bowls of Baskin-Robbins' Pralines 'n Cream helped mend her wounds, though, and after a summer tour she has just wrapped up a three-month sabbatical. "Britney is the kind of person who is crushed for one day and then picks herself up and carries on," says Steve Lunt, a vice president at Jive Records. "She always comes back stronger." Trading in her low-rise jeans for Versace gowns and Dolce & Gabbana suits, Spears is at work on a new album that will reflect her more mature side. "She is going to have to sing songs that are more edgy," says producer Rodney Jerkins, who's working with Spears on her new CD. "The main key is to do something different to pick up a new fan base." Spears, who splits her time between a Hollywood Hills mansion and a New York City loft, could have a backup career on film. Though she didn't score a breakthrough success in last winter's teen drama Crossroads, she has been sent a few new scripts to read. "Some people want to say I'm over. Some can't wait for the next thing. Time will tell," says Spears. "The world hasn't seen all I have to give."
Photograph by MARK LIDDELL

CREATIVE FIRM
People Magazine Special Issues
New York (New York), USA
CREATIVES
Brian Anstey,
Gregery Monfries
CLIENT
People Magazine

It is important to consider the role of legal counsel. If a transaction is not illegal and has been approved by the appropriate levels of a corporation's management, lawyers, whether corporate counsel or with an outside firm, may appropriately provide the requisite legal advice and opinions about legal issues relevant to the transaction. In doing so, lawyers are not approving the business judgment of their clients.

PREPARED WITNESS TESTIMONY OF
VINSON & ELKINS MANAGING PARTNER
JOSEPH DILG AT MARCH 14 CONGRESSIONAL
HEARING ON THE ENRON COLLAPSE

Changing the role of attorney from zealous advocate to paranoid watchdog is no way to improve corporate governance

By Alison Frankel

No Confidence

Some of the people . . . who could have prevented the crash are sitting before us today. They could have acted before matters got out of hand. They could have been more skeptical of the proposals and promises of the business teams. They could have looked to learn what was really happening and warned Enron leadership about what they found. . . . The attorneys are the people others rely on to make sure matters are okay, are legal, are not going to put a company at undue risk. They're the adult supervision.

PREPARED STATEMENT OF
REPRESENTATIVE BILLY TAUZIN JR. LOUISIANA
AT THE SAME HEARING

ILLUSTRATION BY ROBERT NEUBECKER

DECEMBER 2002 **76**

CREATIVE FIRM
The American Lawyer
New York (New York), USA
CREATIVES
Joan Ferrell,
Robert Neubecker
CLIENT
The American Lawyer

305

CREATIVE FIRM
American Way Magazine
Ft. Worth (Texas), USA
CREATIVES
Gilberto Mejia,
Korena Bolding,
Anja Kroencke
CLIENT
American Airlines Publishing

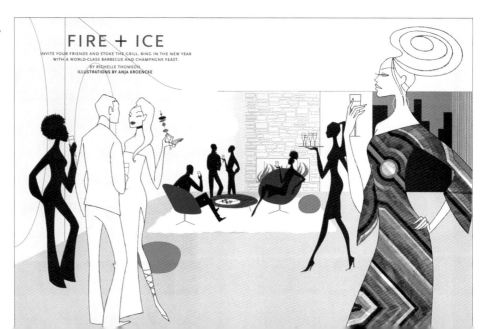

FIRE + ICE
INVITE YOUR FRIENDS AND STOKE THE GRILL. RING IN THE NEW YEAR WITH A WORLD-CLASS BARBECUE AND CHAMPAGNE FEAST.
BY RICHELLE THOMSON
ILLUSTRATIONS BY ANJA KROENCKE

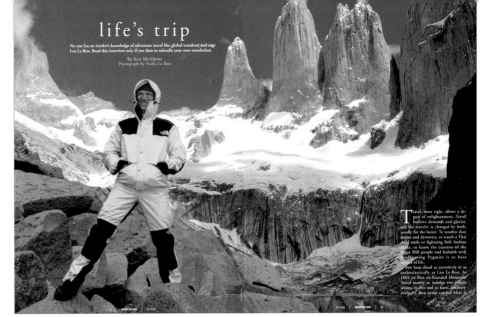

306

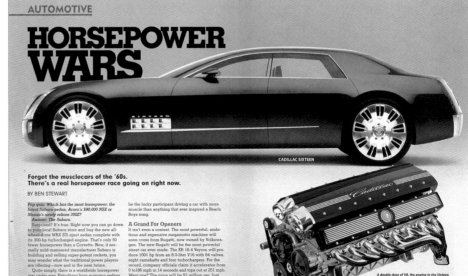

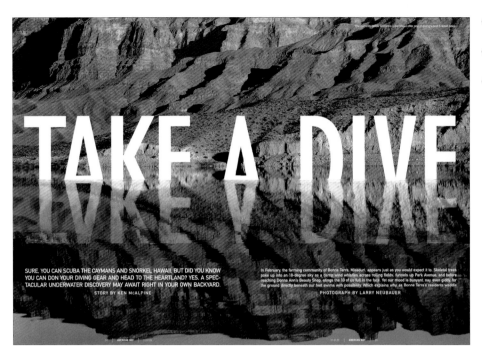

TAKE A DIVE

SURE, YOU CAN SCUBA THE CAYMANS AND SNORKEL HAWAII, BUT DID YOU KNOW YOU CAN DON YOUR DIVING GEAR AND HEAD TO THE HEARTLAND? YES, A SPECTACULAR UNDERWATER DISCOVERY MAY AWAIT RIGHT IN YOUR OWN BACKYARD.
STORY BY KEN McALPINE

In February, the farming community of Bonne Terre, Missouri, appears just as you would expect it to. Skeletal trees poke up into an 18-degree sky as a damp wind whistles across rolling fields, funnels up Park Avenue, and before reaching Donna Ann's Beauty Shop, stings the 10 of us full in the face. Yet our mood is buoyant, nay, even giddy, for the ground directly beneath our feet swims with possibility. Which explains why, as Bonne Terre's residents waddle

PHOTOGRAPH BY LARRY NEUBAUER

CREATIVE FIRM
American Way Magazine
Ft. Worth (Texas), USA
CREATIVES
Gilberto Mejia, Charles Stone,
Larry Neubauer
CLIENT
American Airlines Publishing

307

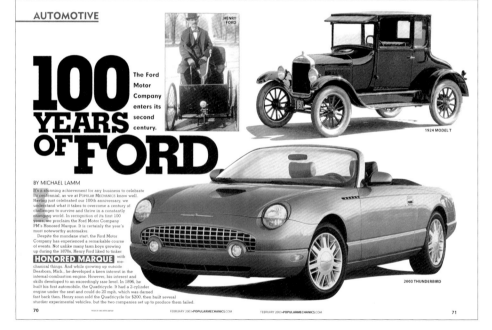

AUTOMOTIVE

HENRY FORD

100 YEARS OF FORD

The Ford Motor Company enters its second century.

BY MICHAEL LAMM

1924 MODEL T

2003 THUNDERBIRD

It's a stunning achievement for any business to celebrate its centennial, as we at POPULAR MECHANICS know well. Having just celebrated our 100th anniversary, we understand what it takes to overcome a century of challenges to survive and thrive in a constantly changing world. In recognition of its first 100 years, we proclaim the Ford Motor Company PM's Honored Marque. It is certainly the year's most noteworthy automaker.

Despite the mundane start, the Ford Motor Company has experienced a remarkable course of events. Not unlike many farm boys growing up during the 1870s, Henry Ford liked to tinker

HONORED MARQUE with mechanical things. And while growing up outside Dearborn, Mich., he developed a keen interest in the internal-combustion engine. However, his interest and skills developed to an exceedingly rare level. In 1896, he built his first automobile, the Quadricycle. It had a 2-cylinder engine under the seat and could do 20 mph, which was darned fast back then. Henry soon sold the Quadricycle for $200, then built several sturdier experimental vehicles, but the two companies set up to produce them failed.

70 FEBRUARY 2003•POPULARMECHANICS.COM FEBRUARY 2003•POPULARMECHANICS.COM 71

CREATIVE FIRM
American Way Magazine
Ft. Worth (Texas), USA
CREATIVES
Gilberto Mejia, Charles Stone,
Chuck Thompson
CLIENT
American Airlines Publishing

CREATIVE FIRM
Popular Mechanics
New York (New York), USA
CREATIVES
Bryan Canniff,
Harriette Lawier
CLIENT
Popular Mechanics

Is your inner Robinson Crusoe yearning for a new adventure? Set him free on the Central American side of the Caribbean, where the beaches are every bit as beautiful, the culture equally as colorful, and the mood even mellower.

Story and photography by Chuck Thompson

Kevin Hiestand, a 36-year-old attorney from Sacramento, California, has seen the Caribbean. He's turned himself into a bronzed god on the sugar-white beaches of Jamaica. Learned to dive in the Virgin Islands. Climbed the majestic Pitons Mountains of St. Lucia. Danced in the mid-enchanted Carnival ritual of J'Ouvert in Trinidad. Now he's ready to declare Laughing Bird Caye as the most beautiful spot in the entire sea.

The surprise for Hiestand is that, until recently, he'd never heard of Laughing Bird Caye, a tiny island sanctuary a few miles off the coast of Belize near the mainland town of Placencia. Now he's seeing what other travelers are discovering. That there's another Caribbean out there — one beyond the traditional leeward and windward islands southeast of Florida — a paradise of up-and-coming beaches, islands, and countries that make up the Central American border along the sea's western edge.

And while on your visit you probably won't brave snarling crocodiles or kneel three river rapids, these outings are absent four-star restaurants and a place to plug in your modem, which for some of you, is adventure enough.

BELIZE

Located on the Yucatán peninsula, just south of Mexico, Belize is a Caribbean country of about 250,000 people, which makes it a little mellower and a lot slower than the city you probably live in. Belize is close to the U.S. (a couple hours from Miami), the official language is English, and vacationers' favorite pastime is eating the catch of the day and downing Belikin beer after a day of snorkeling on the fertile reefs protecting the coast.

For most visitors, Belize has traditionally meant a trip to one of the country's small cayes. Ambergris Caye remains at the head of this list. Heralded as the site of the infamous Temptation Island reality show, the island is, in reality, one of those luxurious disgusts to the

the *other* caribbean

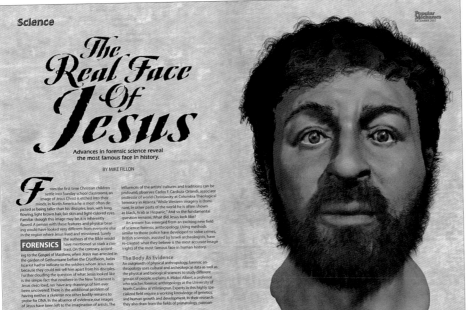

CREATIVE FIRM
Popular Mechanics
New York (New York), USA
CREATIVES
Bryan Canniff
CLIENT
Popular Mechanics

308

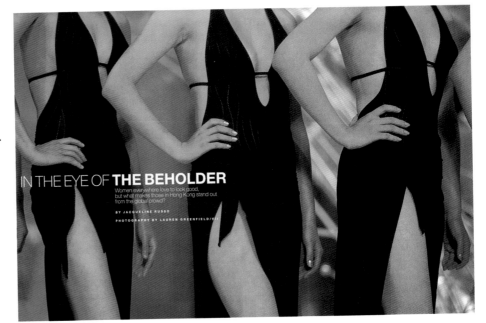

CREATIVE FIRM
Emphasis Media Ltd.
Hong Kong, China
CREATIVES
Percy Chung
CLIENT
Cathay Pacific Airways

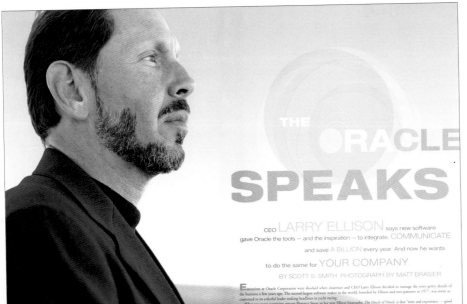

CREATIVE FIRM
American Way Magazine
Ft. Worth (Texas), USA
CREATIVES
Gilberto Mejia,
Betsy Semple,
Matt Braser
CLIENT
American Airlines Publishing

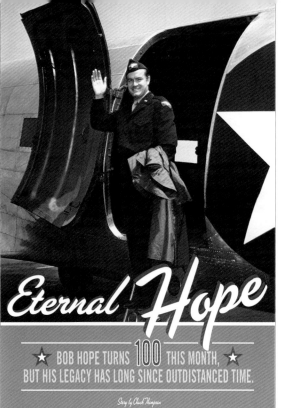

CREATIVE FIRM
American Way Magazine
Ft. Worth (Texas), USA
CREATIVES
Gilberto Mejia,
Korena Bolding
CLIENT
American Airlines Publishing

Eternal Hope

★ BOB HOPE TURNS 100 THIS MONTH, ★
BUT HIS LEGACY HAS LONG SINCE OUTDISTANCED TIME.

Story by Chuck Thompson

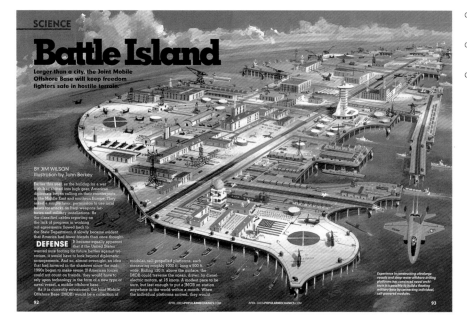

SCIENCE

Battle Island

Larger than a city, the Joint Mobile
Offshore Base will keep freedom
fighters safe in hostile terrain.

BY JIM WILSON
Illustration by John Berkey

CREATIVE FIRM
Popular Mechanics
New York (New York), USA
CREATIVES
Bryan Canniff,
John Perkey
CLIENT
Popular Mechanics

309

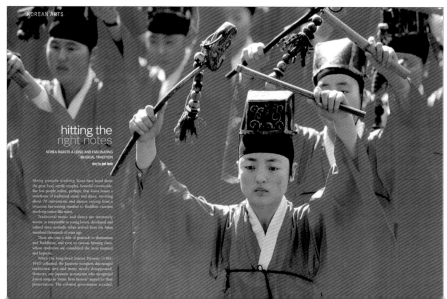

KOREAN ARTS

hitting the
right notes

KOREA BOASTS A LONG AND FASCINATING
MUSICAL TRADITION
story by joel bois

CREATIVE FIRM
Emphasis Media Ltd.
Hong Kong, China
CREATIVES
Hyzein Kamarudin
CLIENT
Korean Air

MAJOR MINOR LEAGUERS

While Major League Baseball struggles to attract fans, minor league teams are packing out parks — and attracting big-time corporate ownership.

I n the old days, a minor league baseball executive like George Habel would have been a grizzled veteran of hardscrabble towns and broken-down ballparks, of Class D leagues, cold-water trailer courts, and hocking the team bus to make the payroll.

But these aren't the old days. Instead, Habel is a longtime broadcasting executive with a swank office in a state-of-the-art stadium. His employer and team owner? A multimillion-dollar media company that has no trouble making payroll.

"The minor leagues," says Habel,

who runs the Class AAA Durham Bulls for Capitol Broadcasting, "are not what they used to be."

That's because minor league baseball has turned into a major league business. Left for dead in the late 1970s and early 1980s, the minors are thriving — attendance is at record levels, the number of teams is at a three-decade high, and many national and regional companies whose primary business is something else are buying not just one team, but as many as they can get their corporate hands on.

"Minor league baseball isn't as glamorous as some of the other businesses we've been in," says Habel. "But it certainly is more profitable — significantly more profitable. The minor leagues have changed from a hobby to a nice business."

Flourishing almost everywhere

The numbers are nothing short of astounding. In 2002, the minors — the 176 professional baseball teams organized into 15 leagues — drew almost 40 million fans. That's the third-highest total ever, and just 1.1 million behind the record, set in the glorious old days of 1949, when 448 teams in 59 leagues drew 39.8 million.

By comparison, Major League Baseball

had an abysmal year, with overall attendance declining 6.1 percent, 20 of its 30 teams showing drop-offs from 2001, and Milwaukee's attendance plummeting by almost 30 percent.

But that's only the beginning of the minors' success.
● Four leagues set all-time attendance records in 2002, including two Class A leagues, the minors' lowest rung. Fans at those games are not paying to see future Hall of Famers, but high school and col-

lege players, most of whom will never make it past Class A.
● Class AAA Sacramento drew more fans during its season than two major league teams — Montreal and Florida — and did it in 10 fewer games.
● A total of 25 teams set franchise records in 2002. The Dayton Dragons, a Class A team in southern Ohio, has sold out every game in the team's three-year history. The Round Rock Express, a Class AA team in central Texas, drew

BY JEFF SIEGEL | 58 | 59 | PHOTOGRAPHY BY KENNY BRAUN

CREATIVE FIRM
American Way Magazine
Ft. Worth (Texas), USA
CREATIVES
Gilberto Mejia,
Betsy Semple,
Kenny Braun
CLIENT
American Airlines Publishing

310

CREATIVE FIRM
Selling Power Magazine
Fredericksburg (Virginia), USA
CREATIVES
Colleen Quinnell, Michael Aubrecht,
Doug Jones
CLIENT
Selling Power Magazine

HOW WELL DO YOU SELL YOUR COMPANY?

At the recent Linux show in New York's cavernous Javits Center, it was easy to miss the modest booth of GeCAD Software. The simple 10-foot-by-10-foot booth, furnished with a vinyl banner and a folding table, was eclipsed by the architectural steel towers erected by bigger names in computing. Sun Microsystems was represented by a two-story structure bigger than many Manhattan apartments. By Betsy Wiesendanger · Illustration by Douglas Jones

H ewlett Packard's octagonal grid, adorned with logos backlit in neon blue, was dotted with comfy workstations where polo-shirted techies tapped at networked PCs. Over at the IBM booth, a dozen earnest staffers, outfitted in matching powder-blue sweaters, paced the plush-carpeted floor.

GeCAD's booth, by contrast, was manned by two lone staffers: Carmen Sebe, a sales and marketing manager, and Dennis Bella, director of sales and alliances. The pair barely seemed to notice their status as David in a world of Goliaths. When a visitor would stop by the booth to compliment the com-

pany's antivirus software, Sebe, a slight, dark-haired woman with a mega-watt smile, beamed. Gushed Sebe: "This is a great company to work for."

Wait a minute. A small, scrappy company, struggling for recognition in a depressed tech market – a great company to work for? You bet. Although GeCAD had been doing business in its native Hungary for the past 10 years, it was a newcomer to the international market. Now, just two years after beginning its cross-border push, the firm was selling software in 60 countries. Said Sebe, "You want to make something important of your career and company. This is what drives you to say, 'Let's do it. We can do

it.' We all worked together. It was a team effort. It's more than money, a salary, a car. You want to build something for you and your company."

Sebe is emblematic of a funny little secret in the world of sales and marketing. Being a great company to work for is hardly a matter of size or name recognition – and it's almost never about the money. So what, exactly, are the magic ingredients that make a company beloved by its sales team?

Numerous organizations have attempted to come up with an answer. The Most Admired Places to Work Institute in San Francisco touts a yardstick of 13 such touchy-feely measures as

60 MAY 2003 SELLING POWER

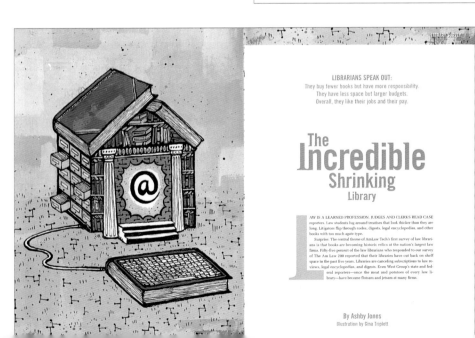

LIBRARY MOVES

LIBRARIANS SPEAK OUT:
They buy fewer books but have more responsibility.
They have less space but larger budgets.
Overall, they like their jobs and their pay.

The Incredible Shrinking Library

L AW IS A LEARNED PROFESSION. JUDGES AND CLERKS READ CASE reporters. Law students lug around treatises that look thicker than they are long. Litigators flip through codes, digests, legal encyclopedias, and other books with too much agate type.

Surprise: The central theme of AmLaw Tech's first survey of law librarians is that books are becoming historic relics at the nation's largest law firms. Fifty-five percent of the law librarians who responded to our survey of The Am Law 200 reported that their libraries have cut back on shelf space in the past five years. Libraries are canceling subscriptions to law reviews, legal encyclopedias, and digests. Even West Group's state and federal reporters—once the meat and potatoes of every law library—have become flotsam and jetsam at many firms.

By Ashby Jones
Illustration by Gina Triplett

CREATIVE FIRM
American Lawyer Media
New York (New York), USA
CREATIVES
Darlene Simidian, Gina Triplett
CLIENT
AmLaw Tech

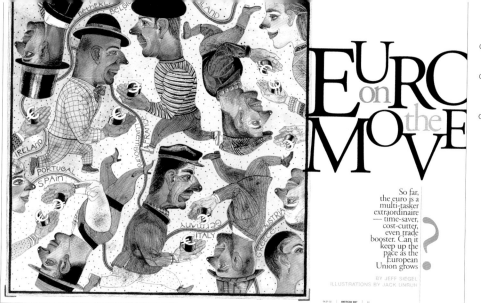

EURO on the MOVE

So far, the euro is a multi-tasker extraordinaire — time-saver, cost-cutter, even trade booster. Can it keep up the pace as the European Union grows?

BY JEFF SIEGEL
ILLUSTRATIONS BY JACK UNRUH

CREATIVE FIRM
American Way Magazine
Ft. Worth (Texas), USA
CREATIVES
Gilberto Mejia,
Betsy Semple,
Jack Unruh
CLIENT
American Airlines Publishing

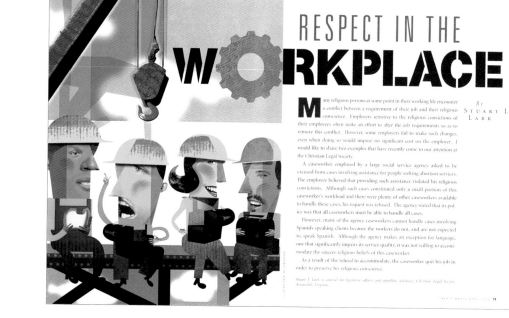

RESPECT IN THE WORKPLACE

By STUART J. LARK

Many religious persons at some point in their working life encounter a conflict between a requirement of their job and their religious conscience. Employers sensitive to the religious convictions of their employees often make an effort to alter the job requirements so as to remove this conflict. However, some employers fail to make such changes, even when doing so would impose no significant cost on the employer. I would like to share two examples that have recently come to our attention at the Christian Legal Society.

A caseworker employed by a large social service agency asked to be excused from cases involving assistance for people seeking abortion services. The employee believed that providing such assistance violated his religious convictions. Although such cases constituted only a small portion of this caseworker's workload and there were plenty of other caseworkers available to handle these cases, his request was refused. The agency stated that its policy was that all caseworkers must be able to handle all cases.

However, many of the agency caseworkers cannot handle cases involving Spanish-speaking clients because the workers do not, and are not expected to, speak Spanish. Although the agency makes an exception for language, one that significantly impairs its service quality, it was not willing to accommodate the sincere religious beliefs of this caseworker.

As a result of the refusal to accommodate, the caseworker quit his job in order to preserve his religious conscience.

Stuart J. Lark is counsel for legislative affairs and appellate advocate, Christian Legal Society, Annandale, Virginia.

311

CREATIVE FIRM
Dever Designs
Laurel (Maryland), USA
CREATIVES
Jeffrey L. Dever,
Ralph Butler
CLIENT
Liberty Magazine

CREATIVE FIRM
Dever Designs
Laurel (Maryland), USA
CREATIVES
Jeffrey L. Dever,
William Rieser
CLIENT
Liberty Magazine

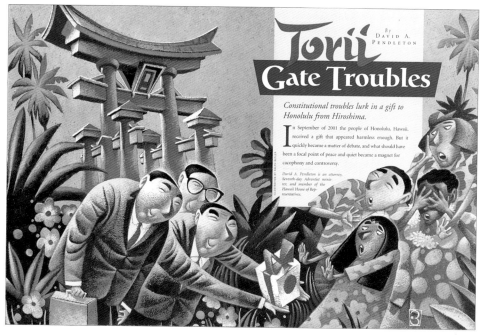

Torii Gate Troubles

By DAVID A. PENDLETON

Constitutional troubles lurk in a gift to Honolulu from Hiroshima.

In September of 2001 the people of Honolulu, Hawaii, received a gift that appeared harmless enough. But it quickly became a matter of debate, and what should have been a focal point of peace and quiet became a magnet for cacophony and controversy.

David A. Pendleton is an attorney, Seventh-day Adventist minister, and member of the Hawaii House of Representatives.

First Amendment: "Congress shall make no law respecting an establishment of religion" — and President Bush's plans to fund "faith-based" social programs. Has it all been said? Probably. But I haven't heard this reality set forth. Once religion is established, it will likely never be disestablished. Why be concerned? Because establishment diminishes the free exercise of religion.

Americans have never had total disestablishment (as is, for example, evidenced by Sunday "blue law" protections, notwithstanding millions of nonbelievers and those who observe Saturday as the Sabbath), though disestablishment was intended by our Founders (as is, for example, evidenced by the First Amendment and the fact that the word "God" appears nowhere in the U.S. Constitution). However, Americans do worship as free from official religion as any other peoples in the world.

In 1970 I had occasion to speak with Andreas Papandreou while he was head of his Greek government-in-exile in Toronto. I asked Mr. Papandreou, "In the event you are ever able to return to Greece and assume power, what will be your first undertaking, your first priority?" He emphatically answered, "I will do all I can to separate church and state. The church is at the root of many of our problems."

The son of a former Greek premier, Mr. Papandreou had a Ph.D. in economics from Harvard, was published widely, taught for years at the University of Minnesota and Northwestern University, and ultimately chaired the School of Economics at the University of California at Berkeley. A 1967 military coup deposed his father's popularly elected government, and Mr. Papandreou was placed in solitary confinement for eight months. With the help of influential Americans, Mr. Papandreou was released, formed a government-in-exile, and taught at York University, in Toronto. Mr. Papandreou was ultimately able to return to Greece as democracy was restored

in 1974. In 1981 he was elected prime minister.

I followed Mr. Papandreou's political career through the New York Times. He was good to his word regarding church and state. He accomplished much, e.g. reformed divorce laws. He even obtained support from some in the church, such as the primate of Greece and certain theologians, who agreed separation would benefit both the church and the government. However, Mr. Papandreou, though critical of our foreign policy at the time, said he envied America for, among other things, its First Amendment.

While not speaking of the establishment clause as an impediment, I believe President Bush sees it as a major hurdle to his desire to channel billions to parochial school and social programs. The president's current plan, it appears to me, is the boldest and most aggressive collateral attack on the establishment clause since its 1791 ratification. America is entering new territory.

If the president's religion assistance program makes it past the U.S. Supreme Court, as it may, I fear religion in this country will never be disestablished. It took a violent revolution to achieve America's establishment clause. Once it is lost in substance we will never get it back. Humanity will have lost its noblest battle. I hope I am wrong. ∎

Gerald C. Grimaud is a former Pennsylvania assistant attorney general. He is engaged in the general practice of law in his hometown of Tunkhannock, Pennsylvania. His cases include constitutional, criminal, and civil rights law.

Leonard Levy, Origin of the Bill of Rights (Yale University Press, 1999), p. 78. ("Equality for all opinions on the subject of religion and for the free exercise of religious conscience cannot exist in the presence of an established creed of religion.")
New York Times, Apr. 13, 1987

Second of Three in a Series...

THE ESTABLISHMENT CLAUSE

That's the Issue

By Gerald C. Grimaud

CREATIVE FIRM
Dever Designs
Laurel (Maryland), USA
CREATIVES
Jeffrey L. Dever,
Ricardo Stamatori
CLIENT
Liberty Magazine

312

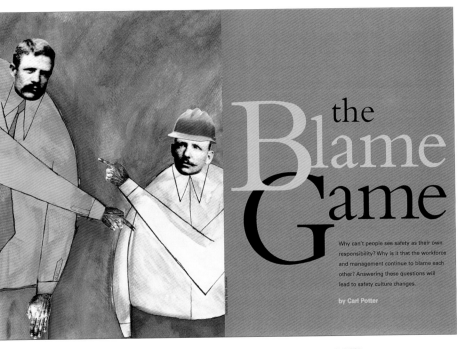

the Blame Game

Why can't people see safety as their own responsibility? Why is it that the workforce and management continue to blame each other? Answering these questions will lead to safety culture changes.

by Carl Potter

CREATIVE FIRM
American Way Magazine
Ft. Worth (Texas), USA
CREATIVES
Gilberto Mejia,
Korena Bolding,
William Taylor
CLIENT
American Airlines Publishing

CREATIVE FIRM
Practical Communications, Inc.
Palatine (Illinois), USA
CREATIVES
Brian Danauer
CLIENT
Utility Safety Magazine

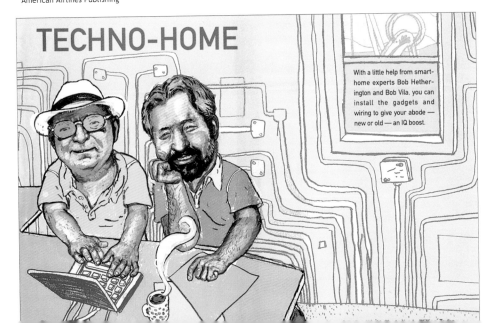

TECHNO-HOME

With a little help from smart-home experts Bob Hetherington and Bob Vila, you can install the gadgets and wiring to give your abode — new or old — an IQ boost.

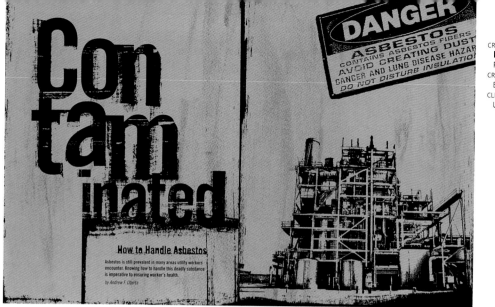

CREATIVE FIRM
Practical Communications, Inc.
Palatine (Illinois), USA
CREATIVES
Brian Danauer
CLIENT
Utility Safety Magazine

Con tam inated

How to Handle Asbestos

Asbestos is still prevalent in many areas utility workers encounter. Knowing how to handle this deadly substance is imperative to ensuring worker's health.

by Andrew F. Oberta

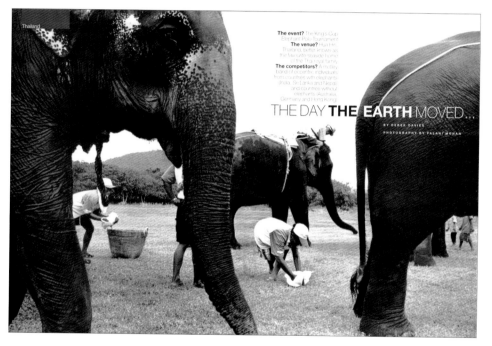

THE DAY **THE EARTH** MOVED...

BY DEREK DAVIES

PHOTOGRAPHY BY PALANI MOHAN

313

CREATIVE FIRM
American Way Magazine
Ft. Worth (Texas), USA
CREATIVES
Gilberto Mejia, Betsy Semple,
Melanie Dunea
CLIENT
American Airlines Publishing

CREATIVE FIRM
Emphasis Media Ltd.
Hong Kong, China
CREATIVES
Percy Chung, Davide Butson
CLIENT
Cathay Pacific Airways

COLIN FARRELL'S DUBLIN

He may be one of the hottest hunks in Hollywood, but this Irish-born actor, who starred in *Minority Report* among other big films, is more at home in a dark Irish pub than a posh L.A. catery. Here's a weekend with the devoted Dubliner at his favorite pubs and points of interest.

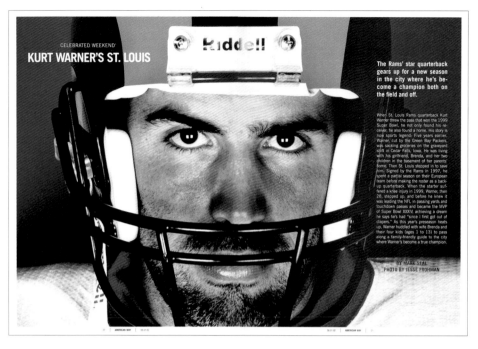

CREATIVE FIRM
American Way Magazine
Ft. Worth (Texas), USA
CREATIVES
Gilberto Mejia,
Jesse Froham
CLIENT
American Airlines Publishing

314

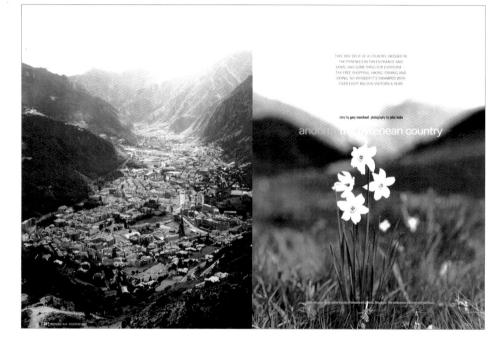

CREATIVE FIRM
Graphiculture
Minneapolis (Minnesota), USA
CREATIVES
Cheryl Watson, Steve Henke
CLIENT
Target

CREATIVE FIRM
Emphasis Media Ltd.
Hong Kong, China
CREATIVES
Hyzein Kamarudin
CLIENT
Korean Air

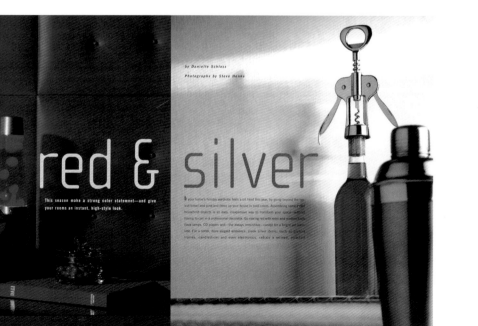

neoncity HONG KONG DISPLAYS A YEAR-LONG LOVE AFFAIR WITH NEON

story by david clive price photography by keith macgregor

CREATIVE FIRM
Emphasis Media Ltd.
Hong Kong, China
CREATIVES
Hyzein Kamarudin,
Davide Butson
CLIENT
Korean Air

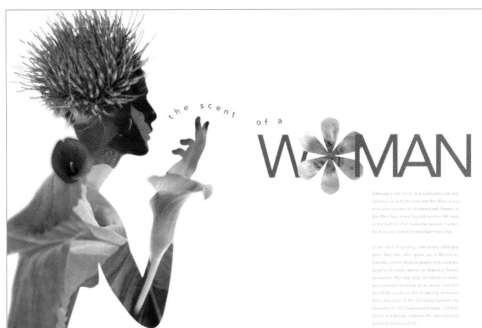

the scent of a

W✲MAN

February is the month that celebrates love and romance in both the East and the West. It is a time when women are showered with flowers. In the West Valentine's Day falls on the 14th and in the East the 15th marks the romantic Lantern Festival, considered Chinese Valentine's Day.

In the spirit of romance, Vietnamese photographer Van Hai, who grew up in Montreal, Canada, combined photography and computer graphics to create women as flowers or flowers as women. Not only does the blend of styles represent the body as a canvas, but also fancifully revels on the mutability of human form and some of the similarities between the two subjects. For flowers and females, in all their bloom and beauty, represent the eternal poetry and watchfulness of life.

February 2003 SILKROAD 23

315

CREATIVE FIRM
American Way Magazine
Ft. Worth (Texas), USA
CREATIVES
Gilberto Mejia, Korena Bolding,
William Taylor
CLIENT
American Airlines Publishing

CREATIVE FIRM
Emphasis Media Ltd.
Hong Kong, China
CREATIVES
Alison Lam,
Davide Butson
CLIENT
Dragonair

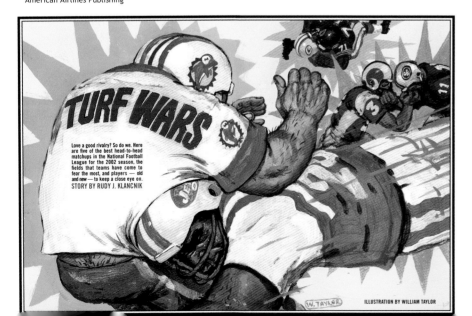

TURF WARS

Love a good rivalry? So do we. Here are five of the best head-to-head matchups in the National Football League for the 2002 season, the fields that teams have come to fear the most, and players — old and new — to keep a close eye on.
STORY BY RUDY J. KLANCNIK

ILLUSTRATION BY WILLIAM TAYLOR

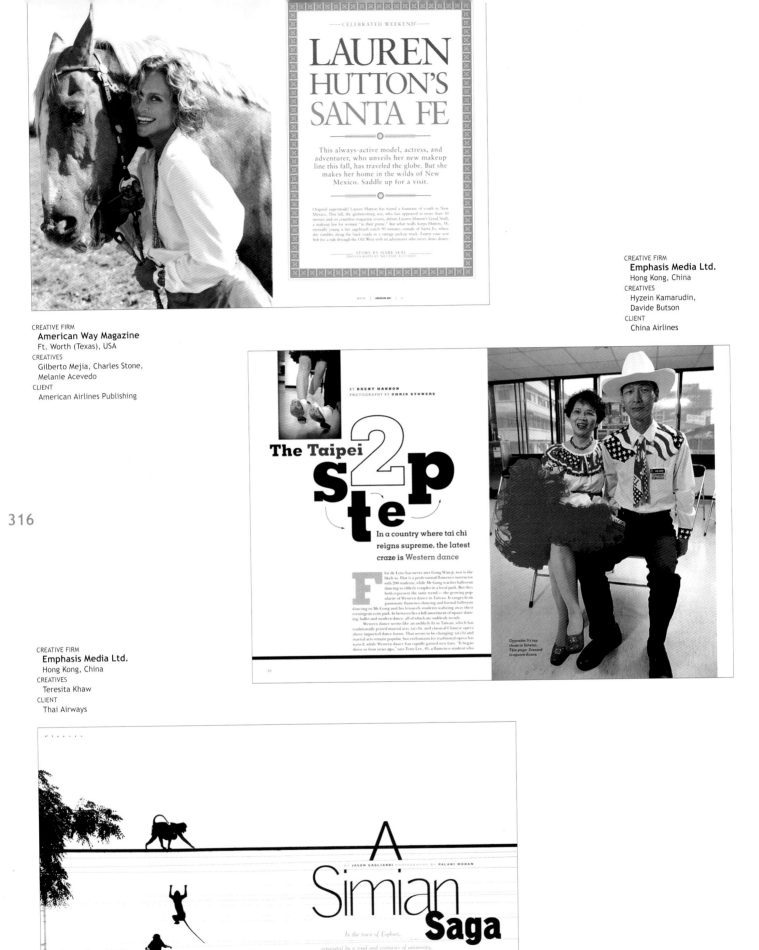

LAUREN HUTTON'S SANTA FE

This always-active model, actress, and adventurer, who unveils her new makeup line this fall, has traveled the globe. But she makes her home in the wilds of New Mexico. Saddle up for a visit.

Original supermodel Lauren Hutton has found a fountain of youth in New Mexico. This fall, the globetrotting star, who has appeared in more than 30 movies and on countless magazine covers, debuts Lauren Hutton's Good Stuff, a makeup line for women "in their prime." But what really keeps Hutton, 58, eternally young is her sagebrush ranch 90 minutes outside of Santa Fe, where she rambles along the back roads in a vintage pickup truck. Fasten your seat belt for a ride through the Old West with an adventurer who never slows down.

STORY BY MARK SEAL
PHOTOGRAPHY BY MELANIE ACEVEDO

CREATIVE FIRM
American Way Magazine
Ft. Worth (Texas), USA
CREATIVES
Gilberto Mejia, Charles Stone,
Melanie Acevedo
CLIENT
American Airlines Publishing

CREATIVE FIRM
Emphasis Media Ltd.
Hong Kong, China
CREATIVES
Hyzein Kamarudin,
Davide Butson
CLIENT
China Airlines

316

The Taipei S2tep

BY BRENT HANNON
PHOTOGRAPHY BY CHRIS STOWERS

In a country where tai chi reigns supreme, the latest craze is Western dance

Flor de Loto has never met Gong Wan-ji, nor is she likely to. Flor is a professional flamenco instructor with 200 students, while Mr Gong teaches ballroom dancing to elderly couples in a local park. But they both represent the same trend — the growing popularity of Western dance in Taiwan. It ranges from passionate flamenco dancing and formal ballroom dancing to Mr Gong and his leisurely students waltzing away their evenings in a city park. In between lies a full assortment of square dancing, ballet and modern dance, all of which are suddenly trendy.

Western dance seems like an unlikely fit in Taiwan, which has traditionally prized martial arts, tai chi, and classical Chinese opera above imported dance forms. That seems to be changing: tai chi and martial arts remain popular, but enthusiasm for traditional opera has waned, while Western dance has rapidly gained new fans. "It began three or four years ago," says Tony Lee, 49, a flamenco student who

Opposite: It's tap shoes in Taiwan. This page: Dressed to square dance.

CREATIVE FIRM
Emphasis Media Ltd.
Hong Kong, China
CREATIVES
Teresita Khaw
CLIENT
Thai Airways

A Simian Saga

BY JASON GAGLIARDI PHOTOGRAPHY BY PALANI MOHAN

In the town of Lopburi, separated by a road and centuries of animosity, are the market monkeys and the temple monkeys, two groups co-starring in a drama that plays out daily

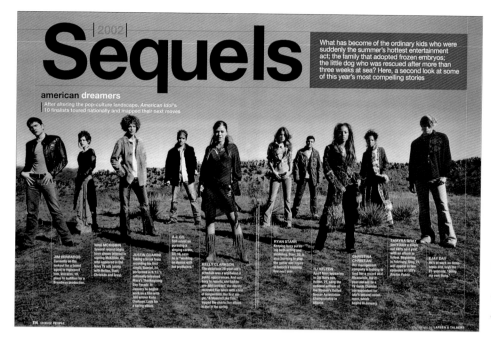

|2002| Sequels

What has become of the ordinary kids who were suddenly the summer's hottest entertainment act; the family that adopted frozen embryos; the little dog who was rescued after more than three weeks at sea? Here, a second look at some of this year's most compelling stories

american dreamers

After altering the pop-culture landscape, *American Idol*'s 10 finalists toured nationally and mapped their next moves

CREATIVE FIRM
People Magazine Special Issues
New York (New York), USA
CREATIVES
Gregery Monfries
CLIENT
People Magazine

317

CREATIVE FIRM
People Magazine Special Issues
New York (New York), USA
CREATIVES
Brian Anstey,
Gregery Monfries
CLIENT
People Magazine

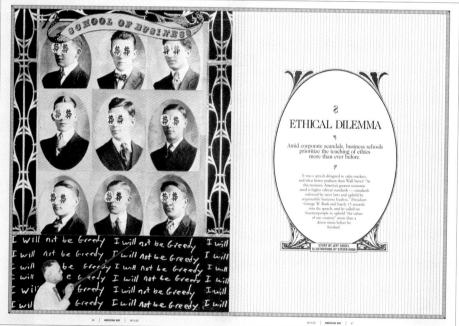

ETHICAL DILEMMA

Amid corporate scandals, business schools prioritize the teaching of ethics more than ever before.

It was a speech designed to calm markets, and what better podium than Wall Street? "At this moment, America's greatest economic need is higher ethical standards — standards enforced by strict laws and upheld by responsible business leaders." President George W. Bush said barely 15 seconds into the speech, and he called on businesspeople to uphold "the values of our country" more than a dozen times before he finished.

STORY BY JEFF SIEGEL
ILLUSTRATIONS BY STEVEN DANA

CREATIVE FIRM
American Way Magazine
Ft. Worth (Texas), USA
CREATIVES
Gilberto Mejia, Betsy Semple,
Steven Dana
CLIENT
American Airlines Publishing

2002 sexiest man alive

Enrique Iglesias

SEXIEST POP STAR Setting hearts afire in sold-out venues around the globe, Madrid-born rocker Enrique Iglesias, 27, has seen some brazen come-ons: panties offered up to be autographed, women ripping off their shirts in the crowd ("The band goes crazy when that happens," he says). But want to know what really turns him on? "I always look at a woman's feet," the #2" bachelor admits. "I like clean, nice feet. My mother always said that feet tell a lot about a person." So much for the image of a gyrating playboy whose erotic video exploits with former tennis pro Anna Kournikova made MTV viewers blush. Underneath his signature knit cap, the son of Latin crooner Julio Iglesias is actually a guy who hates to shop, loves *Jackass the Movie* and listens to John Mayer's *Room for Squares*. "I'm no walking Romeo," he demurs. The triple-platinum recording artist prefers to channel his poetic side into songs, like his upbeat "Don't Turn Off the Lights," and the aching ballad "Hero." "Enrique writes from his heart," says boyhood friend Andres Restrepo. "His lyrics tell exactly what he's been going through." Singer Paulina Rubio, his opening act for this year's concert tour, admires the man she has observed in action. "When Enrique takes the stage," she says, "there's lots of energy—like a great lightning storm."

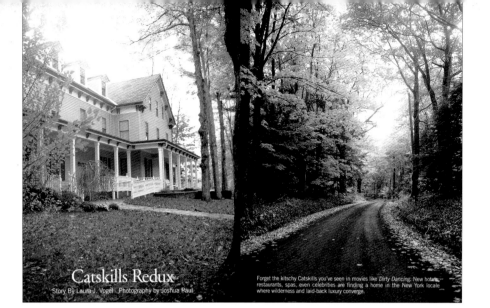

Catskills Redux

Story By Laura J. Vogel Photography by Joshua Paul

Forget the kitschy Catskills you've seen in movies like *Dirty Dancing*. New hotels, restaurants, spas, even celebrities are finding a home in the New York locale where wilderness and laid-back luxury converge.

318

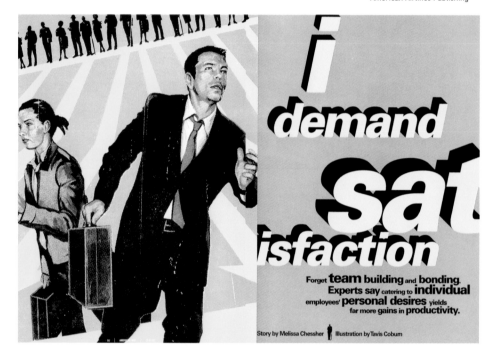

i demand satisfaction

Forget **team** building and bonding. Experts say catering to **individual** employees' **personal desires** yields far more **gains** in productivity.

Story by Melissa Chessher Illustration by Tavis Coburn

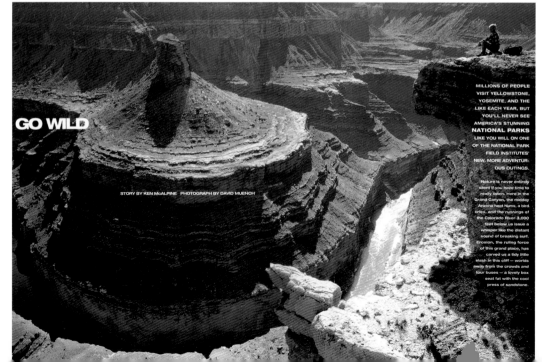

GO WILD

MILLIONS OF PEOPLE VISIT YELLOWSTONE, YOSEMITE, AND THE LIKE EACH YEAR, BUT YOU'LL NEVER SEE AMERICA'S STUNNING **NATIONAL PARKS** LIKE YOU WILL ON ONE OF THE NATIONAL PARK FIELD INSTITUTES' NEW, MORE ADVENTUROUS OUTINGS.

Nature is never entirely silent if you have time to really listen. Here in the Grand Canyon, the midday Arizona heat hums, a bird cries, and the runnings of the Colorado River 3,000 feet below us issue a whisper like the distant sound of breaking surf. Erosion, the ruling force of this grand place, has carved us a tidy little elash in this cliff — worlds away from the crowds and tour buses — a lovely box seat fat with the cool press of sandstone.

STORY BY KEN McALPINE PHOTOGRAPH BY DAVID MUENCH

CREATIVE FIRM
Moby Dick Warszawa
Warsaw, Poland
CREATIVES
Anna Bal, Marcin Bobowicz,
Marcin Kosiorowski
CLIENT
Prosper SA

CREATIVE FIRM
The American Lawyer
New York (New York), USA
CREATIVES
Joan Ferrell, Fredrik Broden
CLIENT
The American Lawyer

319

CREATIVE FIRM
People Magazine
New York (New York), USA
CREATIVES
Maddy Miller
CLIENT
People Magazine

CREATIVE FIRM
Elka Design
Buffalo (New York), USA
CREATIVES
Elka Kazmierczak
CLIENT
2+3D-Design Quarterly
Krakow, Poland

CREATIVE FIRM
KOREK Studio
Warsaw, Poland
CREATIVES
Wojtek Korkuc
CLIENT
VFP Communication

CREATIVE FIRM
KOREK Studio
Warsaw, Poland
CREATIVES
Wojtek Korkuc
CLIENT
VFP Communication

CREATIVE FIRM
The American Lawyer
New York (New York), USA
CREATIVES
Morris Stubbs, Lorraine Tuson
CLIENT
Life, Liberty, Law School Magazine

CREATIVE FIRM
Cantur Design, Inc.
New Hope (Pennsylvania), USA
CREATIVES
Andrel Cantur, Paula Lyhan
CLIENT
Bucks Media Group

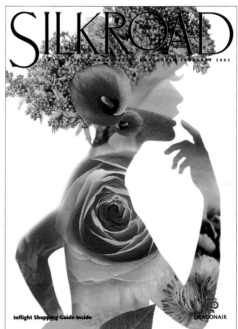

CREATIVE FIRM
People Magazine
New York (New York), USA
CREATIVES
Maddy Miller
CLIENT
People Magazine

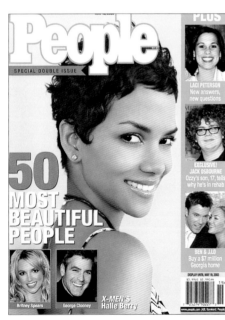

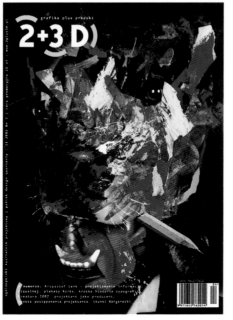

CREATIVE FIRM
Emphasis Media Ltd.
Hong Kong, China
CREATIVES
Alison Lam, Davide Butson
CLIENT
Dragonair

CREATIVE FIRM
KOREK Studio
Warsaw, Poland
CREATIVES
Wojtek Korkuc
CLIENT
Fundacja Rzecz Piekna

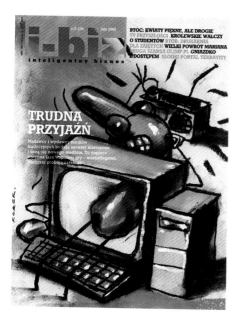

CREATIVE FIRM
KOREK Studio
Warsaw, Poland
CREATIVES
Wojtek Korkuc
CLIENT
VFP Communication

CREATIVE FIRM
Selling Power Magazine
Fredericksburg (Virginia), USA
CREATIVES
Colleen Quinnell, Serge Bloch
CLIENT
Selling Power Magazine

CREATIVE FIRM
Thompson Medical Economics
Montvale (New Jersey), USA
CREATIVES
Irene Brady, Christy Krames
CLIENT
Contemporary Urology

CREATIVE FIRM
Emphasis Media Ltd.
Hong Kong, China
CREATIVES
Percy Chung
CLIENT
Cathay Pacific Airways

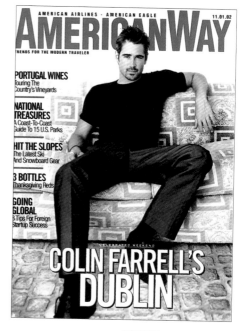

CREATIVE FIRM
Lance Pettiford Design
Washington (D.C.), USA
CREATIVES
Lance A. Pettiford,
Kwaku Alston
CLIENT
Essence Communications

CREATIVE FIRM
American Way Magazine
Ft. Worth (Texas), USA
CREATIVES
Gilberto Mejia, Lorenzo Aguis
CLIENT
American Airlines Publishing

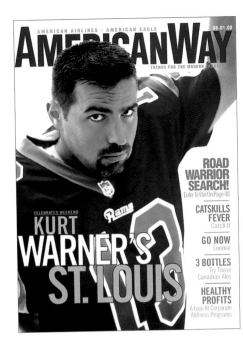

CREATIVE FIRM
American Way Magazine
Ft. Worth (Texas), USA
CREATIVES
Gilberto Mejia, Jesse Frohman
CLIENT
American Airlines Publishing

CREATIVE FIRM
Popular Mechanics
New York (New York), USA
CREATIVES
Bryann Canniff,
Edwin Herder
CLIENT
Popular Mechanics

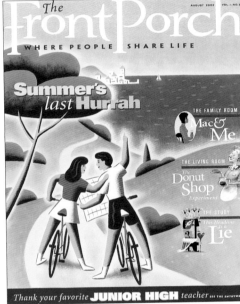

CREATIVE FIRM
Dever Designs
Laurel (Maryland), USA
CREATIVES
Jeffrey L. Dever, Chris Komisar,
Steve Gulbis
CLIENT
The Front Porch Magazine

322

CREATIVE FIRM
Dever Designs
Laurel (Maryland), USA
CREATIVES
Jeffrey L. Dever,
James Endicott
CLIENT
Psychotherapy Networker

CREATIVE FIRM
Popular Mechanics
New York (New York), USA
CREATIVES
Bryann Canniff,
Jim Sugar
CLIENT
Popular Mechanics

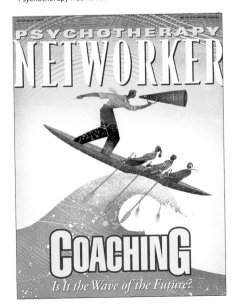

CREATIVE FIRM
Julia Tam Design
Palos Verdes (California), USA
CREATIVES
Julia Tam
CLIENT
Overseas Campus Magazine

CREATIVE FIRM
Dever Designs
Laurel (Maryland), USA
CREATIVES
Jeffrey L. Dever,
Jerzy Kolacz
CLIENT
Psychotherapy Networker

CREATIVE FIRM
Popular Mechanics
New York (New York), USA
CREATIVES
Bryann Canniff,
Paul DiMare
CLIENT
Popular Mechanics

CREATIVE FIRM
Julia Tam Design
Palos Verdes (California), USA
CREATIVES
Julia Tam
CLIENT
Overseas Campus Magazine

CREATIVE FIRM
CSU Fullerton
Fullerton (California), USA
CREATIVES
Jason Bailey,
Arnold Holland
CLIENT
Dimensions Journal/CSUF,NSM

CREATIVE FIRM
Selling Power Magazine
Fredericksburg (Virginia), USA
CREATIVES
Colleen Quinnell,
Michael Aubrecht
CLIENT
Selling Power Magazine

CREATIVE FIRM
KOREK Studio
Warsaw, Poland
CREATIVES
Wojtek Korkuc
CLIENT
VFP Communication

CREATIVE FIRM
Thomson Medical Economics
Montvale (New Jersey), USA
CREATIVES
Nancy Hull, Fred Gambino
CLIENT
Contemporary Pediatrics

CREATIVE FIRM
Thomson Medical Economics
Montvale (New Jersey), USA
CREATIVES
Patrick Gnan, Susan Glaser,
Thomas Darnsteadt
CLIENT
Drug Topics Magazine

CREATIVE FIRM
Thomson Medical Economics
Montvale (New Jersey), USA
CREATIVES
Chris Nurse, Anne Pompeo,
Rona S. Fogel
CLIENT
RN Magazine

CREATIVE FIRM
Thomson Medical Economics
Montvale (New Jersey), USA
CREATIVES
Hans Arentesen, Anne Pompeo,
Rona S. Fogel
CLIENT
RN Magazine

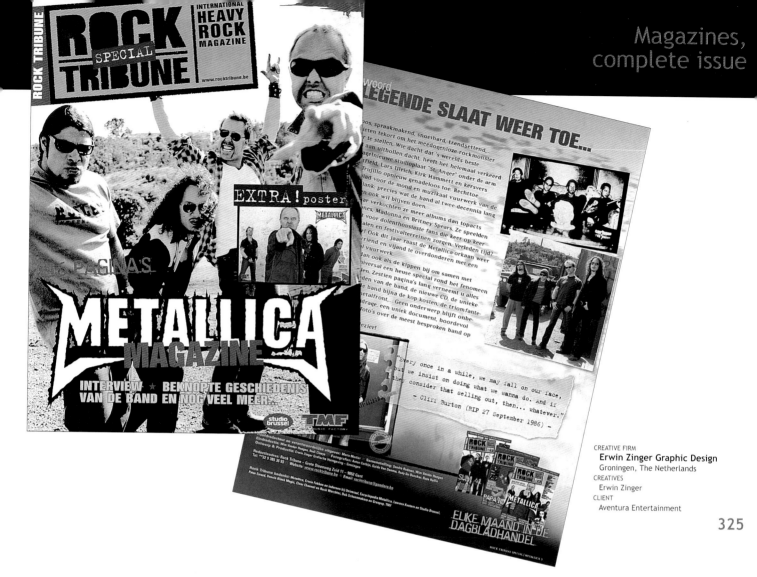

CREATIVE FIRM
Erwin Zinger Graphic Design
Groningen, The Netherlands
CREATIVES
Erwin Zinger
CLIENT
Aventura Entertainment

325

CREATIVE FIRM
Rigdon Graphics, Inc.
Mountain Home (Arkansas), USA
CREATIVES
Jamie Rigdon, Dale McFann
CLIENT
Ozark Mountain Region

326

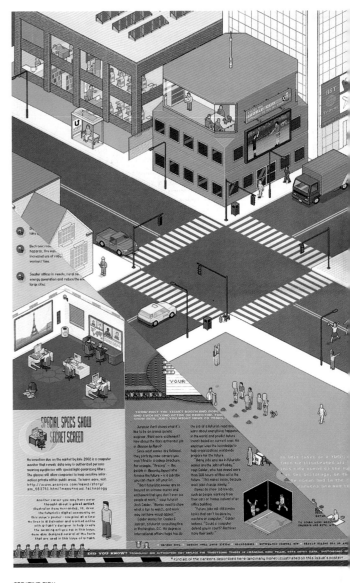

CREATIVE FIRM
Cantor Design, Inc.
New Hope (Pennsylvania), USA
CREATIVES
Andrew Cantor, Paula Cyhan
CLIENT
Bucks Media Group

CREATIVE FIRM
Stacy Thomas
San Antonio (Texas), USA
CREATIVES
Paul Soupiset, Rene Hernandez
CLIENT
USAA

CREATIVE FIRM
Bertz Design Group
Middletown (Connecticut), USA
CREATIVES
Mark Terranova, Richard Uccello
CLIENT
Pratt & Whitney

CREATIVE FIRM
Emphasis Media Ltd.
Hong Kong, China
CREATIVES
Teresita Khaw, Davide Butson
CLIENT
Thai Airways

CREATIVE FIRM
Emphasis Media Ltd.
Hong Kong, China
CREATIVES
Teresita Khaw
CLIENT
Thai Airways

329

CREATIVE FIRM
**Bernhardt Fudyma
Design Group**
New York (New York), USA
CREATIVES
Kristin Reutter
CLIENT
American Express

CREATIVE FIRM
Liquid Agency Inc.
San Jose (California), USA
CREATIVES
Charlotte Jones,
Joshua Swanbeck,
Alfredo Muccino
CLIENT
Seagate

CREATIVE FIRM
Alexander Isley Inc.
Redding (Connecticut), USA
CREATIVES
Alexander Isley, Tara Benyei
CLIENT
The Hearst Corporation

330

CREATIVE FIRM
Bertz Design Group
Middletown (Connecticut), USA
CREATIVES
Andrew Wessels, Chris Hyde
CLIENT
Middlesex Hospital

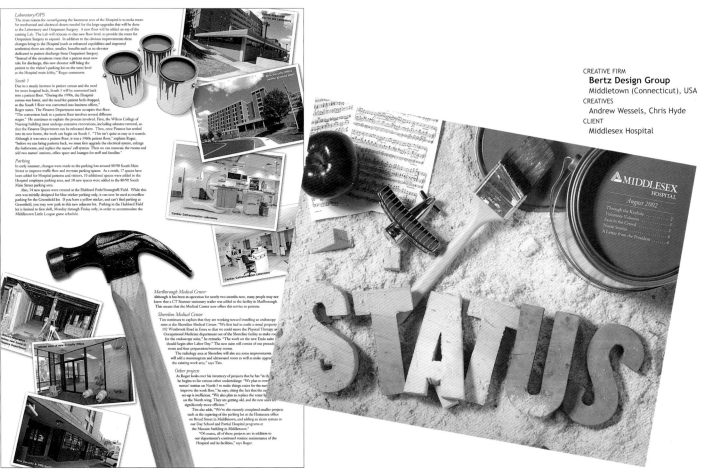